D1487632

1999 Traveler's Guide to Art Museum Exhibitions

Eleventh Anniversary Edition

The Guide "For art lovers who travel, and travelers who love art..." ™

Susan S. Rappaport, Editor & Publisher
Jennifer A. Smith and Amanda Nelson,
Associate Editors

Museum Guide Publications, Inc.™

distributed by
Harry N. Abrams, Inc., Publishers

Front Cover:

Vincent Van Gogh, *Self-Portrait as an Artist,* 1888. From *Van Gogh's Van Goghs: Masterpieces from the Van Gogh Museum, Amsterdam,* a traveling exhibition. Photo courtesy National Gallery of Art, Washington, DC.

National Gallery of Art, Washington, DC: Thru January 3, 1999
Los Angeles County Museum of Art, CA: January 17-April 14, 1999

Acknowledgments

The editors wish to give special thanks to the National Gallery of Art, Washington, DC for the loan of our 11th edition cover image by Vincent Van Gogh, featured in the traveling exhibition; thanks to American Federation of Arts, Art Services International, Curatorial Assistance, Independent Curators Incorporated, Smithsonian Institution Traveling Exhibition Service, and the Trust for Museum Exhibitions for their generous help with the guide; our deepest thanks also to the public relations representatives and curatorial staffs from museums around the world who have shared exhibition and museum information.

ISBN 0-8109-6370-1
Printed in the U.S.A.

Table of Contents

How to Use

The *Traveler's Guide to Art Museum Exhibitions*—the guide for art lovers who travel, and for travelers who love art—is a unique calendar-year index to fascinating national and international exhibitions. It is also a useful and easy reference to the outstanding permanent collections in museums throughout the United States and selected museums in Canada, Europe, Australia, and Japan.

The guide begins with 1999 Major Traveling Exhibitions, where the reader will find exhibitions listed alphabetically, with an itinerary for the entire year. All traveling exhibitions are marked with the symbol (T) in individual museum listings. The individual entries for each museum follow, organized by state (and by city within state) in the United States, and by country in Europe and elsewhere. Each entry includes exhibition schedules for 1999, highlights from permanent collections, a brief architectural history of each museum, as well as hours, admission, and tour schedules. Information about web site addresses, children's programs, and museum cafés and shops is also included.

Every effort has been made to ensure accuracy; however, exhibition dates are subject to change. Be sure to double check by telephoning museums before your visit.

Eleventh Edition—Editor's Choice:

Here we are in 1999—the turn of our century—the end of this millennium. The cover image of the *Traveler's Guide to Art Museum Exhibitions* 11ᵗʰ edition is an intense Van Gogh, *Self Portrait as an Artist*, painted 111 years ago, a central work in **Van Gogh's Van Gogh's: Masterpieces from the Van Gogh Museum, Amsterdam** ... The Guide salutes this museum, the National Gallery in Washington, the Los Angeles County Museum of Art, and the Netherlands Embassy in Washington for organizing the largest survey of work by the artist outside the Netherlands in more than 25 years. Van Gogh, who made more than 700 paintings, sold only one in his short life; yet his work is revered by generations of 20ᵗʰ-century artists and art lovers.

What is notable about this year's offerings?.....The unique Traveling Exhibition Section of the Guide shows that the world is truly a global village—interconnected by cultural dialogue and cultural exchange—as witnessed by the increase of national and international sharing of exhibition venues: **Ancient Gold: Wealth of the Thracians** traveling from Bulgaria to museums throughout the U.S.; **Master Drawings from the Hermitage** at the Morgan Library in New York; **Cindy Sherman's Retrospective** going to Bordeaux, Sydney, and Ontario; **Impressionism: Paintings Collected by European Museums,** from Europe to Atlanta, Seattle, and Denver; and **Mark Rothko** going to the Musée d'Art Moderne de la Ville de Paris.

Is it significant that we are also absorbed by art of the ancients as we enter the new millennium? **Splendors of Ancient Egypt,** in Phoenix and Richmond; **Treasures From the Royal Tombs of Ur,** traveling to Santa Ana, Knoxville, Dallas, and Washington; **Sacred Visions: Early Paintings from Tibet,** at the Metropolitan and then on to the Reitberg in Zürich; **Scythian Gold in the Ukraine,** at San Antonio in November; and **Shamans, Gods, and Mythic Beasts: Columbian Gold and Ceramics in Antiquity,** traveling throughout the U.S.

Then there are overviews of the 20ᵗʰ century as it comes to a close: **Art at the End of the Century** examines the artist as a witness to historical events; **An American Century of Photographs: From Dryplate to Digital** traces the technology of photography; and **Modern Art at the Millennium: the Eye of Duncan Phillips** surveys modern art at the Phillips Collection.

As we wind down our century it is amazing to think back about art in the early 1900s. The Modernism and Cubism of Picasso and Braque were revolutionary—on the cusp of a new style of painting. Would it ever last? It is now mainstream—There is a freedom and diversity of style and culture as seen in the numerous one-person shows and multi-cultural exhibitions of 1999. We're now in the midst of another revolution, a high-tech explosion. It will be exciting to see what new directions artistic expression will take.

Happy museum visiting!

Susan Rappaport, Editor

1999 Major Traveling Exhibitions

El Alma del Pueblo: Spanish Folk Art and its Transformation in the Americas
Chicago Cultural Center, IL: Jan.-Apr.
Crocker Art Museum, Sacramento, CA: May 7-July 3
San Diego Museum of Art, CA: Aug.-Oct.

An American Century of Photography: From Dryplate to Digital
The Phillips Collection, Washington, DC: Jan. 23-Mar. 28
Seattle Art Museum, WA: Sept. 30, 1999-Jan. 2, 2000

American Glass: Masters of the Art
Springfield Museum of Fine Arts, MA: Mar. 6-May 16
Huntsville Museum of Art, AL: June 5-Aug. 15

Ancient Gold: The Wealth of the Thracians, Treasures from the Republic of Bulgaria
New Orleans Museum of Art, LA:
Thru Jan. 4
Memphis Brooks Museum of Art, TN:
Jan. 17-Mar. 14
Museum of Fine Arts, Boston, MA:
Apr. 2-June 6
Detroit Institute of Arts, MI: June 27-
Aug. 29

Ancient Gold Jewelry
Minneapolis Institute of Arts, MN:
Thru Mar. 7
Dallas Museum of Art, TX: May 30-
Sept. 5

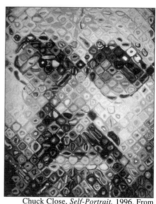

Chuck Close, *Self-Portrait*, 1996. From
Chuck Close, a retrospective. Photo
courtesy Seattle Art Museum.

Architecture of Reassurance: Designing the Disney Theme Parks:
Cooper-Hewitt Museum, NY: Thru Jan. 19
Modern Art Museum, Ft. Worth, TX: Feb. 13-Apr. 11

Art at the End of the Century: Contemporary Art from the Milwaukee Art Museum
Birmingham Art Museum, AL: Jan. 31-Apr. 4
Akron Art Museum, OH: June 19-Sept. 5

Art of the Gold Rush
National Museum of American Art, DC: Thru Mar. 7
Bowers Museum of Cultural Art, Santa Ana, CA: Apr. 17-June 6

Artist/Author: The Book as Art Since 1980
Museum of Contemporary Art, Chicago, IL: Thru Feb. 14
Lowe Art Museum, Coral Gables, FL: Feb. 18-Apr. 4

The Arts of the Sikh Kingdoms
Victoria & Albert Museum, London, England: Mar. 25-July 25
Asian Art Museum of San Francisco, CA: Sept. 22, 1999-Jan. 9, 2000

Audubon's Wilderness Palette: The Birds of Canada
Vancouver Art Gallery, Canada: Thru Jan. 24
Musée des Beaux-Arts de Montréal, Canada: Sept. 9-Nov. 7

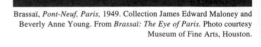

Francis Bacon: A Retrospective Exhibition

Brassaï, *Pont-Neuf, Paris,* 1949. Collection James Edward Maloney and Beverly Anne Young. From *Brassaï: The Eye of Paris.* Photo courtesy Museum of Fine Arts, Houston.

Museum Boijmans van Beuningen, Rotterdam, Netherlands: Thru Jan. 10
Yale Center for British Art, New Haven, CT: Jan. 23-Mar. 21
Minneapolis Institute of Arts, MN: Apr. 11-May 30
Calif. Palace of the Legion of Honor, San Francisco, CA: June 13-Aug. 2
Modern Art Museum, Ft. Worth, TX: Aug. 22-Oct. 24

Baule: African Art/Western Eyes
Museum for African Art, NY: Thru Jan.
National Museum of African Art, Washington, DC: Feb. 7-May 9

Beads, Body, and Soul: Art and Light in the Yoruba Universe
Michael C. Carlos Museum, Atlanta, GA: Feb. 6-Apr. 11
Miami Art Museum, FL: June 25-Aug. 29

Bearing Witness: Contemporary Works by African-American Women Artists
Gibbes Museum of Art, Charleston, SC: Thru Jan. 7
Portland Museum of Art, ME: Apr. 6-May 30
Museum of Fine Arts, Houston, TX: June 20-Aug. 15

Max Beckmann in Paris
Kunsthaus Zürich, Switzerland: Thru Jan. 3
St. Louis Art Museum, MO: Feb. 6-May 9

Bernini's Rome: Italian Baroque Terracottas from The State Hermitage Museum, St. Petersburg
National Gallery of Art, Washington, DC: Thru Jan. 3
State Hermitage Museum, St. Petersburg, Russia: Opens Nov. 1999

Joseph Beuys Multiples
Irish Museum of Modern Art, Dublin, Ireland: May 9-July 25
Barbican Art Gallery, London, England: Oct.-Dec.

Brassaï: The Eye of Paris
Museum of Fine Arts, Houston, TX: Thru Feb. 28
The J. Paul Getty Museum, Los Angeles, CA: Apr. 13-July 4
National Gallery of Art, Washington, DC: Oct. 17, 1999-Jan. 16, 2000

Sir Edward Burne-Jones
Birmingham Museums and Art Gallery, England: Thru Jan. 17
Musée d'Orsay, Paris, France: Mar. 4-June 6

Julia Margaret Cameron's Women
Art Institute of Chicago, IL: Thru Jan. 10
Museum of Modern Art, NY: Jan. 28-May 4
San Francisco Museum of Modern Art, CA: Aug. 27-Nov. 30

Mary Cassatt
Art Institute of Chicago, IL: Thru Jan. 3
Museum of Fine Arts, Boston, MA: Feb. 14-May 9
National Gallery of Art, Washington, DC: June 6-Sept. 6

Catherine the Great and Gustav III
Nationalmuseum, Stockholm, Sweden: Thru Feb. 28
State Hermitage Museum, St. Petersburg, Russia: Apr. 27-Sept. 12

The Cecil Family Collects: Four Centuries of Decorative Arts from Burghley House

Cincinnati Art Museum, OH: Thru Jan. 17
Society of the Four Arts, Palm Beach, FL: Feb. 13-Apr. 7
New Orleans Museum of Art, LA: May 8-July 4
Santa Barbara Museum of Art, CA: July 31-Oct. 10
Lakeview Museum, Peoria, IL: Nov. 6, 1999-Jan. 2, 2000

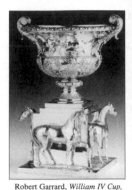

Robert Garrard, *William IV Cup,* 1832. From *The Cecil Family Collects: Four Centuries of Decorative Arts from Burghley House.* Photo courtesy Cincinnati Art Museum and Art Services International.

Chagall, Kandinsky and the Russian Avant-Garde

Hamburger Kunsthalle, Germany: Thru Jan. 3
Kunsthaus Zürich, Switzerland: Jan. 29-Apr. 25

Chokwe!

Birmingham Museum of Art, AL: Thru Jan. 3
Baltimore Museum of Art, MD: June 13-Sept. 5
Minneapolis Institute of Arts, MN: Oct. 24, 1999-Jan. 16, 2000

Chuck Close

Hirshhorn Museum, Washington, DC: Thru Jan. 10
Seattle Art Museum, WA: Feb. 18-May 9

Robert Colescott: Recent Paintings, 47th Venice Biennale

Univ. of Arizona Museum of Art, Tucson, AZ: Thru Jan. 3
Portland Art Museum, OR: Jan. 15-Mar. 21
Berkeley Art Museum, CA: May 12-Aug. 29
Sheldon Memorial Art Gallery, Lincoln, NE: Sept. 24, 1999-Jan. 2, 2000

Collaborations: William Allan, Robert Hudson, William Wiley

Museum of Art, Washington State Univ., Pullman: Jan. 11-Feb. 21
Scottsdale Museum of Contemporary Art, AZ: Apr. 3-June 13

The Collection of Dr. Gachet

Musée d'Orsay, Paris, France: Jan. 27-Apr. 25
Metropolitan Museum of Art, NY: May 25-Aug. 15

Contemporary Japanese Textiles
Museum of Modern Art, NY: Thru Jan. 26
St. Louis Art Museum, MO: June 19-Aug. 15

Copper as Canvas: Two Centuries of Masterpiece Paintings on Copper, 1575-1775
Phoenix Art Museum, AZ: Thru Feb. 28
Nelson-Atkins Museum of Art, Kansas City, MO: Mar. 28-June 6
Mauritshuis, The Hague, Netherlands: June 26-Aug. 22

Joseph Cornell/Marcel Duchamp: In Resonance
Philadelphia Museum of Art, PA: Thru Jan. 3
The Menil Collection, Houston, TX: Jan. 29-May 16

John Steuart Curry: Inventing the Middle West
Nelson-Atkins Museum, Kansas City, MO: Thru Jan. 3 (Last venue)

Honoré Daumier
National Gallery of Canada, Ottawa: June 3-Sept. 6
Galeries Nationales du Grand Palais, Paris, France: Oct. 9, 1999-Jan. 2, 2000

Robert Colescott, *El Tango*, 1995. From *Robert Colescott: Recent Paintings, 47th Venice Biennale.* Photo courtesy Sheldon Memorial Art Gallery.

Roy DeCarava: A Retrospective
Corcoran Gallery of Art, Washington, DC: Thru Jan. 4
Minneapolis Institute of Arts, MN: Feb. 13-Apr. 25

Edgar Degas, Photographer
Metropolitan Museum of Art, NY: Thru Jan. 3
J. Paul Getty Museum, Los Angeles, CA: Feb. 2-Mar. 28
Bibliothèque Nationale, Paris, France: May 11-July 31

Delacroix: The Late Work
Philadelphia Museum of Art, PA: Thru Jan. 3 (Last venue)

The Art of Photographer Jack Delano
El Museo del Barrio, NY: Thru Feb.
Orlando City Hall Terrace Gallery, FL: Sept. 25-Nov. 21

Designed for Delight: Alternative Aspects of 20th-Century Decorative Arts
Virginia Museum of Fine Arts, Richmond: Thru Jan. 31
Speed Art Museum, Louisville, KY: Mar. 8-May 23
Die Neue Sammlung, Munich, Germany: July-Sept.

Richard Diebenkorn
San Francisco Museum of Modern Art, CA: Thru Jan. 19 (Last venue)

Down From the Shimmering Sky: Masks of the Northwest Coast
McMichael Canadian Art Collection, Ontario, Canada: Thru Feb. 28
Portland Art Museum, OR: Apr. 9-July 11
Gilcrease Museum, Tulsa, OK: Aug. 27-Nov. 7
National Museum of the American Indian, NY: Dec. 1999-Mar. 15, 2000

Raoul Dufy
Musée des Beaux-Arts de Lyon, France: Jan. 28-Apr. 18
Museu Picasso, Barcelona, Spain: Apr. 29-July 11

Raoul Dufy: Last of the Fauves
Norton Museum of Art, West Palm Beach, FL: Mar. 27-June 6
Dixon Gallery, Memphis, TN: June 27-Sept. 5
New Orleans Museum of Art, LA: Oct. 2-Nov. 21
McNay Art Museum, San Antonio, TX: Dec. 8, 1999-Feb. 26, 2000

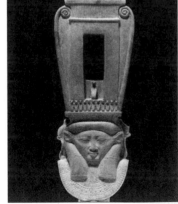

Sistrum, Egyptian Dynasty 26 (c. 664-525 B.C.). From *Gifts of the Nile: Ancient Egyptian Faience.* Photo by Del Bogart, courtesy Museum of Art, Rhode Island School of Design.

The Work of Charles and Ray Eames: A Legacy of Invention
The Design Museum, London, England: Thru Jan. 3
Library of Congress, Washington, DC: May 20-Sept. 4
Cooper-Hewitt Museum, NY: Oct. 12, 1999-Jan. 9, 2000

Max Ernst Retrospective
Haus der Kunst, Munich, Germany: June 11-Sept. 19

M.C. Escher: A Centennial Tribute
San Diego Museum of Art, CA: Thru Jan. 3
Chrysler Museum of Art, Norfolk, VA: Feb. 5-May 2

The Flag in American Indian Art
Houston Museum of Natural Science, TX: Thru Mar. 14
Sheldon Memorial Art Gallery, Lincoln, NE: July 3-Aug. 29

Sigmund Freud: Conflict and Culture
Library of Congress, Washington, DC: Thru Jan. 16
Jewish Museum, NY: Apr. 18-Sept. 9
Sigmund Freud Museum, Vienna, Austria: Oct. 21, 1999-Feb. 10, 2000
Austrian National Library, Vienna, Austria: Oct. 21, 1999-Feb. 10, 2000

Anna Gaskell
Museum of Modern Art, Oxford, England: Apr. 18-June 27
Astrup Fearnley Museum of Modern Art, Oslo, Norway: Aug. 19-Sept. 26

Gifts of the Nile: Ancient Egyptian Faience
Rhode Island School of Design, Providence, RI: Thru Jan. 3
Kimbell Art Museum, Ft. Worth, TX: Jan. 31-Apr. 25

A Grand Design: The Art of the Victoria & Albert Museum
Museum of Fine Arts, Houston, TX: Thru Jan. 10
Calif. Palace of the Legion of Honor, San Francisco, CA: Feb. 13-May 9
Victoria & Albert Museum, London, England: Oct. 1999-Jan. 2000

The Great American Pop Art Store: Multiples of the Sixties
Wichita Art Museum, KS: Apr. 11-June 6
McNay Art Museum, Ft. Worth, TX: Jan. 19-Mar. 14
Joslyn Art Museum, Omaha, NE: Oct. 23, 1999-Jan. 9, 2000

The Great Experiment: George Washington and the American Republic
Huntington Library, San Marino, CA: Thru May 30
Pierpont Morgan Library, NY: Sept. 16, 1999-Jan. 2, 2000

Andreas Gursky
Contemporary Arts Museum, Houston, TX: Thru Jan. 3
Columbus Art Museum, OH: Jan. 22-Mar. 28

Half Past Autumn: The Art of Gordon Parks

Milwaukee Art Museum, WI: Thru Jan. 10
Detroit Institute of Arts, MI: Feb. 7-Apr. 25
Norton Museum of Art, West Palm Beach, FL: Oct. 28, 1999-Jan. 9, 2000

Philippe Halsman: A Retrospective

National Portrait Gallery, Washington, DC: Thru Feb. 7
Grand Rapids Art Museum, MI: Aug. 17-Oct. 17
Toledo Museum of Art, OH: Nov. 1999-Jan. 2000

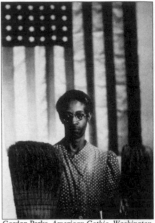

Gordon Parks, *American Gothic, Washington, D.C.,* 1942. From *Half Past Autumn: The Art of Gordon Parks,* a traveling exhibition. Photo courtesy Corcoran Gallery of Art, Washington, D.C.

Duane Hanson

Whitney Museum of American Art, NY: Thru Mar. 21
Memphis Brooks Museum of Art, TN: Apr. 18-June 13

David Hockney

Musée National d'Art Moderne, Centre Georges Pompidou, Paris, France: Jan. 27-Apr. 26
Kunst-und-Austellungshalle, Bonn, Germany: May 28-Sept. 12

The Huguenot Legacy: English Silver 1680-1760

Cooper-Hewitt Museum, NY: Apr. 27-Aug. 8
Indianapolis Museum of Art, IN: Sept. 19-Nov. 28

Images of the Spirit: Photographs by Graciela Iturbide

San Jose Museum of Art, CA: Feb. 28-May 4
Mexican Fine Arts Center Museum, Chicago, IL: May 21-Aug. 29

Impressionism: Paintings Collected by European Museums

High Museum of Art, Atlanta, GA: Feb. 27-May 16
Seattle Art Museum, WA: June 12-Aug. 29
Denver Art Museum, CO: Oct. 2-Dec. 12

Impressionists in Winter: Effets de Neige

The Phillips Collection, Washington, DC: Thru Jan. 3
Yerba Buena Center for the Arts, San Francisco, CA: Jan. 30-May 2

India: A Celebration of Independence, 1947–1997
Knoxville Museum of Art, TN: Thru Feb. 28
Montgomery Museum of Fine Arts, AL: Apr. 2-June 13
Chicago Cultural Center, IL:
Oct. 30-Dec. 30

Portraits by Ingres: Image of an Epoch
National Gallery, London,
England: Jan. 27-Apr. 25
National Gallery of Art,
Washington, DC: May 23-Aug. 22
Metropolitan Museum of Art,
NY: Sept. 27, 1999-Jan. 2, 2000

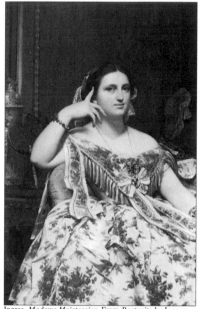

Ingres, *Madame Moistessier.* From *Portraits by Ingres: Image of an Epoch.* Photo courtesy National Gallery, London.

Innuendo Non Troppo: The Work of Gregory Barsamian
Arkansas Art Center, Little Rock, AR: Jan. 22-Mar. 28
Polk Museum of Art, Lakeland, FL: Apr. 17-June 27
Anderson Gallery, Richmond, VA: Aug. 15-Oct. 31
Boise Art Museum, ID: Dec. 4, 1999-Feb. 28, 2000

Inside Out: New Chinese Art
Asia Society, NY: Thru Jan. 3
P.S. 1, Long Island City, NY: Thru Jan. 4
San Francisco Museum of Modern Art, CA: Feb. 25-June 1
Asian Art Museum of San Francisco, CA: Feb. 25-May 30
Museo de Arte Contemporaneo, Monterrey, Mexico: July 9-Oct. 10
Tacoma Art Museum, WA: Nov. 18, 1999-Mar. 7, 2000
Henry Art Gallery, Seattle, WA: Nov. 18, 1999-Mar. 7, 2000

The Invisible Made Visible: Angels from the Vatican Collection
Walters Art Gallery, Baltimore, MD: Thru Jan. 3
Norton Museum of Art, West Palm Beach, FL: Jan. 23-Apr. 4
Art Gallery of Ontario, Toronto, Canada: Apr. 27-June 20

Isaac Israëls
Kunsthal Rotterdam, Netherlands: Sept. 4-Nov. 28
Kröller-Müller Museum, Otterlo, Netherlands: Autumn-Winter 1999

Jasper Johns: Process and Printmaking
Philadelphia Museum of Art, PA: Jan. 23-Apr. 4 (Last venue)

William H. Johnson: Truth Be Told
Montclair Art Museum, NJ: Thru Jan. 10
Arkansas Art Center, Little Rock, AR: Feb. 5-Apr. 25

Ellsworth Kelly: The Early Drawings, 1948-1955
Harvard University Art Museums, Cambridge, MA: Mar. 6-May 16
High Museum of Art, Atlanta, GA: June 12-Aug. 15
Art Institute of Chicago, IL: Sept. 11-Dec. 5

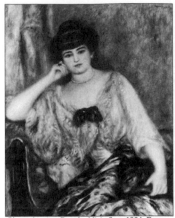

Pierre-Auguste Renoir, *Misia Sert,* 1904. From *Impresssionism: Paintings Collected by European Museums.* Photo courtesy National Gallery, London and High Museum of Art, Atlanta.

The Kingdoms of Edward Hicks
Abby Aldrich Rockefeller Folk Art Center, Williamsburg, VA: Feb. 7-Sept. 6
Philadelphia Museum of Art, PA: Oct. 10, 1999-Jan. 2, 2000

Land of the Winged Horsemen: Poland, 1572-1764
Walters Art Gallery, Baltimore, MD: Mar. 3-May 9
Art Institute of Chicago, IL: June 5-Sept. 5
Huntsville Museum of Art, AL: Sept. 25-Nov. 28
San Diego Museum of Art, CA: Dec. 18, 1999-Feb. 27, 2000

Maya Lin: Topologies
Des Moines Art Center, IA: Feb. 20-May 23
Contemporary Arts Museum, Houston, TX: July 17-Sept. 12

Brice Marden: Works of the 1990s
Dallas Museum of Art, TX: Feb. 14-Apr. 25
Hirshhorn Museum, Washington, DC: June 17-Sept. 12
Miami Art Museum, FL: Dec. 1999-Mar. 2000

Master Drawings from the Worcester Art Museum
Univ. of Michigan Museum of Art, Ann Arbor: Thru Jan. 17
Davenport Museum of Art, IA: Feb. 7-Apr. 4
Michael C. Carlos Museum, Atlanta, GA: May 8-July 11

Mexican Prints from the Collection of Reba and Dave Williams

Cleveland Museum of Art, OH: Mar. 14-May 23
Spencer Museum of Art, Lawrence, KS: Aug. 21-Oct. 17 (Last venue)

Jean-François Millet: The Painter's Drawings

Clark Art Institute, Williamstown, MA: June 18-Sept. 5
Van Gogh Museum, Amsterdam, Netherlands: Oct. 26, 1999-Jan. 4, 2000

Modotti and Weston: Mexicanidad

Joslyn Art Museum, Omaha, NE: May 1-June 27
Dayton Art Institute, OH: Aug. 7-Oct. 3

Monet at Giverny: Masterpieces from the Musée Marmottan

Portland Art Museum, OR: Thru Jan. 1
Musée des Beaux-Arts de Montréal, Canada: Jan. 28-May 9
Albright-Knox Art Gallery, Buffalo, NY: May 23-Aug. 9
Phoenix Art Museum, AZ: Sept. 18, 1999-Jan. 2, 2000

Gustave Moreau

Galeries Nationales du Grand Palais, Paris, France: Thru Jan. 4
Art Institute of Chicago, IL: Feb. 13-Apr. 25
Metropolitan Museum of Art, NY: June 1-Aug. 22

William Sidney Mount: American Genre Painter

Frick Art Museum, Pittsburgh, PA: Thru Jan. 10
Amon Carter Museum, Ft. Worth, TX: Feb. 5-Apr. 4 (Last venue)

Alphonse Mucha: The Flowering of Art Nouveau

Norton Museum of Art, West Palm Beach, FL: Thru Jan. 7
North Carolina Museum of Art, Raleigh, NC: Jan. 31-Mar. 28
Philbrook Museum of Art, Tulsa, OK: Apr. 24-June 20
Nevada Museum of Art, Reno, NV: July 8-Sept. 26
Worcester Art Museum, MA: Oct. 16, 1999-Jan. 2, 2000

Gabriel Münter: The Years of Expressionism, 1903-1920

McNay Art Museum, San Antonio, TX: Thru Jan. 3 (Last venue)

Odd Nerdrum: Two Decades

Astrup Fearnley Museum of Modern Art, Oslo, Norway: Thru Jan. 3
Kunsthal Rotterdam, Netherlands: Jan. 16-Mar. 28

New Worlds from Old: Australian and American Landscape Painting of the 19th Century
Wadsworth Athenaeum, CT: Thru Jan. 3
Corcoran Gallery of Art, Washington, DC: Jan. 27-Apr. 20

Nineteenth Century Dutch Watercolors and Drawings from the Museum Boijmans van Beuningen, Rotterdam
Columbia Museum of Art, SC: Jan. 16-Mar. 21
Grand Rapids Art Museum, MI: Apr. 16-Aug. 15 (Last venue)

Georgia O'Keeffe: The Artist's Landscape: Photographs by Todd Webb
Museum of Fine Art, St. Petersburg, FL: Thru Jan. 10
C.S. Art Galleries, Univ. of Boulder, CO: Jan. 29-Mar. 20

Georgia O'Keeffe: The Poetry of Things
The Phillips Collection, Washington, DC: Apr. 17-July 18
Georgia O'Keeffe Museum, Santa Fe, NM: Aug. 14-Oct. 10
Dallas Museum of Art, TX: Oct. 30, 1999-Jan. 30, 2000

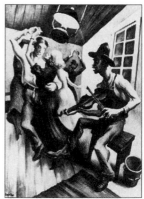

On the Road with Thomas Hart Benton: Images of a Changing America
Minnesota Museum of American Art, St. Paul, MN: Thru Feb. 14
Springfield Museum of Fine Arts, MA: Nov. 14, 1999-Jan. 9, 2000

Thomas Hart Benton, *I Got a Gal on Sourwood Mountain,* 1938. From *On the Road with Thomas Hart Benton: Images of a Changing America.* Photo courtesy Springfield Museum of Fine Arts.

Our Nation's Colors: A Celebration of American Masters
Davenport Museum of Art, IA: Thru Jan. 10 (Last venue)

Tony Oursler
Williams College Museum of Art, Williamstown, MA: Apr. 17-Oct.
Contemporary Arts Museum, Houston, TX: Nov. 1999-Feb. 2000

The Painted Sketch: Impressions from Nature, 1830-1880
Corcoran Gallery of Art, Washington, DC: Thru Jan. 10
Clark Art Institute, Williamstown, MA: Feb. 13-May 9

Maxfield Parrish: 1870-1966
Pennsylvania Academy of Fine Arts, Philadelphia, PA: June 19-Sept. 26
Currier Gallery of Art, Manchester, NH: Nov. 26, 1999-Jan. 23, 2000

Raymond Pettibon
Drawing Center, NY: Feb. 21-Apr. 11
Philadelphia Museum of Art, PA: May 2-June 27
Museum of Contemporary Art, Los Angeles, CA: Sept. 26, 1999-Jan. 2, 2000

Maxfield Parrish, *Princess Parizade Bringing Home the Singing Tree.* From *Maxfield Parrish: 1870-1966.* Photo courtesy Pennsylvania Academy of the Fine Arts.

Picasso and the War Years: 1937-1945
Calif. Palace of the Legion of Honor, San Francisco, CA: Thru Jan. 3
Solomon R. Guggenheim Museum, NY: Feb. 5-May 9
Museo Guggenheim Bilbao, Spain: TBD

Jackson Pollock
Museum of Modern Art, NY: Thru Feb. 2
Tate Gallery, London, England: Mar. 11-June 6

Posters American Style
Oakland Museum, CA: June 12-Aug. 15 (Last venue)

The Printed World of Pieter Breughel the Elder
Middlebury College Museum of Art, VT: Jan. 8-Mar. 7
Bayly Art Museum, Charlottesville, VA: Mar. 26-May 23
Mitchell Gallery, St. John's College, Annapolis, MD: Sept. 17-Nov. 14
Memphis Brooks Museum of Art, TN: Dec. 12, 1999-Feb. 6, 2000

Robert Rauschenberg: A Retrospective
Museo Guggenheim Bilbao, Spain: Thru Mar. 7 (Last venue)

Charles Ray
Museum of Contemporary Art, Los Angeles, CA: Thru Mar. 14
Museum of Contemporary Art, Chicago, IL: June 19-Sept. 12

David Reed Paintings: Motion Pictures
Museum of Contemporary Art, San Diego, CA: Thru Jan. 3
Wexner Center for the Arts, Columbus, OH: Jan. 30-Apr. 18

Rembrandt: By Himself
National Gallery, London, England: June 9-Sept. 5
Mauritshuis, The Hague, Netherlands: Sept. 25, 1999-Jan. 9, 2000

Rembrandt: Treasures from the Rembrandt House, Amsterdam
Georgia Museum of Art, Athens, GA: Thru Jan. 10
Taft Museum, Cincinnati, OH: Apr. 16-June 13

A Renaissance Treasury: The Flagg Collection of European Decorative Arts and Sculpture
Smith College Museum of Art, Northampton, MA: Thru Mar. 14
Honolulu Academy of Arts, HI: Apr. 29-June 20
Memphis Brooks Museum of Art, TN: July 11-Sept. 12
Cantor Center for Visual Arts, Stanford University, CA: Oct. 12, 1999-Jan. 2, 2000

Rhapsodies in Black: Art of the Harlem Renaissance
Museum of Fine Arts, Houston, TX: Thru Feb. 14 (Last venue)

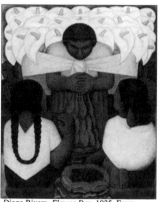

Diego Rivera, *Flower Day*, 1925. From *Diego Rivera: Art and Revolution*. Photo courtesy Los Angeles County Museum of Art, Los Angeles County Fund.

Diego Rivera: Art and Revolution
Cleveland Museum of Art, OH: Feb. 14-May 2
Los Angeles County Museum of Art, CA: May 30-Aug. 16
Dallas Museum of Art, TX: Sept. 12-Nov. 28

Roads Less Traveled: American Paintings 1833-1935
Birmingham Museum of Art, AL: May 2-July 4
Tucson Museum of Art, AZ: Oct. 2-Nov. 28

Alexander Rodchenko (1891-1956)
Kunsthalle Düsseldorf, Germany: Thru Jan. 24
Moderna Museet, Stockholm, Sweden: Mar. 6-May 24

Rodin's Monument to Victor Hugo
Los Angeles County Museum of Art, CA: Thru Mar.
Portland Art Museum, OR: May 14-July 11

Rodin: Sculpture from the Iris and B. Gerald Cantor Collection
Speed Art Museum, Louisville, KY: Thru Jan. 31
Palm Springs Desert Museum, CA: Feb. 17-May 16
Newark Museum, NJ: June 4-Aug. 15

Mark Rothko
Musée d'Art Moderne de la Ville de Paris, France: Jan. 8-Apr. 18 (Last venue)

Royal Persian Paintings: The Qajar Epoch, 1785-1925
Brooklyn Museum of Art, NY: Thru Jan. 24
UCLA Armand Hammer Museum, Los Angeles, CA: Feb. 24-May 9

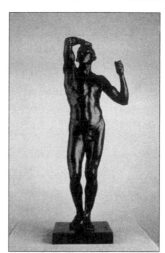

Auguste Rodin, *The Age of Bronze,* 1876. From *Rodin: Sculpture from the Iris and B. Gerald Cantor Collection.* Photo courtesy Iris and B. Gerald Cantor Foundation and Speed Art Museum.

Sacred Visions: Early Paintings from Tibet
Metropolitan Museum of Art, NY: Thru Jan. 17
Reitberg Museum, Zürich, Switzerland: Opens Feb.

John Singer Sargent
Tate Gallery, London, England: Thru Jan. 17
National Gallery of Art, Washington, DC: Feb. 21-May 31
Museum of Fine Arts, Boston, MA: June 23-Sept. 26

Scythian Gold in the Ukraine: Treasures from Ancient Ukraine
San Antonio Museum of Art, TX: Nov. 7, 1999-Jan. 30, 2000
Other venues to be announced in 2000

Searching for Ancient Egypt
Joslyn Art Museum, Omaha, NE: Mar. 27-July 25
Birmingham Museum of Art, AL: Oct. 3, 1999-Jan. 16, 2000

Seeing Jazz
Munson-Williams-Proctor Institute, Utica, NY: Thru Jan. 3
Hunter Museum of American Art, Chattanooga, TN: Jan. 23-Apr. 4
Huntington Museum of Art, WV: Apr. 24-July 4
Museum of the Southwest, Midland, TX: July 24-Oct. 3

Self-Taught Artists of the Twentieth Century: An American Anthology
Amon Carter Museum, Ft. Worth, TX: Thru Jan. 24
Modern Art Museum, Ft. Worth, TX: Thru Jan. 24
Memorial Art Gallery, Univ. of Rochester, NY: Feb. 21-Apr. 18
Wexner Center for the Arts, Columbus, OH: May 15-Aug. 15
Museum of American Folk Art, NY: Sept. 19-Dec. 11

Richard Serra
Museum of Contemporary Art, Los Angeles, CA: Thru Jan. 3
Museo Guggenheim Bilbao, Spain: Spring

Common Man, Mythic Vision: The Paintings of Ben Shahn
Jewish Museum, NY: Thru Mar. 7
Allentown Art Museum, PA: Mar. 28-June 27
Detroit Institute of Arts, MI: July 25-Oct. 31

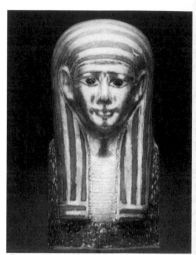

Shamans, Gods, and Mythic Beasts: Columbian Gold and Ceramics in Antiquity
Michael C. Carlos Museum, Atlanta, GA: Thru Jan. 10
Mingei International Museum, La Jolla, CA: Jan. 29-Apr. 11
Orlando Museum of Art, FL: Apr. 30-July 11

Funerary Mask, c. 300 B.C. From *Searching for Ancient Egypt.* Photo courtesy Joslyn Art Museum.

Frick Art Museum, Pittsburgh, PA: July 29-Oct. 10
Bowers Museum of Cultural Art, Santa Ana, CA: Oct. 29, 1999-Jan. 9, 2000

Cindy Sherman: Retrospective
CACP Musée d'Art Contemporain, Bordeaux, France: Feb. 6-Apr. 25
Museum of Contemporary Art, Sydney, Australia: June 4-Aug. 29
Art Gallery of Ontario, Toronto, Canada: Oct. 1, 1999-Jan. 2, 2000

Silver and Gold: Cased Images of the California Gold Rush
National Museum of American Art, DC: Thru Mar. 7
Crocker Art Museum, Sacramento, CA: Aug. 13-Oct. 10

Sinners and Saints, Darkness and Light: Caravaggio and His Dutch and Flemish Followers
Milwaukee Art Museum, WI: Jan. 29-Apr. 18
Dayton Art Institute, OH: May 8-July 18

Sandy Skoglund: Reality Under Seige
Columbia Museum of Art, SC: Thru Jan. 3
Toledo Museum of Art, OH: Feb. 14-May 2
Delaware Art Museum, Wilmington: June 4-Aug. 1
Jacksonville Museum of Contemporary Art, FL: Sept. 10-Nov. 7

Sorolla and The Hispanic Society of America: A Vision of Spain at the Turn of the Century
Fundación Collección Thyssen-Bornemisza, Madrid, Spain: Thru Jan. 17
Valencia Fine Arts Museum, San Pío V, Spain: Feb. 10-May 9

Soul of Africa: African Art from the Han Coray Collection
Toledo Museum of Art, OH: Thru Jan. 3
Carnegie Museum of Art, Pittsburgh, PA: May 1-July 11
Joslyn Art Museum, Omaha, NE: Nov. 20, 1999-Jan. 30, 2000

Chaim Soutine: 1913-1943
Los Angeles County Museum of Art, CA: Thru Jan. 3
Cincinnati Art Museum, OH: Feb. 21-May 2

Splendors of Ancient Egypt
Phoenix Art Museum, AZ: Thru Mar. 27
Virginia Museum of Fine Arts, Richmond, VA: May 28-Nov. 28 (Last venue)

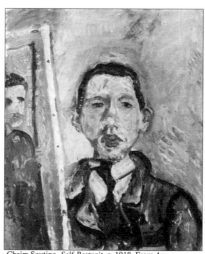

Chaim Soutine, *Self-Portrait*, c. 1918. From *An Expressionist in Paris: The Paintings of Chaim Soutine.* Photo courtesy The Jewish Museum, New York.

Frank Stella and Tyler Graphics
Addison Gallery of American Art, Andover, MA: Thru Jan. 3
Jacksonville Museum of Contemporary Art, FL: Mar. 14-Apr. 26

A Taste for Splendor: Treasures from the Hillwood Museum
Huntsville Museum of Art, AL: Thru Feb. 7
Kalamazoo Institute of Arts, MI: Feb. 27-May 9
San Antonio Museum of Art, TX: May 29-Aug. 8
Dixon Gallery, Memphis, TN: Sept. 19-Nov. 28

James Tissot
Yale Center for British Art, New Haven, CT: Sept. 22-Nov. 22
Musée du Québec, Canada: Dec. 15, 1999-Mar. 12, 2000

To Conserve a Legacy: American Art from Historically Black Colleges and Universities
Studio Museum in Harlem, NY: Mar. 10-June 27
Addison Gallery of American Art, Andover, MA: July-Oct.
Corcoran Gallery of Art, Washington, DC: Nov. 1999-Jan. 2000

Trashformations: Recycled Materials in American Art and Design
Knoxville Museum of Art, TN: Thru Jan. 10
Boise Art Museum, ID: Feb. 13-Apr. 25
Anchorage Museum of History and Art, AK: Nov. 7, 1999-Jan. 2, 2000

Traveling Companions: Monet and Seurat
Glasgow Museum & Art Gallery, Scotland: Thru Jan. 31
Worcester City Museum & Art Gallery, England: Feb. 5-Mar. 21
Castle Museum & Art Gallery, Nottingham, England: Mar. 26-May 23

Treasures of Deceit: Archeology and the Forger's Craft
Memphis Brooks Museum of Art, TN: Thru Jan. 17
Lowe Art Museum, Coral Gables, FL: Feb. 18-Apr. 4
Springfield Museum of Fine Arts, MA: July 7-Aug. 22

Treasures of the Royal Tombs of Ur
Bowers Museum, Santa Ana, CA: Thru Jan. 3
Frank H. McClung Museum, Knoxville, TN: Feb. 6-May 9
Dallas Museum of Art, TX: May 30-Sept. 5
Arthur M. Sackler Gallery, Washington, DC: Oct. 17, 1999-Jan. 17, 2000

Rosemarie Trockel
Whitechapel Art Gallery, London, England: Thru Feb. 7
Staatsgalerie Stuttgart, Germany: Mar. 13-May 30

John Henry Twachtman: An American Impressionist
High Museum of Art, Atlanta, GA: Feb. 26-May 21
Cincinnati Art Museum, OH: June 6-Sept. 5
Pennsylvania Academy of Fine Arts, Philadelphia, PA: Oct. 9, 1999-Jan. 2, 2000

Twentieth Century American Drawings
Philharmonic Center for the Arts, Naples, FL: Thru Jan. 30
Fort Wayne Museum of Art, IN: Feb. 21-Apr. 18
Knoxville Museum of Art, TN: May 16-July 11
Boise Art Museum, ID: Aug. 7-Oct. 17
Mobile Museum of Art, AL: Aug. 8-Oct. 17

Twentieth Century Still Life Paintings from The Phillips Collection
Dayton Art Institute, OH: Jan. 16-Mar. 21
Tokyo Station Gallery, Japan: Apr. 3-May 16
Hiroshima Museum of Art, Japan: May 22-June 20
Museum of Modern Art, Ibaraki, Japan: June 25-Aug. 1
Museum of Fine Gifts, Gifu, Japan: Aug. 10-Sept. 19
Hokkaido Obihiro Museum of Art, Japan: Sept. 29-Nov. 17

A Unique American Vision: Paintings of Gregory Gillespie
Georgia Museum of Art, Athens, GA: Apr. 10-May 30
San Diego Museum of Contemporary Art, CA: June 12-Sept. 12
M.I.T. List Center for the Visual Arts, Cambridge, MA: Oct. 15-Dec. 31

Anthony Van Dyck
Royal Museum of Fine Arts, Antwerp, Belgium: May 15-Aug. 15
Royal Academy of Arts, London, England: Sept. 16-Dec. 16

Van Gogh's Van Goghs: Masterpieces from the Van Gogh Museum, Amsterdam
National Gallery of Art, Washington, DC: Thru Jan. 3
Los Angeles County Museum of Art, CA: Jan. 17-Apr. 4

A Victorian Salon By the Sea: Paintings from the Russell-Coates Collection
Dahesh Museum, NY: Jan. 19-Apr. 17
Frick Art Museum, Pittsburgh, PA: May 7-July 4

Adrien de Vries 1556-1626: Imperial Sculptor
Rijksmuseum, Amsterdam, Netherlands: Thru Mar. 14
National Museum, Stockholm, Sweden: Apr. 15-Aug. 29
The J. Paul Getty Museum, Los Angeles, CA: Oct. 12, 1999-Jan. 9, 2000

Bill Viola
Museum für Modern Kunst, Frankfurt, Germany: Feb. 5-Apr. 25
Schirn Kunsthalle, Frankfurt, Germany: Feb. 5-Apr. 18
San Francisco Museum of Modern Art, CA: June 4-Sept. 7
Art Institute of Chicago, IL: Oct. 16, 1999-Jan. 16, 2000

Ursula von Rydingsvard
Nelson-Atkins Museum of Art, Kansas City, MO: Thru Mar. 28
Indianapolis Museum of Art, IN: May 16-Aug. 8

Ursula von Rydingsvard
Chicago Cultural Center, IL: Thru Jan. 31
Contemporary Museum, Honolulu, HI: Mar. 26-June 6

June Wayne: Retrospective
Los Angeles County Museum of Art, CA: Thru Feb. 15
Palm Springs Desert Museum, CA: June 5-Aug. 5
Purdue Univ. Art Museum, IN: Autumn

Edward Weston and Modernism
Los Angeles County Museum of Art, CA: Feb. 11-May 3
Cleveland Art Museum, OH: Sept. 19-Nov. 28

We Shall Overcome: Photographs from the American Civil Rights Era
New York State Museum, Albany, NY: Thru Feb. 28
Danville Museum of Fine Arts and History, VA: Mar. 20-May 16
Birmingham Civil Rights Institute, AL: June 5-Aug. 1

When Time Began to Rant and Rage: Figurative Painting from Twentieth-Century Ireland
Walker Art Gallery, Liverpool, England: Thru Jan. 10
Berkeley Art Museum, CA: Feb. 10-May 1
New York Univ., Grey Art Gallery, NY: May 25-July 31

Wrapped in Pride: Ghanian Kente and African American Identity
Newark Museum, NJ: Thru Jan. 3
Fowler Museum, UCLA, Los Angeles, CA: Feb. 7-July 7
Anacostia Museum, Washington, DC: Sept. 1999-Jan. 2, 2000
National Museum of African Art, Washington, DC: Sept. 1999-Jan. 2, 2000

SELECTED MUSEUMS
WITHIN THE UNITED STATES

Robert Cottingham, *Art,* 1992. From *Eyeing America:*
Robert Cottingham Prints. Photo courtesy National Museum
of American Art, Washington, D.C.

Birmingham Museum of Art

2000 Eighth Ave. North, Birmingham, AL 35203
(205) 254-2566; 254-2565 (recording)
http://www.artsBMA.org

1999 Exhibitions

Thru January 3
Chokwe! Art and Initiation of Chokwe and Related Peoples
The first U.S. exhibition featuring the art of the Chokwe and related peoples
of Angola, Zaire, and Zambia. Explores the role of art objects in the
transmission of knowledge. (T)

Thru January
*Constructing Structure: Ilya Bolotowski, Al Held, John McLaughlin, and
George Rickey*
Celebrates the acquisition of *Crucifera IV*, a monumental sculpture by
George Rickey. Includes preparatory drawings by Rickey and related
paintings by 20th-century artists.

Thru Winter 1999
The Artist in the Studio
An interactive, hands-on exhibition for both students and adults, designed to
allow visitors to experience the studio environment.

Thru March 21
Perspectives II: Saint Clair Cemin
Sculpture, watercolors, and photographs by this Brazilian-born, New York-
based artist.

January 31-April 4
*Art at the End of the Century: Contemporary Art from the Milwaukee Art
Museum*
An exhibition of extraordinary contemporary art, including work by
Schnabel, Butterfield, Kiefer, Richter, and Rothenberg. (T)

Infra-Slim Spaces: The Spiritual and Physical in the Art of Today
Works focusing on the theme of transcendence by Douglas Gordon, Tatsuo
Miyajima, Georgina Starr, and Christopher Wool, among others.

April 25-July 4
*Remembered Past, Discovered Future: The Alabama Architecture of
Warren, Knight & Davis, 1901-1961*
Architectural drawings, renderings, and photographs illustrate the
importance of the Birmingham firm in the evolution of architecture in
Alabama and the Southeast.

May 2-July 4
Roads Less Traveled: American Paintings 1833-1935
Sixty-nine paintings, including landscapes, marine and coastal scenes,
figurative works, and still lifes, represent the major trends in a definitive
period in American art and culture. (T)

October 3, 1999-January 16, 2000
Searching for Ancient Egypt
A spectacular assemblage of objects
from 3,000 years of Egyptian art,
including statuary, jewelry, ceramics,
funerary objects, and a carved and
painted wall from a 5th Dynasty (2415-
2300 B.C.) tomb chapel. (T)

Permanent Collection

Collection of over 18,000 works of art
dating from ancient to modern times,
including European, American, and
Asian works; growing collections of
African, Native American, and pre-
Columbian art; the Charles W. Ireland
Sculpture Garden. **Highlights:** Kress
Collection of Renaissance art; Beeson
Collection of Wedgwood, the finest
outside England; Hitt Collection of
18th-century French decorative art and
painting; *Birmingham Persian Wall*, a
recently acquired glass installation by
Dale Chihuly; library has 1,200
Wedgwood books, letters, and
catalogues; multilevel sculpture garden
designed by Elyn Zimmerman.
Architecture: 1959 original
International Style building; 1965, 1967, 1974, and 1980 additions by
Warren, Knight, and Davis; 1993 expansion and renovation by Edward
Larrabee Barnes.

Mask. From *Chokwe! Art and Initiation Among Chokwe and Related Peoples.* Photo courtesy Birmingham Museum of Art.

Admission: Free; donations accepted. Handicapped accessible. Braille
signage, auditorium aids for the hearing-impaired, elevators, and
wheelchairs available.
Hours: Tues.-Sat., 10-5; Sun., 12-5. Closed Mon., Thanksgiving, Dec. 25,
and Jan. 1.
Programs for Children: Education Gallery with hands-on interactive
exhibitions for children. Museum school offers art classes for all ages.
Tours: Free tours, Tues.-Fri., 11:30, 12:30; Sat.-Sun., 2; Group tours
available by appointment. Call (205) 254-2318.
Food & Drink: Terrace café, open Tues.-Sat., 11-2; Jazz Brunch, first Sun.
of month, 11-2. Picnics allowed in the garden areas.
Museum Shop: Offers handmade jewelry and other unique gifts, children's
items, and art books.

Montgomery Museum of Fine Arts

One Museum Dr.,
Montgomery, AL 36117
(334) 244-5700
http://arts.ci.montgomery.al.us

1999 Exhibitions

Thru January 10
*Images of the Floating World:
Japanese Prints from the
Birmingham Museum of Art*
A selection of approximately 40
Japanese woodblock prints of
landscapes, actors, beauties, and
warriors.

Thru January 17
*American Impressionism from the
Sheldon Memorial Art Gallery*
Drawn from the Sheldon's
exceptional collection of
American art, this exhibition
features 50 stunning examples of
Impressionism in the U.S.

John Singer Sargent, *Mrs. Louis E. Raphael/
Henriette Goldschmidt*, c.1900-1905. Photo
courtesy Montgomery Museum of Fine Arts,
The Blount Collection.

Alabama Landscapes by Montgomery Artists
A selection of 20 works by local artists.

January 30-March 28
*The Lamps of Tiffany: Highlights from the Egon and Hildegard Neustadt
Collection*
Approximately 40 spectacular, illuminated lamps by the world-renown
craftsman.

Akari Light Sculptures of Isamu Noguchi
Function and aesthetics are combined in the light sculptures of the
prominent 20th-century sculptor.

March 27-May 23
Elayne Goodman
Self-taught artist Elayne Goodman uses recycled, flea-market objects to
create work that is busy, bright, and humorous.

April 10-May 23
Rembrandt Prints from the Weil Collection
An exhibition of about 100 prints by one of the world's greatest artists. The
works in this show present a variety of aspects of the 17th-century artist's
career, including his Old and New Testament scenes and compelling
portraits.

Hogarth Prints from the McAllen Museum
Works by the pioneering and world-renown 18th-century British artist.

June 5-July 18
6th International Shoebox Sculpture Exhibition
A wide range of styles and materials give these works potency and presence
beyond their small size.

Regions: Joni Mabe

August 7-November 7
Spirit Eyes, Human Hands: African Art at the Harn Museum
Addresses the role of the art object as a medium through which the spirit
and human worlds gain access to each other.

November 20, 1999-January 2, 2000
The 33rd Montgomery Art Guild Museum Exhibition
A biennial exhibition to draw attention to local talent.

Permanent Collection

18th-, 19th-, and 20th-century American painting, sculpture, and graphic
arts; Old Master prints; works by Southern historical and contemporary
artists. **Highlights:** The Blount Collection of American Art; First Period
Worcester Porcelain from the Loeb Collection; Master Print Collection;
Weil Graphic Arts Study Center, with audio-visual and computer resources.
Architecture: 1988 building by Barganier, McKee Sims Architects
Associated.

Admission: Free. Handicapped accessible, including ramp and elevator;
touch tours available for the vision-impaired.
Hours: Tues.-Sat., 10-5; Thurs., 10-9; Sun., 12-5. Closed Mon.
Programs for Children: ARTWORKS, more than 30 interactive, hands-on
exhibits encourage creative abilities while learning about art.
Tours: Call tour coordinator at (334) 244-5700.
Food & Drink: The Café M open Tues.-Sat., 11-4. Reservations for groups
are encouraged, call (334) 244-5747.
Museum Shop: Features irresistible gifts including glass, pottery, jewelry,
custom crafts, books, and toys. (334) 244-5763.

Anchorage Museum of History and Art

121 W. Seventh Ave., Anchorage, AK 99501
(907) 343-4326

1999 Exhibitions

Thru May
*Once Upon a Time: A Children's Exhibition of Stories, Myths, and Legends
in Art*
Contemporary artists create works on themes in childhood tales. All artwork
designed to engage and delight young visitors.

January 6-January 24
Alaska Positive
Biennial statewide juried photo exhibition.

January 17-February 28
Lynn Marie Naden
Naden's installation, "Human Transmutation," consists of casts of the figure in natural materials and addresses issues of human transformation.

February 2-March 28
Matt Johnson
Critically acclaimed photographer Matt Johnson juxtaposes his images, allowing viewers to create their own interpretation of his work.

Earth, Fire, and Fibre
Biennial statewide craft exhibition.

February-April 22
Balto Exhibit

March 7-April 4
Anchorage School District Art Show
Annual exhibition of works produced by students grades K-12.

March 7-April 11
Colorprint USA
The 25th annual exhibition of original color prints by 50 distinguished American printmakers.

Harold Wallin
Works by Anchorage artist Harold Wallin, known for his paintings that are at once representational and abstract.

Alaska Inaugural Ball Gown Exhibit
Features the Inaugural Ball Gowns of the First Ladies of Alaska.

May 2-September 19
Drawn from Shadows and Stone: Photographing North Pacific Peoples (1897-1902) Jessup Expedition
Photo-documentation of cultures on both sides of the Bering Strait.

May 6-October 10
Stories from the Water: Small Boats of the Far Northwest
Features early kayaks and canoes, which, until this century, were the means of travel and livelihood in this region.

June 1999-May 2000
Animals and Art
An exhibition designed for children.

October 3-November 14
Alvin Amason Retrospective
Works by one of Alaska's most prolific and talented artists, known for his sympathetic and humorous depiction of animals.

October-November
Rarefied Light
Statewide juried photography show.

November 7, 1999-January 2, 2000
Trashformations: Recycled Materials in American Art and Design
Chronicles the history of recycling in American art. (T)

November 11-December 5
Mary Ver Hoef
Works by a Fairbanks artist whose stylized, expressive paintings are derived from landscapes.

November 26, 1999-January 2, 2000
Dolls and Toys
Annual holiday exhibition of antique dolls, toys, and carousel horses. A favorite tradition for Anchorage families.

December 5, 1999-February 27, 2000
Light Art: New Art Forms Using Light as a Medium
International artists create works of light–holography, projections, and lasers–for a festival based on ancient celebrations of the winter solstice.

December 12, 1999-January 2, 2000
Garry Mealor
An exhibition of large-scale self-portraits and still lifes by nationally known watercolorist Garry Mealor.

Permanent Collection

Traditional and contemporary Alaska art; objects from the Athapaskan, Aleut, Tlingit, Haida, Eskimo peoples, the Russian period, American whaling, the Gold Rush, World War II, contemporary life. **Architecture:** 1968 building and 1975 addition by local firm of Schultz & Maynard; cast concrete frieze encircling the exterior by Alex Duff Combs; 1986 addition by Mitchell/Giurgola of New York.

Admission: Adults, $5; seniors, $4.50; members, children, free. Handicapped accessible.
Tours: Mid-May-mid-Sept: daily, 9-6. Mid-Sept.-mid-May: Tues.-Sat., 10-6; Sun., 1-5. Closed Mon.
Programs for Children: Children's Gallery features shows with themes and interactive activities; special art classes and workshops.
Tours: Summer: Alaska Gallery, daily, 10, 11, 1, 2. Call (907) 343-4326.
Food & Drink: Gallery Café open during museum hours, with full lunch service available 11-2.
Museum Shop: Books on Alaska; Aleut and other Native American art.

The Heard Museum

22 E. Monte Vista Rd., Phoenix, AZ 85004
(602) 252-8840; 252-8848 (recording)
http://www.heard.org

1999 Exhibitions
Continuing
Native Peoples of the Southwest: The Permanent Collection of The Heard Museum

Old Ways, New Ways
Interactive history of Native American life.

Thru January 10
Memories and Imagination: The Legacy of Maidu Artist Frank Day
Illustrates the artistic legacy of Frank Day and the unique traditions of the
Maidu Indians of Northern California.

Thru September 19
*Blue Gem, White Metal: Carvings and Jewelry from the C.G. Wallace
Collection*
Early 20th-century Zuni and Navajo jewelry, silverwork, and carvings from
the most well-documented collection from the early to mid-1900s.

Thru September
Cradles, Corn, and Lizards
Visitors can explore the cultures, landscapes, and wildlife of Arizona in this
unique interactive experience. Includes hands-on activities and a multi-
dimensional mural that both children and adults will enjoy.

Thru January 2000
HORSE
Examines the impact of the horse on indigenous cultures in North America,
from its introduction by 16th-century Spaniards to the present day.

January 23-October
Art in Two Worlds: The Native American Fine Art Invitational 1983-1997
Celebrating the creativity of Native American artists, this exhibit draws
from work featured in the Heard Museum's invitational fine arts exhibits.

February 28-June
Jewels of the Southwest
Marking the opening of the new Lovena Ohl Gallery, this exhibition details
the transition of Southwestern jewelry from craft to art and documents
innovations in contemporary Native American jewelry.

June-September
Transitions: Contemporary Canadian Indian and Inuit Art
Featuring the work of 13 Canadian artists, *Transitions* explores and
challenges the perceptions of contemporary native art in Canada.

November 13, 1999-March 19, 2000
Powerful Images: Portrayals of Native America
Pop culture and Native American art intersect in this unique exhibition
portraying today's Native American culture.

Permanent Collection
Extensive collection of Native American fine art, jewelry, textiles, pottery,
quillwork, beadwork, baskets; Hispanic traditional arts; African and Oceanic
tribal art. **Highlights:** 1,200 katsina dolls from the past 100 years; 4,000-
item Fred Harvey Fine Art Collection; 3,600 20th-century paintings, prints,
and sculptures. **Architecture:** Grand opening of three new galleries and
artist studio on February 28. Charming 1929 Spanish Colonial Revival
building by Herbert Green; 1984 wing following original design; recent
renovation and expansion with unusual museum shop.

Sioux Vest, early 1900s. From *HORSE,* a traveling exhibition. Photo courtesy Heard Museum.

Admission: General, $6; seniors 65+, $5; children 4-12, $3. Handicapped accessible.
Hours: Mon.-Sat., 9:30-5; Sun., 12-5. Closed holidays.
Programs for Children: Regular series of special programs, including hands-on gallery activities, a Zuni pueblo, and a Kiowa longhouse.
Tours: Public tours daily, Sept.-May: Mon.-Sat., 12, 1:30, 3; Sun., 1:30, 3; June-Aug.: Mon.-Fri., 1:30; Sat., 11, 1:30, 3; Sun., 1:30, 3. Group tours, reserve three weeks in advance; call (602) 251-0275.
Museum Shop: Features a variety of fine and traditional jewelry, arts and crafts by Native American artists.

Phoenix Art Museum

1625 N. Central Ave., Phoenix, AZ 85004
(602) 257-1880; 257-1222 (recording)

1999 Exhibitions

Thru January 3
Clocks from the Age of Napoleon

Thru February 28
Copper as Canvas: Two Centuries of Masterpiece Paintings on Copper, 1525-1775
Highlights the practice of painting on copper, featuring 75 to 100 of the most spectacular and best-preserved examples of works by masters. (T)

Thru March 27
Spendors of Ancient Egypt
One of the largest exhibitions of Ancient Egyptian treasures to visit the U.S. in decades, featuring over 200 pieces dating back 4,500 years, including statues, mummy cases, jewelry, wall carvings, and ceramics. Catalogue. (T)

April 15-June 27
Great Design: 100 Masterpieces from the Vitra Design Museum
The Phoenix Art Museum is the first venue for this world-renowned collection of 19th- and 20th-century European and American furniture.

July 24-October 3
Cantos Parallelos
An exhibition of post-WWII Argentinean painting, sculpture, and assemblage that parody Argentine middle-class ideas of good taste.

September 18, 1999-January 2, 2000
Monet at Giverny: Masterpieces from the Musée Marmottan
Blockbuster exhibition features 22 paintings by Claude Monet (1846-1926). Includes lesser-known later works featuring the flower and water gardens of Monet's property in the rural village of Giverny. (T)

Permanent Collection

Exceptional collection of over 13,000 objects including American art, European art of the 18th-19th centuries, Western American art, 20th-century art, Latin American art, Asian art and 18th-20th century fashion design.
Highlights: Monet, *Flowering Arches, Giverny;* Frida Kahlo, *Suicide of Dorothy Hale;* and works by Picasso, Georgia O'Keeffe, and Diego Rivera.
Architecture: 1959 building; recently renovated and expanded; integrates art and architecture with the Southwestern landscape.

Admission: Free. *Splendors of Egypt:* adults, $12; children 6-12, $6; members and children under 6, free. Handicapped accessible; ramps, electronic doors, elevators.
Hours: Tues.-Sun., 10-5; Thurs.-Fri., 10-9; closed Mon. and major holidays. *Splendors of Egypt:* Tues., Wed., 11-5; Thurs., Fri., 11-9; Sat., Sun., 10-5. Last entry two hours before closing.
Programs for Children: "Artworks" interactive gallery for children and families; museum also provides school and children's tours and art classes.
Tours: Groups call (602) 257-4356.
Food & Drink: Art Museum Café.
Museum Shop: Offers a wide variety of unique gifts ranging from Talavera Ware to greeting cards and Noguchi lamps. Merchandise inspired by exhibitions and permanent collections. Posters, prints, and cards of popular works.

Tucson Museum of Art

140 N. Main Ave, Tucson, AZ 85701
(520) 624-2333
http://www.tucsonarts.com

1999 Exhibitions

Thru January 3
Tucson Collects: Tribal Rugs from Arizona Collections
Explores weaving techniques, featuring 100 rugs and a reconstructed traditional Turkish room. Also includes jewelry and related materials.

Directions: Danny Diaz
A contemporary painter's personal interpretations of saints that are popular in traditional Latin American art.

Thru March 7
Miriam Schapiro: Works on Paper
Focuses on the artist's works on paper, multiples, and prints using a variety of techniques, including watercolor, etching, lithography, and collage.

Thru March 31
El Nacimiento
Celebrating 21 years at the museum, this elaborate Mexican nativity scene is a seasonal favorite. Features over 200 handmade miniatures arranged by Maria Luisa Tena.

March 6-April 25
Tucson Photographers in the TMA Collection
Features works by approximately 20 local artists.

March 13-May 2
*Contemporary Southwest Images XIII: The Stonewall Foundation Series–
Fred Borcherdt*
Retrospective of the 20-year career of local artist Fred Borcherdt, whose
monumental stone, steel and wood sculptures are inspired by the
environment of the Southwest.

March 21-April 25
TMA Permanent Collections
A selection of outstanding works from all periods inaugurates 10,000 square
feet of new gallery space.

May 15-July 11
Arizona Biennial '99
Juried exhibition open to Arizona artists working in any media.

September 11-October 31
Contemporary Southwest Images XIV: The Stonewall Foundation Series
Artist not yet announced.

Directions: Katherine Josten's Global Art Project
This international biennial art exchange is a grass roots effort to unite people
around the world in harmony through artistic expression.

October 2-November 28
Roads Less Traveled: American Paintings 1833-1935
Sixty-nine paintings, including landscapes, marine and coastal scenes,
figurative works, and still lifes, represent the major trends in a definitive
period in American art and culture. (T)

November 13, 1999-January 9, 2000
Mexican Silver
Explores the influence of the pre-Columbian motifs used as design elements
by 20th-century artists in the manufacture of silver jewelry in Taxco,
Mexico, from 1930-1960.

November 20, 1999-January 9, 2000
Gottlieb in Arizona
Examines the paintings and works on paper made by the well-known
innovator of abstraction, Adolph Gottlieb, during his stay in Tucson during
the 1930s.

November 20, 1999-January 30, 2000
Mountain Oyster Club Collection
A collection of contemporary Western art donated to the local club by its
members.

Permanent Collection
Pre-Columbian art, Spanish Colonial and Mexican folk art; Western
American art of the 19th and 20th centuries. **Architecture:** The museum
operates five historic properties from the late 1860s to 1907, on long term
lease from the City of Tucson.

Admission: Adults, $2; students and seniors, $1; children under 12, members, Tues., free.
Hours: Mon.-Sat., 10-4; Sun., 12-4; closed holidays, Mon. from Memorial Day to Labor Day.
Tours: Tours of the Museum and Historic Block; call (520) 696-7450.

University of Arizona Museum of Art

P.O. Box 210002,
Speedway Blvd., Tucson,
AZ 85721
(520) 621-7567

1999 Exhibitions

Thru January 3
Robert Colescott: Recent Paintings, 47th Venice Biennale
Recent works by the first African-American artist to be included in the prestigious Venice Biennale exhibition. (T)

Audrey Flack, *Marilyn,* 1977. Photo courtesy University of Arizona Museum of Art.

February-March
Roz Driscoll: A Sense of Touch
Driscoll's tactile sculptures evoke the tensions between the natural and the man-made, interior and exterior, and touch and sight.

Mario Reiss: Memory of a River, A Hydroponic Portrait
Reiss creates portraits of Arizona's rivers by submerging canvas into the rivers' water.

April-May
1999 Master of Fine Arts Thesis Exhibition

September-October
The Order of Pictures: Series, Cycles, Portfolios, and Other Connected Images
Works from the permanent collection explore the centuries-old convention of linked images.

October
Annual Faculty Exhibition of The University of Arizona Art Department

November-December
Women of the Book: Jewish Artists, Jewish Themes
Selection of art books on Jewish themes of the diaspora, mysticism, and family *her*stories created by contemporary Jewish women.

Permanent Collection
More than 4,000 paintings, sculptures, drawings, and prints comprise one of the most complete university collections in the Southwest. Renaissance art

to contemporary European and American art. **Highlights:** Works by Rembrandt, Piranesi, Picasso, O'Keeffe, and Rothko. Pfeiffer and Kress Collections. American paintings and prints of the 1930s; modernist paintings from 1920-1970; 26 panels of 15th-century Spanish altarpiece of the Cathedral of Ciudad Rodrigo.

Admission: Free. Handicapped accessible.
Hours: Mon.-Fri., 9-5; Sun., 12-4. Summer hours: Mon.-Fri., 10-3:30; Sun., 12-4.
Programs for Children: Summer studio programs, student tours, family arts programs.
Tours: Docent-led tours available upon request.
Museum Shop: Variety of books, catalogues, calendars, posters, and cards.

Arkansas Arts Center
Ninth & Commerce Sts., Little Rock, AR 72202
(501) 372-4000

1999 Exhibitions
Thru January 3
Collectors Show and Sale
Annual show featuring over 200 works lent by U.S. galleries.

Thru January 10
European 20th Century Artists' Ceramics from the Collection of the Kruithuis Museum

Attributed to Pietro Francesco Mola (1612-1666), *Battle Scene.* Photo courtesy Arkansas Art Center.

70 ceramic pieces from Kruithuis Museum, The Netherlands, including work by Picasso, Braque, Miro, Chagall, and Europe's CoBrA School.

European Artists' Works from the Arkansas Art Center
Works by Picasso, Derain, Braque, Léger, and others to complement the ceramics exhibition.

January 22-March 28
Innuendo Non Troppo: The Work of Gregory Barsamian
Barsamian's large sculptural, mechanical, 3-D pieces produce surreal images when in motion. (T)

February 5-April 25
William H. Johnson: Truth Be Told
An exhibition of nearly 50 works by African-American artist William H. Johnson (1901-1970). (T)

March 26-May 2
Young Arkansas Artists
Features artwork produced by Arkansas students in grades K-12.

Victor Koulbak: Silverpoint Drawings, 1983-1997
The first museum retrospective of Koulbak's Renaissance-style drawings.

May 7-June 27
Mid-Southern Watercolorists 30th Annual Exhibition

Prints, Drawings, and Photographs
Curated by Townsend Wolfe, Director of the Museum, this exhibition explores contemporary trends in these three media.

Note: The Arkansas Art Center is tentatively scheduled to close July 1999 until January 2000 for building expansion.

Permanent Collection
Major works by Rembrandt, Guercino, Van Gogh, Degas, Cézanne, Tiepolo, Delacroix, and others typify distinguished collection of Old Master and modern European drawings; over 750 American drawings.

Admission: Free. Handicapped accessible.
Hours: Mon.-Thurs., Sat., 10-5; Fri., 10-8:30; Sun., 12-5. Closed Dec. 25.
Tours: Call (501) 372-4000.
Food & Drink: Vineyard in the Park restaurant, Mon.-Fri., 11:15-1:30.
Museum Shop: Souvenirs from current shows, jewelry, local artists' work, and more. Open during museum hours.

Berkeley Art Museum/ Pacific Film Archive

**University of California, 2626 Bancroft Way, Berkeley, CA 94720
(510) 642-0808
http://www.bampfa.berkeley.edu**

1999 Exhibitions
Thru January 3
Rancho Deserta: Photographs by Tim Goodman

The Drawing Speaks: Théophile Bra, Works, 1826-1855

Thru January 17
Transformation: The Art of Joan Brown
The first major retrospective of the late, contemporary Bay-Area artist, ranging from early figurative and abstract expressionist paintings to her interest in mythology and religious symbolism. (Also at Oakland Museum.)

Thru February 28
MATRIX/Peter Shelton: sixtyslippers

January 9-March 14
Rollins KOS

January 16-April 25
MATRIX/Irish Contemporary Works on Paper

Photo by Ben Blackwell, courtesy University Art Museum and Pacific Film Archive, Berkeley.

February-June
MATRIX/Rigo 98

February 10-May 1
When Time Began to Rant and Rage: Figurative Painting from Twentieth-Century Ireland
Surveys Irish art from the 1890s to the present through approximately 70 works by artists such as Sir John Lavery and Jack B. Yeats. (T)

March 20-June 27
Van der Keuken: Photographs

May 12-August 29
Robert Colescott: Recent Paintings, 47th Venice Biennale
Recent works by the first African-American artist to be included in the prestigious Venice Biennale exhibition. (T)

June 5-August 15
The Photographs of Elli Seraridari

September 15-November 28
Indian Painting from the Marshall Collection

December 8, 1999-March 19, 2000
Architectural Drawings for the Phoebe Hearst International Competition

December 15, 1999-March 19, 2000
Equal Partners: Men and Women Principals in Contemporary Architectural Practice

Permanent Collection
Paintings, photographs, prints, drawings, conceptual art, including 16th- to 19th-century works by Cézanne, Renoir, Rubens, Bierstadt; Asian art; 20th-century works by Bacon, Calder, Duchamp, Frankenthaler, Rothko; Sculpture Garden; Pacific Film Archive of over 7,000 international films. **Highlights:** Recent acquisition of *Number 6*, a 1950 drip painting by Jackson Pollock; largest collection of Hans Hoffmann paintings in the world; Asian art galleries; newly installed European and American collections. The Pacific Film Archive, also housed in the museum, presents nightly public showings of film and video. **Architecture:** 1970 building, with exposed-concrete walls and floor-to-ceiling windows, designed by a team of young architects, Richard Jorasch and Ronald Wagner, working with well-known San Francisco architect, Mario Ciampi.

Admission: Adults, $6; seniors, students, $4. Handicapped accessible, including parking; signed tours available, TDD (510) 642-8734.
Hours: Wed.-Sun., 11-5; Thurs., 11-9. Closed Mon.-Tues., holidays.
Programs for Children: Weekday programs for school groups; annual International Children's Film Festival; call (510) 642-2358 for details.
Tours: Thurs., 12; Sun., 2. Groups call (510) 642-5188.
Food & Drink: Café Grace, adjoining the Sculpture Garden, offers salads, light entrees, and desserts; open Tues.-Sun., 11-4.
Museum Shop: Open during gallery hours. Features an intriguing selection of books on art and film, posters, postcards, calendars, and gift items.

Orange County Museum of Art
Orange County Museum of Art, Newport Beach
850 San Clemente Dr., Newport Beach, CA 92660
(714) 759-1122
http://www.ocartsnet.org/ocma

1999 Exhibitions
Ongoing
Celebrating 100 Years of California Art
Over 150 works from the permanent collection trace the development and achievements of 20th-century art.

Thru January 3
James Turrell
Installations that examine the properties of light and space and the creation of visual illusions by controlling the quality and variety of light.

Fashion at the Beach
Historic and contemporary views of fashion, sun, surf, and sand.

Thru January 24
Gold Rush to Pop: 200 Years of California Art
Over 100 paintings examine California's wilderness landscape, immigrant responses to culture, urban life, and modern responses to high-technology.

January 16-April 18
Rauschenberg in Transparency
15 works on plexiglass made from the 1960s to the present by one of the most innovative and influential figures in American art.

January 16-June 20
Houdini's House Installation by Tony De Lap
Examines the angles and reflective surfaces used by magicians such as Harry Houdini to create visual illusions in performances of prestidigitation.

February 6-May 6
1999 Biennial
Recent works by emerging Southern Californian artists.

May 1-July 18
Rico LeBrun
A selection of sensitive drawings and figurative sculptures by one of the leading draftsmen of the early 20th century.

May 29-September 12
Peter Alexander
Survey of the career of the West Coast artist who helped to define the Los Angeles art scene in the 1960s. Includes poured-resin cubes, paintings, and mixed media works.

July 3, 1999-January 3, 2000
Michael Brewster
Brewster manipulates natural phenomena to create interactive and environmental sound installations.

July 24-October 17
Drawings from the Collection
Highlights the variety of styles and media that have fascinated and engaged California artists.

Permanent Collection

American art with a focus on the development of art in California, including early-20th-century Impressionist paintings and contemporary art.
Highlights: Works by Arnoldi, Baldessari, Bengston, Brandt, Burden, Burkhardt, Celmins, Diebenkorn, Dixon, Goode, Kauffmann, McLaughlin, Moses, Park, Payne, Rose, Ruscha, and Viola. **Architecture:** 1929 building; 1986 renovation.

Admission: Adults, $5; seniors, students, $4; children under 16, members, Tues. in summer, free. Handicapped accessible.
Hours: Tues.-Sun., 11-5. Closed Mon.
Programs for Children: Offers hands-on activities and workshops.
Tours: Tues.-Fri., 12:15, 1:15; Sat.-Sun., 2. Groups call (714) 759-1122.
Food & Drink: Sculpture Garden Café open Mon.-Fri., 11:30-2:30.

Orange County Museum of Art at South Coast Plaza Gallery

3333 Bristol St., Costa Mesa, CA 92626
(714) 662-3366

1999 Exhibitions

Thru January 3
Therman Statom
A beautiful, large-scale glass environment work, uniquely designed by the local sculptor, in celebration of the visual excitement of the holiday season.

January 9-April 25
Canyons and Deserts: Picturing the Western Landscape
Paintings and prints by local artists, inspired by the power, beauty, and mystery of the western landscape.

May 9-June 21
Major Art/Minor Artists
Art created by elementary school students who have participated in the museum's education programs.

August 22-October 24
The California Watercolor Movement
Features watercolors made in California in the 1930s and 1940s by artists at the Chinouard Institute in Los Angeles.

Admission: Free. Handicapped accessible.
Hours: Mon.-Fri., 10-9; Sat., 10-7; Sun., 11:30-6:30.

Los Angeles County Museum of Art

5905 Wilshire Blvd., Los
Angeles, CA 90036
(323) 857-6000
http://www.lacma.org

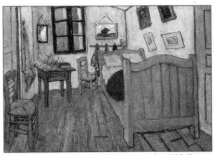

Vincent Van Gogh, *Vincent's Bedroom in Arles*, 1888. From *Van Gogh's Van Goghs: Masterpieces from the Van Gogh Museum, Amsterdam*. Photo courtesy Van Gogh Museum, Amsterdam, and the Los Angeles County Museum of Art.

1999 Exhibitions

Thru January 4
Picasso: Masterworks from The Museum of Modern Art
This exhibition of approximately 115 paintings, drawings, sculptures, collages, and prints from the MoMA explore the artist's development over six decades, from 1904 through 1971.

An Expressionist in Paris: The Paintings of Chaim Soutine
Major exhibition of 50 works by this expressive French painter, focusing on his years in Paris until his death during WWII. Examines the role of Soutine and other Jewish artists in the development of modern art in Paris. Catalogue. (T)

Thru February 15
June Wayne: A Retrospective
A 50-year survey of the innovative printmaking of June Wayne, credited with the revival of lithographic printing in the U.S. (T)

Thru March 29
Ancient West Mexico, Art of the Unknown Region
Overview of West Mexican art and cultural history, 200 B.C. and A.D. 800.

Thru March
Rodin's Monument to Victor Hugo
One of Rodin's least-known, most problematic and politically charged monuments was this tribute to French writer Victor Hugo. 20 sculptures illustrate the different stages of Rodin's concept. (T)

Thru June 14
Ancestors: Art and the Afterlife
An interactive installation examining Ancient Egyptian and African objects used in contacting the spiritual realm. For children and their families.

January 17-April 4
Van Gogh's Van Goghs: Masterpieces from the Van Gogh Museum, Amsterdam
Featuring 70 paintings from the holdings of the Van Gogh Museum in Amsterdam, this exhibition will illustrate Van Gogh's entire career, from the *Potato Eaters,* 1885, through *Wheatfield with Crows,* 1890. An unusual opportunity to view paintings that rarely travel to other venues. Catalogue. (T)

February 11-May 3
Edward Weston and Modernism
152 vintage platinum and gelatin-silver prints illustrate the artist's stylistic evolution from his early constructivist-inspired work through his surreal images of the 1940s. Highlights include portraits of contemporaries Diego Rivera, Igor Stravinsky, and e.e. cummings. (T)

February 25-May 17
Letters in Gold: Ottoman Calligraphy from Sakip Sabanci Collection, Istanbul
A look at exquisitely illuminated manuscripts, prayer manuals, and calligraphic exercises from the conquest of Constantinople in 1453 to the present day.

March 18-May 31
Nancy Riegelman
Twelve drawings by this contemporary Los Angeles artist relate color to different senses and areas of the body.

May 23-August 23
Eleanor Antin: An Anthology
Acclaimed conceptual works by Eleanor Antin, a member of the first generation of American feminist artists and a pioneer in multimedia.

May 30-August 16
Diego Rivera: Art and Revolution
The first major retrospective of the artist's work in 13 years. Includes 125 paintings, drawings, frescoes, and prints executed in Rivera's innovative and highly influential painting style, which combined European traditions with socialist ideals and Mexican culture. Catalogue. (T)

June 10-August 30
Images from a Changing World: Kalighat Paintings of Calcutta
The first U.S. exhibition of Kalighat painting, a synthesis of foreign and indigenous influences that was instrumental in modernizing Indian art.

July 1-September 20
The Age of Piranesi: Printmaking in Italy in the Eighteenth Century
A survey of work from LACMA's collection, highlighting works by one of the greatest printmakers of the period: Giovanni Battista Piranesi.

October 3, 1999-January 24, 2000
African Musical Instruments
Part of the LACMA, UCLA Fowler Museum, and California African-American Museum presentation of music from Africa and the African Diaspora.

October 7, 1999-January 17, 2000
"Ghost in the Shell": Photography and the Human Soul, 1850-2000
The depiction of the human spirit in photography, from the research of physiologist Duchenne de Boulogne to Warhol portraits.

Permanent Collection
Ancient Egyptian, Far Eastern, Indian, Southeast Asian, Islamic art; pre-Columbian Mexican pottery, textiles. Noted European and American paintings, sculptures, prints, drawings, decorative arts; glass from antiquity

to the present; costumes, textiles; photographs. **Highlights:** B. Gerald Cantor Sculpture Garden; Heeramaneck collection of art from India, Nepal, Tibet; de La Tour, *Magdalene with the Smoking Flame;* Rodin bronzes. **Architecture:** 1965 Ahmanson, Bing, and Hammer buildings by William Pereira; 1986 Anderson building and central court by Hardy Holzman Pfeiffer Associates; 1988 Pavilion for Japanese Art by Goff and Prince.

Admission: Adults, $6; seniors, students with ID, $4; children 6-17, $1; members, children under 5, free. Second Tues. of month, free. Handicapped accessible; wheelchairs available.
Hours: Mon., Tues., Thurs., 12-8; Fri., 12-9; Sat.-Sun., 11-8. Closed Wed.
Tours: Daily. Call (213) 857-6108 for information.
Food & Drink: Plaza Café open Tues., 10-3; Wed.-Thurs., 10-4:30; Fri., 10-8:30; Sat.-Sun., 11-5:30.

The Museum of Contemporary Art
MOCA at California Plaza
250 S. Grand Ave., Los Angeles, CA 90012
(213) 626-6222
http://www.MOCA-LA.org

1999 Exhibitions
Continuing
Timepieces: Selected Highlights from the Permanent Collection
Includes works in all media by artists such as Diane Arbus, Jasper Johns, Robert Rauschenberg, Mark Rothko, and Andy Warhol.

Thru February 14
Focus Series: Amy Adler
Features hybrid drawings and photographs manipulated through computer-enhancement by this Los Angeles-based artist.

Kay Rosen: lifeli[k]e
Presents a 20-year survey of text-based paintings, drawings, wall works, and books by this Texas-born artist. (Also at Otis Gallery, Los Angeles.)

Thru March 7
Jessica Bronson
Recent work by the Los Angeles-based artist known for her video installations that address the viewer's relationship to time-based media.

Thru March 14
Charles Ray
Mid-career survey of this internationally-recognized artist, encompassing conceptual photographs, furniture, mannequins, and other work from the 1970s to the present. (T)

March 7-June 20
Afterimage: Drawing through Process
More than 50 drawings by 20 artists depict the a-formal, art-historical territory of "process" or "post-minimalist" art. Includes works by Nauman, Serra, Hesse, and others. Catalogue.

April 11-September 5
The Exercise of Freedom: Lygia Clark, Gego, Mathias Goeritz, Hélio Oiticica and Mira Schendel
Examines the innovative and highly individualistic work of five artists active in Latin America from the late 1950s to the 1970s.

July 11-November 7
In Memory of My Feelings–Frank O'Hara and American Art
Examines the influence of poet and critic O'Hara (1926-1966) on American art, particularly the New York art world of the 1950s and 1960s, with works by Johns, de Kooning, Rivers, and others. Catalogue.

September 26, 1999-January 2, 2000
Raymond Pettibon
The first major American museum presentation of work by Pettibon, known for his compelling drawings and illustrated books. Catalogue. (T)

December 5, 1999-May 14, 2000
The Panza Collection
Eighty key works of abstraction and pop art from the collection of Count and Countess Giuseppe Panza di Biurno. Includes works by Lichtenstein, Rauschenberg, Oldenburg, Rothko, and other contemporary artists.

The Geffen Contemporary at MOCA
152 N. Central Ave., Los Angeles, CA 90013
(213) 626-6222

1999 Exhibitions

Thru January 3
Richard Serra
Installation by this important contemporary artist whose sculptures, made for specific urban or architectural sites, heighten perceptual awareness and encourage interaction. (T)

Thru November 14
Elusive Paradise: Los Angeles Art from the Permanent Collection
Surveys the development of postwar art in Los Angeles, including works by Richard Diebenkorn, Sam Francis, Robert Frank, and Alexis Smith.

March 7-July 25
Sam Francis
Major retrospective exhibition of the achievements of the American painter Sam Francis (1923-1994), from his early paintings made in the 1940s to works made just before his death. Catalogue.

November 14, 1999-February 20, 2000
Barbara Kruger
First comprehensive overview of the work of Kruger, including photographic prints, etched metal plates, sculpture, and audio, film, and video installations dating from 1978 to the present.

Permanent Collection
Art from 1940 to the present, featuring paintings, sculpture, works on paper, photographs, and environmental work of regional and international

importance; also explores new art forms combining dance, theater, film, and music. **Highlights:** Heizer, *Double Negative;* Kline, *Black Iris;* Rauschenberg, *Interview;* Rothko, *Red & Brown;* Rothenberg, *The Hulk;* Ruscha, *Annie;* Syrop, *Treated and Released;* works by Nevelson, Twombly, Warhol. **Architecture:** 1983 The Geffen Contemporary warehouse renovation by Frank Gehry; 1986 California Plaza building by Arata Isozaki.

Admission: Adults, $6; seniors, students with ID, $4; members, children under 12, free. Thurs., 5-8, free. Handicapped accessible.
Hours: Tues.-Sun., 11-5; Thurs., 11-8. Closed Mon., Jan. 1, Thanksgiving, Dec. 25.
Programs for Children: MOCA offers a variety of education programs throughout the year for children, families, and adults.
Tours: Free. Tues.-Sun., 12, 1, 2; Thurs., 6.
Food & Drink: Patinette at MOCA Café open during museum hours.
Museum Shop: The shop at Geffen Contemporary is open during museum hours. The shop at California Plaza is open Tues.-Sun., 11-6; Thurs., 11-9.

The J. Paul Getty Museum

1200 Getty Center Drive, Ste. 400, Los Angeles, CA 90049
(310) 440-7300; (310) 440-7360
http://www.getty.edu

NOTE: New location of The J. Paul Getty Center in Los Angeles. The former location, now called the Getty Villa in Malibu, is closed for renovation and will reopen in 2001 as a center devoted to ancient art, including the museum's collection of Greek and Roman antiquities.

1999 Exhibitions
Thru January 17
A Practical Dreamer: The Photographs of Man Ray
Portraits of Gertrude Stein, James Joyce, Marcel Duchamp, Henry Miller, and Marcel Proust are among the highlights of the exhibition of works by Man Ray, whose experiemental work is associated with Dada and surrealism.

Flemish Manuscript Illumination of the Late Middle Ages
This installation of 19 illuminated manuscripts represents the artistic achievements of some of the most remarkable European painters of the 15th and 16th centuries.

Thru February 21
Monuments of the Future: *Designs by El Lissitzky*
Explores recurring themes in the book arts, architectural and exhibition designs, and photography of Russian artist El Lissitzky (1890-1941).

Thru February 28
Bolognese Drawings from the 1500s through the 1700s
Thirty drawings from the permanent collection provide outstanding examples of Bolognese draftsmanship and distinctive, local style.

Thru May 30
The Making of a Medieval Book
A look at the techniques and materials used in medieval and Renaissance illuminated manuscript production.

February 2-March 28
Edgar Degas, Photographer
Presents 35-40 photographs made by the French artist in the mid-1890s. Includes figure studies, intimate interior views, and self-portraits. (T)

April 13-July 4
Brassaï: The Eye of Paris
Retrospective exhibition celebrates the centenary of the birth of the Transylvanian artist, described by Henry Miller as "the eye of Paris." Includes 150 photographs of the nocturnal life of 1930s Paris. Catalogue. (T)

October 12, 1999-January 9, 2000
Adriaen de Vries 1556-1626: Imperial Sculptor
Sculpture, prints, and drawings by the late-Mannerist Dutch artist who worked under Emperor Rudolf II in Prague. (T)

Permanent Collection

Extensive and important collection of Greek and Roman antiquities; European paintings from the 13th through 19th century; Medieval and Renaissance European manuscripts; French decorative arts; European sculpture and drawings; comprehensive collection of American and European photographs. **Highlights:** Mantegna, *Adoration of the Magi;* van Gogh, *Irises*; paintings by Rembrandt, Monet, Renoir, and Cézanne; sculpture by Cellini, Canova, and Bernini; drawings by Michelangelo, Leonardo, and Raphael; recent acquisition of *Pearblossom Hwy., 11-18th April 1986, #2* by David Hockney. **Architecture:** Beautiful new $1 billion, 6-building, 110-acre arts and cultural campus designed by Richard Meier, completed in 1997. Set in the foothills of the Santa Monica Mountains in the historic Sepulveda Pass, the museum has breathtaking view of the surrounding mountains, Los Angeles, and the Pacific Ocean. Gardens include 3-acre *Central Garden* designed by Robert Irwin.

Admission: Free; parking (reservation required), $5. Handicapped accessible.
Hours: Tues.-Wed., 11-7; Thurs.-Fri., 11-9; Sat.-Sun., 10-6. Closed Mon., major holidays.
Programs for Children: Family Room offers activities and games; interactive learning centers; special hours for school tours, Tues.-Fri., 9-11.
Tours: Available in English and Spanish; call (310) 440-7332 for information.
Food & Drink: Full-service restaurant and two cafés; call for hours.
Museum Shop: Offers wide selection of books related to museum collections and exhibitions.

Oakland Museum of California

The Museum of California Art, Ecology and History
1000 Oak St., Oakland, CA 94607
(888) 625-6873, toll-free
http://www.museumca.org

NOTE: The Museum also operates the Oakland Museum of California
Sculpture Court at the City Center, 1111 Broadway, which features three
exhibits annually of work by contemporary California sculptors.

1999 Exhibitions

Thru January 3
The Discovery of Gold in California: Paintings by Harry Fonseca
A California artist of Nisenan Maidu, Hawaiian, and Portuguese descent
explores the impact of the Gold Rush on California's Indian population.

Thru January 27
Transformation: The Art of Joan Brown
The first major retrospective of the late, contemporary Bay-Area artist,
ranging from early figurative and abstract expressionist paintings to her
interest in mythology and religious symbolism. (Also at Berkeley Museum.)

Thru February 28
Urban Footprints: The Photographs of Lewis Watts
A record of the life, work, and the human and spiritual concerns of the
largely African-American community of West Oakland.

January 23, 1999-January 9, 2000
California Underground: Our Caves and Other Subterranean Habitats
Dramatic images of California's underground world, made by using a highly
specialized photographic process.

February 20-September 12
Awakening from the California Dream: An Environmental History
Photographer Robert Dawson and historian Gray Brechin present a sobering
look at the changes in the California natural environment.

March 6-July 25
Art intr'Action: William T. Wiley, Mary Hull Webster, and Friends
Artists combine various media, live performances, and interactive exhibits
to explore questions about the purpose of museums, art, and human
existence.

March 20-May 30
*All Things Bright & Beautiful: California Impressionist Painting from the
Irvine Museum*
58 Impressionist works painted between 1906 and 1931. Expressed in these
lively, colorful paintings is a deep reverence for the natural environment.

June 12-August 15
Posters American Style
A 100th-anniversary celebration of an American popular art form brings
together 120 compelling images by more than 90 designers and artists. (T)

August 21-November 14
Requiem: By the Photographers Who Died in Vietnam & Indochina
247 photographs by 135 photographers who are known to have died or
disappeared while covering wars in Vietnam, Cambodia, and Laos.

August 28-October 17
Dog Haus: Architecture Unleashed
An entertaining exhibition displaying results of a doghouse competition.

October 16-November 28
Days of the Dead
Annual celebration of the Days of the Dead, with altars made by local artists
and community groups.

October 16, 1999-March 26, 2000
*Maidu Painting by Dal Castro: From the Aeschliman-McGreal Collection
of the Oakland Museum of California*
Retrospective survey of the folk paintings made between 1975 and 1993 by
a Native American artist from Northern California, featuring depictions of
Nisenan Maidu creation myths, animal legends, and historical events.

Permanent Collection

Several galleries combining various disciplines in one museum: **Gallery of
California Art** contains works in all media by California artists or artists
dealing with California themes; **Cowell Hall of California History**
exhibits artifacts and memorabilia illustrating major events and trends that
have shaped the state's history from before recorded history to the 1980s;
and **Hall of California Ecology** depicts the interrelated life activities of
plants and animals. The new **Aquatic California Gallery** presents a broad
view of the region's aquatic environments. **Highlights:** Decorative objects
from California Arts & Crafts movement; 19th-century landscape paintings;
outdoor sculpture; the Dorothea Lange archive; Gold Rush artifacts.
Architecture: Unique and unprecedented tiered garden environment,
housing a three-level museum (science, history, and art). Opened in 1969
and occupying four downtown city blocks, it was Kevin Roche's first major
museum design. Garden landscape design by Daniel Kiley.

Admission: Adults, $6; seniors, students with I.D., youths (6-17), $4;
children 5 and under, members, Fri., 5-9, free. Handicapped accessible;
ramps, elevator, and wheelchairs available.
Hours: Wed.-Sat., 10-5; Fri., 10-9; Sun., 12-5. Closed Mon., Tues., Jan. 1,
July 4, Thanksgiving, Dec. 25.
Programs for Children: Family Explorations! programs throughout the
year. Call (510) 238-3818 for information.
Tours: Weekday afternoons; weekends upon request. Groups call
(510) 238-3514.
Food & Drink: Museum Café open Wed.-Sat., 10-4; Sun., noon-5. Picnic
areas available in the museum gardens.
Museum Shop: Newly remodeled shop offers gifts and books relating to
California culture, art, and history.

Palm Springs Desert Museum

101 Museum Drive, Palm Springs, CA 92262
(760) 325-7186
http://www.psmuseum.org

1999 Exhibitions

Thru January 24
Manuel Neri: A Sculptor and His Drawings
Features wonderfully lush, romantic drawings in relation to the artist's magnificent sculpture, for which he has become world renowned. Catalogue. (Last venue)

Thru February 14
Recycled, Re-Seen: Folk Art from the Global Scrap Heap
Over 800 objects from 50 countries represent the art of turning trash into treasure. Bottles become helicopters, cans become tiny locomotives. Includes devotional objects, utilitarian products, and musical instruments.

February 17-May 16
Rodin: Sculpture from the Iris and B. Gerald Cantor Collection
Works from the world's largest and most comprehensive private collection of works by Rodin. 69 sculptures explore key motifs in Rodin's career, including his interest in conveying movement and emotion. (T)

Auguste Rodin, *Three Shades*, 1881-86. From *Rodin: Sculpture From the Iris and Gerald B. Cantor Collection*. Photo courtesy Palm Springs Desert Museum.

February 17-May 16
Edward Borein: The Artist's Life and Work
Fifty-three works on paper depicting the sun-drenched aridity and vastness of the American West, where the artist lived and worked.

February 23-March 21
Artists Council 30th Annual Juried Exhibition
Works by artists from across the U.S.

March 17, 1999-January 23, 2000
The Roadrunner
A comprehensive exhibition that focuses on the Roadrunner as a desert animal.

March 26-April 25
9th Annual Fine Arts Creativity Awards Exhibition
The most outstanding two- and three-dimensional works of local students.

April 30-May 28
Mitos, Imágenes e Idioma: Myths, Images, and Language
A creative exploration of words and art by California students.

June 5-September 5
June Wayne Retrospective
A 50-year survey of the innovative printmaking of June Wayne, credited
with the revival of lithographic printing in the U.S. (T)

Permanent Collection
Focus on 19th- and 20th-century art, emphasizing the regional developments in
Contemporary California art and historic western American art; dedication to
acquiring collections that contribute to an understanding of the area's Mexican
and Native American heritage; natural science collections.

Admission: Adults, $7.50; seniors 62 and over, $6.50; children 6-17, students
and active military with ID, $3.50; members and children under 6, free. First
Fri. of every month, 10-5, free. Handicapped accessible.
Hours: Sun.-Fri., 10-5. Closed Mon., major holidays.
Tours: Tues.-Sun., 2. Groups call (760) 325-7186.
Food & Drink: Gallery Café open Tues.-Fri., 11-3; Sat.-Sun., 12-3.

Norton Simon Museum
411 W. Colorado Blvd., Pasadena, CA 91105
(626) 449-6840; 449-3730
http://www.nortonsimon.org

1999 Exhibitions
Due to the current renovation project, no exhibitions are scheduled this year.

Permanent Collection
One of the most outstanding collections of European art in the U.S., from
the Renaissance through the 20th century, including works by Raphael,
Rembrandt, Rubens, Zurbarán, Goya, Monet, Degas, Van Gogh, Picasso,
Klee, Kandinsky; sculpture from the Indian subcontinent, the Himalayas and
Southeast Asia; spectacular sculpture garden. **Highlights:** Raphael,
Madonna; Zurbarán, *Still Life with Lemons, Oranges, and a Rose;* Dieric
Bouts, *Resurrection of Christ;* Manet, *Ragpicker;* Degas bronzes.
Architecture: Contemporary 1969 building by Ladd and Kelsey; renovation
in 1975; 1996 interior renovation design by Frank O. Gehry, scheduled to be
completed in autumn of 1999. New sculpture garden design by landscape
architect Nancy Power, currently under construction.

Admission: Adults, $4; seniors, students, $2; members and children under
12, free. Handicapped accessible, including ramps and elevators.
Hours: Thurs.-Sun., 12-6. Closed Mon.-Wed., Jan. 1, Christmas Day,
Thanksgiving.
Tours: Call (626) 449-6840, ext. 245 for information.
Food & Drink: A tea house serving light refreshments is scheduled to open
in the sculpture garden in the autumn of 1999.
Museum Shop: Offers art books, prints, slides, posters, and cards.

Crocker Art Museum

216 O St., Sacramento, CA 95814
(916) 264-5423
http://www.sacto.org/crocker

1999 Exhibitions

January 8-April 25
Netherlandish Drawings: Vision and Belief
A look at the persistence of religious and mythological subjects in Catholic Flanders and Calvinist Holland through the work of Rubens, Jordaens, Goltzius, and Rembrandt.

January 29-April 11
Dürer 1498
Organized around Dürer's *Woman with a Banner*, this exhibition explores the evolution of the artist's work from 1494 through 1505.

May 7-July 25
El Alma del Pueblo: Spanish Folk Art and its Transformation in the Americas
Explores the nature of Spanish folk art–its role in past and present Spanish society and its modification in Mexico and the Latin communities of the U.S. (T)

August 13-October 10
Silver & Gold: Cased Images of the California Gold Rush
Photographic documentation of the Gold Rush following the 1848 discovery of gold in California, featuring daguerreotypes and other "cased" images. (T)

October 3-December 12
Figurative Art from Ancient Israel
Objects spanning more than 12 millennia, from the Natufian period (tenth millennium B.C.) through the Christian crusader period (twelfth century C.E.) that trace the prominence of the human figure in art.

Permanent Collection
Old Master paintings; 19th-century California art; 19th-century German painting; Northern California art since 1945; American Victorian furniture and decorative arts, photography, Asian art; arts of the Americas.
Highlights: Hill, *Great Canyon of the Sierras, Yosemite;* Nahl, *Sunday Morning in the Mines* and *The Fandango.* **Architecture:** 1873 Crocker Art Gallery by Seth Babson; 1969 Herold wing; 1989 Crocker mansion wing by Edward Larrabee Barnes.

Admission: Adults, $4.50; children 7-17, $2; children 6 and under, free. Handicapped accessible.
Hours: Tues.-Sun., 10-5; Thurs., 10-9. Closed Mon., major holidays.
Programs for Children: Hands-on Art activities every Saturday from 12-3; ArtVenture Days one Saturday per month; ArtMasters summer classes.
Tours: By reservation; call (916) 264-5537, Mon.-Fri., 10-12.
Museum Shop: Handcrafted decorative arts and jewelry by regional artists, fine art books, stationery, educational crafts and toys.

Museum of Contemporary Art, San Diego

700 Prospect St., La Jolla, CA 92037
(619) 454-3541

1999 Exhibitions

Ongoing
Roman de Salvo: Garden Guardians
New sculptures created for the museum's indoor and outdoor spaces.

Thru January 3
David Reed Paintings: Motion Pictures
The first U.S. overview of work by San Diego-born artist David Reed, known internationally for his abstract painting. (T)

January 17-March 28
Francis Bacon: The Papal Portraits of 1953
Bacon's longest series, *Study for Portrait I-VIII*, has never before been exhibited in its entirety. This exhibition redresses this art historical oversight by reuniting as many of the paintings as possible.

June 12-September 12
A Unique American Vision: The Paintings of Gregory Gillespie
Survey of work by Gregory Gillespie, known for his realism based as much in the mind as in the realm of physical appearances. Features 45 paintings, including a selection of his celebrated self-portraits. (T)

September 26, 1999-January 26, 2000
Small World: Dioramas in Contemporary Art
Presents works by a younger generation of international artists who use the language of dioramas as a vehicle for artistic expression, exploring the ways we see and understand the world.

MCA Downtown

1001 Kettner Blvd., San Diego, CA 92101
(619) 234-1001

1999 Exhibitions

Thru January 31
Fabrizio Plessi
Four room-size installations by Fabrizio Plessi, considered one of the leading practitioners of video installation in Europe.

Opens February
A changing series of exhibitions presented by the Museum of Photographic Arts.

Museum of Contemporary Art, San Diego.
Photo by Timothy Hursley.

Permanent Collection
20th-century holdings spanning a variety of media, with particularly strong Minimalist, Pop, postmodern work. **Highlights:** André, *Magnesium-Zinc Plain;* Kelly, *Red Blue Green;* Ruscha, *Ace;* Oldenburg, *Alphabet* and *Good Humor;* Warhol, *Flowers;* Stella, *Sinjerli I* and *Sabra III;* Long, *Baja California Circle.* **Architecture:** La Jolla: 1916 private residence by Irving Gill; 1959, 1979 expansions by Mosher; 1996 renovation and expansion by Venturi, Scott Brown & Associates. Downtown: part of 1993 America Plaza complex designed by Helmut Jahn.

Admission: Adults, $4; seniors, students, military, $2; children under 12, free. Downtown: adults, $2; seniors, students, military, $1; children under 12, free. First Tuesday and Sunday of the month, free. Handicapped accessible.
Hours: La Jolla: Tues.-Sat., 10-5; Wed., 10-8; Sun., 12-5; closed Mon. Downtown: Tues.-Sat., 10-5; Sun., 12-5; closed Mon.
Programs for Children: "Free for All First Sundays" Family programs held on the first Sunday of each month, free admission.
Tours: La Jolla, Tues., Sat., and Sun., 2 p.m.; Wed., 6 p.m.
Food & Drink: Museum Café open Tues.-Sun., 11-2; Wed. 11-8; closed Mon.
Museum Shop: Broad selection of contemporary gift items for home or office; personal accessories; contemporary art and architecture books. Many items for children and infants.

San Diego Museum of Art
1450 El Prado, Balboa Park, San Diego, CA 92101
(619) 232-7931
http://www.sddt.com/sdma.html

1999 Exhibitions
Thru January 3
M.C. Escher: A Centennial Tribute
Examines the Dutch artist's contemporary *trompe l'oeil* masterpieces which have been highly popular since the 1960s. (T)

August-October
El Alma del Pueblo: Spanish Folk Art and its Transformation in the Americas
Explores the nature of Spanish folk art–its role in past and present Spanish society and its modification in Mexico and the Latin communities of the United States. (T)

Permanent Collection
European painting and sculpture from the Renaissance to the 20th century, including notable Italian Renaissance and Spanish Baroque works; recently-acquired works by Picasso, Chagall, and Dufy; American paintings by Chase, Eakins, Homer, O'Keeffe, and Peale; world-renowned Indian paintings; Asian art, including Buddhist sculptures and ritual bronzes,

Japanese prints; largest collection of contemporary California art.
Highlights: Beckmann, *Moon Landscape;* ter Borch, *The Love Letter;* Bougereau, *The Young Shepherdess;* Braque, *Still Life;* Giorgione, *Portrait of a Young Man;* Rubens, *Allegory of Eternity;* Sanchez Cotán, *Quince, Cabbage, Melon, and Cucumber;* sculpture garden with works by Hepworth, Moore, Rickey, Rodin. **Architecture:** 1926 Spanish Colonial-style building by William Templeton Johnson, a leading San Diego architect from the pre-WWII era, with Robert W. Snyder. The richly embellished entrance, modeled after one at the University of Salamanca, centers around the seashell (a reference to San Diego-St. James) and features Spanish and Italian masters.

Admission: Adults, $7; seniors, $5; military, $4; children 6-17, $2; children under 6, members, free. Handicapped accessible.
Hours: Tues.-Sun., 10-4:30. Closed Mon., Jan. 1, Thanksgiving, Dec. 25.
Tours: Tues.-Thurs., Sat., 10, 11, 1, 2; Fri., Sun., 1, 2.
Food & Drink: Sculpture Garden Café, Tues.-Fri., 10-3, Sat., Sun., 10-5.

The Friends of Photography at the Ansel Adams Center for Photography

250 Fourth St., San Francisco, CA 94103
(415) 495-7000
http://www.friendsofphotography.org

1999 Exhibitions
Thru January 31
New Voices/New Visions
Explores the ways in which contemporary Native American photographers contend with issues of identity and cultural representation.

Constructing Histories: Portraits of Native Americans
Explores historical representations of Native Americans through works by nine photographers who worked among the people of the Southwest and Plains between the 1880s and 1910.

February 9-April 4
Youth Exhibition
Photographs produced through Friends of Photography's outreach programs.

April 15-May 30
Johan van der Keuken
Features works by the Dutch photographer/filmmaker.

April 29-July 11
Innovation/Imagination: 50 Years of Polaroid Photography
Explores the history of creative expression using a range of Polaroid materials. Includes works by Adams, Warhol, Close, and others.

July 21-September 26
Irving Penn: A Career in Photography
Over 130 prints highlight every stage of the artist's career, including his trend-setting fashion photography and portraits of women. Catalogue.

Permanent Collection
Changing exhibitions showcase a variety of traditional and contemporary photography. **Architecture:** 1989 building by Robinson, Mills & Williams of San Francisco.

Admission: Adults, $5; students, $3; seniors, youth 13-17, $2; members, children under 13, free. Handicapped accessible, including ramp.
Hours: Tues.-Sun., 11-5; first Thurs. of every month, 11-8. Closed Mon.
Tours: Call (415) 495-7000 for information.
Museum Shop: Specializes in photography; open during museum hours.

Asian Art Museum of San Francisco
The Avery Brundage Collection
Golden Gate Park, San Francisco, CA 94118
(415) 379-8801; (415) 752-2635 [TDD]
http://www.asianart.org

1999 Exhibitions
Ongoing
Jade: Stone of Immortality
Examines the technical aspects and cultural significance of jade, which has been in continuous use in China for nearly 7,000 years. Includes 500 pieces from the museum's collection.

Chinese Bronze and Sculpture from the Permanent Collection
Highlights a selection of Chinese bronzes and sculptures dating from the early Neolithic period to the 20th century.

Rhinoceros Zun, late Shang dynasty (c. 11th c. BC). Photo courtesy Asian Art Museum of San Francisco, Avery Brundage Collection.

Thru January 3
New Acquisitions in Indian Art
Showcases recently acquired sculpture, decorative arts, and paintings.

Thru January 17
Hiroshige: Great Japanese Prints from the James A. Michener Collection, Honolulu Academy of Arts
Second in a two-part series featuring exceptional woodblock prints.

February 26-May 30
Inside Out: New Chinese Art
The first major international exhibit exploring how contemporary Chinese art reflects the political, cultural, and economic changes of the 20th century.
(T)

July 2-August 29
From the Rainbow's Varied Hue: Textiles of the Southern Philippines
Rare cloths from the rich, little-known weaving traditions of Mindanao and the Sulu archipelago.

September 22, 1999-January 9, 2000
The Art of the Sikh Kingdoms
Explores the turbulent and fascinating cultural history of the 19th-century
Maharajas of the Punjab through paintings, jewels, textiles, and weapons.
(T)

Permanent Collection
More than 12,000 objects representing the art of China, Japan, Korea,
Southeast Asia, India, the Himalayas; sculptures, paintings, bronzes, jades,
ceramics, textiles, decorative objects, architectural elements representing all
stylistic movements of Asian art. **Highlights:** Oldest-known dated Chinese
Buddha (338 A.D.); largest collection of Gandharan sculpture in North
America. **Architecture:** Construction is currently underway on the future
location of the Asian Art Museum in the 1917 former library building at
Civic Center; design by Gae Aulenti, architect Robert Wong, and Hellmuth,
Obata & Kassabaum; the new building is scheduled to open in 2001.

Admission: Adults, $7; seniors, $5; children 12-17, $4; children under 12,
free. First Wed. of each month, free. Handicapped accessible; wheelchairs
and assistive listening devices available.
Hours: Tues.-Sun., 9:30-5. First Wed. of each month, 10-8:45. Closed
Mon., some holidays.
Tours: Six tours daily; call (415) 379-8839 for group reservations.
Food & Drink: Café located in adjacent de Young Museum.
Museum Shop: Carries books, jewelry, and rare, quality handcrafted
merchandise from throughout Asia, (415) 379-8807.

The Fine Arts Museums of San Francisco
California Palace of the Legion of Honor
Lincoln Park, near 34th Ave. & Clement St., San Francisco, CA 94121
(415) 863-3330 (recording)
http://www.thinker.org

1999 Exhibitions
Thru January 3
Picasso and the War Years: 1937-1945
The first U.S. exhibition to examine the dramatic events that took place
during Picasso's life, from the Spanish Civil War to World War II, and how
the horror of these surfaced in his work. The resulting paintings, prints, and
drawings are some of the strongest and most expressive of his career. (T)

February 6-April 25
Claes Oldenburg: Selections from the Anderson Graphic Arts Collection
The 5th in a series of ongoing exhibitions features approximately 20
innovative prints, multiples, and 3-dimensional editioned works by the
world-renowned sculptor.

February 13-May 9
A Grand Design: The Art of the Victoria and Albert Museum
Presents the history of a museum through a comprehensive exhibition of 250 masterworks from the V&A's immense collections, spanning 2,000 years of artistic achievement. Catalogue. (T)

June 13-August 2
Francis Bacon: A Retrospective Exhibition
A landmark retrospective of one of 20th-century Britain's greatest painters, known for his images of isolation, despair, horror, and tortured human forms. 60 paintings represent each significant period of the artist's career. Catalogue. (T)

September 18, 1999-January 9, 2000
The Gantner-Meyer Collection of Aboriginal Art

Permanent Collection
The city's European art museum, its collections span 4,000 years and include major holdings of Rodin sculpture, 70,000 prints and drawings, a 15th-century Spanish ceiling, and paintings by Rembrandt, Rubens, Watteau, de la Tour, Vigée Lebrun, Cézanne, Monet, and Picasso, among other Dutch, Italian, German, English, and French masters. **Architecture:** Beaux-Arts building by George Applegarth; Newly reopened after 1991-5 expansion and renovation by Edward Larrabee Barnes/John M.Y. Lee & Partners.

Admission: Adults, $7; seniors, $5; youths 12-17, $4; college student annual pass, $10; members, children under 12, free. Handicapped accessible; wheelchairs and assistive listening devices available.
Hours: Tues.-Sun., 9:30-5.
Programs for Children: Call for information on Big Kids/Little Kids and Doing and Viewing Art, (415) 750-3640.
Tours: Free daily tours. For special group or foreign language tours, call (415) 750-3638.
Food and Drink: The Legion of Honor Café and Garden Terrace overlooks the Pacific Ocean, (415) 221-2233.
Museum Shop: Discover unique merchandise inspired by the permanent collection and special exhibitions, (415) 750-3677.

The M. H. de Young Memorial Museum
Golden Gate Park, 75 Tea Garden Drive, San Francisco, CA 94118
(415) 863-3330 (recording)

1999 Exhibitions
Ongoing
Gallery One: An Exhibition for Children

Thru March 28
Arnold Genthe's Photographs of San Francisco's Old Chinatown
30 photographs taken between 1896 and 1906 document the colorful neighborhood before its devastation by earthquake and fire in 1906.

January 16-March 21
Fred Wilson
Shows how African Americans are represented in American museums.

The Museum of Jurassic Technology
A collection of Armenian microminiatures–some so small that they can only be seen with magnifying glasses– from this Los Angeles institution.

Contemporary Art from Cuba
The first U.S. survey of works by contemporary Cuban artists.

November 20, 1999-February 12, 2000
Nurturing the Future: The Art and Collection of David C. Driskell

William M. Harnett, *After the Hunt*, 1885. Photo courtesy Fine Arts Museums of San Francisco, M.H. de Young Memorial Museum.

Permanent Collection
Outstanding holdings in American paintings, sculpture, and decorative arts. Arts of Oceania, Africa, the Americas; jewelry from the ancient world; Egyptian mummies. **Highlights:** American paintings by Bingham, Cassatt, Church, Copley, Harnett, Sargent; Revere silver. **Architecture:** 1921 building by Mullgardt. Set in Golden Gate Park, which also houses the Japanese Tea Gardens.

Admission: Adults, $7; seniors, $5; 12-17 years of age, $4; children under 12, members, free; college student annual pass, $10.
Hours: Wcd.-Sun., 9:30-5 p.m.; first Wed., 9:30-8:45. Closed Mon., Tues.
Programs for Children: Call for information on Big Kids/Little Kids and Doing and Viewing Art, (415) 750-3640.
Tours: Call (415) 750-3638 to arrange special group tours.
Food & Drink: Café de Young serves lunches, aperitifs, and light fare throughout the day. Call (415) 752-0116 for information.
Museum Shop: The Muscum Storc offers a wide selection of art books, exhibition catalogues, jewelry, posters, cards, and gift items.

San Francisco Museum of Modern Art
151 Third Street, San Francisco, CA 94103
(415) 357-4000; 357-4514 [TDD]
http://www.sfmoma.org

1999 Exhibitions
Thru January 3
A Portrait of our Times: An Introduction to the Logan Collection
An selection of works, ranging from major masterworks to those by emerging artists, from the recently acquired Logan Collection.

Thru January 12
New Work: Julia Scher's Predictive Engineering[2]
A video installation that transforms exhibition space into a terrain of supersurveillance. Based on Scher's site specific work of 1993.

Thru January 19
Richard Diebenkorn
The most comprehensive survey to date of this contemporary, late American artist's career, featuring over 150 paintings and works on paper, including his celebrated *Ocean Park* series, figurative works, and early abstractions. Catalogue. (T)

Thru February 23
Incandescence: Watercolors by Lauretta Vinciarelli
Features paintings of luminous interiors by the New York-based architect.

Sitting on the Edge: Modernist Design from the Collection of Michael and Gabrielle Boyd
Over 150 pieces of furniture illustrate important issues of 20th-century design. Includes relevant examples of painting and sculpture.

Thru March 2
Paul Klee: Romantic Reflections
A selection of works from the collection of Dr. Carl Djerassi that demonstrate Klee's ties to the 19th-century Romantic tradition.

January 3-April 20
Mirror Images: Women, Surrealism, and Self-Representation
Spotlights three generations of women artists associated with the surrealist movement of the 1930s and 1940s. Catalogue.

January 22-April 6
New Work: Kerry James Marshall
Part of a continuing series, this exhibition features works deeply influenced by traditional history painting and African-American issues.

Richard Diebenkorn, *Coffee,* 1959. Photo courtesy San Francisco Museum of Modern Art.

SECA Art Award
Works by winners of the 1998 SECA Art Award, sculptors Chris Finley and Gay Outlaw, painter Laurie Reid, and muralist Rigo 98.

February 4-April 20
Glenn McKay: Altered States–Light Projections 1969-1999
A survey of work by the inventor of the liquid light show. Explores the use of light as an artistic medium.

February 19-April 27
New Work: Doris Salcedo's Unland

February 26-June 1
Inside/Out: New Chinese Art
This is the first major international exhibition to explore how the political, economic, and social changes of the late 20th century have spurred artists in the People's Republic of China, Hong Kong, and Taiwan. Catalogue. (T)

March 10-June 15
Archigram 1961-1974
For over 12 years, Archigram, a visionary English architectural collaborative, developed radical alternatives to living environments. Catalogue.

May 14-August 3
Daido Moriyama
Retrospective traces the 35-year career of one of the major figures of 20th-century Japanese photography. Includes approximately 150 works.

June 4-September 7
Bill Viola
A retrospective of works by internationally known video artist Bill Viola. Includes video installations, drawings, and notebooks. Catalogue. (T)

June 25-September 14
Carleton Watkins: The Art of Perception
Explores the creative work of a figure considered to be the greatest American photographer of the 19th century. Features landscape images of California and the West. Catalogue.

August 27-November 30
Julia Margaret Cameron's Women
Explores the emotional content of the innovative 19th-century British photographer's portraits of women. Includes portraits of Julia Jackson and Alice Liddell. Catalogue. (T)

Permanent Collection
20th-century works of international scope in all media. **Highlights:** Gorky, *Enigmatic Combat;* Matisse, *The Girl with Green Eyes;* Pollock, *Guardians of the Secret;* Rauschenberg, *Collection;* Rivera, *The Flower Carrier;* Tanguy, *Second Thoughts;* paintings by Bay-Area artists Diebenkorn, Neri, Oliveira, Thiebaud; exceptional selection of photographs by Adams, Stieglitz, Weston. **Architecture:** Second largest structure in the U.S. devoted to modern art, the stunning new 1995 SFMoMA is Swiss architect Mario Botta's first museum project.

Admission: Adults, $8; seniors, $5; students, $4; members, children 12 and under, free. Handicapped accessible.
Hours: Fri.-Tues., 11-6; Thurs., 11-9. Closed Wed.
Programs for Children: Biannual Family Day; Children's Art Studio for ages 2-6; and a studio for families, the third Sun. of each month, 12-3.
Tours: Weekdays, 11:30, 1:15, 2:30, 3:45, (Thurs. 6:15, 7:15); Sat.-Sun., 11:30, 1, 2:30. Call (415) 357-4095 for information.
Food & Drink: Stunning and delicious Caffè Museo open Fri.-Tues., 10-6; Thurs., 10-9.
Museum Shop: Features outstanding collection of art books, jewelry, clocks, and decorative arts.

Yerba Buena Center for the Arts

701 Mission St., San Francisco, CA 94103
(415) 978-2700; (415) 978-ARTS (Tickets)
http://www.yerbabuenaarts.org

1999 Exhibitions

January 30-May 2
The Impressionists in Winter: Effets de Neige
Examines the type of Impressionist winter landscape characterized by "the effects of snow." Includes 65 paintings by such artists as Monet, Pisarro, Sisley, Caillebotte, and Morisot. Catalogue. (T)

June 5-August 22
Gallery One: Trinh Minh-ha and Lynne Kirby address themes of women's literature in a collaborative film/video installation.
Gallery Three: An exhibition that elaborates on the de Young Museum's investigation of museology.
Terrace Gallery: A collaborative exhibition of ceramic works by Richard Shaw and Robert Hudson.

September 3-November 7
Sounds Like Art: A Music/Sound/Sculpture Project
Gallery One: In his installation, noted Seattle composer/sculptor Trimpin creates innovative aural experiences.
Gallery Two: Bay-Area artist Matt Heckert uses large-scale computer controlled machines to create industrially derived sounds.
Gallery Three: An interactive sound environment by Los Angeles artist Marina Weinstein.
Terrace Gallery: Original instruments by composer/sculptors. Guest curator Beth Custer composes and conducts a musical work for these instruments.
Sculpture Court: An exhibition of contemporary French work as part of a West Coast French art festival.

November 20, 1999-June 2000
Bay Area Now Two
The second annual Yerba Buena survey of Bay-Area art.

Permanent Collection

No permanent collection; constantly rotating exhibitions. Multidisciplinary visual media and performing arts complex presents a diverse cross-section of arts and education. **Architecture:** Two-building complex and garden located across from the San Francisco MoMA; Galleries and Forum designed by architect Fumihiko Maki in association with Robinson, Mills &Williams. Theater designed by James Stewart Polshek and Partners.

Admission: Adults, $5; seniors, students, $3; members, free. Handicapped accessible, including braille signage and sign interpreters.
Hours: Tues.-Sun., 11-6
Programs for Children: In-Conversation discussion series; family programs.
Tours: Second Sat. of each month, 1.
Food & Drink: Two restaurants located in the garden complex.
Museum Shop: Unique variety of jewelry and other hand-crafted objects, art publications, and children's books; open museum hours.

San Jose Museum of Art

110 S. Market, San Jose, CA 95113
(408) 294-2787
http://www.sjmusart.org

1999 Exhibitions

Thru January 3

Holding Patterns: Selections from the Photography Collection of Arthur Goodwin
Works by artists such as Mark, Avedon, and Kertesz.

Crimes and Splendors: The Desert Cantos of Richard Misrach
Retrospective of this San Francisco photographer's ongoing epic series, which examines civilization's relationship to its environment. (last venue)

Thru January

Face to Face: A Site-Specific Installation by Patrick Dougherty
A special installation by the North Carolina-based artist known for his use of twigs and branches.

Thru February 14

Gronk x 3: A Site-Specific Installation, Works on Paper, and Collaborations
Featuring murals, theatrical designs, and prints by this Los Angeles artist who approaches his work with passion, energy, and wit. Catalogue.

January 17-May 9

John Register: A Retrospective
Paintings of everyday scenes–waiting rooms, train stations, coffee shops–characterized by a haunting stillness, for which Register is known. Curated by Barnaby Conrad, III. Catalogue.

January 17-April 4

Bystander: The History of Street Photography
Surveys one of the most important and poignant areas of photography. 80 works from the Art Institute of Chicago by such artists as Robert Doisneau, Henri Cartier-Bresson, Robert Frank, and William Klein, among others.

February 28-May 4

Images of the Spirit: Photographs by Graciela Iturbide
The first major U.S. exhibition of Iturbide's work, known for its dreamlike mixture of history, lyricism, and portraiture. (T)

Material Issues: Recent Gifts from the Collection of Katherine and James Gentry
Post-minimalist works by Bay-Area and West Coast artists, as well as artists from throughout the U.S. and abroad.

April 18-July 11

Stripes and Stars: A Visual History of an American Icon
American flag memorabilia including a variety of media and ephemera that date from the Civil War to the present.

May 23-September 12
The Permanent Collection: Into the 21st Century
A broad, sweeping look at the holdings in the museum's collection: works
by artists such as Dale Chihuly, Manuel Neri, and Christopher Brown.

June 6, 1999-June 11, 2000
*A Century of Landscape Selections from the Permanent Collection of the
Whitney Museum of American Art*
The fourth in a series of exhibitions, this selection of landscapes will serve
as a summation of major themes and movements in 20th century art.
Includes work by Diebenkorn, Hopper, O'Keeffe, and Marin, among others.

July 25-October 10
Girlfriend! The Barbie Sessions with David Levinthal
A series of large-format Polaroid photographs depicting one of the most
enduring toys in American culture.

September 25, 1999-January 10, 2000
Piecing It Together: Personal Narrative in Contemporary Art
Works reflecting artists' self-discoveries and psychological journeys.
Highlights work by emerging Bay-Area artists.

Catherine McCarthy
Luscious paintings infused with the sensibilities of centuries past and
personal mythology.

October 24, 1999-January 9, 2000
Carioca: A Year Among the Natives of Rio de Janeiro
New Work by Sandow Birk
A parody of 19th-century explorers' "objective" documentation of Brazilian
life. Birk reexamines the role of the artist as scientist and social critic.

December 18, 1999-February 27, 2000
Land of the Winged Horseman
Major exhibition of 150 works dating from the golden age of the Polish
Empire, which stretched to the Black Sea. Examples of paintings,
metalwork, textiles, ceramics, furniture, and weaponry trace the influence of
Ottoman Turkish and Oriental cultures on Baroque Poland. (T)

Permanent Collection

Nearly 1000 20th-century artworks, with an emphasis on post-1980 Bay-
Area artists, including sculpture, paintings, prints, and drawings by such
artists as Robert Arneson, Joan Brown, Deborah Butterfield, Dale Chihuly,
Ron Davis, Richard Diebenkorn, Jim Dine, Rupert Garcia, Oliver Jackson,
Manuel Neri, Long Nguyen, Nathan Oliveira, Deborah Oropallo, Wayne
Thiebaud, and William Wiley. **Architecture:** 1892 Richardsonian-
Romanesque building renovated in 1969 by Willoughby Edbrooke;
contemporary 1991 wing by Skidmore, Owings & Merrill; 1997 extensive
renovations and expansion, new Charlotte Wendel Education Center.

Admission: Adults, $7; seniors, students, $4; children 5 and under, free; first
Thurs. of the month, free. First Tues. of month, free to seniors. Thurs., 5-8,
half-price. Handicapped accessible, including ramp, elevator, and parking.
Signed tours and wheelchairs available.

Hours: Tues.-Sun., 10-5; Thurs., 10-8. Closed Mon.
Programs for Children: Kids ArtSunday, last Sun. of month, 11-3, includes hands-on activities. Storytelling, second Sun. of month, 11:15-12.
Tours: Daily, 12:30, 2:30. Signed tours, second Sat. of month, 12:30. Call (408) 291-5393 for information.
Food & Drink: Caffè La Pastaia al Museo open during museum hours. Picnic areas available in public park across the street.
Museum Shop: Open during museum hours.

The Huntington Library, Art Collections, and Botanical Gardens

1151 Oxford Rd., San Marino, CA 91108
(626) 405-2100
http://www.huntington.org

After Charles Wilson Peale, *George Washington Before Princeton*, c. 1780. Photo courtesy The Huntington Library.

1999 Exhibitions

Thru January 11
The Wisdom of the Trail: Jack London, Author and Adventurer
A look at the multifaceted career of Jack London. In addition to being a world-renown author, London was also a sailor, oyster pirate, prospector, tramp, foreign correspondent, photojournalist, sociologist, and rancher.

Thru January 31
Antiquity Revisited: English and French Silver-Gilt from the Collection of Audrey Love
Showcases approximately 50 Regency and Napoleonic objects from one of the finest collections of its kind in North America.

Thru May 30
The Great Experiment: George Washington and the American Republic
The most ambitious exhibition in over a decade on the life of George Washington, timed to coincide with the bicentennial of his death in 1799. T)

Mid-March-early June
Treasures from Mount Vernon: George Washington Revealed
An exhibition of art and artifacts from George Washington's home. In conjunction with *The Great Experiment*.

July 27-September 19
Cultivating Celebrity: Portraiture as Publicity in the Career of Sarah Siddons, Star of the Georgian Stage
A look at the phenomenal celebrity of Sarah Siddons, the renowned actress who dominated the British theatre in the Georgian era.

October 1999-September 2000
The Land of Golden Dreams: California and the Gold Rush Decade, 1848-1858
Marking the sesquicentennial of the California Gold Rush, this exhibition features diaries, letters, original drawings, guidebooks, and artifacts.

Permanent Collection

Fabulous library with rare books, manuscripts from the 11th century to the present; 18th- and 19th-century British paintings; Renaissance paintings and bronzes; important 17th-century works by Claude, van Dyck; 18th-century French paintings by Boucher, Nattier, Watteau; European decorative arts; 18th- to 20th-century American art by Cassatt, Copley, Hopper; decorative art objects by architects Greene & Greene. **Highlights:** Cassatt, *Breakfast in Bed*; Church, *Chimborazo*; Constable, *View on the Stour*; Gainsborough, *The Blue Boy*; Hopper, *The Long Leg*; Lawrence, *Pinkie*; van der Weyden, *Madonna and Child*; Gutenberg Bible; Chaucer's *Canterbury Tales*; early editions of Shakespeare; letters and papers of the Founding Fathers; botanical gardens including the Japanese, Desert, Rose, Jungle gardens. **Architecture:** 1909-11 mansion designed for philanthropist Huntington by Hunt and Grey; 1984 Scott Gallery of American Art by Warner and Grey.

Admission: Adults, $8.50; seniors, $7; students, $5, free for children under 12. Handicapped accessible, with wheelchair map of gardens available.
Hours: Tues.-Fri., 12-4:30; Sat.-Sun., 10:30-4:30. Closed Mon., holidays; summer hours: 10:30-4:30 daily (except Monday).
Programs for Children: Scheduled throughout the year.
Tours: Garden tours, Tues.–Sun. Groups call (626) 405-2127.
Food & Drink: Rose Garden Café open Tues.-Fri., noon-4:30; Sat.-Sun., 10:30-4:30. English tearoom: Tues.-Fri., 12-3:45; Sat.-Sun., 10:30-3:45.
Museum Shop: Offers good selection of books, cards; open Tues.-Fri., 12:30-5; Sat.-Sun., 11-5.

Santa Barbara Museum of Art

1130 State St., Santa Barbara, CA 93101
(805) 963-4364
http://www.sbmuseart.org

1999 Exhibitions

Thru January 10
Time and Place: Landscape Drawings from Four Centuries
Works from the 17th to 20th centuries deal with the broad theme of landscape, ranging from forests of France to deserts of the western U.S.

Portrait in Blue: Charles Lummis's Cyanotypes
Lummis's cyanotypes vividly document the Southwest during the late-19th century.

Thru January 17
g wiz...POP
This unique installation of 448 drawings, arranged in a radiating circle, explores theories of mysticism, theosophy, and new physics.

Thru January 31
American Photographs: The First Century
160 works, from 19th-century daguerrotypes to photodocumentation of the industrial landscape, trace the evolution of the American visual culture.

Thru March 7
In Celebration Part II: Highlights from the Collection of Contemporary Sculpture
A selection of diverse, innovative, and radical sculptures from the permanent collection.

July 31-October 10
The Cecil Family Collects: Four Centuries of Decorative Arts from Burghley House
A collection of decorative arts in gold, silver, diamonds, rubies, and quartz crystals from one of the grandest Elizabethan houses in England. (T)

November 1999-January 2000
Greek Gold
Golden jewelry set with gemstones and pearls from the most magnificent days of the Greek and early Roman Empire.

Permanent Collection

Houses more than 15,000 works; important holdings of American and Asian art, classical antiquities, European paintings, 19th-century French art, 20th-century art, photography, works on paper. Artists represented include Homer, Sargent, Picasso, Matisse, Chagall, Hopper, Kandinsky, and Dalí.
Architecture: 1914 Neoclassical building designed as a post office by John Taylor Knox; 1941 redesign by David Adler; 1991 addition by Paul Gray; 1998 Peck Wing, with new children's gallery.

Admission: Adults, $5; seniors, $3; students, $2; children under 6, free; Thurs., and first Sun. of the month, free. Handicapped accessible.
Hours: Tues.-Sat., 11-5; Fri., 11-9; Sun., noon-5. Closed Mon. and major holidays. The Fearing Art and Reference Library is open Tues.-Fri., 12-4.
Programs for Children: Art: Dig It!, an new children's gallery allows children to participate in a mock archaeological dig. Classes for children and adults are offered throughout the year at the Ridley-Tree Education Center at McCormick House, 1600 Santa Barbara St., (805) 962-1661.
Tours: Tues.-Sun., 1; special focus tours, Wed., Thurs., Sat., Sun., 12; monthly bilingual Spanish-English tour. Call (805) 963-4364.
Food & Drink: The Museum Café offers light, healthy, enticing fare for breakfast and lunch.
Museum Shop: Offers books, jewelry, and unique gift items not found elsewhere.

Iris & B. Gerald Cantor Center for Visual Arts at Stanford University

(formerly the Stanford University Museum of Art)
Lomita Dr. & Museum Way, Stanford, CA 94305
(650) 723-4177
http://www.stanford.edu/dept/ccva

1999 Exhibitions

January 24-March 28
Picasso: Graphic Magician

April 20-June 27
Pacific Arcadia: Images of California 1600-1915

July 13-September 19
Arthur Wesley Dow and the Arts & Crafts Aesthetic

October 12, 1999-January 2, 2000
A Renaissance Treasury: The Flagg Collection of European Decorative Arts and Sculpture
This exhibition features 70 precious objects dating from the 14th to the early 18th century from the private collection of Richard and Erna Flagg. (T)

Permanent Collection

Works from antiquity to the present including early and late 20th-century art; African and Oceanic art; 19th-century European art; Native American art; 19th-century American art; pre-1800 European art; and Asian art. Also, the recently completed New Guinea Sculpture Garden displays the techniques and cultural traditions of the Kwoma and Latmul people of Papua New Guinea. **Architecture:** 1891-93 Beaux-Arts building by Percy & Hamilton, modeled on the National Museum of Athens. 1999 renovations: new 42,000 sq. ft. wing with spacious galleries, auditorium, café, and bookshop; enhanced Rodin sculpture garden.

Admission: Free. Handicapped accessible.
Hours: Wed.-Sun., 11-5; Thurs., 11-8. Closed Mon.,Tues., holidays.
Programs for Children: Monthly family tours for children under 8 and their adult companions; summer classes for older children.
Tours: Call (650) 723-3469 for information.
Food & Drink: New café opening in 1999.
Museum Shop: New museum store opening in 1999.

Denver Art Museum

100 W. 14th Ave. Pkwy., Denver, CO 80204
(303) 640-4433; (303) 640-2789 [TTY]
http://www.denverartmuseum.org

1999 Exhibitions

Ongoing
New Concepts: The Industrial Revolution
Showcases the evolution of industrial design spanning the last two centuries, from patent/innovative furniture to early Modernism, post-WWII Scandinavian design, Pop design, and late Modernism.

Thru January 24
Inventing the Southwest: The Fred Harvey Company & Native American Art
Retrospective of early American railroad travel and its effect on native peoples and Native American art.

Thru March 28
600 Years of British Painting: The Berger Collection
An exceptional collection of more than 150 paintings from the 14th century to the present.

Thru April 11
Crazy Quilts
A selection from the museum's popular textile collection.

Thru August 8
Forging a New Century: Modern Metalwork, 1895–1935–Selections from the Norwest Collection
The second in a series of modern design exhibitions.

Thru October 3
White on White: Chinese Jades and Ceramics from the Tang through Qing Dynasties
Highlights the elegance and subtle beauty of white ceramic and jade objects.

Thru January 9, 2000
Treasures from the Dr. S. Y. Yip Collection: Classic Chinese Furniture, Painting, and Calligraphy
An extraordinary collection of objects from the Ming dynasty (1368-1644).

April 10-July 4
Toulouse-Lautrec in the Metropolitan Museum of Art
More than 100 drawings, paintings, prints, posters, and illustrations from the major exhibition at the Metropolitan Museum of Art in 1996. Catalogue.

May 15-August 15
The Royal Academy in the Age of Queen Victoria (1837-1901)
A dazzling selection of paintings by such artists as William Blake, Sir John Millais, Sir Lawrence Alma-Tadema, and others.

October 2-December 12
Impressionism: Paintings Collected by European Museums
A highly selective and important exhibition of about 60
Impressionist paintings, including works by Monet, Cézanne,
Pissaro, Degas, Renoir, Morisot, Caillebotte, and Sisley, from
major museums in London, Paris, Oslo, Budapest, Cologne, and
Stuttgart. (T)

Permanent Collection
Extensive North American Indian collection; notable pre-
Columbian and Spanish Colonial collections; 19th- and early 20th-
century painting; art of the American West; Renaissance and
Baroque painting; Asian art; modern & contemporary; architecture,
design & graphics. **Highlights:** Remington, *The Cheyenne;*
O'Keeffe, *Petunia and Glass Bottle;* Monet, *Waterloo Bridge;*
Degas, *The Dance Examination;* di Suvero, *Lao-Tzu.*
Architecture: 1971 building by Italian designer and architect Gio
Ponti with Sudler Associates, housing galleries in twin towers with
uniquely shaped windows framing views of the city. New
European, American, and Western art galleries opened in
November 1997. Renovated Asian, Pre-Columbian and Spanish
Colonial Galleries opened in 1993; new Architecture, Design &
Graphics galleries debuted in 1995.

Admission: Adults, $4.50; seniors, students, $2.50; children under
5, free. Handicapped accessible.
Hours: Tues.-Sat., 10-5; Wed., 10-9; Sun., 12-5. Closed Mon.,
major holidays.
Programs for Children: Adventures in Art education center
offers classes for children and adults. Kids Corner available during
museum hours with art-making activities; Eye Spy games on most
floors; special Saturday programs, including Adventure Backpacks
and Family Workshops. Call for more information.
Tours: 45 min. overview tours: Tues.-Sun., 1:30; Sat., 11, 1:30.
Summer schedule: Tues.-Sat., 11, 1:30; Sun., 1:30. Half-hour focus
tours: Wed. & Fri., 12. European/American art tours, Wed., Fri.,
Sat., Sun., 2:30. No reservations required; free with admission.
Groups call (303) 640-7596.
Food & Drink: Restaurant open Tues.-Sun., 11-5; Wed., 11-9.
Café open Tues.-Sat., 10-5; Sun. 11-5.
Museum Shop: Wide selection of art books, Native American and
other handcrafted jewelry, folk art, pots, books, cards, posters,
prints, children's games and toys, and items relating to specific
installations. Open Tues.-Sat., 10-5; Sun., 11-5, (303) 629-0889.

Wadsworth Atheneum

600 Main St., Hartford, CT 06103
(860) 278-2670

1999 Exhibitions
Not available at press time.

Permanent Collection
Sixteenth- and 17th-century Old Master, Hudson River school, and Impressionist paintings; Nutting Collection of Pilgrim-period furniture and two restored period rooms; African-American, 20th-century art.
Highlights: Caravaggio, *Ecstasy of Saint Francis;* landscapes by Church, Cole; Goya, *Gossiping Women;* Pollock, *Number 9;* Picasso, *The Painter;* Renoir, *Monet Painting in His Garden at Argenteuil;* Zurbarán, *Saint Serapion.* **Architecture:** Five connected buildings reflecting the history and growth of the Atheneum, one of America's oldest continuously operated public art museums. Original 1844 Gothic Revival style building by Ithiel Town and A.J. Davis; two buildings designed by Benjamin Morriss in 1907, modest Tudor-style Colt Memorial and the imposing Renaissance Revival style Morgan Memorial; 1934 Avery Memorial with International Style interior; 1969 Goodwin building.
Admission: Adults, $7; seniors, students, $5; youths 6-17, $4; members, children under 6, free. Handicapped accessible; TDD listening devices available.
Hours: Tues.-Sun., 11-5. First Thurs. each month, 11-8. Closed Mon., holidays.
Programs for Children: Offers classes, treasure hunts, workshops, birthday parties, and other activities throughout the year. Call for details.
Tours: Tues.-Fri., 1; Sat.-Sun., 2. Groups call (860) 278-2670, ext. 3046.
Food & Drink: Museum Café open for lunch Tues.-Sat. and for brunch, Sun.; open for dinner on select Thurs.

Yale Center for British Art

1080 Chapel St., New Haven, CT 06520
(203) 432-2800
http://www.yale.edu/ycba

1999 Exhibitions
January 23-March 21
Francis Bacon: A Retrospective
A landmark retrospective of one of 20th-century Britain's greatest painters, known for his images of isolation, despair, horror, and tortured human forms. 60 paintings represent each significant period of the artist's career. Catalogue. (T)

Lucian Freud Etchings from the PaineWebber Art Collection
Portraits and nude studies characterized by the unflinching honesty that has earned Freud world renown. These works are the result of the internationally acclaimed artist's return to the medium of etching in the 1980s. Catalogue.

Henry Moore and the Heroic: A Centenary Tribute

Lucian Freud, *Head of Bruce Bernard*, 1985. Photo courtesy PaineWebber Group Inc. and Yale Center for British Art.

Features over 20 of Moore's celebrated sculptures from the 1930s to the 1970s, which reflect the artist's interest in heroic themes, attitudes, atmospheres and scale.

September 22-November 22
James Tissot (T)

Permanent Collection

The most comprehensive collection of English paintings, drawings, prints, and rare books outside Great Britain. Focuses on British art, life, and thought from the Elizabethan period onwards; emphasis on work created between the birth of Hogarth in 1697 and the death of Turner in 1851, considered the golden age of English art. **Highlights:** Constable, *Hadleigh Castle;* Gainsborough, *The Gravenor Family*; Reynolds, *Mrs. Abington as Miss Prue in Congreve's "Love for Love";* Rubens, *Peace Embracing Plenty;* Stubbs, *A Lion Attacking a Horse;* Turner, *Dort or Dor-drecht: The Dort Packet-Boat from Rotterdam Becalmed.* **Architecture:** 1977 building, the final work of Louis I. Kahn's distinguished career, presents an austere facade of poured concrete filled with matte "pewter-finish" stainless steel panels and reflective plate glass windows. Inside, rooms finished in white oak panelling encircle two open courts filled with natural light.

Admission: Free. Handicapped accessible.
Hours: Tues.-Sat., 10-5; Sun., noon-5. Closed Mon. Labor Day-Thanksgiving: Wed., 10-7.
Programs for Children: Workshops, tours, activity days. Call (203) 432-2855 for information.
Tours: Call (203) 432-2858 for information.
Food & Drink: The Center is located near many of the city's restaurants.
Museum Shop: Offers a wide range of gift items and books from the U.K. for children and adults. Fine reproductions from the museum's collection as postcards, notecards, slides, and posters. Over 1000 titles on British subjects. Hand-painted pottery, blown glass, stuffed animals, and scented soaps are among the unique selection of goods from England, Ireland, Scotland, and Wales.

Yale University Art Gallery

1111 Chapel St. at York, New Haven, CT 06520
(203) 432-0600
http://www.yale.edu/artgallery

1999 Exhibitions

Thru January 3
The Unmapped Body: Three Black British Artists
Sonia Boyce, Sutapa Biswas, and Keith Piper bear witness to the far-reaching cultural changes resulting from waves of post-WWII immigration to the U.K.

Thru February 15
Spirit and Ritual in Asian Art
Explores the power and symbolism of funerary art, including Chinese paintings, ritual bronze vessels, jades, ceramics, and pottery figurines.

January 18-April 11
James Latimer Allen: Portraiture and the Harlem Renaissance

February 2-May 30
Worlds Within Worlds: The Richard Rosenblum Collection of Chinese Scholars Rocks

February 9-June 13
Closing: The Life and Death of an American Factory

April 30-August 15
Please Be Seated: Contemporary Chairs and Benches

Permanent Collection

Works from Ancient Egyptian dynasties to the present. Asian art, including Japanese screens, ceramics, prints; artifacts from ancient Dura-Europos; Italian Renaissance art; 19th- and 20th-century European paintings; early modern works by Kandinsky, Léger, Picasso; American art through the 20th century, featuring paintings, sculptures, furniture, silver, pewter. **Highlights:** Reconstructed Mithraic shrine; Van Gogh, *The Night Café;* Malevich, *The Knife Grinder;* Smibert, *The Bermuda Group;* Trumbull, *The Declaration of Independence;* contemporary sculpture by Moore, Nevelson, Smith.
Architecture: Two connecting buildings house the oldest university art museum in the U.S. 1928 building by Edgerton Swartout based on a gothic palace in Viterbo, Italy; 1953 landmark building by internationally acclaimed architect Louis I. Kahn.

Admission: Free. Handicapped accessible.
Hours: Tues.-Sat., 10-5; Sun., 1-5. Closed Mon., holidays.
Tours: Wed., Sat., 1:30. Call (203) 432-0620 for special tours.

Delaware Art Museum

2301 Kentmere Pkwy., Wilmington, DE 19806
(302) 571-9590
http://www.udel.edu/delart

1999 Exhibitions

Ongoing
Perfect Marvels: The Morris-Rossetti Chairs
Two extraordinary chairs designed and painted by Pre-Raphaelites William
Morris and Dante Gabriel Rossetti.

Thru January 3
Holiday Happenings
A festive display of holiday decorations, gingerbread houses, and colorful
community quilt.

Thru February 21
Wondrous Strange: Pyle, Wyeth, Wyeth, & Wyeth
The first exhibition to examine the inspiration for these artists: the
"wondrous" and "strange" that exist in the mind's eye.

March 18-May 9
Chihuly Baskets
Blown glass from the critically acclaimed artist's *Basket Series,* and
examples of the woven Native American baskets that inspired them.

April 8-April 11
Art in Bloom
25 dramatic floral arrangements based on paintings from the permanent
collection.

June 4-August 1
Sandy Skoglund: Reality Under Siege
The first major retrospective of this sculptor, photographer, and installation
artist. Features *Radioactive Cats*, *Peaches in a Toaster*, and other works. (T)

Permanent Collection

Largest display of Pre-Raphaelite art in the United States; the primary
repository of American illustration, including unrivalled collection of works
by Howard Pyle. American painting from 1840 to the present, including
Church, Eakins, Hassam, Henri, Homer, Hopper, Sloan, Calder, Nevelson,
and Held. **Architecture:** 1938 Georgian-style building; 1956 addition; 1987
wing by Victorine and Samuel Homsey, Inc.

Admission: Adults, $5; seniors, $3; students with ID, $2.50; members,
children under 6, free. Wed., 4-9; Sat., 9-noon, free. Handicapped
accessible.
Hours: Tues.-Sat., 9-4; Sun., 10-4; Wed., 9-9. Closed Mon., Jan. 1,
Thanksgiving, Dec. 25.
Programs for Children: Participatory gallery, Pegafoamasaurus.
Tours: Group reservations, call (302) 571-9590 six weeks in advance.
Food & Drink: Café open during museum hours.
Museum Shop: Open during museum hours.

The Corcoran Gallery of Art

500 17th St. NW, Washington, DC 20006
(202) 639-1700
http://www.corcoran.org

1999 Exhibitions

Thru January 4
Roy DeCarava: A Retrospective
Surveys 200 works spanning half a century by one of the major figures in postwar American photography. Includes themes of social awareness, humanity, and jazz. Catalogue. (T)

Roy DeCarava, *Graduation,* 1949. From *Roy DeCarava: A Retrospective.*
Photo courtesy Corcoran Gallery of Art, Washington, DC.

Thru January 10
The Painted Sketch: American Impressions from Nature, 1830-1880
Explores the emergence of the oil sketch from the private realm of the artist's studio to the public arena of the exhibition hall and marketplace. Includes works by Cole, Durand, Church, Bierstadt, and Gifford. (T)

Thru early January
Jyung Mee Park
Sculptural installations created entirely from 10,000 sheets of folded rice paper.

January 27-April 20
New Worlds from Old: Australian and American Landscape Painting of the 19th Century
Compares the traditions of these former British colonies during a period when landscape became a focus. Includes works by Frederic Church, Thomas Cole, Winslow Homer, Augustus Earle, and John Glover. (T)

February 24-April 26
1999 Bachelor of Fine Arts Senior Exhibition
8 week-long exhibitions featuring projects by students graduating from the Corcoran School of Art.

May 3-17
1999 All Senior Exhibition
A showcase of works by the entire graduating class.

May 15-August 23
Belief: Photographing the 1930s in the USSR and USA
The first exhibition to compare the Farm Security Administration photography of the U.S. with the Socialist Realist works of the USSR. Includes work by Evans, Lange, Shahn, Bulla, Dyebabov, and Ingatovich.

May 26-July 5
Embody/Disembody
Features the work of 7 photographic and installation artists. Addresses issues of the body through various media.

June-September
Roy Lichtenstein: A Sculpture Retrospective
Best known as a painter, Lichtenstein also devoted his career to sculpture. 80 works, ranging from his early ceramics and metal wall hangings of the 1960s to later cast and painted bronzes, constitute the first DC exhibition dedicated exclusively to Lichtenstein's sculpture.

September-December
At the Edge: A Portuguese Futurist, Amadeo de Souza Cardoso
Friends with such artists as Modigliani, Gris, and Brancusi, Souza Cardoso constructed creative variants on fauvism, cubism, and futurism, and was instrumental in the development of international modernism.

September 1-October 4
Corcoran Alumni Annual Exhibition
An impressive range of traditional and non-traditional materials, media, and styles.

November 1999-January 2000
To Conserve a Legacy: American Art from Historically Black Colleges and Universities
This exhibition of more than 100 works highlights not only African-American works, but the full range of American art that each institution holds, including work by Jacob Lawrence, Lois Mailou Jones, Aaron Douglas, Georgia O'Keeffe, and Arthur Dove. (T)

Permanent Collection
American art and photography, from colonial portraits to contemporary works; 17th-century Dutch art; 19th-century Barbizon and Impressionist painting; American sculpture by French, Powers, Remington, Saint-Gaudens. **Highlights:** The Salon Doré; Bellows, *Forty-two Kids;* Bierstadt, *Mount Corcoran;* Church, *Niagara;* Cole, *The Departure* and *The Return;* Eakins, *The Pathetic Song;* Glackens, *Luxembourg Gardens;* Homer, *A Light on the Sea.* **Architecture:** 1897 Beaux Arts building by Ernest Flagg; 1927 Clark Wing by Charles Platt.

Admission: Suggested donation: adults, $3; seniors, students, $1; family groups, $5; members, children under 12, free. Handicapped accessible.
Hours: Wed.-Mon., 10-5; Thurs., 10-9. Closed Tues.
Programs for Children: Throughout the year, including Family Days, art activities, films, music programs, and storytelling.
Tours: Daily, 12; Sat.-Sun., 10:30, 12, 2:30; Thurs., 7:30.
Food & Drink: Café des Artistes, open Mon., Wed., Fri., Sat., 11-3; Sun., 11-2; Thurs. 11-8:30.
Museum Shop: Offers interesting items focusing on current exhibitions; open during museum hours.

Folger Shakespeare Library

201 E. Capitol St. SE, Washington, DC 20003
(202) 544-7077
http://www.folger.edu

1999 Exhibitions

Thru March 20
The Shakespeare Drawings of George Romney

April 3-August 3
Shakespeare: Illustrating the Text

September-December
Food in Modern England

Permanent Collection

A preeminent international center for Shakespeare research; rich collection of 15th-18th-century printed books; prints and engravings, manuscript materials, maps, paintings, memorabilia. **Highlights:** Copy of the 1623 First Folio. **Architecture:** Modernized neoclassical style building by Paul Philippe Cret in 1932, with Art Deco aluminum grilles on windows and doors, and nine bas-reliefs depicting Shakespeare scenes on the facade. Tudor interior reminiscent of an Elizabethan college Great Hall; authentic Elizabethan theatre; elegant Reading Room designed in 1982 by Hartman & Cox.

Admission: Free. Handicapped accessible; entrance ramp at rear driveway.
Hours: Mon.-Sat., 10-4; closed Sun., federal holidays.
Programs for Children: Children's Shakespeare School Festival, Shakespeare's Birthday Open House (around Apr. 23), and workshops.
Tours: Mon.-Sat., 11. Groups call (202) 675-0365.
Museum Shop: Shakespeare, Etc. is open during museum hours.

Freer Gallery of Art

Smithsonian Institution, Jefferson Dr. at 12th St. SW,
Washington, DC 20560
(202) 357-2700

1999 Exhibitions

Continuing
Shades of Green and Blue: Chinese Celadon Ceramics
Illustrates the development of the family of glazes first developed in the Shang dynasty (ca. 1600-1050 B.C.) and known in the West as celadon.

Art for Art's Sake
Examines the rise of Aestheticism, an English artistic movement commonly defined as "art for art's sake." Works by Whistler, Tryon, and other late-19th-century artists.

Arts of the Islamic World
Sixty works celebrating the artistic legacy of the Islamic world, dating from the 9th to the 19th century. Includes Koran pages, metalwork, ceramics, glass vessels, manuscript paintings, and calligraphy.

Charles Lang Freer and Egypt
Explores Charles Lang Freer's eclectic collection of ancient Egyptian artifacts, including faience, glass, stone, and bronze, dating from the New Kingdom to the Roman period. Includes material archiving Freer's travels.

Thru February 15
Japanese Art in the Age of Koetsu
Works produced in the flourishing cultural renaissance of early 17th-century Kyoto, focusing on the art and objects of Hon'ami Koetsu (1558-1637).

Thru June 30
Whistler and the Leylands
The first in a series of small exhibitions focused on James McNeill Whistler's printmaking career. Includes 31 works produced under the patronage of Frederick Richards Leyland.

Opens April 4
Japanese Art
A new selection of works from the Freer's outstanding permanent collection.

Opens Spring
Masterpieces of Chinese Painting
10th- to early-18th-century painting and calligraphy from the Freer's outstanding collection of Chinese art.

Winged Figures
In celebration of the 150th anniversary of artist Abbott Thayer's birth, three monumental winged-figure paintings by the artist will be on view.

Opens Summer
Whistler and the Hadens
Focuses on the artist's printmaking in the early years of his career, while living with his sister and struggling to establish himself as an artist.

October 11-March 14
Beyond the Legacy: Anniversary Acquisitions
The results of a 4-year campaign to acquire extraordinary works of art in celebration of the Freer's 75th anniversary.

Permanent Collection
World-renowned collection of Asian art, comprising Japanese, Chinese, Korean, South and Southeast Asian, and Near Eastern; 19th- and early-20th-century American art collection, including the world's most important collection of works by James McNeill Whistler. **Highlights:** Whistler interior: *Harmony in Blue and Gold:* The Peacock Room; Japanese screens; Korean ceramics; Chinese paintings; Indian bronze sculptures.
Architecture: 1923 building by renowned architect Charles Platt; 1993 renovation and expansion joining Sackler Gallery.

Admission: Free. Handicapped accessible.
Hours: Daily, 10-5:30. Closed Dec. 25.
Tours: Call (202) 357-4880, ext. 245, Mon.-Fri.

Hillwood Museum and Gardens

4155 Linnean Ave. NW, Washington, DC 20008
(202) 686-8500
http://www.hillwoodmuseum.org

NOTE: The museum will be closed for renovation until the spring of 2000.

Permanent Collection

Primarily 18th- and 19th-century French and Russian fine and decorative arts. Mansion, auxiliary buildings, and gardens on 25 acres in the heart of Washington, DC. Art works displayed in a grand setting, as they were used by Hillwood's founder, Marjorie Merriweather Post. **Highlights:** Russian imperial porcelain; nearly 100 pieces by Fabergé, including two imperial eggs; Empress Alexandra's nuptial crown; Sèvres porcelain; French furniture.

Admission: $10 house tour; $2 grounds pass. Handicapped accessible.
Hours: Tues.-Sat., 9-5.
Tours: Tues.-Sat., 9:30, 10:45, 12:30, 1:45, 3. Reservations required. Garden tours Fri. & Sat., 9:30, 3, 4.
Food & Drink: Café open 11-4. Reservations recommended: (202) 686-8893.
Museum Shop: Offers reproductions of Russian and French porcelains, jewelry, crafts, and gifts. Garden gifts also available.

Hirshhorn Museum and Sculpture Garden

Smithsonian Institution, Independence Ave. at Seventh St. SW, Washington, DC 20560
(202) 357-2700
http://www.si.edu.hirshhorn

1999 Exhibitions
Thru Jan. 10
Chuck Close
Surveys the full spectrum of this American artist's remarkable career, including over 90 paintings, drawings, prints, and photographs featuring his early gray-scale works and later colorful patchwork paintings. Catalogue. (T)

Brice Marden, *Cold Mountain 2*, 1989-91. Photo courtesy Hirshhorn Museum and Sculpture Garden, Holenia Purchase Fund in Memory of Joseph H. Hirshhorn.

January 28-June 20
Direction Julião Sarmento

June 17-September 12
Brice Marden: Works of the 1990s
A survey of the American artist's recent paintings, drawings, and prints, on loan from important private and public collections. Catalogue. (T)

July 15-October 17
Directions–Sam Taylor-Wood
Site-specific video installation by British artist Sam Taylor-Wood, who won the best new artist award at the 1997 Venice Biennale.

October 14, 1999-January 17, 2000
Regarding Beauty: Perspectives on Art since 1950
25th anniversary show of the Hirshhorn Museum.

Permanent Collection

Comprehensive holdings of modern and contemporary sculpture, painting, drawing; particular strengths in art since 1950; works by 20th-century masters in the sculpture garden and contemporary sculptors on plaza; mostly 20th-century American and European paintings; smaller sculptures in building, with one floor of contemporary art. **Highlights:** de Kooning, *Queen of Hearts;* Eakins, *Mrs. Thomas Eakins;* Golub, *Four Black Men*; Kiefer, *The Book*; Matisse, *Four Backs*; Moore, *King and Queen;* Rodin, *Monument to Balzac* and *Burghers of Calais;* Smith, *Cubi IX;* Cragg, *Subcommittee*; Munoz, *Conversation Piece;* Oldenburg, *7-UP;* Close, *Roy II;* Cornell, *Medici Princess;* Brancusi, *Sleeping Muse;* Hopper, *First Row Orchestra;* Saar, *Snake Charmer.* **Architecture:** 1974 building by Gordon Bunshaft of Skidmore, Owings, and Merrill; 1981 sculpture garden renovation by Lester Collins; 1992 sculpture plaza renovation by James Urban.

Admission: Free. Handicapped accessible; touch tours for the vision-impaired available, call (202) 357-3235 for reservations.
Hours: Daily, 10-5:30; Sculpture Garden, 7:30-dusk. Closed Dec. 25.
Programs for Children: "Young at Art" Programs with hands-on art workshops for children ages 6-9, offered monthly, Sat.; call for information and reservations.
Tours: Mon.-Fri., 10:30, 12; Sat-Sun., 12, 2. Tours of Sculpture Garden: Mon.-Sat., 12:15 (May, October only). "Family Guide" available at Information Desk. Foreign language tours available with one-month advance reservation. Call (202) 357-3235 for information.
Food & Drink: Full Circle Café open on outdoor plaza overlooking sculpture garden from Memorial Day thru Labor Day, daily, 10-4.
Museum Shop: Offers unusual contemporary jewelry, crafts, and an extensive collection of art books; open during museum hours.

Kreeger Museum

2401 Foxhall Rd., NW, Washington, D.C. 20007
(202) 337-3050
http://www.kreegermuseum.com

Permanent Collection

19th- and 20th-century painting and sculpture from the collection of Carmen and David Lloyd Kreeger. Includes magnificent works by Monet, Van Gogh, Rodin, Picasso, Miro, Moore, Chagall, Stella, Kandinsky, and Washington artists Sam Gilliam, Thomas Downing, and Gene Davis; African, Indian, and Pre-Columbian art. **Highlights:** Picasso, *Man with Golden Helmet;* Henry Moore, *Three-Piece Reclining Figure No.2 Bridge Prop;* Cézanne, *Turn of the Road at Auvers.* **Architecture:** Stunning 1961 building by Philip Johnson and Richard Foster.

Admission: Suggested donation, $5. Reservations required; call (202) 338-3552 or visit website. Children under 12 not permitted. Partially handicapped accessible.
Hours: Tues.-Sat., 10:30-1:30. Closed August.
Tours: 1-1/2 hr. docent-led tours mandatory. For groups of 10 or more, payment of $5 per person required two weeks in advance.

Library of Congress

Thomas Jefferson Building, 10 First St., SE, Washington, DC 20540
(202) 707-5000; (202) 707-5522; (202) 707-6200 [TTY]
http://www.loc.gov

1999 Exhibitions

Ongoing
American Treasures of the Library of Congress
A rotating exhibition of the rarest and most significant items from the Library's collections relating to America's past.

New Acquisitions and Publications
Rotating exhibition from the Library's collections.

Gershwin Room
Permanent, rotating display of artifacts from the lives of George and Ira Gershwin, including sheet music, musical manuscripts, and George Gershwin's piano.

Thru January 16
Sigmund Freud: Conflict and Culture
Vintage photographs, prints, films, manuscript letters, and artifacts explore Freud's life, work, and the impact of psychoanalysis on 20th-century culture. (T)

April-October (tentative)
Prokudin-Gorsky Photographs

W.K.L. Dickson, from *The Edison Kinetoscopic Record of a Sneeze,* 1894. Photo courtesy Library of Congress.

May 20-September 4
The Work of Charles and Ray Eames: A Legacy of Invention
Surveys the career of the 20th-century American husband and wife design team, best known for their mass-produced, form-fitting chairs. (T)

October 1999-January 2000
Library of Congress/British Library: 200 Years of a Special Relationship

Permanent Collection

Repository of the nation's collection of books, including 113 million items, featuring prints, manuscripts, and artifacts of American historical importance. Includes the Ralph Ellison Collection, the Woodrow Wilson Collection, and the Oliver Wendell Holmes Library. **Architecture:** 1873 Italian Renaissance-style building designed by Smithmeyer and Pelz, opened to the public in 1897. Renovation completed in 1997, managed by the Office of the Architect of the Capitol, with consultation by Arthur Cotton Moore & Associates.

Admission: Free. Handicapped accessible; wheelchairs available in Jefferson Building; call (202) 707-6362 to request sign interpretation.
Hours: Jefferson Building: Mon.-Sat., 10-5:30. Closed Sun., federal holidays. Call (202) 707-5000 for Reading Room hours.
Programs for Children: Learning Page on the Library's website.
Tours: Mon.-Sat., 11:30, 1, 2:30, 4. Groups call (202) 707-4684 for reservations.
Food & Drink: Madison Building Cafeteria, 6th floor, open Mon.-Sat., 12:30-3; Montpelier Room (fixed price buffet) open Mon.-Fri., 11:30-2; coffee shop and snack bar located in the Madison Building, ground floor, open Mon.-Sat., 9-10:30, 12:30-4. Picnic areas available in the outdoor plaza facing the U.S. Capitol.
Museum Shop: Two shops, located in the Jefferson and Madison Buildings, offer an unusual collection of cards and stationery; open Mon.-Sat., 9:30-5.

Meridian International Center

1630 Crescent Place, N.W., Washington, D.C. 20009
(202) 667-6800

1999 Exhibitions

Thru February 14
Sing Me a Rainbow: An Artistic Medley from Trinidad and Tobago
Celebrates the traditions and multi-cultural spirit of Trinidad and Tobago through the work of some of the country's outstanding artists.

March 3-May 12
Tango
Music and dancing are combined in this presentation of work inspired by the world-famous dance from Argentina.

May 25-July 11
Outward Bound: American Art at the Brink of the 21st Century
Sixty-five works from different regions of the U.S. present a cross-section of contemporary American art.

Permanent Collection
No permanent collection; rotating exhibitions to promote intercultural understanding.
Admission: Free.
Hours: Wed.-Sun., 2-5.
Programs for Children: School tours available. Call (202) 939-5568 for more information.

National Building Museum

401 F St. at Judiciary Square, NW, Washington, DC 20001
(202) 272-2448
http://www.nbm.org

1999 Exhibitions

Thru January 3
Building Culture Downtown: New Ways of Revitalizing the American City
A look at urban renewal through the construction of new arts centers, theaters, and museums.

Thru January 4
The Business of Innovation: Bechtel's First Century
Traces the San Francisco-based engineering-construction company's projects over the last 100 years, including the Hoover Dam, Boston's Central Artery, and the Channel Tunnel.

Thru February 7
Tools as Art IV: Material Illusions, The Hechinger Collection
Highlights traditional subjects rendered in unconventional materials, from hammers and nails made out of glass to drill presses made from paper.

Thru February 28
City Satire: The Cartoons of Roger K. Lewis
Lewis's humorous illustrations satirize the present state of architecture and urban design.

Thru March 29
El Nuevo Mundo: The Landscape of Latino Los Angeles
A look at the profound changes in the physical character and social texture of Los Angeles through the photography of sociologist Camilo José Vergara.

Thru May 2
Forgotten Gateway: The Abandoned Buildings of Ellis Island
Larry Racioppo's haunting color photographs document the hospital compound of Ellis Island, where sick immigrants were nursed back to health.

January-September
A Return to Elegance: The Houses of Hugh Newell Jacobsen
Surveys Jacobsen's residential design from 1948 to 1998, from his early classic, flat-roofed to later, multi-gabled houses.

February 12-April 5
Personal Edens: The Gardens and Film Sets of Florence Yoch
More than 70 watercolors, photographs, drawings, and objects trace the career of Yoch, whose designs included gardens for Hollywood celebrities and sets for movies such as *Gone with the Wind* and *Romeo and Juliet.* (T)

February 18-August 15
An Urban Experiment in Central Berlin: Planning Potsdamer Platz
Illustrates the urban development concepts and building designs for Postdamer Platz, the heart of central Berlin and the largest construction site in the world.

March 11-August 29
Tools as Art V
Continuing exhibition series of work from the Hechinger collection of tool-related art.

March 31-September
Taming Sprawl
A four-part exhibition series focusing on the causes and consequences of sprawl development, as well as methods for its control.

April 30, 1999-January 2, 2000
Stay Cool! Air Conditioning in America
The first major exhibition to explore the impact of air-conditioning on the design and planning of the places where we live, work, and play.

June 11-October 3
Visions for a New Century
Members of the Washington chapter of the American Institute of Architects express their visions for the new millennium.

September 22, 1999-March 6, 2000
The Corner Store
Looks at the role of the corner store as a neighborhood gathering point, physical anchor, and primary residence.

Permanent Collection

Photographs, documents, architectural plans and models, and artifacts relating to the original design of Washington, D.C. **Architecture:** The old Pension Building, an enormous red brick basilica-shaped structure, with the largest Corinthian columns in the world inside, built in 1887 by Montgomery C. Meigs; 1985 restoration by Keyes, Condon, Florance.

Admission: Free. Handicapped accessible.
Hours: Mon.-Sat., 10-4; Sun., 12-4; summer (June-Aug.): open until 5.
Tours: Docent-led tours, Mon.-Fri., 12:30; Sat., Sun., 12:30, 1:30. For group reservations, call (202) 272-2448, ext. 3300.
Food & Drink: Blueprints, A Café is located in the stunning interior space of the Great Hall and serves sandwiches, salads, baked goods, beverages, and coffee. Open Mon.-Sat., 10-3.
Museum Shop: One of the best, offering fascinating and beautiful designs focusing on architectural items, books, stationery, and desk supplies; open during museum hours.

National Gallery of Art

**Fourth St. at Constitution Ave., NW,
Washington, DC 20565
(202) 737-4215; (202) 842-
6176 [TDD]
http://www.nga.gov**

1999 Exhibitions
Thru January 3
*Van Gogh's Van Goghs:
Masterpieces from the Van
Gogh Museum, Amsterdam*
Featuring 70 paintings from
the holdings of the Van Gogh
Museum in Amsterdam, this
exhibition illustrates Van
Gogh's entire career, from the
Potato Eaters, 1885, through
Wheatfield with Crows, 1890.
An unusual opportunity to
view paintings that rarely
travel outside the

Vincent Van Gogh, *Wheatfield,* 1888. From *Van Gogh's Van
Goghs: Masterpieces from the Van Gogh Museum, Amsterdam.*
Photo courtesy Van Gogh Museum Amsterdam (Vincent Van
Gogh Foundation) and National Gallery of Art.

Netherlands. (Note: special, timed passes required) Catalogue. (T)

*Bernini's Rome: Italian Baroque Terracottas from The State Hermitage
Museum, St. Petersburg*
An exhibition of 35 rarely-exhibited *bozzetti* clay sculptures, originally
created as unfinished, preliminary sketches, they can now be fully
appreciated as works of art. Features works by Gian Lorenzo Bernini and 13
other Italian Baroque artists. Catalogue. (T)

Gifts to the Nation from Mr. and Mrs. John Hay Whitney
Features 16 paintings recently bequeathed to the National Gallery from an
important private collection of 19th- and 20th-century art.

Thru January 31
Love and War: A Manual for Life in the Late Middle Ages
Various secular themes from late-14th-century Germany as illustrated by the
artist known as the Housebook Master. Features Gothic drypoint prints and
the manuscript of the *Housebook,* from which the artist took his name.

Thru February 15
Edo: Art in Japan 1615-1868
This first comprehensive U.S. survey of Edo-period Japanese art examines
themes of religion, landscape, and the Samurai in nearly 300 works.
Includes painted scrolls, screens, costumes, armor, ceramics, lacquer, and
woodblock prints. Catalogue. (Note: timed passes may be required.)

January 24-May 9
*American Impressionism and Realism: The Margaret and Raymond
Horowitz Collection*
Features 49 paintings and works on paper from a private collection of
American Impressionist and realist works. Includes works by Sargent,
Hassam, Prendergast, and others. Catalogue.

January 31-May 31
From Botany to Bouquets: Flowers in Northern Art
Floral still life paintings and related drawings by Bruegel the Elder and other 17th-century Dutch and Flemish masters. Includes books and manuscripts addressing the philosophy of illusionism and the genre.

February 21-May 31
John Singer Sargent
Major survey of prolific American painter John Singer Sargent (1856-1925), known for his astute and elegant society portraits. More than 100 paintings and watercolors include portraits, landscapes, and figure sketches. Catalogue. (T)

April 25-July 5
Photographs from the Collection
Approximately 70 photographs dating from the 19th through 20th century, including works by William Henry Fox Talbot and André Kertész.

May 23-August 22
Portraits by Ingres: Image of an Epoch
The career of Ingres (1780-1867) spanned six decades of French history, including the Revolution, the Napoleonic age, and the Second Empire. Features 40 paintings and 120 drawings. Catalogue. (T)

June 6-September 6
Mary Cassatt
Comprehensive survey of paintings, pastels, drawings and prints by innovative American artist and patron Mary Cassatt (1844-1926), best known for her association with the French Impressionists. Catalogue. (T)

October 17, 1999-January 16, 2000
Brassaï: The Eye of Paris
Retrospective exhibition celebrates the centenary of the birth of the Transylvanian artist, described by Henry Miller as "the eye of Paris." Includes 150 photographs of the nocturnal life of 1930s Paris. Catalogue. (T)

Permanent Collection
A preeminent museum in the United States, focusing on European and American art from the 13th to 20th centuries in diverse media: paintings, sculpture, drawings, prints, decorative art, Kress collection of Renaissance and Baroque paintings, Netherlandish painting from the Golden Age, French Impressionist and Post-Impressionist paintings, outstanding 20th-century collection. **Highlights:** Calder, *Untitled* (mobile); Moore, *Knife Edge Mirror Two Piece;* Motherwell, *Reconciliation Elegy;* Rembrandt Peale, *Rubens Peale with a Geranium;* Picasso, *Family of Saltimbanques;* Pollock, *Number 1, 1950;* Raphael, *Alba Madonna* and *Saint George and the Dragon;* Rembrandt, *Self-Portrait;* Titian, *Venus with a Mirror;* the only painting by Leonardo in this country: *Ginevra de' Benci;* Whistler, *White Girl.* **Architecture:** Neo-Classical 1941 West Building, with a Rotunda fashioned after the Pantheon, by John Russell Pope; dynamic geometric marble and glass 1978 East Building by I. M. Pei. Sculpture Garden to open Autumn 1999.

Admission: Free. (Note: special passes required for certain exhibitions.) Handicapped accessible; wheelchairs available. Call (202) 842-6690, weekdays 9-5, for assistance with disabilities.
Hours: Mon.-Sat., 10-5; Sun., 11-6. Closed Jan. 1, Dec. 25.
Programs for Children: Family Programs; call (202) 789-3030.
Tours: Call (202) 737-4215 for information.
Food & Drink: Terrace Café open Mon.-Sat., 11:30-3; Sun., noon-4. Call (202) 216-2492 for reservations. Concourse Buffet open Mon.-Fri., 10-3; Sat., 10-3:30; Sun., 11-4. Garden Café open Mon.-Sat., 11:30-3, Sun., noon-4. Call (202) 216-2494 for reservations. Cascade Espresso Bar open Mon.-Fri., noon-4:30; Sun., noon-5:30.
Museum Shop: Two locations offer a large selection of books, stationery, posters, games, and books; open during museum hours.

National Museum of African Art

Smithsonian Institution, 950 Independence Ave. SW, Washington, DC 20560
(202) 357-4600
http://www.si.edu

1999 Exhibitions
Ongoing
Images of Power and Identity
An installation of more than 100 works from the collection to foster public appreciation of the artistic achievements of African artists.

The Ancient West African City of Benin, A.D. 1300-1897
The collection of the royal court of the Kingdom of Benin as it existed before British colonial rule.

The Ancient Nubian City of Kerma, 2500-1500 B.C.
A look at the wealth and artistic accomplishment of the city of Kerma, the oldest excavated city in Sub-Saharan Africa.

Ceramic Arts at the National Museum of African Art
The beauty and richness of African pottery is explored in this stunning exhibition.

The Art of Personal Object
Features utilitarian objects from Africa and celebrates their aesthetic values.

Sokari Douglas Camp: Three Sculptures
Work by the acclaimed Nigerian artist Sokari Douglas Camp.

Thru February 28
South Africa 1936-1949: Photographs by Constance Stuart Larrabee
Larrabee's exquisite black-and-white images document the lives of African people and capture poignant moments in the history of South Africa.

February 7-May 9
Baule: African Art/Western Eyes
A unique installation of the private art of the Baule, an Ivory Coast people, simulates the original context for the works, which are generally visually restricted because of their spiritual power. (T)

March 21-June 20
Sokari Douglas Camp: Church Ede, A Tribute to Her Father
A monumental kinetic sculpture, *Church Ede* is reminiscent of a Kalabari funeral bed and is a tribute to the artist's father.

June 20-September 26
Modern Art from South Africa
Drawn from the museum's permanent collection, this exhibition features paintings, prints, and animated film shorts by South African artists.

July 18-October 17
Hats Off: A Salute to African Headgear
Pays tribute to the creative genius of the artisans who fabricate these beautiful objects of personal attire and to those who wear them.

September 12, 1999-January 2, 2000
Wrapped in Pride: Asante Kente and African-American Identity
A look at the art and the significance of Kente, one of Africa's best-known and most widely revered textiles, from its importance in Ghanaian cultural traditions to its role as a symbol of black identity for African Americans. (T)

December 19, 1999-March 19, 2000
The Art of African Money
Explores various objects used across Africa to facilitate trade and measure wealth, from beads and rolled fabric to spear blades and gold weights.

Permanent Collection

Four permanent galleries serve as a comprehensive introduction to the numerous visual traditions of Africa: carved wood, ivory, modeled clay, forged- or cast-metal works, masks, jewelry, textiles, figures, and everyday household objects, mostly from the late 19th and 20th centuries.
Highlights: Extensive photography collection. **Architecture:** Part of a creative three-story underground museum complex by Jean-Paul Carlhian of Shepley, Bulfinch, Richardson, and Abbott, opened in 1987.

Admission: Free. Handicapped accessible.
Hours: Daily, 10-5:30. Closed Dec. 25.
Programs for Children: Hands-on workshops, films, tours, storytelling.
Tours: Call (202) 357-4600, ext. 221 for tour information.
Museum Shop: Exhibition catalogues and publications about African art and culture, as well as posters, tapes, CDs, postcards, and gift items.

National Museum of American Art

Smithsonian Institution, 8th and G Sts. NW, Washington, DC 20560
(202) 357-2700
http://www.nmaa.si.edu

1999 Exhibitions

Thru January 31
Eyeing America: Robert Cottingham Prints
Celebrates the career of a great contemporary American photo-realist painter and printmaker, featuring works from 1972 to the present.

Thru March 7

Art of the Gold Rush

Explores the origins of California regional art. Includes 64 paintings, drawings, and watercolors created between 1849 and the mid-1870s. (T)

Silver and Gold: Cased Images of the California Gold Rush

Photographic documentation of the Gold Rush following the 1848 discovery of gold in California, featuring daguerreotypes and other "cased" images. (T)

April 2-August 22

Image and Memory: Picturing Old New England

Idealized pastoral depictions of New England from 1865 to 1945 by major artists, including Winslow Homer, Childe Hassam, Maurice Prendergast, Edward Hopper, Maxfield Parrish, and Norman Rockwell, among others.

April 23-September 6

Abbott Thayer: The Nature of Art

Thayer's art is reexamined in the context of the 19th-century cultural and artistic environment in which he worked.

October 22, 1999-January 3, 2000

Edward Hopper: The Watercolors

Hopper's early watercolor depictions of New England and the Southwest in the 1920s and 1930s made him one of the most important American artists of the 20th century.

Robert Cottingham, *Frankfurters-Hamburgers* (from the *Cottingham Suite*), 1980. Photo courtesy National Museum of American Art.

Permanent Collection

More than 37,500 works comprise the nation's museum of American painting, sculpture, folk art, photography, and graphic art from the 18th century to the present. **Highlights:** Works by Cassatt, Ryder, Sargent, Brooks, Hopper, and Twachtman; contemporary works in the Lincoln Gallery, by artists such as Hockney, Motherwell, Frankenthaler, and Nevelson; stained glass windows by La Farge in the Gilded Age rooms; Catlin's Indian paintings; African-American art. **Architecture:** 1836 Old Patent Office by Robert Mills, completed in 1867 by Thomas Ustick Walter. Building also houses the Archives of American Art and the National Portrait Gallery.

Admission: Free. Handicapped accessible, entrance at 9th and G Sts.
Hours: Daily, 10-5:30. Closed Dec. 25.
Programs for Children: Frequent activities including Family Days and monthly "Saturday Art Stop" programs.
Tours: Call (202) 357-3111 for information.
Food & Drink: Patent Pending Café open daily, 10-3:30, overlooking lovely courtyard where summer visitors may enjoy lunch from the grill.
Museum Shop: Books, photos, and other items that focus on American art.

National Museum of Women in the Arts

1250 New York Ave. NW, Washington, DC
20005
(202) 783-5000
http://www.nmwa.org

Camille Claudel, *Young Girl with a Sheaf*, c. 1890. Photo courtesy National Museum of Women in the Arts.

1999 Exhibitions

Thru January 10
Tatyana Nazarenko: Transition
Moscow-based artist Nazarenko deftly brings contemporary Russian life into high relief.

Thru January 16
Book as Art X
57 imaginative, one-of-a-kind and limited-edition artist's books features illustrated poetry, interactive books, and morality fables. (Closed Sundays)

Thru January 19
Berenice Abbott's Changing New York, *1935-1939*
A monumental project by the talented photographer, *Changing New York* chronicles the transformation of New York City as it rose out of the Depression to become a shining new metropolis.

Thru July 5
Painting in a Lonely Arena: Joyce Treiman and the Old Masters
13 large-scale figurative works based on Old Master paintings.

February 4-May 9
The Narrative Thread: Women's Embroidery from Rural India
Communally embroidered quilts depict scenes of village life, Hindu epics, and political events, and offer women a means of personal expression.

Permanent Collection

Offers the single most important collection of art by women in the world. The permanent collection provides a survey of art from the 16th century to the present. **Highlights:** Eulabee Dix Miniature Gallery; Cassatt, *The Bath;* Kahlo, *Self Portrait;* works by Camille Claudel, Elisabeth Vigée-LeBrun, Rosa Bonheur, Georgia O'Keeffe and Helen Frankenthaler. **Architecture:** 1907 Renaissance Revival style building, once served as the Masonic Grand Lodge of the National Capital, by Waddy Wood; award-winning renovation/restoration began in 1984 and was completed in 1987 by David Scott and Keyes, Condon, and Florance; 1997 Elisabeth A. Kasser Wing by RTKL.

Admission: Donation suggested: adults, $3; seniors, students, $2; members, free. Handicapped accessible; wheelchairs available.
Hours: Mon.-Sat., 10-5; Sun., noon-5. Closed major holidays.
Programs for Children: Family Days, workshops, and other programs offered throughout the year. Call (202) 783-7370 for information.
Tours: Docent-led tours offered. Call (202) 783-7370 for reservations.
Food & Drink: Mezzanine Café open Mon.-Sat., 11:30-2:30.
Museum Shop: Offers books and unique items created by women.

National Portrait Gallery

Smithsonian Institution, Eighth and F Sts. NW, Washington DC 20560
(202) 357-2700
http://www.npg.si.edu

1999 Exhibitions

Thru January 24
Recent Acquisitions
More than 50 works of art in various media, including recently discovered photographs of Marilyn Monroe by Dave Greary and a portrait of Daniel Webster by Francis Alexander.

January 29-April 18
Paul Robeson: Artist and Citizen
A look at the extraordinary career of Paul Robeson, son of an escaped slave, brilliant scholar, singer, actor, athlete, human rights activist, and one of this century's most talented artists.

January 29-October 3
Recent Acquisitions

Thru February 7
Theodore Roosevelt: An American Presence
About 75 paintings, sculptures, photographs, and caricatures follow the life and career of this outdoorsman, writer, and 26th president of the U.S.

Philippe Halsman: A Retrospective
A *Life* magazine photographer from the 1940s through the 1970s, Halsman's portraits of Albert Einstein, Marilyn Monroe, and Salvador Dalí have become 20th-century icons. (T)

February 19-August 8
Portraits of George and Martha Washington in the Presidential Years, 1789-1797
This exhibition of images of the Washingtons made during the terms of office marks the 200th anniversary of the death of this first U.S. president.

April 16-September 6
Franklin and His Friends: Portraying the Man of Science in 18th-Century America
Period scientific objects and portraits by Gilbert Stuart, John Singleton Copley, Charles Wilson Peale, and others, represent the 18th-century fascination with science and men who embodied the ideal "Man of Science."

April 30-September 6
Hans Namuth: Photographs
A selection of photographs by this German-born artist, who established his reputation in the 1950s by his compelling images of Jackson Pollock.

May 7-October 3
Recent Acquisitions

June 18-November 7
In His Time: A Portrait of Ernest Hemingway
In celebration of the 100th anniversary of Hemingway's birth, this exhibition features portraits by Abbott, Man Ray, and Stieglitz.

July 2-November 7
Unauthorized Portraits: The Drawings of Edward Sorel
Approximately 30 posters, drawings, and illustrations that have given Sorel a reputation as one of the wittiest satirical caricaturists of our time.

September 24, 1999-January 2, 2000
Augustus Washington: African American Daguerreotypist
This first major exhibition of Washington's work explores the artist's personal history as a free person of color in antebellum America.

October 29, 1999-January 8, 2000
Tête à Tête: Portraits by Henri Cartier-Bresson
Includes portraits of Truman Capote, William Faulkner, Che Guevara, Alfred Stieglitz, Ezra Pound, Robert Kennedy, and Martin Luther King, Jr., by one of the most distinguished photojournalists of the 20th century.

Permanent Collection
Paintings, sculptures, prints, drawings, and photographs of Americans who contributed to the history and development of the United States. **Highlights:** Portrait sculptures by Davidson; Civil War gallery; one of the last photographs of Lincoln; the Hall of Presidents, including portraits of George Washington and Thomas Jefferson by Gilbert Stuart. **Architecture:** 1836 Old Patent Office by Mills, completed in 1867 by Thos. Ustick Walter.

Admission: Free. Handicapped accessible, wheelchairs available.
Hours: Daily, 10-5:30. Closed Dec. 25.
Tours: Mon.-Fri., 10-3; Sat.-Sun., holidays, 11-2.
Food & Drink: Café open Mon.-Fri., 10-3:30; Sat.-Sun., 11-3:30.

The Phillips Collection

1600 21st St. NW, Washington, DC 20009
(202) 387-2151

1999 Exhibitions
Thru January 3
Impressionists in Winter: Effets de Neige
Examines the type of Impressionist winter landscape characterized by "the effects of snow." Includes 65 paintings by such artists as Monet, Pisarro, Sisley, Caillebotte, and Morisot. Catalogue. (T)

Thru January 6
Whistler in Venice
Features 20 etchings by James McNeil Whistler (1834-1903), dating from the artist's productive trip to Venice, Italy, in 1879-1880.

Thru April
A Calder Centennial at the Phillips Collection
Commemorates the centennial of the birth of Alexander Calder (1898-1976) with an indoor and outdoor installation of the innovative 20th-century artist's work, including mobiles, "stabiles," and "constellations."

January 23-March 28
An American Century of Photography: From Dryplate to Digital
Approximately 140 images, drawn from the Hallmark Photographic Collection, provide a broad perspective on the art and history of modern American and European photography from the late 19th century to the present. Catalogue. (T)

April 17-July 18
Georgia O'Keeffe: The Poetry of Things
Examines the aesthetics of the acclaimed 20th-century American artist through her paintings of objects, including shells, rocks, trees, bones, and doors. Features approximately 60 paintings and works on paper. (T)

May 15-August 15
Works by Judith Rothschild
Traces the progression of the painting styles of Rothschild (1921-1993) over five decades, featuring 31 rarely exhibited works created between 1945 and 1991.

September 25, 1999-January 23, 2000
Modern Art at the Millennium: The Eye of Duncan Phillips
Outstanding works from the permanent collection examines the Phillips Collection's early history and its place in the introduction of modern art to the United States, featuring 250 works by modern artists such as Bonnard, Klee, Cézanne, Avery, Marin, Rothko, and Lawrence. Catalogue.

Permanent Collection

Founded by Duncan Phillips, who sought to create "a museum of modern art and its sources"; late 19th- and early 20th-century European and American painting and sculpture, including Impressionist and post-Impressionist masterpieces; works by Bonnard, Vuillard, Cézanne, Picasso, Matisse, Van Gogh; American artists range from Inness and Homer to American Impressionists Prendergast and Twachtman and artists of the Stieglitz circle. **Highlights:** Renoir, *Luncheon of the Boating Party;* Bonnard, *The Palm;* Cézanne, *Self-Portrait;* Chardin, *Bowl of Plums, a Peach, and a Water Pitcher;* Delacroix, *Paganini;* El Greco, *The Repentant Peter;* Ingres, *The Small Bather;* Picasso, *The Blue Room;* collections of Klee and Rothko. **Architecture:** 1897 Renaissance Revival building and 1907 Music Room by Hornblower and Marshall; 1920 and 1923 additions by McKim, Mead, and White; 1960 bridge and annex by Wyeth and King; 1980s expansion by Arthur Cotton Moore Associates.

Admission: Tues.-Fri.: donation suggested; Sat.-Sun: adults, $6.50; seniors, students, $3.25; children 18 and under, members, free. Some special exhibitions may require an additional charge. Artful Evenings on Thurs., 5-8:30, $5; members, free. Handicapped accessible.
Tours: Tues.-Sat., 10-5; Thurs., 10-8:30; Sun., 12-7. Closed Mon., Jan. 1, July 4, Thanksgiving, Dec. 25. Sunday summer hours may differ. Call to confirm.
Programs for Children: Please call for information.
Tours: Tours can be specially designed. Reservations are requested at least one month in advance. Call (202) 387-2151, ext. 247.
Food & Drink: Café open Tues.-Sat., 10:45-4:30; Sun., 12-5. Sunday summer hours may differ. Please call to confirm. Closed Mon.
Museum Shop: Open during museum hours. (202) 387-2151, ext. 239.

Renwick Gallery

National Museum of American Art, Smithsonian Institution,
Pennsylvania Ave. at 17th St. NW, Washington, DC 20560
(202) 357-2700
http://www.nmaa.si.edu/renwick/renwickhomepage.html

1999 Exhibitions

Thru January 3
The Stoneware of Charles Fergus Binns
60 stoneware vessels (dating from 1888 to 1943) by Charles Fergus Binns,
known for his initiation of the "Alfred pot."

Thru January 10
Daniel Brush: Gold Without Boundaries
More than 60 objects showcase the creations of one of the foremost artists in metals working today. Catalogue.

Daniel Brush, *Butterfly Bowl,* 1991-94. Private Collection.
From *Daniel Brush: Gold Without Boundaries.* Photo courtesy Renwick Gallery.

March 19-July 25
Shaker: The Art of Craftsmanship
An exhibition of Shaker furniture, decorative arts, and tools that embody the society's ideals of harmony through utility and simplicity. (last venue)

Dominic Di Mare
The first-ever survey of fibre artist Di Mare's 30-year career creating
enigmatic works of autobiographical and transcendental significance.

September 24, 1999-January 30, 2000
Glass! Glorious Glass!
Approximately 40 works of blown, cast, slumped, lampworked, and flat
glass are featured in a medium-focused exhibition from the permanent
collection.

Permanent Collection

Focus on 20th-century American crafts and decorative arts, including works
by Albert Paley, Dale Chihuly, and Beatrice Wood. **Architecture:** 1859
Second Empire-style building by James Renwick, Jr., designed originally to
house William Wilson Corcoran's art collection; Octagon Room and Grand
Salon restored and furnished in 1860s and 1870s style.

Admission: Free. Handicapped accessible.
Hours: Daily, 10–5:30. Closed Dec. 25.
Tours: Call (202) 357-2531.

Arthur M. Sackler Gallery

Smithsonian Institution, 1050 Independence Ave. SW, Washington, DC
20560
(202) 357-2700
http://www.si.edu/asia

1999 Exhibitions

Thru January 3
The Buddha's Art of Healing: Tibetan Medical Paintings from Buryatia
An exhibition of 14 paintings from an extraordinary medical treatise
examines the medical traditions of Buddhist healing.

Thru February 7
Roy Lichtenstein: Landscapes in Chinese Style
26 examples of Lichtenstein's Chinese-inspired landscapes, which he
executed between 1994 and 1997, juxtaposed with the paintings that
influenced him.

Thru April 4
The Mughals and the Jesuits
Paintings, books, and objects examining the blending of Eastern and
Western artistic styles that resulted from early Catholic missions in Asia
following Vasco de Gama's 1498 discovery of the sea route to the Indian
Ocean.

January 31-August 1
Behind the Himalayas: Paintings of Mustang by Robert Powell
Dazzling watercolor paintings of Mustang, a remote region of Tibet by
Robert Powell, an expatriate Australian artist residing in Nepal.

March 28-September 6
Devi: The Great Goddess
Depictions of the Indian mother goddess Devi in bronze, stone, terra cotta,
and painting, ranging over a period of 2,000 years.

April 25-July 18
Paintings by Nainsukh
A look at the painting of Nainsukh of Guler (1710-1778) and the royal
Rajput court for which he painted. A 304-page, color illustrated catalogue
by B. N. Goswamy accompanies the exhibition.

August 1-October 17
Yoshida Hiroshi: Japanese Prints of India and Southeast Asia
Impressive monuments and sites are the subject of one of Hiroshi's most
beautiful and engaging print series.

October 17, 1999-January 17, 2000
Treasures of the Royal Tombs of Ur
The 1920s excavations of the royal cemetery of Ur revealed one of the most
spectacular troves of ancient Mesopotamian artifacts ever discovered.
Includes elaborate jewelry, musical instruments, furniture, and more. (T)

November 7, 1999-mid-April 2000
Antoin Sevruguin and the Persian Image
The photography of Antoin Sevruguin is a pictorial record of the social
history and the visual culture of Iran through from the late 1850s until 1934.

Permanent Collection

Asian art spanning cultures and centuries: ancient Chinese bronzes and jades, contemporary Japanese ceramics, South Asian sculpture, ancient Near Eastern metalware, Persian and Indian painting. **Highlights:** Sasanian rhyton; Shang dynasty bells; Ming dynasty paintings; Chinese furniture; Persian painting and calligraphy; ancient Near Eastern silver and gold. **Architecture:** 1987 building, part of a three-story underground complex by Jean-Paul Carlhian of Shepley, Bulfinch, Richardson and Abbott.

Admission: Free. Handicapped accessible.
Hours: Daily, 10–5:30. Closed Dec. 25.
Tours: Free. 11:30 and 12:30 daily. Groups call (202) 357-4880, ext. 245.
Food & Drink: Beverage cart available at public programs.
Museum Shop: Wonderful shop offers clothing and gift items related to Asian art.

Lowe Art Museum, University of Miami

1301 Stanford Dr., Coral Gables, FL 33124
(305) 284-3535
http://www.lowemuseum.org

1999 Exhibitions

Thru February 7
Walter O. Evans Collection of African-American Art
Paintings, sculpture, collage, and photographs that reflect African or African-American historical ideology.

February 18-April 4
Artist/Author: The Book as Art since 1980
The entire spectrum of artists' books: "fanzines," assemblies, catalogues, visual poetry, sketchbooks, documentation, and illustrated books. (T)

Treasures of Deceit: Archaeology and the Forger's Craft
Organized by the Nelson-Atkins Museum of Art, this exhibition explores how art historians and scientists determine whether a work of art is a genuine antiquity or a forgery. (T)

April 15-May 30
University of Miami Student/Master of Fine Arts Exhibition

Musical Chairs: An Installation by Emilie Benes Brezinski
An installation utilizing chair forms, which have recently been incorporated into the artist's *oeuvre*.

June 10-July 31
Pure Vision: American Bead Artists
The rich history of beads as a vehicle for cultural expression and personal adornment is the subject of this visually stunning exhibition.

The Venerable Bead: Beaded Objects from the Permanent Collection
A selection of objects from the permanent collection that illustrate the use of beads in Native American and African art forms.

August 5-September 5
4th Annual Florida Artists Series

September 16-November 14
Fibers and Forms: Native American Basketry of the West
This exhibition traces the development of technique, form, and decoration in the art of the Native American basketry in the far west from the late-19th century to the Great Depression.

Dream Weavers: Guatemalan Textiles from the Permanent Collection

December 2, 1999-January 30, 2000
Canadian Silver from the National Gallery of Canada
A rare opportunity to examine various phases of the silversmith's art in the Canadian context, from the 17th to the mid-20th century.

Treasures of Chinese Glass Workshops: Peking Glass from the Gadient Collection

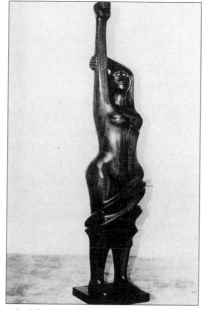

Jacob Lawrence, *Genesis Creation Sermon #5*, 1989. From the Walter O. Evans Collection of African American Art. Photo courtesy Lowe Art Museum.

Features exquisite examples of Qing dynasty (1644-1912) glass, including the intensely colored, monochromatic glass of the 18th century.

Permanent Collection

Greco-Roman antiquities; Renaissance and Baroque paintings; 17th- to 20th-century works by renowned American and European artists; Pre-Columbian, Asian, and African art. **Highlights**: Major non-Western collection, including some of the finest North American Indian textiles; Kress Collection of Italian Renaissance and Baroque art. **Architecture:** 1996 expansion/renovation by Charles Harrison Pawley.

Admission: Adults, $5; seniors, students, $3; under 12, free. Handicapped accessible.
Hours: Tues.-Sat., 10-5; Thurs., 12-7; Sun., 12-5.
Tours: Call (305) 284-3535 for information.

Museum of Art, Fort Lauderdale

One E. Las Olas Blvd., Fort Lauderdale, FL 33301
(954) 525-5500; 763-6464 (recording)

1999 Exhibitions

Thru January 10
Pictures of the Times: A Century of Photography from the New York Times
Presents a visual synopsis of the 20th century through 154 unforgettable
photographs from the archives of the *New York Times.*

Thru January 17
Janet Fish: Selected Works: 1970s-1990s
Celebrates the 60th birthday of one of the leading realist painters of the late
20th century, featuring large-scale still lifes by the Boston-born artist.

Thru March 28
Gropper Collection
Political and social cartoons by New York-born social realist painter
William Gropper (1897-1977), who studied with Henri and Bellows.

Thru April 4
Works by Madeline Denaro
Large canvases depict a mastery of color and an imaginative handling of
textures by the local artist in her first solo museum exhibition.

Thru May 23
Intimate Glackens
Highlights the exquisite draftsmanship in 50 paintings and illustrative
drawings by this early 20th-century artist known as "America's Renoir."

Thru July
CoBrA: A Celebration
Works by the Surrealist artists of the short-lived Northern European art
movement (1948-1951), named for the native cities of the founding
members: Copenhagen, Brussels, and Amsterdam.

Thru August 2
African Collection
Selections from the permanent collection examine the influence of African
art's abstract forms, patterns, and geometric designs on 20th-century artists.

February 6-May 2
Herb Ritts: Work
Photographs by the chronicler of the chic worlds of fashion, celebrity, and
popular culture, whose work has been featured in *Vogue*, *Vanity Fair*, and
Rolling Stone.

April 10-June 6
Forgotten Faces: Vintage Photographic Images and Techniques
Explores the 19th-century use of glass negatives to produce daguerreotypes–
detailed photographic images formed on silver-plated sheets of copper.

May 15-August 15
Javier Marin: Sculptures
Life-size clay figures and other works by the 35-year-old Mexican artist,
who has been called the "Michelangelo of the Americas."

June 5-September 12
1999 South Florida Cultural Consortium Exhibition
Annual juried exhibition featuring works by regional artists.

Permanent Collection
European and American art with emphasis on the 20th century including Picasso, Matisse, Calder, Moore, Dali, Warhol; impressive holdings of CoBrA art; largest U.S. repository of works by William Glackens; Oceanic, West African, Pre-Columbian, American Indian art; regional art. **Highlights:** Appel, *Personality;* Frankenthaler, *Nature Abhors a Vacuum;* Glackens, *Lenna in a Chinese Costume,* Warhol, *Mick Jagger.* **Architecture:** 1985 building by Edward Larrabee Barnes.

Admission: Adults, $6; seniors, $5; students with ID, $3; youth ages 5-18, $1; children under 5, members, free. Groups of 10 or more, $4 per person. Handicapped accessible; wheelchairs available.
Hours: Tues., Thurs., Sat., 10-5; Fri., 10-8; Sun., 12-5. Closed Mon., holidays.
Programs for Children: Offers art classes, family days, and other programs throughout the year; call for details.
Tours: Tues., 1-7; Thurs.-Fri., 1. Group reservations required.

The Jacksonville Museum of Contemporary Art
4160 Boulevard Center Dr., Jacksonville, FL 32207
(904) 398-8336

1998 Exhibitions

Thru January 3
International Holiday Spirit

Thru February 7
Bob Willis Photography

January 17-February 28
Rivka Rosenthal
Paintings by the Israeli artist.

March 14-April 26
Frank Stella at Tyler Graphics: A Unique Collaboration
Documents the 30-year collaboration between artist Frank Stella and masterprinter Kenneth Tyler, called "one of the great partnerships in modern American art," and traces Stella's stylistic evolution in this medium. (T)

May
Senior High School Exhibition

June 12-August 8
Cerj Lalonde

September 11-November 7
Sandy Skoglund: Reality Under Siege
The first major retrospective of this sculptor, photographer, and installation artist. Features *Radioactive Cats, Peaches in a Toaster,* and other works. (T)

Permanent Collection
Concentrates on the contemporary and visual arts. **Highlights:** Miro, *Metras*; Calder, *Dawn* and *Dusk*; Paschke, *Malibu*; Pomodoro, *Modello Per Disco*; Oldenburg, *Arch in the Form of a Screw for Times Square, NYC* and *Lipstick Ascending on Caterpillar.* Other featured artists include Longo, Gillam, Frankenthaler and Picasso. **Architecture:** 1966 building by Robert Broward and Taylor Hardwick.

Admission: Adults, $3; students and seniors, $2; children under 6 and members, free. Fees for special exhibitions. Handicapped accessible.
Hours: Tues., Wed., Fri., 10-4; Thurs., 10-10; Sat., Sun., 1-5; closed Mon. and holidays.
Tours: No walk-in tours. Call (904) 398-8336, ext. 18 for reservations and information.

Miami Art Museum
101 West Flagler St., Miami, FL 33130
(305) 375-3000; 375-1700 (recording)

1999 Exhibitions
Thru January 10
New Work: Miralda, Grandma–Miami Bureau
An installation that examines the multifaceted character of Miami through regional cuisine.

Thru March 7
George Segal, a Retrospective: Sculptures, Paintings, Drawings
A major exhibition of the work of U.S. artist George Segal, from his early figurative paintings and pastels of the 60s to his haunting plaster casts of the human figure, for which he is best known. Catalogue.

Thru May 2
Focus on Photography: Dream Collection . . . part four
The fourth in a series of exhibitions on the museum's collection highlights photography.

January 29-April 4
New Work: Nancy Rubins
A seemingly weightless, large-scale sculpture created from found industrial materials, reflects the artist's interest in the dynamic manipulation of space.

March 26-June 6
Re-Aligning Vision: Alternative Currents in South American Drawing
120 2- and 3-dimensional works, ranging in size from postcards to room-size installations, by 46 established South American artists. Includes works by Waltercio Caldas, Cildo Meireles, Liliana Porter, and others.

April 23-July 4
New Work: Liisa Roberts–Blind Side
An installation that incorporates film as a sculptural element to break down the traditional relationship between the viewer and the film screen.

May 14-October 31
Dream Collection . . . part five
The latest acquisitions and gifts to the permanent collection.

June 25-August 29
Beads, Body, and Soul: Art and Light in the Yoruba Universe
Looks at the extraordinary complexity of Yoruba beaded arts, which span nearly 1,000 years and have flourished throughout the African Diaspora. (T)

July 16-October 3
New Work: Steven Pippin
Paying homage to 19th-century photographer Eadweard Muybridge, Pippin includes sculpture and performance in his photographic work.

December 1999-March 2000
Brice Marden: Work of the 1990s
A survey of the American artist's recent paintings, drawings, and prints, on loan from important private and public collections. Catalogue. (T)

Permanent Collection
International art with a focus on the art of the Western Hemisphere from the World War II era to the present.

Admission: Adults, $5; seniors, students, $2.50; children 6-12, free. Handicapped accessible; wheelchairs available.
Hours: Tues.-Fri., 10-5; Thurs., 10-9; Sat.-Sun., 12-5. Closed Mon.
Programs for Children: Second Saturdays are free for families; free interactive programs from 1-4 on second Sat. of each month.
Tours: Call (305) 375-4073 for information.

Bass Museum of Art
2121 Park Ave., Miami Beach, FL 33139
(305) 673-7530
http://ci.miami-beach.fl.us/culture/bass/bass.html

1999 Exhibitions
Thru February 21
Maxim Kantor
One of Russia's preeminent visual artists, Maxim Kantor's expressionist work focuses on fear, misery, hunger, and social isolation.

Liza Lou: Beaded Wonders
Resplendent, lifesize installations by Liza Lou, nationally known for her visually seductive and satirical work *Kitchen*.

March 5-May 9
Roy Lichtenstein: Man Hit by the 21st Century
The first opportunity to view a unique grouping of preparatory studies, sketches, and collages that provide insight into the artist's creative process. The last exhibition in which the late artist was personally involved. Catalogue.

Permanent Collection
Features Old Master paintings and sculpture, contemporary art, architectural arts; textiles, ecclesiastical artifacts.
Highlights: Works by Rubens, Dürer, Bol, Hopper, Delacroix, Toulouse-Lautrec, van Haarlem. **Architecture:** 1930 Art Deco building by Russell Pancoast; 1964 addition by Robert Swartburg; 1999 major renovations and expansion.

Roy Lichtenstein, Study for *Roommates,* 1993. From *Roy Lichtenstein: Man Hit by the 21st Century.* Photo courtesy Bass Museum of Art and Estate of Roy Lichtenstein.

Admission: Adults, $5; seniors, students, $3; children under 6, members, free. Handicapped accessible, including ramps and elevators; sign language interpreters available.
Hours: Tues.-Sat., 10-5; Sun., 1-5. Second and fourth Wed. of the month, 1-9. Closed Mon. and holidays.
Programs for Children: Art classes; summer art camps; interactive concerts, lectures, and dance performances; family days. Call for details.
Tours: Call (305) 673-7530 for information and reservations.
Museum Shop: Newly expanded museum shop to be unveiled in 1999.

Flagler Museum
One Whitehall Way, P.O. Box 969, Palm Beach, FL
(561) 655-2833
http://www.flagler.org

1999 Exhibitions
Thru January 24
Ponce de Leon in Florida *by Thomas Moran*

January 5-March 5
A Splendid Little War

Permanent Collection

Whitehall, the Gilded Age estate home of industrialist Henry Morrison Flagler, is now open to the public as the Flagler Museum. Henry Flagler, a founding partner of Standard Oil, linked the coast of Florida through his railroad holdings and many luxury hotels, and established tourism as a major industry in the state. Flagler's estate was completed in 1902, at which time it was hailed as "the Taj Mahal of America."

Admission: Adults, $7; children 6-12, $3. The first floor of the museum is wheelchair accessible.
Hours: Tues.-Sat., 10-5; Sun., 12-5.
Programs for Children: Organized school tours available.
Tours: Guided tours available. Group rates available with advanced reservation.
Museum Shop: Open during museum hours. Offers items related to America's Gilded Age and to Florida history.

The Society of the Four Arts

2 Four Arts Plaza, Palm Beach, FL 33480
(561) 655-7226
http://SFourarts@aol.com

1999 Exhibitions

Thru January 3
60th Annual National Exhibition of Contemporary American Paintings

Thru January 30
Land of Wonders: Highlights of the Rutgers Collection of Original Illustrations for Children's Literature

January 9-February 7
Northwest Passage: Photographs of Robert Glenn Ketchum

February 13-April 7
The Cecil Family Collects: Four Centuries of Decorative Arts from Burghley House
A collection of decorative arts in gold, silver, diamonds, rubies, and quartz crystals from one of the grandest Elizabethan houses in England. (T)

March 6-April 4
Memory is a Painter: The Art of Grandma Moses

February 25-April 17
21st Annual Gifted Child Art Exhibition of the Exceptional Student Education Department of Palm Beach County

Permanent Collection

Features a new exhibition monthly during the winter-spring season; small permanent collection includes the monumental sculptures *Intetra,* by Isamu Noguchi, *Maternidad,* by Carlos Castenada, and *Reaching,* by Edward Fenno Hoffman, III. **Architecture:** 1929 building by Addison Mizner; 1974 renovation by John Volk.

Admission: Suggested donation: $3; gardens and libraries, free.
Hours: Mon.-Sat., 10-5; Sun., 2-5.
Programs for Children: Children's library offers regularly scheduled story hours and special events. Call (561) 655-2776 for information.
Tours: Call for information and reservations.
Museum Shop: Reception desk offers exhibition catalogues, postcards, and note cards, Mon.-Sat., 10-5; Sun., 2-5.

Museum of Fine Arts

255 Beach Dr. NE, St. Petersburg, FL 33701
(813) 896-2667
http://www.fine-arts.org

1999 Exhibitions

Ongoing
Rodin Bronzes from the Iris and B. Gerald Cantor Foundation

Thru January 10
Georgia O'Keeffe: The Artist's Landscape, Photographs by Todd Webb

January 24-May 30
Glass from Chinese Studio Workshops

March 21-June 13
American Paintings from the Lawrence Collection

Permanent Collection

European and American art from the 17th century to the present; French Impressionist paintings; outdoor sculpture garden; decorative arts, including Steuben glass, Jacobean and Georgian period rooms; African, Asian, pre-Columbian, and Native American art; ancient Greek and Roman art.
Highlights: Barye, *War* and *Peace;* Cézanne, *Oxen Hill at the Hermitage;* Monet, *Road to the Village of Vétheuil, Snow; Springtime in Giverny, Afternoon; Parliament, Effect of Fog;* Rodin, *Invocation;* Morisot, *Reading;* Gauguin, *Goose Girl, Brittany;* Renoir, *Woman Reading;* Thomas Moran, *Florida Landscape (Saint Johns River);* O'Keeffe, *Poppy* and *White Abstraction (Madison Avenue).* **Architecture:** Palladian-style building by John Volk, opened to public in 1965; 1989 expansion by Harvard, Jolly, Marcet, and Associates.

Admission: Adults, $6; seniors, $5; groups of 10 or more, $4 each; students, $2; members, children under 6, Sun., free. Handicapped accessible; wheelchairs, elevators, and signed tours available.
Hours: Tues.-Sat., 10-5; Sun., 1-5. Closed Jan. 1, Thanksgiving, Dec. 25.
Programs for Children: Classes, workshops, tours, films, and summer camp; Eye to Eye program; docent classroom visits.
Tours: Tues.-Fri., 10, 11, 1, 2, 3; Sat., 11, 1, 2, 3; Sun., 1, 2. Call (813) 896-2667 for foreign language and signed tours.
Food & Drink: Membership Garden available for picnics.
Museum Shop: Includes original jewelry, porcelain, housewares, books, posters, T-shirts, and gifts for children.

The John and Mable Ringling Museum of Art

5401 Bay Shore Rd., Sarasota, FL 34243
(813) 359-5700
http://www.ringling.org

1999 Exhibitions
Ongoing
Alexander Series Tapestries
Three monumental tapestries on the theme of Alexander the Great.

Dutch Baroque Portraiture
Including works by Paulus Lesire, Isaak Luttichuys, Nicolaes Maes, Jan Mostaert and Pieter Nason.

January 30-May 2
Blurring the Boundaries: Installation Art 1969-1996

Museum of the Circus
Ongoing
John Ringling: Circus King

Sarasota Winter Quarters of the Circus: Photographs by Loomis Dean

Circus Posters/French Gypsy Circus

Permanent Collection
Outstanding collection of European Renaissance, Baroque

Ludovico David (1648-1729), *The Judgment of Paris.*
Photo courtesy Ringling Museum of Art.

and Rococo paintings; antiquities, decorative arts, tapestries, photographs, drawings, prints; modern and contemporary art. Museum of the Circus features circus costumes, wagons, props, complete scale model of a miniature circus; circus-related fine art and memorabilia. Evolution of sculpture is traced through full-size reproductions in the Italian Renaissance –style courtyard. **Highlights:** Ludovico David, *Judgment of Paris;* Italian 16th- and 17th-century paintings; French, Dutch, Flemish, Spanish Baroque works. **Architecture:** 1924-26 Venetian Gothic Ringling residence, the Ca' d'Zan. 1927-29 Renaissance-style villa museum; 1966 addition.

Admission: Adults, $9; seniors, $8; Florida teachers, students, children 12 and under, free; group rates available. Sat., free except during Medieval Fair. Handicapped accessible.
Hours: Daily, 10-5:30. Closed Jan. 1, Thanksgiving, Dec. 25.
Tours: Call (813) 359-5700 for information.
Food & Drink: Banyan Café open 11-4.
Museum Shop: Three gift shops on premises. Free entry.

Norton Museum of Art

1451 S. Olive Ave., West Palm Beach, FL 33401
(561) 832-5196
http://www.norton.org

1999 Exhibitions

Thru January 3
Red Grooms: Moby Dick Meets the New York Public Library
A monumental installation by Red Grooms, one of the leading living
American artists, that depicts Herman Melville as he wrote *Moby Dick* in
the New York Public Library.

Thru January 7
Alphonse Mucha: The Spirit of Art Nouveau
The first comprehensive exhibition of the work of Alphonse Mucha in the
U.S. since 1921. Features paintings, posters, decorative panels, and pastels
in *le style Mucha*, which became synonymous with French Art Nouveau.
Catalogue. (T)

Tiffany and Art Nouveau from the Segel Collection
Examples of European and American decorative art nouveau to complement
The Spirit of Art Nouveau.

Thru January 10
*Dynasties: Masterpieces from the Chinese Collection of the Norton Museum
of Art*
Expanded installation of the museum's holdings, featuring jades, bronzes,
ceramics, and Buddhist sculpture from 2,000 B.C. to the 19th century.

Thru January 24
Mostly Prague: Photographs by Anna Tomczak
In this photo series Tomczak used a rare, large-format Polaroid camera to
create luminous and mysterious prints of found objects and figures.

January 23-April 4
*The Invisible Made Visible: Angels
from the Vatican*
A truly remarkable exhibition of
angels in art from 1000 B.C. to the
present day. More than 100 rare
and sacred objects by Gentile da
Fabriano, Fra Angelico, Masolino,
Veronese, Raphael, and Dalí,
among others. Catalogue. (T)

March 27-June 6
Raoul Dufy: Last of the Fauves
Presents 50 of the strongest oil
paintings of the French artist's
oeuvre and aims to restore his
reputation as one of the most
original and talented artists of the
first half of the 20th century.
Catalogue. (T)

Raoul Dufy, *Nude on a Pink Sofa,* 1902.
Photo courtesy Norton Museum of Art.

April 10-June 20
Lynne Butler: Photographs
By taking photographs on horseback, Butler creates work that is uniquely impressionistic and colorful.

October 28, 1999-January 9, 2000
Half Past Autumn: The Art of Gordon Parks
The first retrospective exhibition to synthesize different aspects of Parks's art, his films, books, poetry, and music compositions, with his photojournalism, for which he is best known. Catalogue. (T)

Permanent Collection

Features European, American, Chinese, and contemporary art. Over 4,000 works, including French Impressionist and post-Impressionist paintings by Cézanne, Matisse, Monet, and Renoir; American art from 1900 to the present, featuring works by Davis, Hopper, Marin, Motherwell; Chinese archaic bronzes, jades, ceramics, and Buddhist sculpture. **Highlights:** Gauguin, *Agony in the Garden;* Braque, *Still Life with a Red Tablecloth;* Bellows, *Winter Afternoon;* Pollock, *Night Mist.* **Architecture:** 77,500 sq. ft. expansion, completed in January 1997, includes galleries, an Education wing, three gardens, and a café.

Admission: Adults $5, students ages 14-21, $3; children under 13, members, free. Additional charges for special exhibitions. Handicapped accessible.
Hours: Tues.-Sat., 10-5; Sun., 1-5. Closed Mon., major holidays.
Programs for Children: Offered every Sun.; call (561) 832-5196.
Tours: Call (561) 832-5196 for information and reservations.
Food & Drink: Taste By the Breakers Café open seasonally, Mon.-Sun.; call (561) 832-5196 for dates and hours. Offers a selection of salads, sandwiches, and entrees in a relaxed outdoor setting.
Museum Shop: Carries a delightful selection of art-related and gift merchandise for children and adults.

Georgia Museum of Art

90 Carlton Street, University of Georgia, Athens, GA 30602
(706) 542-GMOA or 4662; (706) 542-1007 [TDD]

1999 Exhibitions

Thru January 3
Elements of Style: The Legacy of Arnocroft
Includes furniture, porcelain, and carpets representing the full spectrum of American and English styles.

Thru January 10
Rembrandt: Treasures from the Rembrandt House, Amsterdam
Seventy-five etchings and drawings by the 17th-century Dutch master, including self-portraits, landscapes, portraits, and studies. (T)

By or After Rembrandt: Two Paintings from the Bader Collection
A small exhibition consisting of *A Man Writing by Candlelight* and *David Presenting the Head of Goliath to Saul*. Both are attributed to the artist and relate to works in *Treasures from the Rembrandt House*.

Thru January 24
The Age of Rembrandt: Seventeenth Century Prints
An abbreviated survey of Dutch, Flemish, Italian, and French etchings and engravings to complement *Treasures from the Rembrandt House*.

January 15-March 14
Before 1948: American Paintings from Georgia Collections
In honor of the museum's 50th anniversary, this exhibition showcases some of the finest examples of American art from collections throughout Georgia.

January 16-March 21
With These Hands
Approximately 20 objects made by slaves and free men from the late-18th to the early-19th century; these utilitarian wares may have been their sole means of artistic expression.

January 26-March 28
A Visual Legacy: The Founding of the Print Collection
Over 6,000 American, European, and Japanese prints constitute the print collection. Highlights gifts to the museum during its early years.

January 30-March 28
Heritage of the Brush: The Roy and Marilyn Papp Collection of Chinese Painting
More than 60 Chinese paintings from the Ming and Qing dynasties (15th through 19th centuries) show how major styles of painting were passed from master artists and scholars to their followers and descendants.

March 27-May 9
Master of Fine Arts Degree Candidates' Exhibition

March 30-June 13
Jackson Lee Nesbitt: Prints from the Collection of S. William and Leona Pelletier
A student of Thomas Hart Benton, this artist's lithographs depict rural life in the Midwest during the Great Depression.

April 10-May 30
A Unique American Vision: The Paintings of Gregory Gillespie
Survey of work by Gregory Gillespie, known for his realism based as much in the mind as in the realm of physical appearances. Features 45 paintings, including a selection of his celebrated self-portraits. (T)

June-August
Contemporary Realism
In honor of its 50th anniversary and the end of the 20th century, the museum looks forward with this and other contemporary exhibitions. Features artists Michael Leonard, Margaret Cheeseman, Odd Nerdrum, and John Whalley.

June 3-September 5
Inner Eye: Contemporary Art from the Marc and Livia Straus Collection
Works by some of the most important contemporary artists: Louise Bourgeois, Anslem Kiefer, Jeff Koons, Kiki Smith, and others.

June 19-September 19
Contemporary Works on Paper
An exhibition of contemporary prints curated by printmaker Carmon Colangelo.

Permanent Collection

Over 7,000 works, featuring 19th- and 20th-century American paintings and American and European prints and drawings dating from the 16th century to the present. Also includes Japanese prints, the Samuel H. Kress Study Collection of Italian Renaissance Paintings, and British watercolors and Neoclassical sculptures on long-term loan from the West Foundation.
Architecture: The new museum building, which opened in 1996 as part of the Performing and Visual Arts Complex of the East Campus of the University of Georgia, was designed by Thompson Ventulett Stainback & Associates.

Admission: Suggested donation: $1. Handicapped accessible, including ramps, elevators, braille signage, and wheelchairs.
Hours: Tues.-Sat., 10-5; Sun., 1-5.
Programs for Children: Guided tours, monthly Family Day programs, and occasional films and special events.
Tours: Reservations can be made for group tours. Call (706) 542-4662.
Food & Drink: The On Display Café, open Mon.-Fri., 10-2; closed most state and federal holidays.
Museum Shop: Offers a variety of art-related, educational gifts, including jewelry by local artisans, hand-blown glass, and ceramics.

Michael C. Carlos Museum

Emory University
571 South Kilgo Street, Atlanta, GA 30322
(404) 727-4282
http://www.cc.emory.edu/CARLOS/

1999 Exhibitions

Thru January 10
Shamans, Gods, and Mythic Beasts: Colombian Gold and Ceramics in Antiquity
Gold and ceramic objects, from 1200 B.C. to A.D. 1600, comprise this first traveling exhibition to highlight ancient Colombian ceramic sculpture. (T)

Thru February 21
The Social Life of Kuba Cloth
A look at the textiles of the Kuba, a Sub-Saharan African group. Examines the production techniques and its social and commercial significance.

February 6-April 11
Beads, Body, and Soul: Art and Light in the Yoruba Universe
Looks at the extraordinary complexity of Yoruba beaded arts, which span
nearly 1,000 years and have flourished throughout the African Diaspora. (T)

May 8-July 11
*Master Drawings from the
Worcester Art Museum*
100 drawings and works on
paper dating from 1275 to 1975.
(T)

Permanent Collection
Houses 16,000 objects, including
art from Egypt, Greece, Rome,
the Near East, the Americas,
Asia, Africa, and Oceania;
European and American prints
and drawings from the Middle

Pair of Beaded Shoes. From *Beads, Body and Soul: Art
and Light in the Yoruba Universe.* Photo by Don Cole,
courtesy UCLA Fowler Museum of Cultural History
and Michael C. Carlos Museum.

Ages to the 20th-century. **Architecture:** 1919 Georgian marble facade
building, with traditional clay tile roof, located on the historic quadrangle of
the university campus; renovation and major expansion by Michael Graves
completed in 1993.

Admission: Suggested donation: $3. Handicapped accessible, including
parking, elevators, and braille signage.
Hours: Mon.-Sat., 10-5; Sun., noon-5. Closed major holidays.
Programs for Children: Programs and workshops throughout the year.
Call (404) 727-4282 for information.
Food & Drink: Caffè Antico, European-style cafe, offers lunch fare,
coffees, desserts. Open Mon.-Fri., 8:30-4:30; Sat., 12-4:30; Sun., noon-5.
Museum Shop: Offers books on art, architecture, and archeology, jewelry,
gifts, magazines, notecards, and children's games. (404) 727-0509.

High Museum of Art

1280 Peachtree St. N.E., Atlanta, GA 30309
(404) 733-HIGH or 4444
http://www.high.org

1999 Exhibitions
Thru January 17
Monet and Bazille: Early Impressionism and Collaboration
Examines the brief but momentous relationship of these two 19th-century
artists, who shared a Paris studio and struggled to develop the new style of
painting that later became known as Impressionism. Catalogue.

Pop Art: Selections from the Museum of Modern Art, New York
Focuses on the 1960s, a defining decade for the American Pop Art
movement and features work by Warhol, Lichtenstein, Oldenburg, and
Rosenquist.

February 26-May 21
John Henry Twachtman: An American Impressionist
A major retrospective of the Cincinnati-born artist arranged thematically to highlight the four important periods of his career: his early work, European period, Connecticut and Gloucester years, and late work. (T)

February 27-May 16
Collecting Impressionism: Impressionist Paintings from European Museums
A highly selective and important exhibition of about 60 Impressionist paintings, including works by Monet, Cézanne, Pissaro, Degas, Renoir, Morisot, Caillebotte, and Sisley, from major museums in London, Paris, Oslo, Budapest, Cologne, and Stuttgart. (T)

June 12-August 15
Ellsworth Kelly: The Early Drawings, 1948-1955
Approximately 220 drawings, many never before exhibited, trace the development of Kelly's abstract aesthetic. Catalogue. (T)

June 12-September 26
Art and Enterprise: The Virginia Carroll Crawford Collection of American Decorative Arts, 1825-1917
Featuring work from one of the leading public collections of its kind, in celebration of the publication of a comprehensive, scholarly catalogue.

Permanent Collection

European painting and sculpture from the Renaissance to the 20th century; sub-Saharan African art; American and European prints, photographs, decorative arts; American 18th- to 20th-century paintings and sculptures. **Highlights:** Lichtenstein, *Sandwich and Soda;* Peale, *Senator William H. Crawford of Georgia;* Prendergast, *Procession, Venice;* Rauschenberg, *Overcast III;* Stella, *Munteneia I;* Whittredge, *Landscape in the Harz Mountains.* **Architecture:** Award-winning 1983 building by Richard Meier.

Admission: Adults, $6; seniors, students with ID, $4; children 6-17, $2; children under 6, members, free. Thurs., 1-5, free. Handicapped accessible.
Hours: Tues.-Sat., 10-5; Sun., 12-5; fourth Fri. of every month, 10-9. Closed Mon., holidays.
Programs for Children: Interactive, Visual Arts Learning Space for children of all ages.
Tours: Call (404) 733-4444 for information.
Food & Drink: High Café serves sandwiches, soups, baked goods, desserts, and coffee. Open Mon., 8:30-3; Tues.-Fri., 8:30-5; Sat.-Sun., 10-5.

High Museum of Art Folk Art and Photography Galleries
30 John Wesley Dobbs Ave., N.E., Atlanta, GA 30303
(404) 577-6950

1999 Exhibitions
Thru January 3
Collecting Folk Art at the High: The Last 40 Years of Collecting
Celebrates the history of exhibiting and collecting folk art over the past 40 years. Features portraits, furniture, ceramics, textiles, and more.

Thru February 27
*Collecting Folk Art at the High: Recent Acquisitions in Southern
Decorative Arts*
Significant examples of southern decorative art dating from the 19th
century.

March 6-May 29
Ted Gordon
An exhibition of 40 works by Ted Gordon, known for his intricate,
brilliantly colored stylized drawings of cats, birds, fish, and flowers.

May 16-July 31
*"I Made This Jar...": The Life and Works of the Enslaved African-
American Potter, Dave*
Features 25-30 pots turned by Dave, one of a small number of identified
African-American craftsmen who worked in South Carolina in the
antebellum period.

Architecture: 1986 building by Parker and Scogin Architects, Inc.
Admission: Free.
Hours: Mon.-Sat., 10-5.

The Contemporary Museum

2411 Makiki Heights Drive, Honolulu, HI 96822
(808) 526-1322
http://www.tcm@hi.org

1999 Exhibitions
Thru January 3
First Decade: Highlights from The Contemporary Museum's Collection
10th anniversary exhibition of works in all media from the permanent
collection.

Thru January 17
Nadine Ferraro
A selection of paintings and drawings by this compelling artist.

January 15-March 14
Susan Rothenberg: Drawings and Prints
Work by one of the foremost American women artists.

February 18-May 7
Contemporary Prints from Hawai'i Collections

May 19-July 23
Robert Colescott: Recent Paintings, 47th Venice Biennale
Recent works by the first African-American artist to be included in the
prestigious Venice Bienniale exhibition. (T)

March 26-June 6
Ursula von Rydingsvard
Wood sculpture by this prominent, German woman artist. (T)

June 18-August 22
Fourth TCM Biennial of Hawaii Artists

December 2, 1999-February 6, 2000
Geoffrey Beene
Innovative clothing by this designer who has been at the cutting edge of fashion for over 30 years.

The Contemporary Museum at First Hawaiian Center

999 Bishop Street, Honolulu, HI 96813

1999 Exhibitions
Thru February 17
Takeo Miji–Oil Paintings
Randall Shiroma–Sculpture
Marcia Morse–Mixed Media

February 5-May 12
Geoff Fricker–Photographs

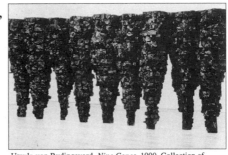
Ursula von Rydingsvard, *Nine Cones*, 1990. Collection of Emily Landau. Photo courtesy The Contemporary Museum.

Permanent Collection
Includes over 1200 works in all media by local, national, and international artists from approximately 1940-present. In addition to recently acquired works by Edward and Nancy Reddin Kienholz, Andy Warhol, Robert Motherwell, and Dennis Oppenheim, the collection includes artists such as Robert Graham, Mark Tobey, Louise Nevelson, Jim Dine, Jasper Johns and Deborah Butterfield. **Highlights:** Permanent installation by David Hockney based on the set from 1925 Ravel opera *L'Enfant et les Sortileges;* Viola Frey's *Two Women and a World.* Downtown Annex Gallery at First Hawaiian Center. Features art by Hawaiian artists. **Architecture:** Maliki Galleries located on the Spalding Estate, a 3.5 acre sight formerly home to Alice Cooke Spalding. Built in the 1920s, building has been expanded and renovated many times, most recently by the CJS Group in 1988. A new space, the Milton Cades Pavillion, was created to house the Hockney installation.

Admission: Makiki Galleries: Adults, $5; students, seniors, $3; children 12 and under, free; First Hawaiian Center: Free. Handicapped accessible, including parking and restrooms.
Hours: Makiki Galleries, Tues.-Sat., 10-4; Sun., 12-4. First Hawaiian Center, Mon.-Thurs., 8:30-4; Fri., 8:30-6.
Programs for Children: Guided tours; "Expression Session" art workshops; "Art off the Wall" performance-art based on exhibitions.
Tours: Makiki Galleries, Tues.-Sun., 1:30.
Food & Drink: Contemporary Café at Makiki Galleries, open Tues.-Sat., 11-3; Sun., 12-3. Serves lunch specials and al fresco menu; homemade desserts; fresh-squeezed lemonade.
Museum Shop: Makiki Galleries store has a wide variety of one-of-a-kind gifts, unique jewelry, clothing, books, and more. Hours: same as Galleries'.

Honolulu Academy of Arts

900 S. Beretania St., Honolulu, HI 96813
(808) 532-8700; 532-8701 (recording)
http://www.honoluluacademy.org

1999 Exhibitions

Thru January 10
Toys and Trains from the Rick Ralston Collection
Classic American toys from the late 19th and early 20th century.

Thru January 15
Holiday Gifts from Hawaii's Youth
Oversized, papier mâché toys made by Hawaiian students.

Thru January 17
Art of the Goldsmith: Masterworks from Buccellati
Over 50 works, including 14 masterworks, that illustrate the art of jewelry making and small-scale sculpture.

Hawai'i and Its People
Pictorial heritage of Hawaii includes examples of "documentary" art created during the late-18th and 19th centuries by voyaging artists.

Thru April 4
From the Rainbow's Varied Hue: Textiles of the Southern Philippines
Rare cloths from the rich, little-known weaving traditions of Mindanao and the Sulu archipelago.

January 8-February 3
Chen Ke Zhan: Contemporary Chinese Paintings
A major exhibition featuring Chinese brush works on paper by internationally acclaimed Singapore artist Chen Ke Zhan.

February 4-April 4
Kayumangi
Recent works by Hawaii's contemporary artists of Filipino descent.

February 25-May 7
Art and Life in Colonial America
Specifically designed for school tours.

February
George Woollard: Prints

The Hawaii Regional Scholastic Art and Photography Exhibition

March
Honolulu Printmakers Juried Exhibition

Kauai Society of Artists

March 11-May 2
Fruits and Flowers: Botanical Painting by Geraldine King Tam

April 24-30
Young People's Spring Exhibition
Work by young students in Academy Art Center classes.

April 29-June 20
A Renaissance Treasury: The Flagg Collection of European Decorative Arts and Sculpture
This exhibition features 70 precious objects dating from the 14th to the early 18th century from the private collection of Richard and Erna Flagg. (T)

May 1-May 15
Fibre Art Exhibition
Sponsored by Hawaii Craftsmen, this exhibition features recent works by local contemporary artists.

May 11-July 11
June Schwarcz: 40 Years/40 Pieces

May
Hawaii Potter's Guild 30th Anniversary Exhibition

July 22-August 22
Artists of Hawai'i
This annual exhibition highlights the best of Hawaii's artistic community.

July 20, 1999-January 16, 2000
Hawai'i and Its People

September 16-November 7
Interaction of Cultures: Indian and Western Painting (1710-1910) from the Ehrenfeld Collection
An extraordinary look at India's development through the eyes of Western and Indian painters.

September
Hawaii Craftsmen 32nd Annual Juried Exhibition

Tea Bowl Exhibition

November
Watercolor Exhibition by Juanita Kenda

December
Mokichi Okada Association's Annual Children's Exhibition

December 2, 1999-June 2000
Art by, with, and for Children

Permanent Collection
Hawaii's only general art museum; objects from cultures around the world and throughout history. Asian art, including James A. Michener collection of Japanese woodblock prints; Kress collection of Renaissance and Baroque paintings; American paintings and decorative arts from the Colonial period to the present day; works from Africa, Oceania, the Americas; contemporary graphic arts. **Highlights:** Delaunay, *The Rainbow*; van Gogh, *Wheatfields*; Ma Fen, *The Hundred Geese*; Monet, *Water Lilies*; Chinese and Persian bronzes; six garden courts.
Architecture: 1927 building by Bertram Goodhue.

Admission: Adults, $5; seniors, students, military, $3; children 12 and under, free. Handicapped accessible.
Hours: Tues.-Sat., 10-4:30; Sun., 1-5. Closed Mon., holidays.
Tours: Tues.-Sat., 11; Sun., 1. For special tours, call (808) 532-8726.
Food & Drink: Garden Café open Tues.-Sat.

Boise Art Museum
670 S. Julia Davis Drive, Boise, ID 83702
(208) 345-8330

1999 Exhibitions

Thru January 31
Mountain Majesty: The Art of John Fery
The work of painter John Fery (b. 1859) portrays the rugged splendor of the Rocky Mountains.

Thru February 21
Stephanie Wilde
A Boise artist creates poetic art that explores social issues, including AIDs, illness, and injustice.

Thru May 16
Marilyn Lysohir: The Dark Side of Dazzle
The installation addresses the seduction of war. Includes taped war stories of veterans from WWII, Korea, and Vietnam.

February 13-April 25
Trashformations: Recycled Materials in American Art and Design
Chronicles the history of recycling in American art. (T)

February 27-May 16
Jim Talbot
Talbot's unique photographic portraits are penetrating explorations of his subjects' psychology and environment.

May 8-May 23
Primary Colors
Elementary students create works inspired by history's great masterpieces.

June 5-July 20
Original Nature: The Art of Brad Rude
Pastels, paintings, and bronze sculptures that express Rude's deep reverence for the beauty of the natural world.

August 7-October 17
Twentieth Century American Drawings
Drawings by Milton Avery, Edward Hopper, Thomas Hart Benton, Georgia O'Keeffe, and others from one of the finest drawing collections in the U.S. (T)

December 4, 1999-February 13, 2000
Jack Dollhausen: Date for a Millennium
Lively sculptures engage the viewer through sound, light, and sensory interaction.

December 4, 1999-February 28, 2000
Innuendo Non Troppo: The Work of Gregory Barsamian
Barsamian's large sculptural, mechanical, 3-D pieces produce surreal images when in motion. (T)

Permanent Collection
34,000 sq. ft. facility features the work of contemporary, Northwest artists and traveling exhibitions. Education Center; outdoor sculpture garden.

Admission: Adults, $4; college students, seniors, $2; children, grades 1-12, $1; children 6 and under, members, free.
Hours: Tues.-Fri., 10-5; Sat.-Sun., 12-5. June 1-August 31, open Mon., 10-5.
Programs for Children: Albertsons Education Center, art classes, after-school workshops, Kids' Day, tours for children.
Tours: Call (208) 345-8330, ext. 21.
Museum Shop: Features fine crafts by regional and native artists, art books, contemporary jewelry, toys, cards, and much more.

The Art Institute of Chicago
111 South Michigan Ave. at Adams St., Chicago, IL 60603
(312) 443-3600; 443-3500 (recording)
http://www.artic.edu/aic/

1999 Exhibitions
Thru January 3
Japan 2000: Kisho Kurokawa
This look at the work of Kurokawa, one of the most distinguished architects in Japan, marks the finale of *Japan 2000*, a celebration of Japanese design.
Mary Cassatt
Comprehensive survey of paintings, pastels, drawings, and prints by innovative American artist and patron Mary Cassatt (1844-1926), best known for her association with the French Impressionists. Catalogue. (T)

Thru January 10
Julia Margaret Cameron's Women
Explores the emotional content of the innovative 19th-century British photographer's portraits of women. Includes portraits of Julia Jackson and Alice Liddell. Catalogue. (T)

Thru February 28
Revival and Reform: A Growing 19th-Century Textile Collection
A juxtaposition of two opposing trends in textile arts: the reintroduction of classical motifs and the impact of technological advances in the art of weaving.

Thru March 14
Masterpieces from Central Africa: Selections from the Belgian Royal Museum for Central Africa, Tervuren
125 of the finest objects from the Belgian Royal Museum's dazzling collection, from figures to masks to musical instruments.

February 13-April 25
Gustave Moreau
In honor of the 100th anniversary of the death of the French symbolist painter, this exhibition features masterpieces from each stage of his career. (T)

June 5-September 5
Land of the Winged Horsemen: Art in Poland, 1571-1764
Major exhibition of 150 works dating from the golden age of the Polish Empire, which stretched to the Black Sea. Examples of paintings, metalwork, textiles, ceramics, furniture, and weaponry trace the influence of Ottoman Turkish and Oriental cultures on Baroque Poland. (T)

September 11-December 5
Ellsworth Kelly: The Early Drawings, 1948-1955
Approximately 220 drawings, many never before exhibited, trace the development of Kelly's abstract aesthetic. Catalogue. (T)

October 16, 1999-January 16, 2000
Bill Viola
Surveys the work of this influential contemporary artist, including 15 major video installations and drawings from the 1970s to the present. (T)

Permanent Collection
One of the major museums in the U.S., spanning 40 centuries of art. Chinese bronzes, ceramics, jades; Japanese prints; African, Oceaniac, ancient Meso-American and Peruvian art; Harding collection of arms and armor; acclaimed Impressionist collection; American and European fine and decorative arts; major collection of 20th-century art. **Highlights:** Impressionist and Post-Impressionist collection, including Caillebotte, *Paris Street; Rainy Day;* Cassatt, *The Bath;* Goya, *The Capture of Maragato by Fray Pedro;* El Greco, *Assumption of the Virgin;* Monet, *On the Bank of the Seine, Bennecourt;* large group of Picassos; Seurat, *A Sunday on La Grand Jatte–1884;* Wood, *American Gothic;* six extraordinary panels from a large early Renaissance altarpiece by Giovanni di Paolo depicting the life of Saint John the Baptist; reconstructed Chicago Stock Exchange Trading Room designed by Adler and Sullivan. **Architecture:** 1894 Beaux Arts building by Shepley, Rutan, and Coolidge; 1986 renovation by Skidmore, Owings, and Merrill; 1988 South Building by Hammond, Beeby, and Babka; 1991 Modern Art renovation by Barnett and Smith, Architects, and the Office of John Vinci; 1992 Asian Gallery renovation by Cleo Nichols Design, with Japanese Screens Gallery by Tadao Ando; 1994 opening of Galleries of Ancient Art, designed by architect John Vinci.

Admission: Suggested: adults, $7; seniors, students with ID, children, $3.50. Tues., free. Handicapped accessible, use Columbus Dr. entrance.
Hours: Mon., Wed.-Fri., 10:30-4:30; Tues., 10:30-8; Sat., 10-5; Sun., holidays, 12-5. Closed Thanksgiving, Dec. 25.
Programs for Children: Family programs throughout the year.
Tours: Call (312) 443-3933.
Food & Drink: Court Cafeteria open Mon.-Sat., 10:30-4; Tues., 10:30-7; Sun., 12-4. Restaurant on the Park open Mon.-Sat., 11-2:30.

Museum of Contemporary Art

220 E. Chicago Ave., Chicago, IL 60611
(312) 280-2660; 280-5161 (recording)
http://www.mcchicago.org

1999 Exhibitions

Ongoing
Dan Peterman
A site-specific work by the Chicago-based artist, known for his work with
reprocessed materials.

Jacob Hashimoto, An Infinite Expanse of Sky (10,000 Kites)
An installation of 10,000 kites in the museum's M Café.

Thru January 3
Jana Sterbak
Mid-career survey of this Canada-based Czech artist best known for a dress
made of flank steak that evokes themes of 17th-century *vanitas* paintings.
Includes sculptures, installations, photographs, and videos.

Artist/Author: The Book as Art Since 1980
Surveys contemporary artists' book production, including fanzines,
assemblies, visual poetry, sketchbooks, illustrated books, and collaborations
with the commercial world. (T)

Thru Winter
Henry Darger: Peering into the Realms
Features 6 imaginative and other-worldly watercolor, collage, and pencil
works on paper by the self-taught artist.

Thru March 14
Mariko Mori
Large photographs and video installations present fantastic and futuristic
scenarios in which the artist often "stars" in various forms of masquerade.

Thru May
Damien Hirst, Pharmaceutic Wall Painting, Five Blacks
Celebrated and notorious artist Damien Hirst paints two "spot paintings,"
aesthetic constructions of 150 arbitrarily colored dots, directly on the walls
of the MCA lobby.

Thru Spring
Envisioning the Contemporary: Selections from the MCA Collection
Some of the best-loved works of art from the collection, including pieces by
Andy Warhol, Alfredo Jaar, and Clarie Zeisler, return to the galleries.

January 16-April 11
Jim Hodges
Hodges's installation-based works combine delicate everyday objects to
evoke a sense of memory, longing, nostalgia, and loss.

January 16-April 18
Transmute: A Collection Exhibition Guest-Curated by Joshua Decter
The second of four annual interactive, multimedia exhibition projects.

January 23-March 14
Recent Acquisitions
Features works that enrich the MCA collection, including late-surrealist, minimalist, conceptual, and Chicago art.

April 10-May 30
Katharina Fritsch
A new installation work created especially for the MCA, by one of the most prominent contemporary German artists.

April 24-July 11
Sarah Sze
As part of the Projects Series, Sze creates a site-specific work consisting of meticulously arranged found objects.

June 19-September 12
Charles Ray
A major mid-career survey of the work of Charles Ray, known for exploring the authenticity of representation in his sculpture, photography, film and performance. (T)

Autumn
Robert Heinecken
Examines the manipulated photographic images, dating from the 1960s to the present, by this artist who has been called an "image scavenger."

Permanent Collection
20th-century works in all media, including photographs, films, videotapes, audio pieces by Abahakowicz, Christo, Dubuffet, Duchamp, Holzer, Oldenburg, Rauschenberg, Segal. **Highlights:** Bacon, *Man in Blue Box;* Magritte, *The Wonders of Nature;* Calder sculptures and mobiles, conceptual and minimal works. **Architecture:** Newly opened building and sculpture garden, designed by Josef Paul Kleihues.

Admission: Adults, $6.50; seniors, students, $4; children 12 and under, members, free; First Tues. of each month, free. Handicapped accessible, including elevators; wheelchairs available.
Hours: Tues., Thurs., Fri., 11-6; Wed., 11-8; Sat., Sun., 10-6. Closed Mon., major holidays. Galleries may be closed for new installations.
Programs for Children: Activities throughout the year. For information, call (312) 280-2660.
Tours: Weekdays, 12:15; additional tour Wed., 7:15; Sat., Sun., 11:15, 12:15, 2:15.
Food & Drink: M Café features al fresco dining with magnificent view of Lake Michigan as well as inside dining surrounded by works of contemporary art. Tues., Thurs., Fri., 11-5; Wed., 11-7; Sat., Sun., 10-5
Museum Shop: Culturecounter offers an exciting array of contemporary works, wares, books, souvenirs, jewelry, housewares, gifts, and books. Tues., Thurs., Fri., 11-5:30; Wed., 11-8; Sat., Sun. 10-6:30.

Terra Museum of American Art

666 N. Michigan Ave.,
Chicago, IL 60611
(312) 664-3939

1999 Exhibitions
Thru January 3
Robert Capa: Photographs
A retrospective of one of this
century's greatest
photojournalists. Features over
180 images spanning Capa's
career, including his
documentation of the Spanish
Civil War, and 12 vintage prints
by his companion Gerda Taro.

January 16-April 18
*American Masters: Sculpture
from Brookgreen Gardens*
40 sculptural works and two
photographic murals by
preeminent American artists
document 175 years of
sculpture.

Spring-Ongoing
Masters of Color and Light:

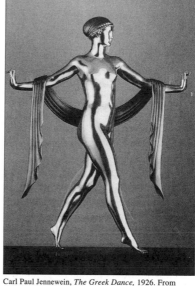

Carl Paul Jennewein, *The Greek Dance*, 1926. From
American Masters: Sculpture from Brookgreen Gardens.
Photo courtesy Terra Museum of American Art.

Homer, Sargent, and the American Watercolor Movement
Dazzling works by two of the most influential American artists illustrate the
watercolor's evolution from a study tool to a revered art form in its own
right.

Permanent Collection
Based on the personal collection of the late Daniel Terra, spanning two
centuries of American art. **Highlights:** Morse, *Gallery of the Louvre;* works
by Cassatt, Homer, Sargent, Whistler. **Architecture:** Award-winning 1987
design by Booth-Hansen and Associates, blending two formerly distinct
buildings.

Admission: Suggested donation; adults, $5; seniors, $2.50; members,
educators, students (with valid I.D.), children under 14, free; Tues., first
Sun. of every month, free. Handicapped accessible.
Hours: Tues.-Sat., 10-7; Sun., noon-5. Closed Mon.
Programs for Children: Free Family Day, first Sun. of month; Family Fair
for ages 5-12 offered daily, 1-3, includes hands-on studio workshop and
tours; free Family Activity Guides for exhibitions; school programs,
including creative writing and hands-on art projects; summer art camps.
Tours: Mon.-Fri., 12, 6; Sat.-Sun., 12, 2. Groups call (312) 664-3939.
Museum Shop: A variety of books and other items that relate to the Terra
collection and reflect American culture.

Indianapolis Museum of Art

1200 W. 38th St., Indianapolis, IN 46208
(317) 923-1331
http://web.ima-art.org

1999 Exhibitions
May 16-August 8
Ursula von Rydingsvard
Sculptural work by the internationally known German artist. (T)
Visions of Home

September 19-November 28
The Huguenot Legacy: English Silver 1680-1760, from the Alan and Simone Hartman Collection
Examines the influence of French Huguenot silversmiths on the stylistic evolution of English silver. (T)

Permanent Collection
J. M. W. Turner Collection of watercolors and drawings; Holliday Collection of Neo-Impressionist Art; Clowes Fund Collection; Eli Lilly Collection of Chinese Art; Eiteljorg Collection of African Art.
Architecture: Lilly Pavilion of Decorative Arts: original J. K. Lilly mansion modeled after 18th-century French chateau; 1970 Krannert Pavilion by Ambrose Richardson; 1972 Clowes Pavilion; 1973 Showalter Pavilion; 1990 Mary F. Hulman Pavilion by Edward Larrabee Barnes.

Admission: Free. Fee for special exhibitions, free on Thurs. Handicapped accessible.
Hours: Tues.-Sat., 10-5; Thurs., 10-8:30; Sun., 12-5. Closed Mon., major holidays.
Tours: Call (317) 923-1331 for information.
Food & Drink: Museum Café, Garden on the Green.

Davenport Museum of Art

1737 West 12th St., Davenport IA 52804
(319) 326-7804
http://www.gconline.com/arts/DMA

1999 Exhibitions
Thru January 10
Our Nation's Colors: A Celebration of American Painting
Highlights modernist American painting, with important works by Bellows, Cassatt, Henri, Eakins, Homer, Hopper, and O'Keeffe. Catalogue. (T)

February 7-April 4
Master Drawings from the Worcester Art Museum
100 drawings and works on paper dating from 1275 to 1975. (T)

April 18-June 13

Africa! A Sense of Wonder: African Art from the Faletti Family Collection
An exploration of Sub-Saharan African and Ethiopian art through more than
85 works from the 16th to the early 20th century. (Last venue)

June 17-September 12

Davenport Museum of Art Bi-State Competitive Art Exhibition
A biennial exhibition of works by upcoming artists from Iowa and Illinois.

Thomas Eakins, *Billy Smith,* 1898. Roland P.
Murdock Collection. From *Our Nation's
Colors: A Celebration of American Painting.*
Photo courtesy Davenport Museum of Art.

Permanent Collection

Includes many nationally and
internationally known objects and bears
witness to more than seven decades of
philanthropy and civic pride. The
collections, organized in seven areas–
America, Regionalist, Mexican Colonial,
Haitian, Asian, European, and
Contemporary–offer a distinctive look at
art from the 15th century to the present.

Admission: Varies with exhibition.
Handicapped accessible: enter through
Wiese Fine Arts addition.
Hours: Tues.-Sat., 10-4:30; Thurs., 10-8;
Sun., 1-4:30.
Programs for Children: Children's
Learning Center located in Wiese Fine Arts addition.
Museum Shop: Offers books, gifts, and crafts by local artists.

Des Moines Art Center

4700 Grand Ave., Des Moines, IA 50312
(515) 277-4405

1999 Exhibitions

Thru January 3

Styles of the Times: Works on Paper from the 1990s
Features works from the permanent collection created in the 1990s.

Thru January 24

Shifting Visions: O'Keeffe, Guston, Gerhard Richter
Major works by each of these distinguished 20th-century artists
demonstrate their range of style from abstraction to realism.

February 20-May 23

Maya Lin: Topologies
5 site-specific works by the internationally acclaimed artist/architect fuse
20th-century science and technology with Asian minimalist sensibility. (T)

March 5-May 9

Photoimage: Printmaking 60s to 90s
More than 100 American and European prints and books in a variety of
media by such artists as Rauschenberg, Richter, and Warhol.

Permanent Collection

Nineteenth- and 20th-century European and American paintings and sculptures; African and primitive arts. **Highlights:** Bacon, *Study after Velázquez's Portrait of Pope Innocent X;* Johns, *Tennyson;* Judd, *Untitled;* Kiefer, *Untitled;* Monet, *Rocks at Belle-Île;* MacDonald-Wright, *Abstractions on Spectrum;* Marden, *Range.* **Architecture:** 1948 building by Eliel Saarinen; 1968 addition by I. M. Pei & Partners; 1985 addition by Richard Meier & Partners.

Admission: Daily, 1-4: Adults, $4; seniors, students with ID, $2; daily, 11-1, Thurs. (all day), members, children under 12, scheduled docent tours, free. Handicapped accessible.
Hours: Tues.-Sat., 11-4; Thurs., first Fri. of every month, 11-9; Sun., 12-4. Closed Mon., holidays.
Programs for Children: Offers classes and workshops throughout the year. Children's scholarships available. Call for information.
Tours: Please make reservations with the Education Dept. 3-4 weeks in advance.
Food & Drink: Restaurant open Tues.-Sat., 11-2; Thurs. dinner, 5:30-9, reservations recommended; first Fri. of every month, 5-8.
Museum Shop: Open during museum hours.

Spencer Museum of Art

University of Kansas, Lawrence, KS 66045
(785) 864-4710
http://www.ukans.edu/~sma

1999 Exhibitions

Thru January 10
Wrapped, Tied, and Packaged: Print Portfolios from the Collection
A survey of the print portfolio tradition, in which the outer packaging or portfolio is an integral part of the exhibition.

January 23-March 21
Art of the Sixties
Investigates American art of the 1960s from the permanent collection.

January 30-March 28
Six Bridges: The Making of a Modern Metropolis
Documents the career of 20th-century bridge engineer Othmar H. Ammann and the six bridges he built around New York City from 1927 to 1964.

June 12-August 7
Quilt National 97
Contemporary quilts from the annual juried exhibition.

Quilts from the Spencer Museum of Art Collection
An exhibition of historical quilts from the permanent collection to complement *Quilt National 97.*

August 21-October 17
Mexican Prints from the Collection of Reba and Dave Williams
Approximately 130 works drawn from one of the largest private collections of prints, surveys the full range of Mexican graphic arts from the 1920s to 1950s. (T)

Late Fall
About Time: Wendell Castle
A selection of conceptual time pieces by Wendell Castle.

September-October 12
Native American Art
Annual exhibition in conjunction with the Lawrence Indian Arts Show.

October 23-December 5
Facing Death: Portraits from Cambodia's Killing Fields
Recently uncovered photographs of Cambodian prisoners awaiting execution by the Khmer Rouge.

Permanent Collection

American and European painting, sculpture; Edo period paintings; Korean ceramics; Japanese prints; contemporary Chinese painting. **Highlights:** Homer, *Cloud Shadows;* Kandinsky, *Kleine Welten VI*; Studio of Sassetta, *Head of an Angel;* Rossetti, *La Pia de' Tolommei;* Fragonard, *Portrait of a Young Boy*; Benton, *The Ballad of the Jealous Lover of Lone Green Valley.*

Admission: Free. Handicapped accessible.
Hours: Tues.-Sat., 10-5; Thurs., 10-9; Sun., noon-5. Closed Mon., Jan. 1, July 4, Thanksgiving, Dec. 24-25.
Tours: Call (785) 864-4710 for information.
Museum Shop: Offers a variety of excellent art reference books and art-related merchandise. Specialty in books and gifts relating to quilting.

Wichita Art Museum

619 Stackman Dr., Wichita, KS 67203
(316) 268-4921
http://www.feist.com/~wam

1999 Exhibition

Thru January 10
Lester Raymer Retrospective Exhibition
Paintings, religious sculptures, furniture, and other decorative objects by this influential artist who taught and worked in Kansas for more than 40 years.

January 24-February 14
1999 Kansas Regional Scholastic Art Awards Exhibition
Work in a wide range of media by Kansas highschool students.

January 31-March 21
Defining Eye: Women Photographers of the 20th Century
Explores the subject of women as photographers and their perspectives.
Includes work by Berenice Abbott, Imogen Cunningham, Nan Goldin,
Cindy Sherman, Dorothea Lange, and Tina Modotti, among others.

February 28-July 11
Pop Culture Hot and Cool I
A print exhibition featuring works from the Wichita Art Museum and the
Ulrich Museum of Art to complement *The Great American Pop Art Store.*

April 11-June 6
The Great American Pop Art Store: Multiples of the Sixties
Celebrates the delightful and witty world of Pop Art multiples and its
influence on later object design, featuring 100 pieces by Jim Dine, Jasper
Johns, Andy Warhol, and others. Catalogue. (T)

July 18-November 7
Pop Culture Hot and Cool II
The second of this two-part exhibition series.

June 27-September 12
Kansas Watercolor Society Seven State Exhibition
The 29th annual juried watercolor exhibition.

September 5, 1999-January 2,2000
*Maurice Prendergast and His Associates: American Impressionist and
Early Modernist Works on Paper from the WAM Collection*
Organized to complement *Maurice Prendergast: The State of the Estate.*

October 3, 1999-January 2, 2000
Maurice Prendergast: The State of the Estate
Comprised of 45 oils, watercolors, monotypes, drawings, letters, and
memorabilia, this exhibition provides insight into the methods and
personality of one of the most innovative artists of the 20th century.

Permanent Collection
American painting, graphics, sculpture, decorative arts, with an emphasis on
painting from 1900 to 1950: American Impressionism, The Eight, early
modernism, Regionalism and American Scene. **Highlights:** Major works by
Copley, Eakins, Ryder, Cassatt, Henri, Prendergast, Glackens, Hopper,
Marin, Dove; works by Charles M. Russell.

Admission: Free. Handicapped accessible.
Hours: Tues.-Sat., 10-5; Sun., 12-5. Closed Mon.
Programs for Children: Seasonal Family Days, weekend workshops,
children's gallery, Artventure backpacks.
Tours: Call (316) 268-4907 three weeks in advance.
Food & Drink: Truffles Café, located in Riverside, near Riverside Park,
offers American cuisine and casual dining. Open Tues.-Sat., 11:30-1:30;
Sun. brunch with performances by area musicians, 12-2. Closed Sat. during
summer. (316) 268-4973.
Museum Shop: "Art for your lifestyle": original artwork, jewelry,
stationery, art books, children's books and toys, and innovative gift ideas.

University of Kentucky Art Museum

**Rose Street and Euclid Avenue,
Lexington, KY 40506
(606) 257-5716**

1999 Exhibitions
January 17-March 21
Mark Priest: The Railroad Series

February 7-May 23
*Made in Kentucky: Regional Artists in
the Collection*
Part II of this exhibition series features
contemporary art.

**November 14, 1999-February 27,
2000**
*Henry Chodkowski: Mavros
Labyrinthos Series 1986-1998*

Jay Bolotin, *A Mortal Pilgrimage IV,* 1983.
Photo courtesy University of Kentucky Art
Museum.

Permanent Collection
Collection of over 3,000 works includes 17th-20th century European and
American paintings by Carracci, Crespi, Willard Metcalf, Miró, Dubuffet;
photographs by Bernice Abbott, Ansel Adams, Meatyard, Frank; decorative
arts of Tiffany, Galle; old master and contemporary prints by Dürer,
Rembrandt, Motherwell, Katz, Kruger; and contemporary regional art.

Admission: Free. Handicapped accessible.
Hours: Tues.-Sun., 12-5.
Tours: Group tours available with advance reservation by calling (606)
257-5716; tours given Mon.-Fri., 8:30-3:30.
Programs for Children: Group tours available for preschool through high
school; writing and special-interest tours available with advance reservation.
Museum Shop: Posters, postcards, and exhibition catalogues are available
in the gallery or by calling (606) 257-5716.

The Speed Art Museum
**2035 S. Third St., Louisville, KY 40208
(502) 634-2700
http://www.speedmuseum.org**

1999 Exhibitions
Thru January 31
Rodin: Sculpture from the Iris and B. Gerald Cantor Collection
Works from the world's largest and most comprehensive private collection
of works by Rodin. 69 sculptures explore key motifs in Rodin's career,
including his interest in conveying movement and emotion. (T)

Thru Fall
Objects of Faith: Sacred Art from The Jewish Museum
Explores the role and function of religious objects in Jewish life.

127

March 8-May 23
Designed for Delight: Alternative Aspects of 20th-Century Decorative Arts
Over 200 decorative objects explore the major stylistic movements from art
nouveau and art deco to postwar and postmodern. Catalogue. (T).

Permanent Collection
Over 3,000 works, including European and American paintings, sculptures,
and prints from antiquity to the present; Native American and Asian art;
17th-century Dutch art; 18th-century French art; 20th-century sculpture and
painting. **Highlights:** In celebration of recent renovation, re-installation of
permanent collection to engage the viewer and provoke interpretations and
investigations. New Tapestry Gallery of the Preston Pope Satterwhite Wing,
featuring rotating exhibitions of tapestries from the museum's outstanding
tapestry and textile collection, as well as medieval, Renaissance, and
Baroque furniture. Elaborately carved oak-paneled English Renaissance
room; sculpture garden; Brancusi, *Mlle Pogany;* Rubens, *The Triumph of
the Eucharist;* Audrey Flack, *Colossal Head of Medusa.* **Architecture:**
1927 building; 1954 and 1973 wings; 1983 addition by Geddes; extensive
renovation, 1997.

Admission: Free. Charge for selected special exhibitions.
Hours: Tues., Wed., Fri., 10:30-4; Thurs., 10:30-8; Sat., 10:30-5; Sun., 12-
5. Closed Mon.
Tours: Call for information and reservations.
Food & Drink: Café Bristol open Tues.-Sat., 11:30-2.
Museum Shop: Offers everything from unique handmade art to one of
Louisville's best selections of museum notecards, stationery, posters, and art
books. Stunning array of beautiful handcrafted scarves and distinctive
jewelry.

New Orleans Museum of Art

1 Collins Diboll Circle, City Park, New Orleans, LA 70124
(504) 488-2631
http://www.noma.org

1999 Exhibitions
Thru January 4
*Ancient Gold: The Wealth of the Thracians, Treasures from the Republic of
Bulgaria*
Over 200 masterpieces of gold and silver metalwork from ancient Thrace,
located in central Europe between 4,000 B.C. and the 4th century A.D. (T)

Noel Rockmore: Fantasies and Realities
Focuses on Rockmore's 40-year career in New Orleans, ranging from his
portraits of Preservation Hall jazz musicians to works of surrealist fantasy.

Thru January 17
Colorprint USA
The 25th annual exhibition of original color prints by 50 distinguished
American printmakers.

Parian Porcelains from the Collection of Carl & Dixie Butler
One of the South's most extensive collection of the white, marble-like
Parian porcelain of the mid-19th century.

January 30-April 11
The Art of Eddie Kendrick: A Spiritual Journey
Magnificently colored works on paper and fabric explore the self-taught
artist's spirituality.

February 20-April 18
Hospice: A Photographic Inquiry
Five contemporary photographers deal with issues of death, dying, and grief
in their examination of the
Hospice movement.

May 1-August 29
*Degas and New Orleans: A
French Impressionist in
America*
An assemblage of works by
Degas, completed during his
stay in New Orleans and
upon return to Europe.

May 8-July 3
*The Cecil Family Collects:
Four Centuries of
Decorative Arts from
Burghley House*
A collection of decorative
arts in gold, silver,
diamonds, rubies, and
quartz crystals from one of the grandest Elizabethan houses in England. (T)

Edgar Degas, *Girl Sitting in the Garden*. From *Degas and New
Orleans: A French Impressionist in America*. Photo courtesy
New Orleans Museum of Art.

October 2-November 21
Raoul Dufy: Last of the Fauves
Presents 50 of the strongest oil paintings of the French artist's oeuvre and
aims to restore his reputation as one of the most original and talented artists
of the first half of the 20th century. (T)

John Clemmer: A Fifty Year Retrospective
Traces the development of Clemmer's career, from his early figurative work
of the late 1940s, to his uniquely lyrical abstractions of the 60s and 70s, to
his current experiments with urban scenes and landscapes.

October 30-November 21
Hugo Montero–Day of the Dead

December 4, 1999-February 6, 2000
Henry Casselli: Master of the American Watercolor
A retrospective of the New Orleans artist Henry Casselli's highly skilled
work, which has been compared to that of Sargent, Homer, and Wyeth.

Permanent Collection

Extraordinary strengths in French and American art; the nation's sixth-
largest collection of glass; photography from its beginnings to the present;

the arts of Africa; Japanese works, particularly from the Edo period; and the Weisman Galleries, dedicated to contemporary Louisiana artists. The collection also includes pre-Columbian, Native American, and Oceanic art. **Highlights:** Degas, especially *Portrait of Estelle Muson Degas;* other Impressionists including Monet, Renoir, and Cassatt; Fabergé Imperial Easter eggs and the bejeweled *Imperial Lilies-of-the-Valley Basket,* on extended loan from the Matilda Geddings Gray Foundation; Vigée-LeBrun, *Marie Antoinette, Queen of France.* **Architecture:** 1911 Beaux Arts structure by Samuel Marx in a 1,500-acre city park; 1993 addition doubled museum size.

Admission: Adults, $6; seniors, $5; children 3-17, $3. Thurs., 10-12, free to Louisiana residents.
Hours: Tues.-Sun., 10-5. Closed Mon., holidays.
Programs for Children: stARTing point is an interactive educational gallery that explores where artists get their ideas.
Tours: Discounts for groups of 20 or more with reservations. Call (504) 488-2631 for information.
Food & Drink: Courtyard Café, Tues.-Sun., 10:30-4:30; view of City Park.
Museum Shop: Offers jewelry, books, and a special children's section.

Bowdoin College Museum of Art

9400 College Station, Walker Art Building, Brunswick, ME 04011
(207) 725-3275
http://www.bowdoin.edu/cwis/acad/museums

1999 Exhibitions
January 28-March 21
A Tale of Two Cities: Eugene Atget's Paris and Berenice Abbott's New York

April 8-June 6
Hung Liu: A Survey 1988-1998

September 23-December 12
Abelardo Morell and the Camera Eye

Permanent Collection
Over 12,000 objects, including Assyrian, Greek, Roman antiquities; European and American paintings, prints, drawings, sculpture, decorative arts; Kress study collection; Molinari Collection of Medals and Plaquettes; Winslow Homer memorabilia; Far Eastern, African, New World, and Pacific art. **Architecture:** 1894 building by Charles Follen McKim of McKim, Mead and White; 1975 addition by Edward Larrabee Barnes.

Admission: Free. Handicapped accessible; ramp and elevator in rear of building.
Hours: Tues.-Sat., 10-5; Sun., 2-5. Closed Mon., holidays. The Winslow Homer Gallery of wood engravings open during summer only.
Tours: Available by appointment; call (207) 725-3276 for reservations.

Portland Museum of Art

7 Congress Sq., Portland, ME 04101
(207) 775-6148
http://www.portlandmuseum.org

1999 Exhibitions

Thru January 3
The Portland Museum of Art Biennial
A selection of works by emerging artists in Maine.

Thru January 24
Will Barnet Prints
Features little-seen prints by well-known painter Will Barnet and traces the artist's development from the 1930s to the present.

January 21-March 21
Louise Nevelson: Structure Evolving
This exhibition includes 43 works and examines Nevelson's wide range of media in both sculpture and works on paper.

April 6-May 30
Bearing Witness: Contemporary Works by African-American Women
The collective artistic achievement of Alison Saar, Faith Ringgold, Carrie Mae Weems, and Lorna Simpson, among others. (T)

June 24-October 17
Love and the American Dream: The Art of Robert Indiana
Most widely recognized by his famous image *Love*, Indiana has always distinguished himself from other pop artists through his interest in the American Dream. Includes 65 paintings, sculptures, and prints.

Permanent Collection:

Maine's oldest arts institution, founded in 1882, featuring a collection of 18th- through 20th-century fine and decorative arts. **Highlights:** Major European movements, from Impressionism through surrealism, represented by the Joan Whitney Payson, Albert Otten, and Scott M. Black collections featuring Renoir, Degas, Monet, Picasso, Munch, and Magritte. Other highlights include works by Winslow Homer, John Singer Sargent, Rockwell Kent, Marsden Hartley, and Andrew Wyeth. **Architecture:** 1983 award-winning building designed by I.M. Pei, & Partners.

Admission: Adults, $6; students, seniors, $5; children 6-12, $1; children under 6, free. Handicapped accessible.
Hours: Tues., Wed., Sat., 10-5; Thurs.-Fri., 10-9; Sun., 12-5. Closed Mon. Memorial Day through Columbus Day, the museum is open on Mondays, 10-5.
Programs for Children: Family Festivals, first Fri. of month.
Tours: Daily, 2; Thurs., Fri., 6. Groups $4 per person; call 3 weeks ahead for reservations.
Food & Drink: Year-round Museum Café; call for hours.
Museum Shop: Open during museum hours.

Farnsworth Art Museum

P.O. Box 466, Main & Museum Sts., Rockland, ME 04841
(207) 596-6457
http://www.farnsworthmuseum.org
http://www.wyethcenter.com

1999 Exhibitions

Ongoing
Maine in America
Reinstallation of the permanent collection in celebration of the museum's
50th anniversary.

Thru February 21
Fairfield Porter from the Permanent Collection of The Parrish Art Museum
A selection of landscapes of New York and Maine by one of the most
acclaimed American realist painters of the 20th century.

June 13-October 24
Inventing Acadia: Artists and Tourists at Mount Desert
Explores the contributions of landscape painters who shaped the aesthetic
appreciation of Mount Desert. Includes work by Cole, Church, Fitz Hugh
Lane, William Stanley Haseltine, and Sanford Robinson Gifford.

November 7, 1999-February 13, 2000
John W. McCoy
A retrospective of nearly 40 watercolors by John W. McCoy (1910-1989).

Permanent Collection

Acclaimed collection of American art of the 19th and 20th centuries,
including works by the Wyeth family, Fitz Hugh Lane, John Marin, and
Edward Hopper; special emphasis on artists from Maine. **Highlight:**
Collection of 60 works by Louise Nevelson. **Architecture:** 1850
Farnsworth Homestead and Olson House on the museum grounds. New
Farnsworth Center for the Wyeth Family opened in June 1998.

Admission: Includes entry to Farnsworth Art Museum, the Wyeth Center,
the Homestead, and the Olson House. Memorial Day-Columbus Day: adults,
$9; seniors, $8; students 18 and over (with valid I.D.), $5; children under 18,
free. Winter: adults, $8; seniors, $7; students 18 and over (with valid I.D.),
$4; children under 18, free. Olson House only, adults, $3; children 8-18, $1.
Handicapped accessible, including ramps and elevators.
Hours: Memorial Day-Columbus Day: Farnsworth Art Museum, Olson
House, 9-5 daily. Winter: Farnsworth Art Museum, Tues.-Sat., 10-5; Sun.,
1-5.
Programs for Children: School tours, outreach, story hours, and in-school
programs.
Tours: Call (207) 596-5789 for information.
Museum Shop: Offers books, gifts, and limited-edition prints.

American Visionary Art Museum
800 Key Highway, Baltimore, MD 21230
(410) 244-1900
http://www.doubleclickd.com/avamhome.html

1999 Exhibitions
Thru May 30
Love: Error and Eros
Examines love as a powerful human emotion as interpreted through 205 works by 71 self-taught artists. Includes creations by Leonard Knight, Alex Grey, and Ruby Williams.

Summer
Self-Made Worlds

Fall 1999-Fall 2000
We Are Not Alone: Angels and Other Aliens

Permanent Collection
Features visionary art by self-taught ("outsider") artists, including Gerald Hawkes, Ted Gordon, and Dr. Otto Billig. **Highlights:** Outdoor wind-powered *Whirligig* sculpture by Vollis Simpson. **Architecture:** Complex includes a Sculpture Barn (formerly the Four Roses whisky warehouse, with 45-ft. ceilings); wild flower sculpture garden; and wooden meditation chapel by Ben Wilson. Main building's central stair balustrade and garden gates cast by artist David Hess.

Admission: Adults, $6; children, students, seniors, $4; groups of 10 or more, $3 per person. Handicapped accessible, including ramps and elevators.
Hours: Tues.-Sun., 10-6. Closed Mon.
Programs for Children: Call (410) 244-1900 for information.
Tours: Offered daily; call for more information.
Food & Drink: Joy America Café features acclaimed chef Peter Zimmer.
Museum Shop: Open during museum hours.

The Baltimore Museum of Art
10 Art Museum Dr. at N. Charles & 31st Streets, Baltimore, MD 21218
(410) 396-7100 (recording)
http://www.artbma.org

1999 Exhibitions
Thru January 3
Degas and the Little Dancer
Focuses on the evolution of the famous bronze sculpture *Little Dancer, Fourteen Years Old* by the French Impressionist. (T)

The Pious and the Profane: Looking at Renaissance Prints
65 prints from the museum's collection, including works by Albrecht Dürer, Lucas van Leyden, and Andrea Mantegna.

Thru January 31
Starry Nights: Star-Patterned Quilts from the Collection
A sampling of six star quilts from the mid-19th century.

January 20-March 21
Frederick Sommer Photographs and Collages/Surrealist Photos
A look at the hauntingly surreal art of the 20th century's most inventive
photographers. Accompanied by a survey of the museum's surrealist work.

January 27-April 11
Dancing at the Louvre: Faith Ringgold's French Collection and Other Story Quilts
In her quilts, Ringgold uses pictorial and narrative traditions to bring to light
issues of cultural identity and feminisim.

Elizabeth Catlett Sculpture: A Fifty-Year Retrospective
An exhibition of over 50 sculptures chronicles the evolution of the African-
American artist's work and distinguished career.

February 17-July 4
Nouveau to Deco: Textiles of the Early 20th Century
A survey of textiles from the museum's collection, ranging in style from the
sensuous lines of art nouveau to the bold dynamism of art deco.

April 7-June 30
Print Fair Acquisitions/PDS Anniversary
In celebration of the 10th anniversary of the Baltimore Contemporary Print
Fair, an exhibition of works purchased at the event.

June 13-September 5
Chokwe! Art and Initiation of Chokwe and Related Peoples
The first U.S. exhibition featuring the art of the Chokwe and related peoples
of Angola, Zaire, and Zambia. Explores the role of art objects in the
transmission of knowledge. (T)

October 10, 1999-January 30, 2000

Impressionist Portraits from American Collections
Demonstrates how the
Impressionists worked to
create a "modern" form of
portraiture. Includes nearly
60 works by Cassatt,
Cézanne, Degas, Gauguin,
Manet, Monet, Renoir, and
more.

Paul Gauguin, *Le Voiloncelliste (Portrait of
Upaupa Schneklud)*, 1894. Given by Hilda K.
Blaustein in memory of Jacob Blaustein. Photo
courtesy Baltimore Museum of Art.

Permanent Collection

European paintings and sculpture from the Renaissance to the present; 18th- to 19th-century American paintings; The Cone Collection, featuring works by Matisse and Picasso; West Wing for contemporary art, featuring 20th-century American and European paintings and sculpture; prints; drawings, especially 19th-century French; photographs; American and European decorative arts and textiles; pre-Columbian, Native American, and African art. **Highlights:** Cézanne, *Mont Sainte-Victoire Seen from the Bibemus Quarry*; Van Gogh, *A Pair of Boots;* Matisse, *Large Reclining Nude and Purple Robe* and *Anemones*; Picasso, *Dr. Claribel Cone* and *La Coiffure;* Pollock, *Water Birds*; Raphael, *Emilia Pia da Montefeltre*; Rembrandt, *Titus*; Van Dyck, *Rinaldo and Armida*; West, *Self-Portrait;* Warhol, *Last Supper.* **Architecture:** 1929 building and 1937 addition by Pope; 1980 Wurtzburger Sculpture Garden by Bower Fradley Lewis Thrower and George Patton; 1982 wing and 1986 addition by Bower Lewis Thrower; 1988 Levi Sculpture Garden by Sasaki Associates; 1994 West Wing for Contemporary Art by Bower Lewis Thrower, Architects.

Admission: Adults, $6; full-time students with ID, seniors, $4; age 18 and under, members, Thurs., free. Handicapped accessible; wheelchairs available.
Hours: Wed.-Fri., 11-5; Sat.-Sun., 11-6. First Thurs. of month, 11-9. Closed Mon., Tues., major holidays.
Programs for Children: Education programs and activities year-round.
Tours: Available by appointment. Call (410) 396-6320 for information.
Food & Drink: Gertrude's features Chesapeake cuisine of chef John Shields. Tues.-Thurs., 11:30.-9:30; Fri.-Sat., 11:30-11; Sun., 10-9.
Museum Shop: Offers art books, gifts, jewelry, reproductions, and items for children.

The Walters Art Gallery

600 N. Charles St., Baltimore, MD 21201
(410) 547-9000; 547-ARTS (recording)
http://www.TheWalters.org

1999 Exhibitions

Note: The 1974 Building will be closed for renovation until spring of 2001.

Thru January 3
The Invisible Made Visible: Angels from the Vatican Collection
Traces the iconography of angels in various cultures from the 9th century B.C. to the 20th century A.D., including more than 100 works of art and artifacts never before seen outside the Vatican. (T)

Thru March 14
Make Them Laugh: Slapstick and Satire in Japan
Fascinating and weird Japanese prints inspire smiles and laughter.

March 3-May 9
Land of the Winged Horsemen: Art in Poland, 1572-1764
Major exhibition of 150 works dating from the golden age of the Polish
Empire, which stretched to the Black Sea. Examples of paintings, metalwork,
textiles, ceramics, furniture, and weaponry trace the influence of Ottoman
Turkish and Oriental cultures on Baroque Poland. (T)

Permanent Collection

Antiquities of Egypt and the ancient
Near East; Asian, Greek, Etruscan,
Roman art; early Christian and
Byzantine art; medieval art of Western
Europe; Islamic art; illuminated
manuscripts; 16th- to 19th-century
paintings, sculptures, prints; Ethiopian
religious art; Hackerman House, the
Walters Art Gallery Museum of Asian
Art. **Highlights:** Bellini, *Madonna and
Child Enthroned with Saints and
Donors;* Fabergé Easter eggs from the
Russian Imperial collection; Géricault,
Riderless Racers at Rome; Manet, *At
the Café;* Raphael, *Virgin of the
Candelabra;* van der Goes, *Donor with
Saint John the Baptist.* **Architecture:**

Tiffany & Company, *Iris Corsage Ornament.*
Photo courtesy Walters Art Gallery.

1904 Renaissance Revival building by Adams and Delano; courtyard
modeled after Palazzo Balbi in Genoa, Italy; 1974 wing by Shepley,
Bulfinch, Richardson, and Abbott. Hackerman House: 1850 mansion; 1991
renovation by Grieves, Worrall, Wright & O'Hatrich.

Admission: Adults, $6; seniors, $4; students, $3; children ages 6-17, $2;
members and children under 6, free. Handicapped accessible.
Hours: Tues.-Fri., 10-4; Sat.-Sun., 11-5. First Thurs. of each month, 10-8.
Closed Mon., holidays.
Tours: Walk-in tours twice weekly. Groups call (410) 547-9000, ext. 232.
Food & Drink: Museum Café offers light fare during museum hours.
Museum Shop: Offers gifts, books, fine estate and reproduction jewelry.

The Addison Gallery of American Art

Phillips Academy, Andover, MA 01810
(508) 749-4015
http://www.andover.edu/addison/home.html

1999 Exhibitions

Thru January 3
Frank Stella at Tyler Graphics: A Unique Collaboration
Documents the 30-year collaboration between artist Frank Stella and
masterprinter Kenneth Tyler, called "one of the great partnerships in modern
American art," and traces Stella's stylistic evolution in this medium. (T)

Hans Hofmann: Continuing the Search for the Real
Highlights Hofmann's work from the 40s, 50s, and 60s and traces his quest
for spirituality in nature and abstract art.

Thru January 4
Phillips Academy Student Show

Selections from the Permanent Collection
January-March
Willem de Kooning: The Seeing Hand
Features paintings and drawings by the important Abstract Expressionist
artist.

Framed
Explores the history, design, and use of frames on works of art.

Selections from the Permanent Collection
Includes paintings, prints, and photography.

April-June 30
Photography and the West
A selection of photographic works.

April-July
Selections from the Permanent Collection

April-July 31
Artistic Legacies
Includes works by artists such as Josef Albers, David Smith, Gerald Shertzer
and his students, on the occasion of Shertzer's retirement.

July-October
*To Conserve a Legacy: American Art from Historically Black Colleges and
Universities*
This exhibition of more than 100 works highlights not only African-
American works, but the full range of American art that each institution
holds, including work by Jacob Lawrence, Lois Mailou Jones, Aaron
Douglas, Georgia O'Keeffe, and Arthur Dove. (T)

November 1999-January 2000
Nathan Lyons: Riding First Class on the Titanic

Permanent Collection
Over 11,000 American paintings, sculpture, works on paper, and
photography. Includes works by Davis, Homer, Hopper, LeWitt, and Frank
Stella. **Architecture:** Neoclassical building by Charles Platt, 1930.

Admission: Free. Handicapped accessible.
Hours: Tues.-Sat., 10-5; Sun., 1-5. Closed Mon., holidays, Dec. 24,
August 1 through Labor Day.
Programs for Children: School tours and art activities, call the Education
Coordinator at (508) 749-4017 for information and reservations.
Tours: For information, call (508) 749-4017.

Isabella Stewart Gardner Museum

280 The Fenway, Boston, MA 02115
(617) 566-1401
http://www.boston.com/gardner

1999 Exhibitions

Thru January 3
Abelardo Morell, Face to Face: Photographs at the Gardner
New work by this photographer known for his black-and-white images that
examine familiar objects and environments.

January 22-April 25
Josiah McElheny
Artist-in-residence and master glassblower Josiah McElheny creates new
work for this exhibition.

May 21-September 26
Sargent: The Late Landscapes
After 1907 Sargent began to devote himself to the study of landscapes,
turning away from portrait painting, for which he was widely recognized.
The resulting depictions of Palestine, the Alps, and the Rocky Mountains are
among the most experimental and abstract works of his career.

Permanent Collection

Italian Renaissance paintings; Dutch, French, German, Spanish
masterpieces; American paintings; rare books, manuscripts; decorative arts.
Works permanently arranged as Isabella Stewart Gardner specified.
Highlights: Indoor sculpture and flower garden; Botticelli, *Madonna of the
Eucharist;* Crivelli, *Saint George and the Dragon;* Giotto, *Presentation of
the Child Jesus at the Temple;* Rembrandt, *Self-Portrait;* Sargent, *Isabella
Stewart Gardner;* Titian, *Europa.* **Architecture:** 1899-1902 designed after
15th-century Venetian building that incorporates 15th- and 16th-century
architectural details by Sears.

Admission: Adults, $10; seniors, $7, students with current ID, $5; children
under 18, members, free. Wed., college students, $3. Handicapped
accessible.
Hours: Tues.-Sun., 11-5. Closed Mon., holidays.
Tours: Guided tour on Friday at 2:30 p.m., limited to 20 people on a first-
come, first-served basis. To schedule a tour group, call (617) 278-5174.
Food & Drink: Gardner Café open Tues.-Fri., 11:30-4; Sat.-Sun., 11-4.
Museum Shop: Excellent selection of beautiful gifts reflecting the
museum's collection and founder, from handcrafted jewelry and scarves,
Asian and Tuscan pottery, to guide books, prints, notecards, and postcards
of works from the permanent collection.

The Institute of Contemporary Art

955 Boylston St., Boston, MA 02115
(617) 266-5152
http://www.primalpub.com/ica

1999 Exhibitions

Thru January 3
Carol Rama
The only U.S. exhibition of the Italian artist Carol Rama's aggressive, erotic, sensual, and subversive artwork.

January 20-March 14
Tracey Moffatt

Wall Paintings

March 30-May 16
Collectors Collect Contemporary

June 9-August 22
Kerry James Marshall

September 8-October 17
Steve McQueen

Rineke Dijkstra

November 10, 1999-January 2, 2000
Shimon Attie

Permanent Collection

No permanent collection. **Architecture:** 1886 Richardsonian building by Vinal; 1970s façade restoration and interior renovation by Gund.

Admission: Adults, $6; seniors and students with I.D., $4; members and children under 12, free. Thurs., 5-9, free.
Programs for Children: For Docent Teen Tours, call (617) 927-6607.
Hours: Wed-Sun., 12-5; Thurs., until 9 p.m. Closed Mon.-Tues., holidays.
Tours: During gallery hours. Call (617) 266-5152.
Museum Shop: Books and videos related to current exhibitions. Open daily, 9-5, Thurs. until 9 p.m.

Museum of Fine Arts, Boston

465 Huntington Ave., Boston, MA 02115
(617) 267-9300
http://www.mfa.org

1999 Exhibitions

Thru January 10
French Prints from the Musketeers
Examines printmaking and society in 17th-century France, featuring 125 prints by major and lesser-known artists.

Thru May
Beyond the Screen: Chinese Furniture of the 16th and 17th Centuries
Showcases Ming period Chinese furniture in decorative period rooms.

February 14-May 9
Mary Cassatt
Comprehensive survey of paintings, pastels, drawings, and prints by innovative American artist and patron Mary Cassatt (1844-1926), best known for her association with the French Impressionists. Catalogue. (T)

April 2-June 6
Ancient Gold: The Wealth of the Thracians, Treasures from the Republic of Bulgaria
Over 200 masterpieces of gold and silver metalwork from ancient Thrace, located in central Europe between 4,000 B.C. and the 4th century A.D. (T)

June 23-September 26
John Singer Sargent
Major survey of prolific American painter John Singer Sargent (1856-1925), known for his astute and elegant society portraits. More than 100 paintings and watercolors include portraits, landscapes, and figure sketches. Catalogue. (T)

Permanent Collection
Extensive holdings include Egyptian and Classical works; Asian and Islamic art including Chinese export porcelain; Peruvian and Coptic textiles, costumes; French and Flemish tapestries; European and American paintings, decorative arts; ship models; ancient musical instruments. **Highlights:** *Bust of Prince Ankh-haf*; *Minoan Snake Goddess*; *Greek Head of Aphrodite*; Cassatt, *Five o'clock Tea*; Chen Rong, *Nine Dragon Scroll;* Copley, *Mrs. Samuel Quincy*; Duccio, *Crucifixion*; Monet, *Haystack* series; O'Keeffe, *White Rose with Larkspur No. 2;* Picasso, *Rape of the Sabine Women;* Renoir, *Le Bal à Bougival*; Revere, *Liberty Bowl;* Sargent, *The Daughters of Edward D. Boit;* Turner, *The Slave Ship;* Velázquez, *Don Balthasar Carlos and His Dwarf;* Warhol, *Red Disaster.* **Architecture:** 1909 building by Guy Lowell; 1915 Evans Wing; 1928 White Wing by Stubbins; 1981 West Wing by I. M. Pei.

Admission: Adults, $10; seniors, college students, $8; children 17 and under, free. Thurs. and Fri. after 5, $2; Wed. 4-closing, free. Handicapped accessible.
Hours: Mon., Tues., 10-4:45; Wed.-Fri., 10-9:45; Sat.-Sun., 10-5:45.
Programs for Children: Offers workshops, classes, and other programs.
Tours: For adults and college students, available by appointment call (617) 369-3368. Admission discount available. School and youth groups tours also available by appointment, call (617)369-3310.
Food & Drink: Cafeteria open Tues., Sat.-Sun., 10-4; Wed.-Fri., 10-8. Fine Arts Restaurant open Tues.-Sun., 11:30-2:30; Wed.-Fri., 11:30-2:30 and 5:30-8:30. Galleria Café open Tues., Sat.-Sun., 10-4; Wed.-Fri., 10-9:30; Sun., 10-5.

Harvard University Art Museums
Busch-Reisinger Museum
32 Quincy St., Cambridge, MA 02138
(617) 495-9400
http://www.artmuseums.harvard.edu

1999 Exhibitions
Thru January 10
A Laboratory of Modernity: Aspects of Art in Weimar Germany
Forty photographic works dating from the Weimar period (1919-1933)
including abstract photograms, figurative studies and photomontages.

February 13-April 25
W.O. Schulze ("WOLS") Photographs
Features photographs dating from the 1930s by a German artist who rose to
fame in post-1945 Europe as the founder of *Informel* painting.

May 22-August 1
Multiple Configurations: Presenting the Contemporary Portfolio
Explores the different ways of presenting an artist's collection of works in a
museum setting, featuring the entire contents of six multi-media portfolios
by members of the Fluxus art movement.

Permanent Collection
Specializes in art of German-speaking Europe: 16th-century painting; late
medieval, Renaissance, Baroque sculpture; 18th-century porcelain from
Germany, Austria, the Low Countries; 20th-century art. **Architecture:**
1921 building by Bestelmeyer; 1991 building by Gwathmey, Siegel, and
Associates.

Fogg Art Museum
32 Quincy St., Cambridge, MA 02138
(617) 495-9400

1999 Exhibitions
Ongoing
The Art of Identity: African Sculpture from the Teel Collection
Examines the complexity of Sub-Saharan African art traditions through
diverse representations of identity.

Gian Lorenzo Bernini: Sketches in Clay
A selection of 14 terracotta studies by the great Baroque sculptor, acquired
by the museum in 1937.

January 23-April 11
*Building Respresentation: Photography and Architecture, Contemporary
Interactions*
Selected works by contemporary artists investigate the conceptual
foundation of photography through the visual language of architecture.

March 6-May 16
Ellsworth Kelly: The Early Drawings, 1948-1955
Approximately 220 drawings, many never before exhibited, trace the development of Kelly's abstract aesthetic. Catalogue. (T)

May 8-July 18
Death by Hogarth
Explores the seeming incongruities of pleasure gardens and gallows in eighteenth-century London life as seen in Hogarth's dramatic images, including three different interpretations of the verb "to execute."

June 10-September 5
Sargent in the Studio
Features drawings, sketch books, and oil sketches by major American artist John Singer Sargent (1856-1925).

Permanent Collection
Masterpieces of Western painting, sculpture, graphic art.
Highlights: Rembrandt; Fra Angelico, *Crucifixion*; Van Gogh, *Self-Portrait*; Ingres, *Odalisque*; Monet, *Gare Saint-Lazare*; Picasso, *Mother and Child*; Poussin, *Infant Bacchus Entrusted to the Nymphs*; Renoir, *Seated Bather*. **Architecture:** 1927 Neo-Georgian exterior by Coolidge Bulfinch & Abbott; Italianate courtyard.

John Singer Sargent, *Female Head in Profile*, c. 1890-1916. Gift of Mrs. Frances Ormond. From *Sargent in the Studio*. Photo courtesy Harvard University Art Museums.

The Arthur M. Sackler Museum
485 Broadway, Cambridge, MA 02138
(617) 495-9400

1999 Exhibitions
Ongoing
Wall Drawing #830: Four Isometric Figures with Color Ink Washes Superimposed
Features a major wall drawing by American conceptual artist Sol LeWitt.

Selections from the Nelson Goodman Collection of Ancient Art
Artifacts dating from ancient Sumer to end of the Byzantine empire include stone and bronze sculpture, jewelry, and tools.

Thru January 3
Symbol and Substance: The Elaine Ehrenkranz Collection of Japanese Lacquer Boxes
Highlights an important collection of 56 Japanese lacquers dating from the 15th through 19th century, acquired by the museum in 1996. Catalogue.

Thru January 31
Mastery and Elegance: Two Centuries of French Drawings from the Collection of Jeffrey Horvitz
A selection of 115 works from the early 17th to late 18th century by approximately 70 French artists, including remarkable drawings by Watteau, Fragonard, and David. Catalogue.

March 6-May 16
Ellsworth Kelly: The Early Drawings, 1948-1955
Approximately 220 drawings, many never before exhibited, trace the development of Kelly's abstract aesthetic. Catalogue. (T)

October 9, 1999-January 2, 2000
Letters in Gold: Ottoman Calligraphy from the Sakip Sabanci Collection
A Grand Legacy: Arts of the Ottoman Empire

Permanent Collection
Renowned collections of ancient Chinese art, Japanese prints, Indian and Islamic paintings, Greek and classical sculpture, Roman coins; Oriental carpets. **Highlights:** Chinese jades, cave reliefs, bronzes; Japanese woodblock prints; Persian paintings, calligraphy. **Architecture:** 1985 building by James Stirling.

All Three Museums:
Admission: Adults, $5; seniors, $4; non-Harvard students, $3; age 18 and under, Sat., 10-12, Wed., free. Handicapped accessible, including wheelchair-accessible entrances; hearing assists; sign interpreters upon request (with reservation).
Hours: Mon.-Sat., 10-5. Sun., 1-5. Closed holidays.
Tours: Daily, Mon.-Fri. Call (617) 496-8576 for information.
Museum Shop: Two small shops in the Fogg Museum courtyard and one at the Sackler Museum. Speciality in Harvard publications and educational art history books. Offer reproductions and gifts inspired by the collection.

Smith College Museum of Art
Elm Street at Bedford Terrace, Northampton, MA 01063
(413) 585-2760

1999 Exhibitions
Thru March 14
A Renaissance Treasury: The Flagg Collection of European Decorative Arts and Sculpture
This exhibition features 70 precious objects dating from the 14th to the early 18th century from the private collection of Richard and Erna Flagg. (T)

April 1-May 30
Idea<>Form: Looking at the Creative Process
10 faculty members create work that explores how artists find inspiration.

May 1-September 5
Dwight W. Tryon
Celebrates the 150th anniversary of the artist and museum founder's birth with an exhibition of his paintings of landscapes and seascapes.

Permanent Collection
Emphasis on 18th- to 20th-century French and American works in all media. **Highlights:** Late Roman head of Emperor Gallienus; Bouts, *Portrait of a Young Man*; Courbet, *La Toilette de la Mariée*; Degas, *Jephthah's Daughter*; Eakins, *Mrs. Edith Mahon*; Elmer, *Mourning Picture*; Kirchner, *Dodo and her Brother*; Lehmbruck, *Torso of the Pensive Woman*; Picasso, *Table, Guitar, and Bottle*; Rembrandt, *The Three Crosses*; Rodin, *Walking Man*; Sheeler, *Rolling Power*; Terbrugghen, *Old Man Writing by Candlelight*. **Architecture:** 1973 building by John Andrews/Anderson/ Baldwin.

Admission: Free. Handicapped accessible, including parking; wheelchairs, assisted-listening devices, and signed tours available (2 weeks notice).
Hours: Sept.-June: Tues., Wed., Fri., Sat., 9:30-4; Sun., 12-4; Thurs., 12-8. July-Aug.: Tues.-Sun., 12-4. Closed Mon., Jan. 1, July 4, Thanksgiving, Dec. 24-Jan. 1
Tours: Groups call (413) 585-2760 for information and reservations.
Museum Shop: Open during museum hours.

Springfield Museum of Fine Arts

220 State St., Springfield, MA 01103
(413) 263-6800
http://www.spfldlibmus.org

1999 Exhibitions
Thru January 3
The Stories Woven In: Navajo Weaving in a Storytelling Context
Viewed from the perspective of an ongoing oral tradition, a selection of 45 rugs is presented with attention to their cultural significance and design.

Patty Hawkins, *Beyond the Blue Horizon*, 1990. From *Crossing Boundaries: Contemporary Art Quilts*. Photo courtesy Springfield Museum of Fine Arts.

February 28-April 18
Crossing Boundaries: Contemporary Art Quilts
39 textile artists incorporate techniques and materials from such media as painting, photography, and printmaking into their quilts.

March 6-May 16
American Glass: Masters of the Art
An exhibition of works by some of the foremost contemporary artists working in glass. (T)

July 7-August 22
Treasures of Deceit: Archaeology and the Forger's Craft
Organized by the Nelson-Atkins Museum of Art, this exhibition explores how art historians and scientists determine whether a work of art is a genuine antiquity or a forgery. (T)

September 15-October 31
Art Scene: John Roy
An exhibition that traces Roy's evolution as an artist from his realist style of the 1960s to his recent pointillist paintings.

November 14, 1999-January 9, 2000
On the Road with Thomas Hart Benton: Images of a Changing America
77 of the artist's paintings and drawings from his travels during the 1920s and 30s. These works document America's transition from a rural nation to an industrialized world power. (T)

Permanent Collection

American paintings from the 18th to 20th centuries; European paintings from the 14th to the 20th centuries; works by Canaletto, Degas, Bonnard, Brueghel the Elder, Géricault, Pissarro, and others. **Highlights:** Erastus Salisbury Field, *Historical Monument of the American Republic;* Homer, *The New Novel*; Monet, *Haystack.* **George Walter Vincent Smith Art Museum:** 19th-century American paintings, Japanese decorative arts, and Islamic textiles. **Highlights:** Shinto shrine; ancient and Renaissance sculpture. **Architecture:** 1896 Neoclassical palazzo.

Admission: Adults, $4; children 6–18, $1; children under 6, free. Handicapped accessible, including elevator to all floors.
Hours: Wed.–Sun., noon–4. Closed Mon.–Tues., Jan. 1, July 4, Thanksgiving, Dec. 25.
Programs for Children: Sat. and afternoon classes, summer art camp, school programs, and afternoon family programs. Call museum for details.
Tours: Call (413) 263-6800, ext. 472, for information.
Museum Shop: Offers unique ceramics, glassware, and jewelry.

Davis Museum and Cultural Center

106 Central Street, Wellesley College, Wellesley, MA 02481
(781) 283-2051

1999 Exhibitions

Continuing

Sol Lewitt Wall Installation: Process and Product
Visitors are allowed to watch as students and Lewitt assistants execute a
full-scale wall drawing, which is part diagram, part sketch, and part fresco.

African Art In/Out of Context
Examines the ways to represent African art from a non-Western approach to
art history, culture, society, and education.

Spring

Mexico City: 1941: Photographs by Helen Levitt
A selection of Levitt's photographs documenting street life in Mexico City
in the early years of World War II.

Inspired by the Collection
Triennial faculty exhibition, including recent works that respond to objects
in the museum's permanent collection.

Reinstallation of the Meso-American Collection
A selection of objects representing the Olmec, Teotihuacan, Zapotec, Maya,
Classic Veracruz, and Aztec cultures of Meso-America.

Autumn

Sending Charcoal in Snowy Weather
Compelling photographs by contemporary rural Chinese women,
documenting their daily activities and conditions of work and health.

Divine Mirrors: The Madonna Unveiled
Examines the changing status and representation of women through
depictions of the Virgin Mary from all time periods, in diverse media.

Salem Mekuria
Solo exhibition of video work by Art Department professor and noted
filmmaker Salem Mekuria.

Permanent Collection

Includes Greek and Roman, Meso-American, Asiatic, African, and medieval
objects, Renaissance and Baroque paintings and sculpture, 19th century
French sculpture, early modernist works, vintage and contemporary
photographs, and contemporary paintings and sculpture. **Architecture:**
1993 building featuring a central stair that scissors back and forth allowing
views to galleries, by acclaimed Spanish architect, Jose Rafael Moneo.

Admission: Free. Handicapped accessible.
Hours: Tues., Fri., Sat., 11-5; Wed., Thurs., 11-8; Sun., 1-5. Closed Mon.,
Wed. and Thurs. evenings in January, June, July, and August.
Tours: Call (617) 283-2081.
Food & Drink: Collins Café open for lunch, Mon.-Fri.; new menu daily.
Call (781) 283-3379 for more information.

Sterling and Francine Clark Art Institute

225 South St., Williamstown, MA 01267
(413) 458-9545
http://www.clark.williams.edu

1999 Exhibitions

Thru January 3
Farewell to the Wet Nurse: Etienne Aubry and Images of Breast-Feeding in 18th-Century France
Features two versions of Aubry's *Farewell to the Wet Nurse* with associated prints, drawings, books, and decorative arts and explores the social and metaphorical significance of breast-feeding in 18th-century France.

Charles White: Progress of the American Negro (1939-40)
Detailing the history of African Americans, this mural is one of the most poignant works commissioned during the Works Progress Administration.

Dürer's Apocalypse
In celebration of the 500th anniversary of the landmark woodcut series, this exhibition examines the themes of religious anxiety and instability that appear in Dürer's work.

February 13-May 9
The Painted Sketch: American Impressions from Nature, 1830-1880
Explores the emergence of the oil sketch from the private realm of the artist's studio to the public arena of the exhibition hall and marketplace. Includes works by Cole, Durand, Church, Bierstadt, and Gifford. (T)

June 18-September 5
Jean-François Millet: The Painter's Drawings
An exhibition of pastels, paintings, watercolors, and drawings by the 19th-century French painter. Includes the world-renown work *The Gleaners* and explores the social issues that Millet addressed in his art. (T)

Permanent Collection

Outstanding collection of Old Master paintings, prints, drawings by Piero, Gossaert, Memling, Rembrandt, Ticpolo; distinguished holdings of French 19th-century Impressionist and academic painting and sculpture; work by Barbizon artists Corot, Millet, Troyon; English silver; American works by Cassatt, Homer, Remington, Sargent. **Highlights:** Degas, *Dancing Lesson*; Homer, *Saco Bay, Prout's Neck*; Renoir, *Sleeping Girl with Cat;* Turner, *Rockets and Blue Lights*; Fragonard, *Portrait of a Man (The Warrior);* over 30 works by Renoir. **Architecture:** 1955 building by Daniel Perry; 1973 building by Pietro Belluschi and The Architects Collaborative, with 1996 addition by Ann Beha, Associates; 1963 service building with 1986 addition.

Admission: November 1-June 30, free; July 1-October 31, Wed.-Sun., $5. Members, children under 18, and students with valid I.D., free at all times. Handicapped accessible, including braille signage and tour transcripts for the hearing impaired; wheelchairs available.
Hours: September-June, Tues.-Sun., 10-5. Open daily, July and August. Closed Mon., Jan. 1, Thanksgiving, Dec. 25.
Programs for Children: Children's activity handouts available at Information Desk. Call for special programs.
Tours: July-Aug.: Mon.-Sun., 3. Call for group reservations.
Food & Drink: Snack cart, July-Oct., 10-5; picnic facilities.
Museum Shop: Open during museum hours.

Williams College Museum of Art

Main St., Williamstown, MA 01267
(413) 597-2429
http://williams.edu/WCMA

1999 Exhibitions

Ongoing

An American Identity: Nineteenth-Century American Art from the Permanent Collection
Examines the role the visual arts played in establishing an American national identity in the early years of the new republic. Includes works by Eakins, Harnett, La Farge, Remington, Saint-Gaudens, and Whistler.

Art of Ancient Worlds
A selection of ancient sculptures, vases, and artifacts from Greece, Rome, Egypt, the Near East, and the Americas, from the permanent collection.

Vital Traditions: Old Master Works from the Permanent Collection
A selection of 17 paintings by artists such as Gaurdi, Ribera, and van Ostade highlight the artistic transition from the Renaissance to the Baroque periods.

"Inventing" the Twentieth Century: Selections from the Permanent Collection (1900-1950)
Examines the change in outlook and artistic representation caused by science and technology in the self-consciously "new" world of the early 20th century.

The Edges of Impressionism
Explores the definition of "Impressionism" through approximately 30 paintings and watercolors dating from the 1850s to the 1920s.

Thru January 24

A Sampling of the Eighteenth Century
Portraits, genre scenes, and history paintings from the permanent collection and other institutions document the life and society of the 18th century.

Romare Bearden in Black and White: Photomontage Projections, 1964

Thru February 14

A Leap of Faith: Abstract Art from the Albright-Knox Art Gallery
11 important abstract expressionist works by Lee Bontecou, Herbert Ferber, Robert Motherwell, David Smith, and Clifford Still, among others.

Two Portfolios from the Collection of Sol LeWitt: Robert Ryman and Tim Rollins and the Kids of Survival
Includes 6 aquatints by minimalist Robert Ryman and 14 prints from the *Temptation of St. Anthony* by Tim Rollins and young inner-city artists.

Thru December
Tradition and Transition—African Art from the Brooklyn Museum of Art
Explores African royal and colonial art through postcolonial art collecting, featuring functional objects used in religious or political ceremonial life.

April 17-mid-October
Tony Oursler
Retrospective of popular artist Tony Oursler, who has been working in the field of video art since the 1970s. (T)

May 14-June 6
Senior Studio Majors Show
Annual exhibition of work by graduating studio majors of Williams College.

July 3-September 6
William Wegman: Photographs and Paintings

July 24, 1999-January 2000
The Panama Canal and the Art of Construction
A selection of approximately two dozen paintings, prints, and photographs of canal construction, 1904-1914.

Permanent Collection
Late 18th- to 19th-century American art by Copley, Eakins, Harding, Harnett, Hunt, Inness, Peto, Stuart; early modern works by Demuth, Feininger, Hopper, Marin, O'Keeffe, Prendergast, Wood; contemporary works by de Kooning, Avery, Hofmann, Holzer, Motherwell, Rauschenberg, Warhol; South Asian art including 10th- to 18th-

Maurice Prendergast, *Yacht Race,* c. 1920-23. Bequest of Mrs. Charles Prendergast. Photo courtesy Williams College Museum of Art.

century Indian sculpture, 17th- to 19th-century Mughal paintings. **Highlights:** American modernist painting and sculpture; Cambodian and Indian sculptures; Charles and Maurice Prendergast; Warhol, *Self-Portrait.* **Architecture:** 1846 Classical Revival building by Tefft; 1983 and 1986 additions by Charles Moore.

Admission: Free. Handicapped accessible.
Hours: Tues.-Sat., 10-5; Sun., 1-5. Closed Mon., Jan. 1, Thanksgiving, Dec. 25.
Programs for Children: Call the Education Office (413) 597-2038.
Tours: Call (413) 597-2038 for information and group reservations.
Museum Shop: Offers a fine assortment of Maurice and Charles Prendergast reproductions, exhibition posters, bound journals and sketch books, magnets, cards, unique jewelry, and children's products.

Worcester Art Museum

55 Salisbury St., Worcester, MA 01609
(508) 799-4406
http://www.worcesterart.org

1999 Exhibitions

Thru January 3
Blurring the Boundaries: 25 Years of Installation Art
Three decades of installation art by 20 leading contemporary artists.

Currier and Ives
Approximately 50 lithographs by Currier and Ives provide a glimpse into American society of the early 19th century.

February 27-May 2
Urban Visions
Three international contemporary artists create work that examine issues of social space and urban environment. Catalogue.

March 14-June 27
"All That is Glorious Around Us": Paintings from the Hudson River School
Showcases 65 works that established landscape painting as America's first national art form, with themes of tourism, industrialization, and the land.

April 17-July 4
Terrific Tokyo–A Panorama in Prints from the 1870s to the 1930s
Traces the 60-year evolution of modern Tokyo in 50 woodblock prints.

June 19-September 2
Domesticated
Recent photography of domestic interiors by international artists.

October 16, 1999-January 2, 2000
Alphonse Mucha: The Flowering of Art Nouveau
First comprehensive exhibition of work of Alphonse Mucha in the U.S. since 1921. Features paintings, posters, decorative panels, and pastels in *le style Mucha,* which became synonymous with French Art Nouveau. (T)

Permanent Collection

Fifty centuries of art from East to West, antiquity to the present: Indian, Persian, Japanese, Chinese art; 17th-century Dutch paintings; American 17th- to 19th-century paintings; contemporary art. **Highlights:** Benson, *Portrait of Three Daughters*; Copley, *John Bours*; Hokusai, *The Great Wave at Kanagawa*; del Sarto, *Saint John the Baptist.* **Architecture:** 1898 Neoclassical building by Stephen C. Earle; 1933 addition by William T. Aldrich; 1970 Higgins Wing by the Architects Collaborative; 1983 Hiatt Wing by Irwin A. Regent.

Admission: Adults, $8; seniors, students, $6; children 17 and under, Sat. 10-12, free. Handicapped accessible; parking, wheelchairs and assisted-listening devices available.
Hours: Wed.-Fri., Sun., 11-5; Sat., 10-5. Closed Mon., Tues.
Tours: For group tours call (508) 799-4406, ext. 3061.
Food & Drink: Museum Café open Wed.–Sun., 11:30-2.

University of Michigan Museum of Art

525 S. State St., Ann Arbor, MI 48109
(734) 764-0395
http://www.umich.edu/~umma

1999 Exhibitions

Ongoing
African Arts: Objects of Power, Knowledge, and Mediation
Fascinating and rarely seen objects from the museum's impressive collection of African art.

Thru January 17
Master Drawings from the Worcester Art Museum
An exhibition of one hundred drawings and works on paper dating from 1275 to 1975 which represent major trends of style and content. (T)

Thru January 24
Drawings of Eugene Delacroix
In celebration of the bicentennial of the birth of Delacroix, this exhibition features a small selection of works from the permanent collection.

January 23-March 21
Bill Jacobson Photographs 1992-1998
Haunting and evocative works explore feelings of vulnerability and tentativeness in the age of AIDS.

February 13-May 2
Magdalena Abakanowicz
An installation of sculpture, weavings, and drawings reflects the artist's concern with the human condition.

October 16, 1999-January 2, 2000
Glories of the Middle Kingdom: Masterpieces of Chinese Painting from the University of Michigan Museum of Art
This selection of works from the museum's outstanding collection of Chinese painting features work from the Southern Sung Dynasty (1126-1280) through the Chinese republic of the early 20th century.

Permanent Collection
Close to 14,000 objects, with representative holdings from both the Western, African and Asian traditions. Of special note are its collections of Chinese and Japanese paintings and ceramics; 20th-century sculpture; works of art on paper, including more than 150 etchings and lithographs by J. M. Whistler.
Architecture: Located in the University of Michigan's Alumni Memorial Hall building, a Neo-Classical structure built in 1910.

Admission: Free, donations welcome. Handicapped accessible.
Hours: Tues.-Sat., 10-5; Thurs., 10-9; Sun., 12-5. Summer hours (Memorial Day-Labor Day): Tues.-Sat., 11-5; Thurs., 11-9, Sun., 12-5. Closed Mon., major holidays.
Programs for Children: Family Days throughout the year.
Tours: For free docent-led group tours call (734) 647-2067.
Museum Shop: Jewelry, books, posters, and fine collectibles.

The Detroit Institute of Arts

5200 Woodward Ave., Detroit, MI 48202
(313) 833-7900 (general information); 833-2323 (ticket office)
http://www.dia.org

1999 Exhibitions

Thru January 31
Where the Wild Things Are: *Animals in Ancient Art at the Detroit Institute of Arts*
Explores various ancient Mediterranean and Near East cultures' representations of animals and their meanings. Designed for children and families.

Thru February 7
Prints by Terry Winters: A Retrospective from the Collection of Robert and Susan Sosnick
A mid-career survey of prints based loosely on spores, shells, and fossils.

Thru February 14
A Passion for Glass: The Aviva and Jack A. Robinson Collection
Glass gifts to the museum that range from paperweight size objects to large sculptural works, dating from 1971 and 1995 and representing 57 practitioners of the studio glass movement.

January 27-May 2
Personal Artifacts in the World of the Samurai Warrior
Swords, armor, *inro*, and *netsuke* from the permanent collection.

February 7-April 25
Half Past Autumn: The Art of Gordon Parks
The first retrospective exhibition to synthesize different aspects of Parks's art, his films, books, poetry, and music compositions, with his photojournalism, for which he is best known. (T)

April
Detroit Public Schools Student Exhibition

April 14-June 27
Walker Evans Simple Secrets: Photographs from the Collection of Marian and Benjamin A. Hill
Spanning five decades, the 89 prints in this exhibition range from architectural views and scenes of 1920s New York to purely abstract graffiti of the 1970s and illustrate the complexity of Evans's artistic achievement.

May 19-September 19
Wisdom and Perfection: Lotus Blossoms in Asian Art
The lotus blossom, a symbol of wisdom, purity, and enlightenment, in Chinese, Indian, Southeast Asian, Japanese, and Korean art.

June 27-August 29
Ancient Gold: The Wealth of the Thracians, Treasure from the Republic of Bulgaria
Over 200 masterpieces of gold and silver metalwork from ancient Thrace, located in central Europe between 4000 B.C. and the 4th century A.D. (T)

July 11-September 26
Women Printmakers: Selections from the Permanent Collection

July 25-October 31
Common Man, Mythic Vision: The Paintings of Ben Shahn
Survey of more than 50 works by the 20th-century American artist known for his social realism. (T)

July 25-November 7
Women Photographers: Selections from the Permanent Collection

Permanent Collection

Extensive holdings of African and Native American arts; European and American masterpieces from the Middle Ages to the present; decorative arts; graphic arts; theater arts; textiles; Asian and Near Eastern art; 20th-century decorative arts; period rooms. **Highlights:** Brueghel, *Wedding Dance*; Caravaggio, *Conversion of the Magdalen;* Degas, *Violinist and Young Woman;* van Eyck, *Saint Jerome in His Study;* Picasso, *Bather by the Sea;* Rembrandt, *The Visitation;* Van Gogh, *Self-Portrait;* Whistler, *Arrangement in Gray: Portrait of the Painter* and *Nocturne in Black and Gold: The Falling Rocket;* Rachel Ruysch, *Flowers in a Glass Vase on a Marble Ledge;* German Expressionist paintings by Kirchner, Klee, Nolde; courtyard with Rivera's *Detroit Industry* fresco. **Architecture:** 1927 Italianate building by Paul Cret; two wings, 1966 and 1971, designed by Harley, Ellington, Cowin & Stirton. Michael Graves chosen in 1989 as Master Plan architect for renovation and proposed expansion.

Admission: Adults, $4; children, students, $1. Fees for special exhibitions. Handicapped accessible.
Hours: Wed.-Fri., 11-4; Sat.-Sun., 11-5. Closed Mon.-Tues., holidays.
Tours: Wed.–Sat., 1; Sun., 1, 2:30. For guided group tour reservations call (313) 833-7981.
Food & Drink: Kresge Café open Wed.-Fri., 11-3:30; Sat.-Sun., 11-4:30. Gallery Grill open Wed.-Fri., 11:30-2; Sun., 11-3, closed Sat. Crystal Gallery Café open one hour prior to DFT shows.
Museum Shop: Offers gifts and museum souvenirs; (313) 833-7944.

Grand Rapids Art Museum

155 Division North, Grand Rapids, MI 49503
(616) 459-4677
http://www.gram.mus.mi.us

1999 Exhibitions

Thru January 24
Mathias Alten
Retrospective exhibition of work by this well-known painter who worked in Grand Rapids in the early 1900s.

Thru January 24
Saints and Angels in Art
Paintings, sculpture, and works on paper from the late medieval period to the 19th century.

February 12-February 21
Black Heroes from History
An educational exhibition for children exploring the accomplishments of prominent African Americans.

March 23-May 16
Cover the Bases
Annual artists competition for the West Michigan Whitecaps program cover.

April 16-August 15
Quiet Grandeur: Four Centuries of Dutch Art
A major project consisting of four exhibitions and a children's orientation exhibition.

Van Gogh and His Countrymen: 19th-Century Dutch Watercolors and Drawings from the Museum Boijmans Van Beuningen, Rotterdam
This overview of Dutch art from 1800 to 1900 features 80 of the finest watercolors and drawings from the world-renowned museum. Catalogue. (T)

A Moral Compass: Seventeenth and Eighteenth Century Dutch Master Paintings
Major examples from the golden age of Dutch painting.

Implements of Invention: New Work by Elona Van Gent
This Grand Rapids artist's sculpture, maquettes, and computer drawings reflect traditional issues of Dutch art.

The Holland Suite: A Photographic Exhibition and Portfolio by David Lubbers
A specially commissioned photographic portfolio by Grand Rapids photographer David Lubbers features black-and-white images of the Netherlands.

April 16-December 31
A Touch of Dutch
An interactive exhibition for children highlighting components of Dutch art.

August 17-October 17
Portraits from Life: Photography of Philippe Halsman
A *Life* magazine photographer from the 1940s through the 1970s, Halsman's portraits of Albert Einstein, Marilyn Monroe, and Salvador Dalí have become 20th-century icons. (T)

October 22, 1999-January 2, 2000
Canaletto to Constable: The Great Tradition of English Painting
English Churches Portfolio, Photography of Howard Bond

Permanent Collection

Old Master prints, drawings; American and European paintings, furniture, photographs, sculpture, decorative arts. **Highlights:** Chase, *The Opera Cloak*; Schmidt-Rottluff, *Harvest*; Pechstein, *Reflections*; Diebenkorn, *Ingleside*; Hartigan, *Riviera*; Calder, *Red Rudder in the Air;* Mathias Altens murals, *The Sources of Wealth,* and *The Uses of Wealth;* prints by Vlaminck, Miró, Braque, Matisse, Moore, Picasso; English, French, Italian, Asian furniture from the late 18th century to present; furniture by Nelson, Wright and Eames. **Architecture:** 1910 Beaux Arts Federal Building by James Knox Taylor.

Admission: Adults, $3; seniors, $1.50; students, $1; children 5 and under, members, Thurs., 5-9, free. Handicapped accessible.
Hours: Tues., Sun., 12-4; Wed., Fri., Sat., 10-4; Thurs., 10-9; closed Mon.
Programs for Children: Hands-on interactive gallery and other programs.
Tours: Call (616) 459-4677 for group reservations.

The Minneapolis Institute of Arts

2400 Third Ave. South, Minneapolis, MN 55404
(612) 870-3131; 870-3200 (recording)
http://www.artsMIA.org

1999 Exhibitions

Thru January 3
100 Years of Gund Toys
A small exhibition of Gund toys.

Holiday Traditions in the Period Rooms
The museum's period rooms are decorated to reflect 18th- and 19th-century holiday traditions from the U.S. and Europe.

Thru January 10
The Mechanics of Motion: Photographs by Eadweard Muybridge and Dr. Harold E. Edgerton
Sequential motion photographs by 19th-century scientist Eadweard Muybridge and the early flash photography of Harold E. Edgerton.

Thru January 17
Isn't S/He a Doll? Play and Ritual in African Sculpture
African conceptions of "dolls" challenge the Western notion of them as playthings, featuring 212 sculptures from 24 countries.

Thru February 9
6 Sculptors
Features the work of contemporary sculptors Alan Wadzinski, Jan Elftmann, Bill Klaila, Joy Kops, Rollin Marquette, and Rick Salafia.

Thru March 7
Ancient Gold Jewelry from the Dallas Museum of Art
Over 100 superb examples of Greek, Etruscan, Roman, and Near Eastern gold jewelry dating from the seventh to the first centuries B.C. (T)

February 13-April 25
Roy DeCarava
Surveys 200 works spanning half a century by one of the major figures in
postwar American photography. Includes themes of social awareness,
humanity, and jazz. (T)

April 11-May 30
Francis Bacon: Retrospective
A landmark retrospective of one of 20th-century Britain's greatest painters,
known for his images of isolation, despair, horror, and tortured human
forms. 60 paintings represent each significant period of the artist's career.
Catalogue. (T)

April 28-May 1
Art in Bloom
Area garden clubs create floral arrangements inspired by works from the
museum's collection.

May 15-October 10
Helmut Stern Collection of Central African Art
Features approximately 100 masks, sculptures, and personal adornments,
which demonstrate the influence of Central African art on American artists.

March 27-July 25
Ralph Rapson: Midwest Modernist
An impressive collection of drawings and architectural elements, models,
photographs, furniture, and video installations trace pioneering architect
Ralph Rapson's contributions to the modernist style.

June-October
Recent Accessions 1999
In celebration of the museum's grand re-opening, a selection of notable
acquisitions is on view.

October 9, 1999-January 23, 2000
Portraits of Jeremiah Gurney
Approximately 150 photographs of royalty, celebrities, and everyday people
by one of the most important portrait photographers of the 1850s and 1860s.
Includes daguerreotypes, cartes-de-visite, stereocards, and cabinet cards.

October 24, 1999-January 16, 2000
Chokwe! Art and Initiation of Chokwe and Related Peoples
The first U.S. exhibition featuring the art of the Chokwe and related peoples
of Angola, Zaire, and Zambia. Explores the role of art objects in the
transmission of knowledge. (T)

Permanent Collection

African and Asian art; European and American paintings, prints, drawings,
sculptures, photographs, decorative art; period rooms; American textiles.
Highlights: Chinese bronzes, jades, silks; Greco-Roman Doryphoros;
American and British silver; works by Poussin, Rembrandt, van Gogh,
Degas, Goya, Bonnard; prints, drawings by Goya, Rembrandt, Watteau,
Blake, Ingres, Toulouse-Lautrec, Johns; photography by Stieglitz, Steichen,
Adams; sculpture by Picasso, Brancusi, Calder; nine period rooms.
Architecture: 1915 Neoclassical building by McKim, Mead, & White;

1974 wing by Kenzo Tange; 1998 major renovation by RSP Architects of Minneapolis with expanded exhibition space, brand new galleries, and interactive visitor services.

Admission: Free. Small fee for some exhibitions.
Hours: Tues.-Sat., 10-5; Thurs., 10-9; Sun., noon-5. Closed Mon., July 4, Thanksgiving, Dec. 25.
Tours: Tues.-Sun., 2; Thurs., 7; Sat.-Sun., 1. American Sign Language interpretation first Sun. of month. Call (612) 870-3140 for group tours.
Food & Drink: ArtsCafé Restaurant, open Tues.-Sun., 11:30-2:30. ArtsBreak Coffee Shop, open during museum hours.
Museum Shop: Articles, the new store, open during museum hours.

Minnesota Museum of American Art

Landmark Center Galleries, 75 W. 5th St., St. Paul, MN 55102
(651) 292.4355
http://www.mtn.org/MMAA

1999 Exhibitions
Thru February 14
On the Road with Thomas Hart Benton: Images of a Changing America
77 of the artist's paintings and drawings from his travels during the 1920s and 30s. These works document America's transition from a rural nation to an industrialized world power. (T)

March 7-May 23
Drawing on the Collection
A rare opportunity to view important works on paper by American artists from the museum's collection.

June 13-August 22
Hmong Artistry: Preserving a Culture on Cloth
Decorative textiles, produced by members of the Kansas City Hmong Project Refugee Center, reflecting ancient needlework traditions.

Permanent Collection
Features American paintings, prints, and sculpture by some of the most noted American artists of the late-19th to mid-20th century, including works by Thomas Hart Benton, Joan Brown, Albert Pinkham Ryder, Charles Burchfield, Romare Bearden, Clementine Hunter, Grant Wood, and Donald Sultan. Sculpture by Minnesotans Evelyn Raymond and Paul Manship. Contemporary Midwest works by Francis Yelvo, Patrick DesJarlait, and Hazel Belvo; recent acquisitions include Yi Kai, *Mixture Forever;* Ed Archie Noisecat, *Sea Monster* and *Otter.* **Highlights:** Childe Hassam, *The Pearl Necklace;* Jacob Lawrence, *Procession.* **Architecture:** A magnificent 1906 Richardsonian-Romanesque building, formerly a United States Court of Appeal, restored as Landmark Center; 1997 renovation by architect Joan Soranno and Hammel Green & Abrahamson.

Admission: Free. Handicapped accessible, including ramps, elevators, special tours, and braille signage.
Hours: Tues.–Sat., 11–4; Thurs. 11–7:30; Sun., 12–5. Closed Mon.
Programs for Children: Offers a full range of educational programs for students K-6. Special tours for young people by appointment.
Tours: Call (518) 292-4367 for information. Special tours for hearing impaired or blind may be arranged in advance.
Food & Drink: Lunch restaurant open Mon.-Fri.
Museum Shop: Catalogues and museum publications are available for sale at the visitors services desk during regular museum hours.

Walker Art Center

Vineland Place, Minneapolis, MN 55403
(612) 375-7622; 375-7585 [TDD]
http://www.walkerart.org

Claes Oldenburg and Coosje van Bruggen, *Spoonbridge and Cherry,* 1985-1988. Gift of Frederick R. Weisman in honor of William and Mary Weisman. Photo courtesy Walker Art Center.

1999 Exhibitions
Thru January 20
Unfinished History

Thru March 7
Love Forever: Yayoi Kusama, 1958–1968
Includes 80 installations, paintings, and other works by this post-minimalist Japanese artist, dating from her most influential years.

Thru April 4
Selections from the Permanent Collection
Presents a fresh look at art history, including works by Johns, Nevelson, Warhol, and lesser-known, emerging artists.

February 14-May 9
Robert Gober: Sculpture and Drawing
Over 100 drawings trace the psychological and formal roots of the artist's compelling sculptural work.

June 13-September 5
Edward Ruscha: Editions 1962-1999
The first major retrospective of Ruscha's prints since the 1970s.

June 15-September 5
Wing Young Huie: Lake Street Project
Photographer Wing Young Huie's 2-year documentation of the diverse communities that stretch along Lake Street in Minneapolis.

July 18-October 10
Matthew Barney: Cremaster 2
In his ongoing installation series, Barney explores the life and motivations of convicted killer Gary Gilmore.

August 8-November 14
Andy Warhol Drawings: 1942-1986
Retrospective of the least-studied area of Warhol's career, consisting of over 200 drawings and focusing on the artist's work from the 1950s and 1960s.

October 10, 1999-January 2, 2000
2000 B.C.: The Bruce Conner Story Part II
Explores Conner's lifelong fascination with light, which he expresses in his
film, painting, drawing, sculpture, collage, printmaking, and photography.

Permanent Collection
Primarily 20th-century art of all major movements; over 11-acre outdoor
sculpture garden containing works by modern and contemporary artists.
Highlights: Johns, *Green Angel*; Marc, *The Large Blue Horses*; works by
O'Keeffe, Nam June Paik, Rothko; Warhol, *16 Jackies*; Minneapolis
Sculpture Garden: 40 works by established 20th-century masters and by
leading contemporary artists. **Architecture:** 1971 building, 1983 addition,
and 1988 Minneapolis Sculpture Garden by Barnes; 1992 expansion by
Michael van Valkenburgh Associates, Inc.

Admission: Adults, $4; students with I.D., youth 12–18, groups of 10 or
more, seniors, $3 per person; members, children under 12, free. Thurs., first
Sat. of each month, free. Sculpture Garden free. Handicapped accessible.
Signed interpretation, touch tours, and wheelchairs available. Please call
ahead.
Hours: Tues., Weds., Fri., Sat., 10–5; Thurs., 10–8; Sun., 11–5. Closed
Mon., major holidays. Sculpture Garden: 6 am–midnight.
Programs for Children: Sunday Fun Workshops, Weekday Play, Art Lab,
Free First Saturdays.
Tours: Thurs., 2, 6; Sat.–Sun., 2. Groups call (612) 375-7609.
Food & Drink: Gallery 8 Restaurant open Tues.–Sun., 11:30–3.
Museum Shop: Open during museum hours.

Mississippi Museum of Art

201 E. Pascagoula St., Jackson, MS 39201
(601) 960-1515
http://www.msmuseumart.org

1999 Exhibitions

Thru January 10
Mississippi Watercolor Society Grand National Watercolor Exhibition
Annual presentation of watercolors by artists across the U.S.

Thru January 17
Light of the Spirit: Portraits of Southern Outsider Artists
Portraits by Georgia-based photographer Karekin Goekjian of artists from
across the Southern United States.

Irwin Kremen: Collages
Intimate, lyrical collages the North Carolina-based artist reveal the artist's
personal exploration into form, shape, color, and texture.

Thru January 31
*Craft is a Verb: Selections from the Collection of the American Craft
Museum*
Outstanding examples of contemporary crafts in all media.

January 16-February 14
Mississippi Regional Scholastic Art Awards
Annual presentation of works by elementary and highschool students.

January 23-March 14
Work in Progress: Lesley Dill
Part of an exhibition series that examines the creative process by focusing on Dill's evolving and unfinished works.

Recent Acquisitions of Contemporary Art
Gifts and purchases in diverse media from the museum's rapidly growing contemporary collection.

February 13-April 18
Mississippi Invitational
A selection of work by Mississippi artists.

May 1-July 4
Bats and Bowls: A Celebration of Lathe-Turned Art
A selection of turned wooden objects by contemporary woodturners.

July 10-August 22
Large Drawings from the Collection of the Arkansas Art Center Foundation
An exhibition of large-scale drawings by contemporary artists explore various approaches taken today.

September 4-October 31
Mississippi: The Nineteenth Century
Paintings, works on paper, sculptures, and photographs created in and about 19th-century Mississippi are assembled together for the first time.

November 13, 1999-February 6, 2000
Crossing the Threshold
A celebration of the art of elderly women artists working with various issues, themes, and media.

Permanent Collection
More than 3,100 works of art spanning thousands of years of art history. The MMA is home to the world's largest collection of art by and relating to Mississippians and their culturally diverse heritage. Its collections are also notably strong in 19th and 20th century American landscape paintings, 18th century British paintings and furniture, Japanese prints, pre-Columbian ceramics, and Oceanic art. **Highlights:** Collection Gallery. **Architecture:** Building opened in 1978; includes galleries, sculpture garden, research library, and art school.

Admission: Adults, $5; seniors 60+, college students, $3; children 6-18, $2; members, children under 6, free. Handicapped accessible.
Hours: Mon.-Sat., 10-5; Sun., 12-5; Tues. 10-8. Closed major holidays.
Programs for Children: Offers programs and special tours year-round.
Tours: Please contact the Education Department for information.
Food & Drink: Palette Restaurant offers gourmet dining, light music, and a seasonal menu. Open Mon.-Fri., 11-1.
Museum Shop: Offers handmade gifts by local artists, paper products, t-shirts, jewelry, children's toys. Open Mon., 11-2; Tues.-Fri., 10-4; Sat., 12-4; Sun., 1-4.

The Nelson-Atkins Museum of Art

4525 Oak St., Kansas City, MO 64111
(816) 561-4000; (816) 751-1ART (recording); (816) 751-1263 [TDD]
http://www.nelson-atkins.org

1999 Exhibitions

Thru March 28
Ursula von Rydingsvard
Sculptural work by the internationally known German artist. (T)

March 28-June 6
Copper as Canvas: Two Centuries of Masterpiece Paintings on Copper, 1525-1775
Highlights the practice of painting on copper, featuring 75 to 100 of the most spectacular and best-preserved examples of works by masters. (T)

Permanent Collection

European and American paintings, sculptures, prints, decorative arts; American, Indian, Oceanic, pre-Columbian art; renowned collection of Asian art; modern sculpture. **Highlights:** Largest permanent U.S. display of Bentons; Bingham, *Canvassing for a Vote;* Caravaggio, *Saint John the Baptist;* Guercino, *Saint Luke Displaying a Painting of the Virgin;* de Kooning, *Woman IV;* Kansas City Sculpture Park; Oldenburg and van Bruggen, *Shuttlecocks;* Poussin, *The Triumph of Bacchus;* Rembrandt, *Youth with a Black Cap;* Renoir, *The Large Bather.* **Architecture:** 1933 Neoclassical building, designed by Thomas and William Wight.

Admission: Adults, $5; students with ID, $2; children 6-18, $1; children under 5, free. Sat., free to all. Handicapped accessible; elevators and wheelchairs available.
Hours: Tues.-Thurs., 10-4; Fri., 10-9; Sat., 10-5; Sun., 1-5. Closed Mon., Jan. 1, July 4, Thanksgiving, Dec. 24-25.
Programs for Children: Classes, tours, and more. Call the Creative Arts Center at (816) 751-1236 for information.
Tours: Tues.-Sat., 10:30, 11, 1, 2; Sun., 1:30, 2, 2:30, 3. To schedule school tours, call (816) 751-1238.
Food & Drink: Gorgeous enclosed courtyard restaurant, Rozzelle Court open Tues.-Thurs., 11-3; Fri., 11-3 and 5-8; Sat., 11-3; Sun., 1-3.
Museum Shop: Offers and extensive collection of art and design books, children's books, magazines, cards, exhibition catalogues, and unique gift items.

The Saint Louis Art Museum

One Fine Arts Drive, Forest Park, St. Louis, MO 63110
(314) 721-0072
http://www.slam.org

1999 Exhibitions

February 6-May 9
Max Beckmann in Paris
A look at Max Beckmann's relationship to his contemporaries, including Braque, Delaunay, Léger, Matisse, Picasso, and Rouault, through 100 paintings from public and private collections. (T)

June 19-August 15
Early American Decorative Arts from St. Louis Collections
Features American furniture, silver, textiles, and decorative arts dating from 1700 to 1820.

Contemporary Japanese Textiles
Focuses on 20 influential artists who use a variety of techniques to create some of the most innovative and beautiful contemporary textiles. (T)

Permanent Collection

Encompasses art of many periods, styles, and cultures: African, Asian, Oceanic, American Indian, Pre-Columbian art; European Old Master paintings, drawings; American art from colonial times to the present; French Impressionism, Post-Impressionism, German Expressionism; 20th-century European art; decorative arts, including six period rooms.
Highlights: Chagall, *Temptation*; Fantin-Latour, *The Two Sisters*; van Goyen, *Skating on the Ice near Dordrecht*; Smith, *Cubi XIV*; Vasari, *Judith and Holofernes*; Stella, *Marriage of Reason and Squalor*; Kiefer, *Breaking of the Vessels*; world's largest Max Beckmann collection.
Architecture: 1904 building by Gilbert for World's Fair; 1977 renovation by Hardy Holzman Pfeiffer Associates; 1980 South Wing by Howard, Needles, Tammen, and Bergendorff; 1988 West Wing renovation by SMP/Smith-Entzeroth.

Admission: Free. Entrance fee for special exhibitions: Adults, $5; seniors and students, $4; children 6-12, $3; Tues., free. Members, free. Handicapped accessible; wheelchairs available.
Hours: Tues., 1:30–8:30; Wed.-Sun., 10-5. Closed Mon., Jan. 1, Thanksgiving, Dec. 25.
Tours: Thirty-minute tour, Wed.–Fri., 1:30; hour tour, Sat.–Sun., 1:30.

Yellowstone Art Museum

410 N. 27th St., Billings, MT 59101
(406) 256-6804
http://www.yellowstone.artmuseum.com

1999 Exhibitions

March 12-April 4
Recent Acquisitions and Loans
Major works by Theodore Waddell, Jaune Quick-to-See Smith, Deborah Butterfield, Dennis Voss, Freeman Butts, and other regional artists.

March 12-May 23
Focus Anne Appleby
Luminous paintings offer a profound and intimate vision of the natural world and Montana landscape.

April 9-May 23
Roy DeForest/Gaylen Hansen
Examines the work of the West's legendary storytelling artists, whose paintings elaborate on the region's fabulous mythological traditions.

May 29-July 25
Clarice Dreyer
Through her cast aluminum sculptural work, Dreyer conveys a love of nature and gardening.

August-September
Mario Reis, Natural Watercolors
An ambitious project to document the rivers of the West by the German conceptual artist.

September-October
Ken Little
Sculptural works that range from suits made of dollar bills to compact suburban houses covered with Bible pages to animal figures from old shoes.

Richard Notkin
Technically masterful, symbol-laden works express Notkin's deeply personal views of life and art.

November-December
Jaune Quick-to-See Smith
Smith explodes myths about Native Americans that abound in mainstream culture through her powerfully satirical mixed-media works.

Permanent Collection
Nearly 2,000 objects, in a variety of media, highlighting contemporary and regional art. Artists include Rudy Autio, Russell Chatham, Clarice Dreyer, Churck Forsman, Will James, Jaune Quick-to-See Smith, and Bill Stockton. **Highlights:** John Buck/Deborah Butterfield, *Collaboration.* **Architecture:** Turn-of-the-century brick building, the former Yellowstone County Jail, renovated in 1964. Two new wings designed by architect Thomas Hacker, completed in early 1998.

Admission: Adults, $3; seniors, $2; children, $1. Handicapped accessible.
Hours: Tues.-Sun., 10-5; Thurs., 10-8.
Programs for Children: Educational studio offers art classes for children; free Family Fun days; summer camp; Teen Ambassador program offers volunteer opportunities for youth.
Tours: Group tours available; call (406) 256-6804 for reservations.
Museum Shop: From pottery to playthings, the Museum Store offers a wide variety of art-related gifts, mementos, and specialty items.

Sheldon Memorial Art Gallery and Sculpture Garden

University of Nebraska, 12th and R Sts., Lincoln, NE 68588-0300
(402) 472-2461
http://sheldon.unl.edu

1999 Exhibitions

Thru January 17
Working with the Grain: Wooden Bowls and Boxes
Features the art of woodturning.

Thru February 7
Pablo Picasso and Peers
Graphics and ceramics by Picasso, Braque, Metzinger, Gris, and Duchamp.

Thru February 14
Icons of Public Memory: Photographs from the Collection of the College of Journalism
A selection of 80 photojournalism images of the nearly 500 donated to the permanent collection.

Thru March 14
Selected Acquisitions in Photography and Prints
Recent acquisitions, including work by William Burroughs, Jim Dine, Starn Twins, and Louis Gonzalez Palma.

January 19-March 28
UNL Studio Faculty Exhibition
Biennial exhibition showcasing recent work of studio faculty.

February 9-March 21
Robert Rauschenberg
10 works from the permanent collection that reflect the artist's creative use of assemblage, collage, silkscreen, lithography, and photo transfer.

March 19-June 27
Fletcher Benton: New Constructivism
40 recent works including freestanding and pedestal sculpture, new wall reliefs, and recent paintings.

March 23-June 13
Larry Schwarm: Prairie Fire
Photographs of prairie landscape fires.

Jam: C. S. Wilson and John Gierlach
Original story board illustrations for underground comics.

June 15-August 22
Charles Rain: Magic Realism
Highly detailed paintings and shadow boxes.

June 30-September 19
*The Flag in American Art
from the Sheldon Memorial
Art Gallery Collection*
Depictions of the American
flag from the museum's
collection to complement *The
Flag in American Art.*

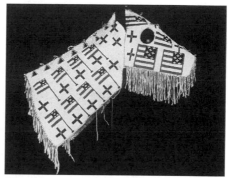

July 3-August 29
*The Flag in American Indian
Art*
Works from the late 19th to
early 20th century illustrate
how the Lakota, Navajo,
Kiowa, and other Native
artists recast the traditional
patriotic symbol to express their own heritage. (T)

Horse Mask, Lakota, c. 1900. From *The Flag in American Indian
Art.* Photo courtesy Sheldon Memorial Gallery.

September 1, 1999-January 2, 2000
Black Image and Identity: African American Art
Use of social/political imagery by African-American artists.

September 24, 1999-January 2, 2000
Robert Colescott: Recent Paintings, 47th Venice Biennale
Recent works by the first African-American artist to be included in the
prestigious Venice Biennale exhibition. (T)

Permanent Collection

Prominent holdings of American art from the 18th century to the present,
with an emphasis on the 20th century, including paintings, sculpture, prints,
photographs, ceramic, and decorative arts. American Impressionism, early
modernism, geometric abstraction, Abstract Expressionism, Pop,
Minimalism, and contemporary art represented. **Highlights:** Outdoor
Sculpture Garden, featuring 34 works by Lipchitz, Smith, Serra, Oldenburg,
and others. **Architecture:** 1963 Italian travertine marble building by Philip
Johnson. Fund-raising campaign for new expansion is currently in progress.

Admission: Donation suggested. Handicapped accessible, including
elevators; guide animals permitted.
Hours: Tues.-Sat., 10-5; Thurs.-Sat. 7-9; Sun., 2-9. Closed Mon., major
holidays.
Programs for Children: Annual public school tours; annual family day.
Tours: Call (402) 472-2461 for reservations (2 weeks in advance).
Food & Drink: Picnic areas available in campus-wide sculpture garden.
Museum Shop: Notecards, posters, books, and catalogues related to the
gallery's collection and unique crafts, gifts, and jewelry. Open Tues.-Sat.,
10-5; Sun., 2-5..

Joslyn Art Museum

2200 Dodge St., Omaha, NE 68102
(402) 342-3300
http://www.joslyn.org

1999 Exhibitions

Thru January 3
Elihu Vedder's Drawings for the Rubáiyát *from the National Museum of American Art*
Showcases 54 of Vedder's drawings for an 1884 publication of *Rubáiyát,* which attempted to prove the futility of mathematics, science, and religion in determining the meaning of life.

Thru January 10
Images of the Floating World: Japanese Prints from the Collection of the Joslyn Art Museum
19th- and 20th-century woodblock prints depict the lifestyles of popular actors, beauties, and bon vivants of the Edo period.

Thru January 17
Allure of the Exotic
Explores the fascination with foreign cultures and peoples through art, ranging from early, fanciful depictions of American natives to 19th-century photographs by Baron Gros of Spanish Islamic architecture.

Thru January 31
20/21: José Bedia
Part of a series highlighting rising contemporary artists, this exhibition focuses on Bedia's paintings and installations that evoke his Cuban heritage and spiritual guidance from Tibetan monks and Lakota and Sioux elders.

Thru September 5
Show Me a Story
An installation exploring the ways that art presents or implies a narrative. Includes illustrations for *The Jungle Book* and renderings of Indian battles.

January 23-April 18
Dali's Mustache: A Photographic Interview by Salvador Dali and Philippe Halsman
31 photographs from this photographic series on Dali's mustache demonstrate a "witty and often absurd verbal photographic exchange."

March 27-July 25
Searching for Ancient Egypt: Art, Architecture, and Artifacts from the University of Pennsylvania Museum
A spectacular assemblage of objects from 3,000 years of Egyptian art, including statuary, jewelry, ceramics, funerary objects, and a carved and painted wall from a 5th Dynasty (2415-2300 B.C.) tomb chapel. (T)

May 1-June 27
Modotti and Weston: Mexicanidad
Photographs from the mid-1920s document the period that Modotti and Weston lived and worked in Mexico. 65 vintage gelatin silver prints. (T)

July 17-October 24
Recent Acquisitions: Works on Paper
Works by Jacques Tissot, Duane Michaels, and Zig Jackson are among the recent acquisitions of the Joslyn Art Museum.

October 23, 1999-January 9, 2000
The Great American Pop Art Store: Multiples of the Sixties
Celebrates the delightful and witty world of Pop Art multiples and its influence on later object design, featuring 100 pieces by Jim Dine, Jasper Johns, Andy Warhol, and others. Catalogue. (T)

November 6, 1999-January 9, 2000
Deck the Halls: Holiday Photography by Roger Mertin and Christina Patoski
Two artists focus on the visual phenomenon of Christmas decorations both inside and outside the home and in public spaces.

November 20, 1999-January 30, 2000
Soul of Africa: African Art from the Han Coray Collection
More than 200 outstanding works from Central and West Africa assembled between 1916 and 1928, including masks, sculptures, and objects. (T)

Permanent Collection

Works from antiquity to the present; major holdings of 19th- and 20th-century European and American art; Native American art; works by artist-explorers Bodmer, Catlin, Miller, Remington, documenting the movement to the American West. **Highlights:** Degas, *Little Dancer, Fourteen Years Old*; Pollock, *Galaxy*; Renoir, *Young Girls at the Piano*; Segal, *Times Square at Night*; Titian, *Man with a Falcon*; Monet, *Small Farm at Bordighera*; Storz Fountain Court. **Architecture:** Art Deco building, clad in Georgia Pink marble, by John and Alan McDonald opened in 1931. 1994 renovation and expansion, including a glass atrium which joins the original building to the newest wing, by Sir Norman Foster and Partners, of London.

Admission: Adults, $5; seniors (62+), college students with ID, $3; children 5-17, $2.50; children under 5, members, free. Group rates available. Handicapped accessible. Signed tours available with 2-3 weeks notice.
Hours: Tues.-Sat., 10-4; Sun., 12-4. Closed Mon., holidays.
Programs for Children: Classes and camps throughout the year.
Tours: Select Wed., 1; Select Sat., 10, 11. Call (402) 342-3300, ext. 206 two weeks in advance for group reservations.
Food & Drink: Café Durham offers light meals and refreshments. Tues.-Sat., 11-3; Sunday, 12-3.
Museum Shop: Features a comprehensive selection of art books, videos, slides, cards, posters; jewelry by local artists; original art; clothing; children's art kits; and gifts. Open during museum hours.

Currier Gallery of Art

201 Myrtle Way, Manchester, NH 03104
(603) 669-6144

1999 Exhibitions

Thru January 4
Moments in Time: Master Photographs from the Currier Gallery of Art

January 16-February 22
New Hampshire Art Association 52nd Annual Exhibition

March 6-May 3
Prints by John James Audubon

March 13-June 14
Henry Melville Fuller Collection of Paperweights

July 10-October 11
Modern Design in American, 1930-1960

November 26, 1999-January 23, 2000
Maxfield Parrish, 1870-1966
Retrospective explores the artistic influences of this American illustrator's
70-year career, including paintings, mural studies, drawings, prints, artifacts,
and ephemera. (T)

Permanent Collection

European and American painting, sculpture, and decorative arts from the
13th century to the present. Collection contains many significant works by
New Hampshire artists and craftsmen including the Dunlap family; European
paintings by Joos Van Cleve, Jan De Bray, Monet, Rouault, Picasso, and
Tiepolo; works by American artists including Bierstadt, Cropsey, Church,
Hassam, Hartley, O'Keeffe, Sheeler, and Wyeth; sculpture by Remington,
Saint-Gaudens, Nevelson, Calder, Caro, Lachaise, and Matisse.
Architecture: 1929 museum building by Tilton and Githens in the Beaux-
Arts Italianate style; mosaics by Salvatore Lascari, listed on the National
Register of Historic Places; 1982 pavilions added by Hardy Holzman
Pfeiffer. The Zimmerman House, designed in 1950 by American architect
Frank Lloyd Wright, is the only Wright-designed residence in New England
open to the public; "Usonian" house includes original built-in and
freestanding furniture, textiles, and landscaping designed by Wright.

Admission: Adults, $5; seniors, students, $4; under 18, members, Sat. 10–1,
free. Zimmerman House (includes admission to museum): Adults, $7;
seniors, students, $5. Handicapped accessible.
Hours: Mon., Wed., Thurs., Sun., 11-5; Fri., 11-8; Sat., 10-5. Closed Tues.
Programs for Children: Offers classes and workshops.
Tours: Groups call (603) 626-4158 for reservations.
Food & Drink: The Currier Café open for lunch: Mon., Wed.-Sat., 11:30-2;
Coffee/pastries served 2-4; open Sun. for seasonal brunch. Closed Tues.
Museum Shop: Open during museum hours.

Hood Museum of Art

**Wheelock St., Dartmouth
College, Hanover, NH 03755
(603) 646-2808
http://www.dartmouth.edu/
~hood**

José Clemente Orozco, *The Epic of American Civilization:
The Departure of Quetzalcoatl (Panel 7)*, 1932-34. Photo
courtesy Hood Museum of Art, Dartmouth College.

1999 Exhibitions

Thru February 28
*Resonances of Power: Figural
Sculpture from Central and West
Africa*
This exhibition of recent
acquisitions of 19th- and 20th-
century African sculpture focuses on themes of incarnate power.

January 9-March 14
Winter's Promise: Willard Metcalf in Cornish, New Hampshire, 1909-1920
Features lyrical renderings of the New Hampshire landscape by this admired
American Impressionist. Catalogue.

January 16-March 14
From the Heart: The Power of Photography–A Collector's Choice
100 images from the Sondra Gilman collection span the history of 20th-
century photography, including works by Ansel Adams and Alfred Stieglitz.

April-June
*From the Great War to the Balkans: Eighty Years of American and
European War Posters*
A selection of WWI and WWII posters from the permanent collection.

Focus on the Body–African Body Ornaments
Juxtaposes the ornamental solidity and near-architectural quality of African
armlets and anklets with the exquisitely detailed neck and hair ornaments.

April-Ongoing
Art and Archaeology of Ancient Peru
Objects from 1000 B.C. through the Spanish invasion of the 15th century
reveal aspects of Andean social and religious life.

April 10-June 20
Jacob Lawrence–Aesop's Fables
23 ink illustrations by the world-renowned African American artist for a
1969 publication of *Aesop's Fables*.

mid-October-late-December
José Clemente Orozco in the United States, 1927-1934
Focuses on easel paintings, prints, drawings, and murals created by Orozco
during the seven years he spent in the U.S.

Permanent Collection

Represents nearly every area of art history and ethnography; strengths
include African, Oceanic, and Native North American art; early American
silver; 19th- and 20th-century American painting, European prints, and

contemporary art. **Highlights:** Assyrian reliefs; Panathenaic Prize amphora by the Berlin painter; Orozco murals; Lorraine, *Landscape;* Eakins, *Portrait of John Joseph Borie;* Picasso, *Guitar on the Table;* recent acquisition of 120 outstanding European master prints. **Architecture:** 1985 building by Charles Moore and Chad Floyd of Centerbrook Architects.

Admission: Free. Handicapped accessible; assisted listening devices available for lectures.
Hours: Tues.-Sat., 10-5; Sun., noon-5; Wed., 10–9. Closed Mon., holidays.
Programs for Children: Family Days with self-guiding materials including stories and games, studio art projects, occasional performances; monthly guided ArtVentures program. Call for details.
Tours: Most Sat., 2. Special Programs many Wed. evenings. For group tours call (603) 646-1469.
Food & Drink: Courtyard Café open during museum hours.
Museum Shop: Open Tues.–Fri., 10–4; Sat.–Sun., 12–4; Wed. until 9.

The Montclair Art Museum

3 South Mountain Ave., Montclair, NJ 07042
(973) 746-5555
http://www.montclair-art.com

1999 Exhibitions
Thru January 10
Masterworks on Paper from the Collection of the Montclair Art Museum
Features watercolors, gouaches, pastels, and drawings by Homer, Marin, Pollock, Motherwell, and many others.

William H. Johnson: Truth Be Told
An exhibition of nearly 50 works by African-American artist William H. Johnson (1901-1970). (T)

Dan Namingha
The Native American experience is reflected in this exhibition of painting and sculpture by contemporary Hopi artist Dan Namingha.

February 1-April
Consuelo Kanaga: An American Photographer
More than 100 works by photojournalist Consuelo Kanaga (1894-1978), renowned for her technical virtuosity and innovations.

Selections from the Permanent Collection
Highlights photographic works from 1850 to the present.

February-April
The Moving Panorama of Bunyan's "Pilgrim Progress" (1851)
A rare, surviving 19th-century moving panorama, featuring enormous, posed figures.

Highlights from the Native American Collection
Focuses on the original Native American collection given to the Montclair Art Museum in 1914.

May
Waxing Poetic: Encaustic Art
The first museum exhibition featuring encaustic wax painting, one of the oldest and most beautiful formal easel-painting methods.

September 1999-January 2000
Paris 1900: The "American School" at the Universal Exposition
A recreation of the first establishment of a uniquely "American School" of art.

Permanent Collection

American paintings, sculptures, works on paper, costumes; Native American art. **Highlights:** 18th-century paintings by Copley, West, Peale, Stuart, Sully, Smibert; 19th-century landscapes by Cole, Durand, Kensett, Church, Moran, Bierstadt, Inness; other 19th-century paintings by Allston, Morse, Cassatt, Eakins, Sargent; 20th-century paintings by Sloan, Glackens, Henri, the Soyer brothers, Gorky, Motherwell, Albers; Henry Reed Collection of paintings and documents of Morgan Russell. **Architecture:** 1914 Neoclassical building by Albert B. Ross.

Admission: Adults, $5; seniors, students with ID, $4; children under 12, members, free. Sat., 11-2, free. Slightly higher admission fees may be charged in connection with specific exhibitions. Handicapped accessible.
Hours: Tues.-Wed., Fri.-Sat., 11-5; Sun., Thurs., 1-5. Closed Mon., holidays. Call for summer hours.
Programs for Children: Offers concerts, lectures, symposia, films, teacher-training sessions, demonstrations, art classes, workshops, and family events.
Tours: Sun., 2; call (973) 746-5555, ext. 25 or 21 to schedule a tour.
Museum Shop: Features Native American art and books.

Newark Museum

49 Washington Street, Newark, NJ 07101
(973) 596-6550; 1 (800) 7MUSEUM

1999 Exhibitions

Thru January 3
Wrapped in Pride: Ghanaian Kente and African American Identity
A look at the art and the significance of Kente, one of Africa's best-known and most widely revered textiles, from its importance in Ghanaian cultural traditions to its role as a symbol of black identity for African Americans. (T)

Broadloom Kente Cloth, Asante People, Ghana. From Wrapped in Pride: Ghanian Kente and African American Identity. Photo courtesy The Newark Museum.

171

Christmas in the Ballantine House: Feasting with Family and Friends
A walk through a 19th-century Victorian mansion, authentically decorated for the Christmas holidays.

Thru June 2000
Needless Necessity: Jewelry, Silver, and Personal Meaning
150 pieces of sumptuous jewelry and precious objects are selected from the permanent collection.

January 2-March 28
The Toussaint L'Ouverture Series by Jacob Lawrence
A series of 41 tempera paintings depicting the history of Blacks in Santo Domingo, from its discovery in 1492 to its independence in 1804. These paintings are considered to be among Lawrence's best-known works.

February 19-May 16
Off Limits: Rutgers University and Avant Garde Art, 1957-1963
Works by an extraordinary group of artists–Brecht, Hendricks, Kaprow, Lichtenstein, Samaras, Segal, Watts, and Whitman–who, while working at Rutgers, challenged conventional notions of art to create various "New Art" forms, including pop art, performance art, and art installation.

March 5-March 28
28th Annual Newark Teen Arts Festival
Highlights the visual and performing arts talents of area students.

April 2-December
Celebrating The Newark Museum at Ninety
Commemorates the museum's 90th anniversary by surveying the history of its first two decades.

April 16-June 27
My Father's List
An installation by artist Thelma Mathias depicting over 150 objects her father took as he fled Germany on the eve of WWII.

June 4-August 15
Rodin: Sculpture from the Iris and B. Gerald Cantor Collection
Works from the world's largest and most comprehensive private collection of works by Rodin. Sixty-nine sculptures explore key motifs in Rodin's career, including his interest in conveying movement and emotion. (T)

Masterworks in Bronze from The Newark Museum
Showcases select pieces from the collection, ranging from American and European works to bronzes from Asia, Africa, and the ancient Mediterranean.

July 16-September 26
New Jersey Printmaking Council Anniversary Exhibition
This exhibition of contemporary prints marks the council's 25th anniversary.

September 27, 1999-January 20, 2000
Sacred Realm: Treasures of Tibetan Art in the Collection of The Newark Museum
Highlights Tibetan art from the 13th through 20th century. Features a selection of objects from the museum's collection of Tibetan art and artifacts, including textiles, jewelry, and an altarpiece, to explore all facets of Tibetan life.

October 15-December 26
Imaging/Aging: Visual Responses to Growing Older
Works by New Jersey artists to raise awareness of the challenges faced by
seniors and to examine different responses to the aging process.

November 26, 1999-January 3, 2000
Christmas in the Ballantine House

Permanent Collection

Eighty galleries, including the newly restored Ballantine House; American
painting and sculpture; Decorative Arts; arts of Africa, the Americas, and the
Pacific; classical art; arts of Asia; and the sciences. **Highlight:** Consecrated
Tibetan Buddhist altar.

Admission: Free. Handicapped accessible, including elevator, café seating,
and restrooms; call (973) 596-6615 for special needs.
Hours: Wed.-Sun., 12-5; Thurs., 12-8:30.
Programs for Children: Junior studios; garden, planetarium, and programs.
Tours: Groups call (973) 596-6615 for information and reservations.
Food & Drink: Englehard Court, open Wed.-Sun., 12-3:30.
Museum Shop: Unusual selection of art books, jewelry, and gifts. Junior
Shop offers moderately priced children's items.

Museum of New Mexico
Museum of Fine Arts
107 West Palace Ave. on the Plaza, Santa Fe, NM 87501
(505) 827-4468; recorded information (505) 476-5072
http://www.nmculture.org

1999 Exhibitions

Thru January
Joel-Peter Witkin: Unpublished and Unseen Works
Rare examples from the oeuvre of Witkin, including Coney Island images of
the mid-1950s and little-known etchings, drawings, and recent work.

Thru January 4
Stony Silence: Experimental Prints by Frederick O'Hara
Experimental works made during the 1940s and 1950s in a multi-process
technique that combines lithography, woodcut, and monoprint.

Thru January 25
Land, Sky, and All That is Within: Visionary Photographers in the Southwest
Views of New Mexico's light, atmosphere, inhabitants, geography and
geology made over the past century.

Thru March 8
*I Saw Whole Paintings Right Before My Eyes: The Founding of the Taos Art
Colony*
Celebrates the 100th anniversary of the wagon wheel accident that led to the
founding of the Taos art community. Includes work by 19 local artists.

Thru March 22
Pueblo Architecture and Modern Adobes: The Residential Designs of William Lumpkins
Plans for experimental homes designed by architect and abstract painter Lumpkins since 1965. Includes 48 solar homes based on prehistoric floorplans and 19th-century pueblo facades.

February 19-May 24
Ancient Iranian Ceramics from the Arthur M. Sackler Collections
Exhibition of objects from pre-Islamic Iran, dating back 5,000 years.

March 24-May 31
Susan Rothenberg: Drawings and Prints
Examines the iconography and graphic processes of the 20th-century American painter.

April 9-June 27
Milton Avery: Paintings from the Collection of the Neuberger Museum of Art

June 18-September 20
John Candelario: Photographic Modernist

Permanent Collection
Twentieth-century American art, primarily by artists working in the Southwest; photography, sculpture; extensive holdings of American Indian art, including work by Taos and Santa Fe masters. **Architecture:** 1917 building patterned after mission churches.

Museum of International Folk Art
706 Camino Lejo, Santa Fe, NM 87501
(505) 827-6350
http://www.state.nm.us/moifa

1999 Exhibitions
Ongoing
Multiple Visions: A Common Bond
Examples of folk art from more than 100 countries.

Familia y Fe/Family and Faith
Illuminates the importance of family and faith to New Mexican Hispanic culture, through textiles, jewelry, religious objects, and decorative arts.

Thru January 3
Las Obras de un Santero (The Works of a Santero): Ramón José López
Retrospective of the work of the Santa Fe *santero* and 1997 winner of the National Heritage Fellowship.

Thru March 14
At Home Away From Home: Tibetan Culture in Exile
Examines the drama of living in exile, featuring paintings by Tibetan children now living in India and photographs from the Tibetan resettlement community of Santa Fe.

Thru November
The Extraordinary in the Ordinary from the Collections of Lloyd Cotsen and the Neutrogena Corporation
Selections from the gift of 2,600 textiles and other objects by the Neutrogena Corporation and
Lloyd Cotsen.
Includes a behind-the-scenes storage area.

January 24-June 27
La Escultería de Don José Aragón
Explores the life and work of Aragón, one of New Mexico's most prominent 19th-century *santeros.*
Includes 30-40 *retablos* and *bultos,* photomurals of altar screens, and the artist's tools.

June 6, 1999-September 5, 2000
Antecedentes: Hispana and Hispano Artists of Early Twentieth Century New Mexico
Presents masterworks by early 20th-century Hispana and Hispano artists, linking colonial and contemporary art.
Includes over 200 items produced through the WPA, paintings, sculptures, embroidery, and mixed media.

Photo courtesy Museum of New Mexico.

June 6, 1999-December 31, 2000
Casa Colonial
Hands-on interactive exhibit features an early 19th-century colonial house, containing replicas of artifacts from the period.

Museum of Indian Arts and Culture
710 Camino Lejo, Santa Fe, NM 87501
(505) 827-6344

1999 Exhibitions

Ongoing

Here, Now and Always
Native Southwestern American peoples give voice to their story, featuring
1,500 weavings and other art objects.

The Buchsbaum Gallery of Southwestern Pottery
Surveys Southwestern Indian ancestral, historical, and contemporary pottery
styles from the museum's collections.

Thru January

A Critical Century: Ancestral Rock Art Before and After AD 1300
Examines the images of geometric forms, animals, and masked figures
depicted on 12th-century rock art of the southwest region.

February-May

*Changing Traditions, Three Generations: Pablita Velarde, Helen Hardin,
and Margarete Bagshaw-Tindel*
Examines the changing traditions of contemporary Native American art as
seen in the work of Hardin (1943-1984) and members of her family.

June 13-December

Weaving at the Margins: Navajo Men as Weavers

June 27, 1999-May 2000

Of Stone and Stories: Voices from the Dinetah
Explores the history of the "pueblitos," ancient Navajo strongholds that
sheltered families from local raids and the turmoil of the Río Grande during
the later 17th century.

The Palace of Governors
105 West Palace Ave. on the Plaza, Santa Fe, NM 87501
(505) 476-5100
http://www.nmculture.org

1999 Exhibitions

Ongoing

Art of Ancient America, 1500 B.C.-1500 A.D.
Outstanding examples of 3,000 years of pre-Columbian art from Mexico,
Peru, and other Meso-American cultures, including metals, ceramics, and
devotional objects.

Another Mexico: Spanish Life on the Upper Río Grande
Presents an overview of life in New Mexico from the Colonial period,
beginning with the Spanish presence in 1540, to the present.

Society Defined: The Hispanic Resident of New Mexico, 1790
Features artifacts and documents related to the detailed state census taken in
1790 by order of the Spanish crown.

Period Rooms
Includes the Governor Bradford L. Prince Parlor of 1893, the 1846 Mexican Governor's Office, and Northern New Mexico Chapel, with items dating from 1820-1880.

The Segesser Hide Paintings
Paintings depicting early New Mexico history recorded on bison hides between 1701 and 1730.

The Georgia O'Keeffe Museum
217 Johnson St., Santa Fe, NM 87501
(505) 995-0785
http://www.okeeffe-museum.org

1999 Exhibitions
Continuing
Rotating selection of 100 paintings, watercolors, drawings, pastels, and sculptures created between 1914 and 1982, highlighting the work of Georgia O'Keeffe. Includes newly lent works and selections from the museum's growing collection.

August 14-October 10
Georgia O'Keeffe: The Poetry of Things
Examines the aesthetics of the acclaimed 20th-century American artist through her paintings of objects, including shells, rocks, trees, bones, and doors. Features approximately 60 paintings and works on paper. (T)

Permanent Collection
This newly opened museum showcases works by Georgia O'Keeffe (1887-1986) in the first U.S. museum dedicated to the work of an individual woman artist. **Highlights:** O'Keeffe, *Jimson Weed; Nude Series (Seated Red); Autumn Trees-The Maple; Abstraction; White Rose II; Kachina.*

All five museums:
Admission: Adults, four-day pass to all five museums, $10; one-day pass, one museum, $5; youth under 17, Fri. eves. 5-8, free; Sun., $1 for New Mexico residents; Wed., free for New Mexico seniors (60+).
Hours: Tues.-Sun., 10-5. Closed Mon., major holidays.
Tours: Call (505) 476-5000 for information.

Albany Institute of History & Art

125 Washington Ave., Albany, NY 12210
(518) 463-4478
http://www.albanyinstitute.org

1999 Exhibitions
Under construction and renovation in 1999; please call ahead for exhibition information.

Permanent Collection
Hudson River school landscape paintings; early Dutch limner portraits; Albany-made silver; 18th- and 19th-century New York furniture, sculpture, pewter, ceramics; 19th-century cast-iron stoves; work by contemporary regional artists; Egyptian Gallery; paintings by Walter Launt Palmer; late-19th- and early-20th-century architectural renderings; period room depicting 18th-century Dutch colonial *groote kamer*; sculpture by Erastus Dow Palmer; textiles, costumes, and societal artifacts. **Architecture:** 1907 Classical Revival style building by Albert Fuller; 1894 Beaux Arts-style William Gorham Rice mansion by Richard H. Hunt. Both buildings are listed on the National Register of Historic Places.

Admission: Wed., free. Thurs.-Sun., Adults $3; seniors and students, $2; children under 12, free. Handicapped accessible.
Hours: Wed.–Sun., noon–5. Closed Mon., Tues., major holidays.
Tours: Group tours available. Reservations required. For more information, please call (518) 463-4478.
Museum Shop: Open during museum hours.

Brooklyn Museum of Art

200 Eastern Pkwy., Brooklyn, NY 11238
(718) 638-5000
http://www.brooklynart.org

1999 Exhibitions
Thru January 24
Royal Persian Paintings: The Qajar Epoch 1785-1925
Examines the representational and monumental artistic traditions of the Qajar dynasty, which ruled present-day Iran from 1779 to 1924. Includes life-size paintings, illustrated manuscripts, lacquer works, and enamels. Catalogue. (T)

Thru February 14
Japonism in Fashion: Japan Dresses the West
120 costumes and 30 textiles dating from the 17th century to the present day illustrate the emergence of *Japonism* in European fashion.

Thru March 14
Working in Brooklyn: Domestic Transformations
Brooklyn artists Ann Agee, Ron Baron, Jean Blackburn, and Andy Yoder transform everyday objects into innovative sculptural works.

Thru April 4
Lewis Wickes Hine: The Final Years
Explores the last years of one of America's most important photographers, including examples from Hine's *Men at Work* project and rare landscapes.

Thru September
The Sloan Collection: BARD Second Year
A collection of fine 18th-century American furniture recently given to the Brooklyn Museum of Art.

April 9-July 4
From Hip to Hip-Hop: Black Fashion and a Culture of Influence
Explores contemporary African-American fashion, from the complex and controversial elements that constitute it to its worldwide impact.

April 23-August 15
Jack Levine Print Retrospective
72 prints by Jack Levine, known for his caustic wit and political commentary.

May 19, 1999-August 13, 2000
William Merritt Chase: Painting in Brooklyn and Manhattan, 1886-1891
Brooklyn and Manhattan landscapes by one of the most important American Impressionists.

September 3, 1999-January 23, 2000
Vivian Cherry Photographs
Works by photojournalist Vivian Cherry, known for her documentary series of New York neighborhoods at a time when immigration and Manhattan were booming.

October 8, 1999-January 2, 2000
Vital Forms: American Art in the Atomic Age, 1940-1960
Illustrates how objects of popular culture, art, and architecture came to embrace organic forms as a response to the threat of nuclear war.

October 29, 1999-February 6, 2000
Eastman Johnson
An exploration of the entire breadth of work by one of the most important American artists of the 19th century.

Permanent Collection

Represents virtually the entire history of art, ranging from one of the world's foremost Egyptian collections to comprehensive holdings of American painting and sculpture; significant holdings of Greek, Roman, ancient Middle Eastern, and Islamic art; Asian, pre-Columbian, African, Oceanic art; European painting, sculpture; decorative arts; prints, drawings; American period rooms. **Highlights:** Assyrian reliefs; Egyptian female figure, 3500 B.C; Rodin Sculpture Gallery; Monet, *Doge's Palace;* Eakins, *William Rush Carving the Allegorical Figure of the Schuylkill.*
Architecture: Monumental Beaux Arts building designed by McKim, Mead & White in 1893; West Wing renovation, Arata Isozaki & Associates/James Stewart Polshek and Partners, 1993.

Admission: Donation suggested: adults, $4; seniors, $1.50; students, $2; children under 12 with adult, free. Handicapped accessible.
Hours: Wed.-Fri., 10-5; Sat., Sun., 11-6. Closed Mon., Tues., major holidays. Beginning Oct. 1, first Sat. of month, 11-11.
Programs for Children: "Arty Facts" program, for ages 4-7, Sat. and Sun., 11, 2; "Stories + Art" for kids 7-12 and their families, Sat., 4.
Tours: Call (718) 638-5000, ext. 221.
Food & Drink: Museum Café open Wed.-Fri., 10-4; Sat.-Sun., 10-4.
Museum Shop: Open Wed.-Fri., 10:30-5:30; Sun., 11-6.

Albright-Knox Art Gallery
1285 Elmwood Ave., Buffalo, NY 14222
(716) 882-8700
http://www.albrightknox.org

1999 Exhibitions
NOTE: Due to renovations, there will be no special exhibitions until May.

May 23-August 29
Monet at Giverny: Masterpieces from the Musée Marmottan
Blockbuster exhibition features 22 paintings by Claude Monet (1846-1926). Includes lesser-known later works featuring the flower and water gardens of Monet's property in the rural village of Giverny. (T)

Permanent Collection
Sculpture from 3,000 B.C. to the present; 18th-century English and 19th-century French and American painting; noted holdings of modern and contemporary art. **Highlights:** Gauguin, *Spirit of the Dead Watching* and *Yellow Christ*; Hogarth, *The Lady's Last Stake*; Kiefer, *The Milky Way*; Lichtenstein, *Picture and Pitcher*; Matisse, *La Musique*; Moore, *Reclining Figure*; Pollock, *Convergence*; Samaras, *Mirrored Room*; Segal, *Cinema*.
Architecture: 1905 Greek Revival building by Green; 1962 addition with sculpture garden by Gordon Bunshaft of Skidmore, Owings, and Merrill.

Admission: Adults, $4; seniors, students, $3; children 12 and under, free. Handicapped accessible.
Hours: Tues.-Sat., 11-5; Sun., 12-5. Closed Mon., Jan. 1, Thanksgiving, Dec. 25.
Programs for Children: Offered throughout the year. Call for details.
Tours: Wed.-Thurs., 12:15; Sat.-Sun., 1:30. Groups call (716) 882-8700.
Food & Drink: Garden Restaurant by Just Pasta open Tues.-Sat., 11:30-4:30; Sun., 11-4. Picnic areas available at Delaware Park, across the street.
Museum Shop: Offers a large selection of art-related books and gift items.

Herbert F. Johnson Museum of Art

Cornell University, Ithaca, NY 14853
(607) 255-6464
http://www.museum.cornell.edu

1999 Exhibitions

January 16-March 7
Sylvia Plymack Mangold Paintings

January 23-March 14
Women Photographers: Works from the Eastman House
Rubell Collection: Contemporary American Paintings

March 27-June 13
Livingston Collection
Strong Hearts: Native American Photography

June 9-August 15
Cornell's Attics: Collections at Cornell

June 19-August 15
Birds in Art

June 19-August 18
Verhoeven Collection

August 28-October 17
Edgerton Photographs

August-October
Korean Ceramics
Works from the Donald Byrd Collection
DeHooghe Works from Dallett Collection

August-November
Andy Goldsworthy: Two

November-January 2000
History of Costume

Permanent Collection

Art in all media from 30 centuries and six continents with strengths in Asian, American, and graphic arts. **Highlights:** Daubigny, *Fields in the Month of June;* Durand, *View of the Hudson Valley;* Giacometti, *Walking Man II;* Dubuffet, *La Bouche en Croissant*; Rauschenberg, *Migration;* Leoni, *Portrait of Angela Gratiani;* Russell, *Synchrony No. 5;* Stieglitz, *The Steerage;* Tiffany blue vase. **Architecture:** Building by I. M. Pei, built in 1973 of concrete and long panels of glass, with commanding views of Fall Creek gorge, and Cayuga Lake.

Admission: Free. Handicapped accessible.
Hours: Tues.–Sun., 10–5. Closed Mon., holidays.
Programs for Children: Workshops are scheduled throughout the year.
Tours: Call (607) 255-6464.
Food & Drink: Food services are available nearby on the Cornell campus.
Museum Shop: Gift items are on sale in the museum lobby.

Storm King Art Center

Old Pleasant Hill Rd., Mountainville, NY 10953
(914) 534-3115
http://www.skac.org

1999 Exhibitions

Ongoing
The Fields of David Smith
Features approximately 25 major
sculptures by one of the foremost
American artists of the 20th
century, in a setting resembling the
artist's studio and home in upstate
New York. Catalogue.

Permanent Collection
A 500-acre sculpture museum in the
Hudson River Valley collecting and
exhibiting post-1945 sculpture.
Highlights: Magdalena
Abakanowicz, *Sarcophagi in Glass
Houses*; Serra, *Schunnemunk Fork*;

David Smith, *Volton XX,* 1963. Gift of the
Ralph E. Ogden Foundation. Photo courtesy
Storm King Art Center.

Armajani, *Gazebo for Two Anarchists: Gabriella Antolini and Alberto
Antolini;* 13 sculptures by David Smith; Aycock, *Three-Fold Manifestation
II*; Calder, *The Arch*; Nevelson, *City on The High Mountain*; Noguchi,
Momo Taro; Snelson, *Free Ride Home*; di Suvero, *Mon Père, Mon Père*;
Andy Goldsworthy, *The Wall that Went for a Walk.* **Architecture:** 1935
French Normandy-style building designed by architect Maxwell Kimball.

Admission: Adults, $7; seniors, $5; students, $3; members, children under
5, free. Discounted admission for groups of ten or more. Partially
handicapped accessible.
Hours: Apr. 1-Nov. 14: daily, 11-5:30. Special evening hours during June,
July, and August, Sat., 11-8. Closed Nov. 15–Mar. 31.
Programs for Children: Call for details.
Tours: Daily, 2. May-Oct.: Sat.–Sun., 1, 2. Advance reservations required,
call (914) 534-3115.
Food & Drink: Extensively landscaped picnic areas available.
Museum Shop: Books, jewelry, and many gift items.

The Isamu Noguchi Garden Museum

32-37 Vernon Boulevard, Long Island City, New York 11106
(718) 721-1932
http://www.noguchi.org

Permanent Collection
Comprehensive collection of artwork by American/Japanese sculptor Isamu
Noguchi (1904-1988) representing over 60 years of his career. Thirteen

galleries and a tranquil sculpture garden designed by the artist on the site of his New York studio display over 250 works, including stone, bronze, and wood sculptures; elements of dance sets designed for Martha Graham; photo documentation and models for public projects and gardens; and the artist's Akari lanterns.

Overview of Area 2 of the Isamu Noguchi Garden Museum. Photo by Shigeo Anzai.

Architecture: Noguchi converted an old, brick photoengraving plant across the street from his New York studio into galleries and a garden that currently house his work. A 1985 addition, designed with architect Shoji Sadao, was added to complete the museum.

Admission: Suggested donation: Adults. $4; seniors, students, $2. Handicapped accessible to 1st floor only (two-thirds of collection), including assisted listening systems.
Hours: Apr.-Oct.: Wed.-Fri., 10-5; Sat.-Sun., 11-6. Closed Mon., Tues.
Programs for Children: Public school education program. Baby/child backpack-carriers are available.
Tours: Daily, 2. Groups call (718) 721-1932 for reservations.
Food & Drink: Small café serves coffee, cold beverages, and pastries. Limited seating in upstairs gallery amid Noguchi's Akari light sculptures. Open Wed.-Sun., 12-4. Picnic areas available at nearby Rainey Park or Socrates Sculpture Park.
Museum Shop: Offers books, catalogues, postcards, posters, video tapes, and Noguchi's Akari light sculptures.

American Craft Museum

40 W. 53rd St., New York, NY 10019
(212) 956-3535

1999 Exhibitions
Thru January 10
Transformation: Prix Saidye Bronfman Award 1977-1996
Examines Canadian craft over the past 20 years, including over 70 handcrafted objects by some of Canada's finest craftspeople.

Thru January 17
Wendy Ramshaw: Picasso's Ladies
Works inspired by the women in Picasso's paintings, by one of Britain's leading jewelry artists.

January 22-May 2
Art and Industry: 20th-Century Porcelain from Sèvres
Porcelain works produced at the Sèvres factory by such artists as Louise Bourgeois, Roberto Matta, Adrian Saxe, Alexander Calder, and Jean Arp.

Permanent Collection

Documents the history and development of 20th-century craft in America, concentrating on objects created after World War II; significant objects in all craft disciplines: clay, enamel, fiber, glass, metal, mixed media, paper, plastic, wood; outstanding collections of contemporary jewelry, baskets, furniture, art quilts, and functional and sculptural works in all media. **Architecture:** 1986 building by Fox & Fowle, Architects.

Admission: Adults, $5; students, seniors, $2.50; children under 12, free. Handicapped accessible. including ramps and elevators.
Hours: Tues., Wed., Fri.-Sun., 10-6; Thurs., 10-8. Closed Mon., major holidays.
Programs for Children: Contact the Education Dept. for details.
Tours: Call (212) 956-3535 for information.
Museum Shop: Small selection of crafts and jewelry; open during museum hours and Mon., 10-6.

Cooper-Hewitt, National Design Museum

Smithsonian Institution, 2 E. 91st St., New York, NY 10128
(212) 849-8404
http://www.si.edu/ndm

1999 Exhibitions

Thru January 19
The Architecture of Reassurance: Designing the Disney Theme Parks
Explores the architecture of one of the great postwar American icons: Disneyland. Includes plans, drawings, paintings, and models. (T)

Thru March 21
Unlimited by Design
First major exhibition of products, services, and environments designed to meet the needs of all people throughout their life spans.

February 9-May 30
Graphic Design in the Mechanical Age: Selections from the Merrill C. Berman Collection
More than 200 works of international graphic design from a world-renowned private collection. Includes posters, paintings, drawings, and collages.

April 27-August 8
The Huguenot Legacy: English Silver, 1680-1760, from the Alan & Simone Hartman Collection
Examines the influence of French Huguenot silversmiths on the stylistic evolution of English silver. (T)

September 15, 1999-February 6, 2000
Contemporary Jewelry: Selections from the Helen Williams Drutt Collection
A look at one of America's preeminent collections of jewelry and some of the most provocative jewelry design over the past thirty years.

October 12, 1999-January 2, 2000
The Work of Charles and Ray Eames: A Legacy of Invention
Surveys the career of the 20th-century American husband and wife design team, best known for their mass-produced, form-fitting chairs. (T)

Permanent Collection
Covers 3,000 years of design history in cultures around the world. Major holdings include drawings, prints, textiles, furniture, metalwork, ceramics, glass, woodwork, wall coverings. **Highlights**: Egyptian, Islamic, Mediterranean, and Near Eastern textiles from the 3rd to 15th centuries; large group of Homer drawings; 19th-century jewelry by Castellani and Giuliano. **Architecture:** 1902 Carnegie mansion by Baab, Cook, and Willard. 1997 renovation by Polshek & Partners Architects.

Admission: Adults, $5; students and seniors, $3; members, children under age 12, free. Free admission Tues., 5-9. Handicapped accessible.
Hours: Tues., 10-9; Wed.-Sat., 10-5; Sun., noon-6. Closed Mon. and Federal holidays.
Tours: Call (212) 849-8387 for reservations.
Food & Drink: Café to open in future.
Museum Shop: Books, objects d'art, ceramics, jewelry, toys. Open during museum hours.

Dahesh Museum
601 Fifth Ave., New York, NY 10017
(212) 759-0606
http://information@daheshmuseum.org

1999 Exhibitions
Thru January 2
French Oil Sketches and the Academic Tradition
Reveals the importance and range of oil sketches in 17th- through 19th-century France. Works by Simon Vouet, François Boucher, and more.

January 19-April 17
A Victorian Salon by the Sea: Paintings from the Russell-Cotes Collection
A rare opportunity to view 19th-century British art in its original aesthetic context: a salon-style installation. (T)

June 8-August 28
Revealing the Holy Land: The Photographic Exploration of Palestine
Rare and exquisite 19th-century photographs document the most historic area in the Middle East.

Paul Cesaire Gariot, *Pandora's Box.* Photo by Robert Mates, courtesy Dahesh Museum.

September 14, 1999-January 2000
The Women of the Académie Julian
Works completed at the prestigious Parisian atelier by women artists such as
Elizabeth Gardner Bouguereau, Cecilia Beaux, and Louise Bourgeois.

Permanent Collection
With more than 2,000 19th- and 20th-century paintings, drawings, watercolors,
sculptures, prints, and decorative arts, the Dahesh Museum is the only museum
in the U.S. dedicated exclusively to art of the academic tradition. **Highlights:**
Work by William Adolphe Bouguereau, Lord Leighton, Jean-Léon Gérôme,
and Alexandre Cabanel. **Architecture:** 1911 commercial building.

Admission: Free. Handicapped accessible.
Hours: Tues.-Sat., 11-6.
Tours: Docent-led tours at lunchtime daily. Group tours arranged by
appointment.

Dia Center for the Arts
548 W. 22nd St., New York, NY 10011
(212) 989-5566
http://www.diacenter.org

1999 Exhibitions
Thru June 13
Robert Irwin: Excursus: Homage to the Square Cubed
An ode to German abstract artist Josef Albers, by California-based artist
Robert Irwin. Includes 18 chambers illuminated in multi-colored lights.

Joseph Beuys: Drawings After the Codices Madrid of Leonardo da Vinci
All 96 drawings from a book by Beuys, inspired by Leonardo da Vinci's
Codices Madrid, which was rediscovered in 1976.

Andy Warhol: Shadows
Reinstallation of Warhol's series of brilliantly colored silhouettes of
unidentified objects, which caused consternation when first exhibited in 1979.

Thomas Schutte: Scenewright
Surveys the career of German artist Thomas Schutte, including large-scale
sculptures, installations, drawings, and photographs.

Double Vision
Stan Douglas and Douglas Gordon

Note: The galleries are closed from June 14 until September 8. Please call for
the Fall 1999 schedule of exhibitions and programs.

Permanent Collection
From 1974 to 1984, Dia collected in depth the works of a focused group of
artists, including Joseph Beuys, John Chamberlain, Walter De Maria, Dan
Flavin, Donald Judd, Imi Knoebel, Blinky Palermo, Fred Sandback, Cy
Twombly, and Andy Warhol. The collection is representative of a period that
gave rise to pop, Minimalist, conceptual, and land art. **Architecture:** A
40,000 sq.-ft. warehouse renovated by Richard Gluckman Architects; recently
renovated additional space located at 545 W. 22nd St.

Admission: Adults, $4; students, seniors, $2; children under 10, members, free. Handicapped accessible, including elevator.
Hours: Thurs.-Sun., 12-6. Closed Mon.-Wed.
Programs for Children: Offers various programs for schools; call (212) 989-5566, ext. 119 for information.
Tours: Call (212) 989-5566, ext. 520 for information.
Food & Drink: Rooftop Café and Video Lounge serves coffee, pastries, and other refreshments.
Museum Shop: Printed Matter Bookstore at Dia is the nation's largest seller and distributor of artists' publications. Open during museum hours.

The Frick Collection

1 East 70th St., New York, NY 10021
(212) 288-0700
http://www. frick.org

1999 Exhibitions

Thru January 17
Victorian Fairy Painting
Critically and commercially popular during the 19th century, Victorian fairy painting is the subject of this enchanting and unusual exhibition. Includes work by Richard Dadd, John Aster Fitzgerald, Turner, and more.

Johannes Vermeer, *Officer and Laughing Girl,* 1655-60.
Photo courtesy Frick Collection.

January 26-April 25
From The National Gallery, London, to The Frick Collection: Drouais' Portrait of Madame de Pompadour
This portrait of Louis XV's mistress was the first major 18th-century female portrait in the collection of the National Gallery. Although the work has traveled to venues throughout England, this is its first U.S. presentation.

February 8-April 26
French and English Drawings of the Eighteenth and Nineteenth Centuries from the National Gallery of Canada
A stunning collection of masterpieces that have rarely traveled, rarely been published, and are largely unknown to U.S. audiences.

May 11-July 5
The Hausbuch Master
The *Hausbuch*, an illustrated manuscript of secular recipes and instructions, is legendary among scholars, but is not often shown in the United States.

October 18, 1999-January 9, 2000
Watteau and His World: French Drawings from 1700 to 1750
Approximately 80 works convey Watteau's vision and place it within the
wider context of the brilliant artists who surrounded him as mentors,
contemporaries, and pupils.

Permanent Collection
The Frick Collection is the carefully preserved Gilded Age mansion of a
private collector. Includes works by Goya, Ingres, Rembrandt, Renoir,
Titian, van Dyck; Renaissance sculptures, enamels, porcelain; Renaissance
and French 18th-century furniture. **Highlights:** Bellini, *Saint Francis in
Ecstasy*; della Francesca, *St. John the Evangelist*; van Eyck, *Virgin with
Child, with Saints and Donor*; Vermeer, *Officer and Laughing Girl*;
Holbein, *Sir Thomas More* and *Thomas Cromwell*; Rembrandt, *Self-
Portrait*; Stuart, *George Washington*. **Architecture:** Handsome 1913–1914
Frick residence by Thomas Hastings; 1931–1935 additions by John Russell
Pope; 1977 garden by Russell Page.

Admission: Adults, $7; seniors, students, $5. Children under 16 must be
accompanied by adult; children under 10 not admitted. Handicapped
accessible, including ramps and elevators; aids for the hearing-impaired and
wheelchairs available.
Hours: Tues.-Sat., 10-6; Sun., 1-6. Closed Mon., holidays.
Programs for Children: School programs exist within a set program.
Tours: "The Frick Collection: An Introduction," a twenty-minute
audiovisual presentation, is shown in the Music Room hourly, Tues.-Sat.,
10:30-4:30, and Sun., 1:30-4:30. Individual tours available in 5 languages
with an Acoustiguide INFORM™ "ArtPhone," free of charge. Call for
group reservations.
Museum Shop: Offers books, catalogues, cards, reproductions, CD-roms,
and audiovisual introductions. Open Tues.-Sat., 10-5:45; Sun., 1-5:45.

The Solomon R. Guggenheim Museum

1071 Fifth Ave., New York, NY 10128
(212) 423-3500
http://www.guggenheim.org

1999 Exhibitions
Ongoing
Thannhauser Collection: Masterpieces from the Permanent Collection

Thru January 24
*Rendez-Vous: The Centre Georges Pompidou, Paris & the Guggenheim
Collections in Dialogue*

February 5-May 9
Picasso and the War Years: 1937-1945
The first U.S. exhibition to examine the dramatic events that took place
during Picasso's life, from the Spanish Civil War to World War II, and how
the horror of these surfaced in his work. The resulting paintings, prints, and
drawings are some of the strongest and most expressive of his career. (T)

February 25-May 25
Jim Dine: I Love What I'm Doing, 1959-1969
Over 65 works, mostly from the years 1959-69, including canvases with
attached objects, documentation of early happenings, and Dine's famous
paintings of mundane objects such as bathrobes.

Permanent Collection

Nineteenth- and twentieth-century works including contemporary and avant-
garde paintings; paintings by Appel, Bacon, Bonnard, Cézanne, Chagall,
Davis, Dubuffet, Gris, Kokoschka, Louis, Marc, Miró, Modigliani,
Mondrian, Manet, Monet, Picasso, Pollock, Renoir, Rousseau, Seurat,
Soulages, Villon, Warhol; sculptures by Archipenko, Arp, Brancusi,
Pevsner, Smith. **Highlights:** Cézanne, *Man with Crossed Arms*; Gris, *Still
Life*; noted collection of works by Kandinsky, Klee, Louis, Saraband;
Mondrian, *Composition;* Picasso, *Mandolin and Guitar;* Pissarro, *The
Hermitage at Pontoise.* **Architecture:** 1959 building by Frank Lloyd
Wright; 1992 wing by Gwathmey Siegel & Associates. Guggenheim SoHo:
Loft building in SoHo Cast Iron District; museum space designed by Arata
Isozaki, 1993.

Admission: Adults, $12; seniors, students, $7; accompanied children under
12, members, free. Special 7-day combination pass for both museum
locations: Adults, $15; seniors, students, $10. Handicapped accessible;
wheelchairs available. TDD (212) 423-3607.
Hours: Sun.-Wed., 10-6. Fri.-Sat., 10-8. Closed Thurs., Dec. 25.
Tours: Call (212) 423-3652 for information; group tours require
reservations three weeks in advance.
Food & Drink: Guggenheim Museum Café, open Mon.-Wed., 9-6; Fri.-
Sun., 9-8; closed Thurs.
Museum Shop: Open Sun.-Wed., 10-6; Thurs., 10-4; Fri.-Sat., 10-8.

Guggenheim Museum SoHo
575 Broadway (at Prince St.), New York, NY 10012
(212) 423-3500 (recording)

1999 Exhibitions
Thru January
L'Art en France: 1960 to the Present

Thru January 10
*Premises: Invested Spaces in Visual Arts, Architecture, and Design from
France, 1958-1998*

February-May
Joseph Beuys
Retrospective of artist Joseph Beuys, from his early drawings and sculptures to the vitrines and large-scale environments that he created before his death.

Admission: Adults, $8; seniors, students, $5; under 12, members, free.
Hours: Sun., Wed.-Fri., 10-6; Sat., 11-8. Closed Mon., Tues., Thanksgiving, Dec. 25.
Museum Shop: Open Sun.-Fri., 11-6; Sat., 11-8.

International Center of Photography
Uptown
1130 Fifth Ave. (at 94th St.), New York, NY 10128
(212) 860-1777
http://www.icp.org

1999 Exhibitions
Thru March 7
Bruce Davidson: The Brooklyn Gang, 1959

March 12-June 6
Newman's Gift: 50 Years of Photography

June 12-September 26
Sea Change: The Seascape in Contemporary Photography

Midtown
1133 Avenue of the Americas (at 43rd St.), New York, NY 10036
(212) 860-1778

1999 Exhibitions
February 11-May 16
Artists in an Archive: Images, History, and Memory

Permanent Collection
More than 12,500 prints, including works by Abbott, Capa, Eisenstadt, Vishniac, "Weegee" (Arthur Fellig); archives include audio- and videotape recordings and cameras, housed in the Midtown facility. **Architecture:** 1915 Neo-Georgian building by Delano & Aldrich, uptown location.

Admission: Adults, $6; students, seniors, $4; members, free; Fri. 5-8, voluntary contribution. Admission price to one location includes a free pass to other, valid for one week. Midtown location is handicapped accessible, assistance provided.
Hours: Tues.-Thurs., 10-5; Fri., 10-8; Sat.-Sun., 10-6.
Programs for Children: Family Days, workshops, and community programs throughout the year.
Tours: By appointment; call (212) 860-1777, ext. 154.
Museum Shop: A complete line of photographic books, posters, post cards, as well as frames, t-shirts, tote bags, photo albums, and videos.

The Jewish Museum

1109 Fifth Ave., New York, NY 10128
(212) 423-3200
http://www.thejewishmuseum.org

1999 Exhibitions

Thru February 28
Holidays! Jewish Seasons and Celebrations
Interactive exhibition for children and families introduces visitors to major Jewish holidays. Includes related objects and photographs.

The Jewish Museum, New York. Photo by Peter Aaron.

Thru March 7
Common Man, Mythic Vision: The Paintings of Ben Shahn
Survey of more than 50 works by the 20th-century American artist known for his social realism. (T)

February 7-May 16
Ikat: Splendid Silks of Central Asia from the Guido Goldman Collection
Vibrantly colored ikat textiles, including wall hangings and robes, from the Goldman Collection, one of the largest and finest of its kind.

April 18-September 9
Sigmund Freud: Culture and Conflict
Vintage photographs, prints, films, manuscript letters, and artifacts explore Freud's life, work, and the impact of psychoanalysis on 20th-century culture. (T)

June 20-October 17
Facing West: Oriental Jews of Central Asia and the Caucasus
Drawn from the unique collection of the Russian Museum of Ethnology in St. Petersburg, 300 objects represent the stunningly beautiful ceremonial art of little-known Jewish communities in these regions.

Mid-November 1999-Mid-March 2000
Berlin Metropolis: Jews and the New Culture, 1890-1918

Permanent Collection

Over 27,000 artworks and artifacts covering 4,000 years of Jewish culture. Paintings, graphics, sculptures inspired by the Jewish experience; Jewish ceremonial art; archaeological artifacts; objects from Central European homes and synagogues brought to the museum after the Holocaust; Israeli art; contemporary art; National Jewish Archive of Broadcasting.
Highlights: Israeli archaeological artifacts, textiles; paintings by Chagall, Shahn, Weber; multimedia installation by Eleanor Antin. **Architecture:** 1908 Warburg mansion by Gilbert; 1959 sculpture court; 1963 List Building; 1993 renovation and expansion by Roche, Dinkeloo & Associates.

Admission: Adults, $8; students, seniors, $5.50; members, children under 12, free. Tues. after 5, free. Handicapped accessible, including tours for visitors with hearing disabilities; call (212) 423-3225 for more information.
Hours: Sun.-Mon., Wed.-Thurs., 11-5:45; Tues., 11-8. Closed Fri., Sat., major legal and Jewish holidays.
Programs for Children: Interactive exhibition, Sun. art workshops, storytelling, and other programs; call (212) 423-3225 for details.
Tours: Call (212) 423-3225 for reservations.
Food & Drink: Café Weissman open during museum hours.
Museum Shop: Cooper Shop, located at 1109 Fifth Avenue, features gifts, books, and museum reproductions. Celebrations: The Jewish Museum Design Shop, located at 1 E. 92nd St., features ceremonial objects and gifts.

The Metropolitan Museum of Art

Fifth Ave. at 82nd St., New York, NY 10028
(212) 879-5500; 535-7710 (recording)
http://www.metmuseum.org

1999 Exhibitions

Thru January 3
From Van Eyck to Brueghel: Early Netherlandish Paintings in the Metropolitan Museum of Art
Reexamines one of the formative schools of European painting, featuring nearly 100 paintings seen together for the first time. Catalogue.

Edgar Degas, Photographer
Presents 35-40 photographs made by the French artist in the mid-1890s. Includes figure studies, intimate interior views, and self-portraits. (T)

Thru January 10
The Nature of Islamic Ornament, Part II: Vegetal Patterns
The second exhibition in a four-part series focusing on the major types of ornament found in Islamic art.

Thru January 17
Sacred Visions: Early Paintings from Tibet
Examines the development of painting styles in Tibet, featuring 60 paintings dating from the late 11th through the early 15th century. Catalogue. (T)

Heroic Armor of the Italian Renaissance: Filippo Negroli and His Contemporaries
Features Negroli's unique style of Renaissance armor inspired by heroic deeds of antiquity, created in his Milan workshop between 1530 and 1550.

Thru January 31
Louis Comfort Tiffany at The Metropolitan Museum of Art
Tiffany decorative objects from the permanent collection in celebration of the 150th anniversary of the birth of Louis Comfort Tiffany.

Thru February 14
Beyond the Edges, An Insider's Look at Early Photographs
An exhibition of fifty 19th-century images investigating early photographers' recognition that their medium was changing the very notion of representation.

Thru February 28
Jade in Ancient Costa Rica
Features approximately 100 pre-Columbian jade objects dating from 300 B.C. to 700 A.D., including personal ornaments and functional tools.

Thru Summer
"The Academy of the Sword": Illustrated Fencing Books, 1500-1800
An exhibition of more than 75 rare books, accompanied by period weapons, traces how the accessibility of illustrated books democratized martial skills.

Thru March 21
Anselm Kiefer: Works on Paper, 1969-1987
Surveys the ideas and themes of the first two decades of this German artist's career, featuring 54 works on paper.

Edgar Degas, *Daniel Halévy,* 1895. From *Edgar Degas, Photographer.* Photo courtesy Metropolitan Museum of Art and the Musée d'Orsay, Paris (don des enfants de Mme. Halévy-Joxe en 1994).

Thru January 2, 2000
Native Paths: American Art from the Collection of Charles and Valerie Diker
A special installation of more than 75 Native American works of art, ranging from Hopi pottery to masks from the Pacific Northwest.

February 2-April 25
Eighteenth-Century French Drawings in New York Collections
Surveys the accomplishments of 18th-century French drawing, from Watteau and the early Rococo to the Neoclassicism of David.

February 16-June 20
American Folk Paintings and Drawings in the Metropolitan Museum of Art
Oil paintings, drawings, watercolors, and portrait miniatures represent the museum's distinguished collection of folk art.

March 3-June 6
Picasso: Painter and Sculptor in Clay
Despite the fact that Picasso is the most documented artist of the 20th-century, his work in clay is little-known and rarely exhibited. This exhibition is the first survey of Picasso's dazzling work in this medium.

March 9-mid-July
Mirror of the Medieval World
An outstanding selection of medieval art, from Bronze Age jewelry through Byzantine silver and enamels, precious Anglo-Saxon brooches, illuminated manuscript pages, and Gothic stained glass, stone sculpture, and statuary.

March 16-June 27
The Treasury of Saint Francis of Assisi
Masterpieces of medieval goldsmiths' work, panel paintings, textiles, and manuscripts illustrate the birth of the new style of art in the 13th century that gave rise to the accomplishments of Cimabue and Giotto.

mid-March-mid-July
The Nature of Islamic Ornament, Part III: Geometric Patterns
Examines ornamental motifs based on geometric patterns.

April 13-October 17
Hans Hofmann at The Metropolitan Museum of Art
Features Hofmann's *Renate Series* (1965), a tribute to his wife that synthesized cubism and gestural abstraction. Also includes paintings and drawings from the permanent collection.

April 13, 1999-January 9, 2000
Guardians of the Longhouse: Art in Borneo
Exquisite masks, jewelry, figures, and other objects represent the beautifully sinuous designs of the island of Borneo.

May 1-late-Fall
The Iris and B. Gerald Cantor Roof Garden
An open-air roof garden, featuring works by a 20th-century sculptor, offers a spectacular view of Central Park and the New York City skyline.

May 11-August 29
Prayer Book for a Queen: The Hours of Jeanne d'Évreux
Created by Parisian illuminator Jean Pucelle between 1324 and 1328 for Jean d'Évreux, queen of France and patron of the arts.

Devotions and Diversions: Prints and Books from the Late Middle Ages in Northern Europe
Features some of the earliest Northern European prints and books from the museum's exceptional collection. Presented in conjunction with *Prayer Book for a Queen.*

May 25-August 15
The Collection of Dr. Gachet
More than 50 paintings and drawings from the Gachet collection, Musée d'Orsay, that have never traveled before to other venues. Presents major examples of work by Van Gogh, Cézanne, Monet, Renoir, and others. (T)

late-May-mid-November
The Annenberg Collection of Impressionist and Post-Impressionist Masterpieces
One of the most distinguished collections of its kind, the Annenberg Collection includes the work of Manet, Renoir, Monet, Van Gogh, Gauguin, and Picasso.

June 1-August 22
Gustave Moreau
In honor of the 100th anniversary of the death of the French symbolist painter, this exhibition features masterpieces from each stage of his career. (T)

July-November
Design in the 20th Century, Part I: 1900-1925
The first in a four-part series surveying 20th-century design, this exhibition highlights arts and crafts, art nouveau, and art deco.

September 27, 1999-January 2, 2000
Portraits by Ingres: Image of an Epoch
The career of Ingres (1780-1867) spanned six decades of French history, including the Revolution, the Napoleonic age, and the Second Empire. Features 40 paintings and 120 drawings. Catalogue. (T)

Permanent Collection

One of the largest and most comprehensive museums in the world, covering every culture and period in depth. **Highlights:** Babylonian Striding Lions; Temple of Dendur; grand drawing room in American wing; Astor Court Chinese rock garden; Song dynasty Tribute Horses; Cantor Roof Garden sculpture (May 1–Oct. 30); Brown collection of musical instruments; Louis XIV bedroom; Bingham, *Fur Traders Descending the Missouri*; Brueghel the Elder, *The Harvesters*; Church, *Heart of the Andes*; Degas, *Dance Class*; van Eyck, *Crucifixion*; El Greco, *View of Toledo*; Leutze, *Washington Crossing the Delaware*; Matisse, *Nasturtiums* and *Dance*; Picasso, *Gertrude Stein*; Rembrandt, *Aristotle Contemplating the Bust of Homer*; Velázquez, *Juan de Pareja*; Vermeer, *Young Woman with a Water Jug*. **Architecture:** 1880 building by Vaux and Mould; 1902 central pavilion by Hunt; 1913 wings by McKim, Mead, and White; 1975 Lehman Wing, 1979 Sackler Wing, 1980 American Wing, 1982 Rockefeller Wing by Roche, Dinkeloo, & Associates; 1987 Lila Acheson Wallace Wing for 20th-century art; 1999 renovations and expansion of Greek and Roman art galleries.

Admission: Donation suggested: adults, $8; seniors, students, $4; members, children under 12 accompanied by adult, free. Handicapped accessible.
Hours: Tues.-Thurs., Sun., 9:30-5:30; Fri.-Sat., 9:30-9. Closed Mon., Jan. 1, Thanksgiving, Dec. 25. Certain galleries are operating on an alternating schedule; call (212) 570-3791 for information.
Programs for Children: Offers lectures, films, tours, and workshops throughout the year. Call for details.
Tours: Daily; call museum for information.
Food & Drink: Cafeteria open Tues.-Thurs., Sun., 9:30-4:30; Fri.-Sat., 9:30-8:30. Café open Tues.-Thurs., Sun., 11:30-4:30; Fri.-Sat., 11:30-9; Great Hall Balcony Bar open Fri.-Sat., 4-8:30; with music, 5-8; Restaurant open Tues.-Thurs., Sun., 11:30-3; Fri.-Sat., 11:30-10 .
Museum Shop: Offers books, cards, and museum reproductions.
Branch: The Cloisters, Fort Tryon Park, New York, (212) 923-3700. Open Tues.-Sun., 9:30-5:30. Closes at 4:45 from Nov.-Feb.

The Pierpont Morgan Library

29 East 36th St., New York, NY 10016
(212) 685-0610

1999 Exhibitions

Thru January 10
Master Drawings from the Hermitage and Pushkin Museums
First opportunity for Americans to view 120 western European drawings from the 15th to the 20th century.

Thru January
Russian Arts and Letters
Includes the only known copy in America of the Moscow 1663 Bible in Church Slavonic.

Charles Dickens: A Christmas Carol
Display of the author's manuscript and other items relating to the work.

January 27-May 2
The Wormsley Library: A Personal Selection by Sir Paul Getty, K.B.E.
More than 100 works from this important collection of illuminated
manuscripts, early printed books, drawings, paintings, and more.

February 10-May 31
Pierpont Morgan: An American Life
Letters, manuscripts, photographs, and other documents from the Library's
archives, most of which have never been shown publicly.

May 19-August 29
*Twentieth-Century
Drawings from New
York Private
Collections*
Features over 100
drawings by artists
such as Gorky,
Kandinsky, Klee, de
Kooning, Matisse,
Mondrian, Picasso,
Pollock, and many
others.

**September 16, 1999-
January 2, 2000**
*The Great Experiment:
George Washington
and the American
Republic*
The most ambitious
exhibition in over a
decade on the life of George Washington, timed to coincide with the
bicentennial of his death in 1799. (T)

William Blake, *Songs of Innocence and of Experience Shewing the
Two Contrary States of the Human Soul,* 1794. From *The Wormsley
Library: A Personal Selection by Sir Paul Getty, K.B.E.* Photo
courtesy The Wormsley Library and The Pierpont Morgan Library.

Permanent Collection
Medieval and Renaissance illuminated manuscripts; printed books; bindings
from the 5th to the 20th century; European drawings; autograph
manuscripts; early children's books; original music manuscripts; ancient
Near Eastern seals; Gilbert and Sullivan archive; Chinese, Egyptian, Roman
objects d'art. **Highlights:** Three Gutenberg Bibles; Carolingian covers of
Lindau Gospels; drawings by Mantegna, Dürer, Rubens, Rembrandt, Degas;
paintings by Memling, Perugino, Botticelli and Francia; autograph
manuscripts including Milton's *Paradise Lost*, Dickens's *A Christmas
Carol*; original manuscript of Saint-Exupéry's *The Little Prince*.
Architecture: 1906 Italian Renaissance revival building by Charles F.
McKim; 1928 west wing; 1852 Victorian brownstone, The Morgan House;
1991 Garden Court by Voorsanger & Associates.

Admission: Suggested contribution: adults, $7; students, seniors, $5. Handicapped accessible.
Hours: Tues.-Thurs., 10:30-5; Fri., 10:30-8; Sat., 10:30–6; Sun., 12–6. Closed Mon.
Tours: Walk-in exhibition and historic tours offered daily; all groups of ten or more must book in advance.
Food & Drink: Charming space in Morgan Court Café offers light luncheon and afternoon tea. Open Tues.-Fri., 11-4; Sat., 11-5; Sun. noon-5.
Museum Shop: Offers a wide selection of reproductions, cards, and various gift items.

El Museo del Barrio
1230 Fifth Ave., New York, NY 10029
(212) 831-7272
http://www.elmuseo.org

1999 Exhibitions
Thru February
Art from El Salvador
Presents a selection of paintings by Salvadoran artists and attests to the stylistic and iconographic diversity of the 20th century art of El Salvador.

The Art of Photographer Jack Delano
Brings together the complete range of Delano's work, including his portraits, landscapes, interiors, photographs, film stills, and illustrations. (T)

Contemporánea

Casitas: Gardens of Reclamation, Ejlat Feuer and Daniel Winterbottom
Photographer Ejlat Feuer's and landscape architect Daniel Winterbottom's documentation of New York's *casitas*, which transform vacant lots into safe places for social interaction and are powerful works of cultural expression.

April-Ongoing
Taíno: Pre-Columbian Art & Culture from the Caribbean
Pan-Caribbean artifacts, photographs, texts, and maps.

Santos Santería: Part II of the Rotating Santos Installation
Focuses on the relationship of *santos*, Puerto Rican, wood-carved depictions of saints, to the Afro-Cuban religion *santería*, which combines Catholic imagery and Yoruba religious beliefs.

April-June
Traditional Arts from the Permanent Collection

Studio Visits: An On-going Series

Joaquin Torres Garcia: Drawings & Paintings

Marta Chilindrón
A site-specific installation by Marta Chilindrón, whose foam and wood constructions challenge spatial perception.

April
Project Wall

July-October
The S-Files
The first annual selection of work by promising young artists. Includes site-specific installations, performances, and videos.

Tandem: Shirin Neshat and Roseangela Rennó
Juxtaposes the work of Iranian-born photographer Shirin Neshat with the work of Brazilian-born photographer Roseangela Rennó, both of whom explore the cultural inscription of the human form.

June-October
Contemporánea

November 1999-February 2000
The South Texas Ice House
Documents the phenomenon of the Texas Ice House, a spontaneous form of community center, now threatened by urban development.

Parallel Histories: Puerto Rican/Chicano Dialogue
Explores the parallel histories of Puerto Rican and Chicano posters and prints, which deal with issues of migration, settlement, and bi-culturalism.

November 1-Ongoing
Day of the Dead Altar

November 12, 1999-February 2000
Pepon Osorio

Permanent Collection
Over 8,000 objects trace the development of Latin American art and celebrate this cultural heritage.

Admission: Adults, $4; students, seniors, $2; children under 12, members, free.
Hours: Wed.-Sun., 11-5. Closed Mon., Tues., holidays. Summer: Wed.-Sun., 11-5; Thurs., 11-8.
Programs for Children: Family Days, art workshops, and other programs.
Tours: Call (212) 831-7272 for information.

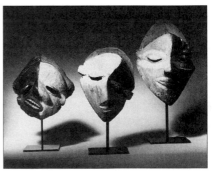

Three Masks: Mbango. Left to right: collection Donald Morris Gallery, Private Collection, Jeff Soref. Photo by Jerry Thompson, courtesy Museum for African Art.

The Museum for African Art

593 Broadway, New York, NY 10012
(212) 966-1313

1999 Exhibitions

Thru January
Baule: African Art/Western Eyes
A unique installation of the private art of the Baule, an Ivory Coast people, simulates the original context for the works, which are generally visually restricted because of their spiritual power. (T)

February 12-August 15
Liberated Voices
Approximately 100 works illustrate major trends in contemporary, post-Apartheid South African art. Catalogue.

Mid-September, 1999-January 15, 2000
Hair in African Art and Cultures
Examines the role and importance of hair, from a sign of social or religious authority to a meaningful element in art, in African cultures. Catalogue.

Permanent Collection

No permanent collection. **Architecture:** 1860s building. Interior renovation by Maya Lin and David Hotson, 1992.

Admission: Adults, $5; students, seniors, children, $2.50; members, free. Handicapped accessible.
Hours: Tues.–Fri., 10:30–5:30; Sat.–Sun., 12–6. Closed Mon., holidays.
Tours: Group tours available; call (212) 966-1313, ext. 118 for information.
Museum Shop: Distinctive pottery, jewelry, beadwork, and textiles from African artisans. All items acquired directly from African villages.

The Museum of Modern Art

11 W. 53rd St., New York, NY 10019
(212) 708-9400
http://www.moma.org

1999 Exhibitions

Thru January 5
UFA Film Posters
Approximately 50 posters representing productions by the German film studio UFA, which was founded in 1918.

Thru January 12
The New York School
Drawings from the museum's collection by artists affiliated with the New York School, including Frankenthaler, Gottlieb, and Motherwell.

New Photography 14: Jeanne Dunning, Olafur Eliasson, Rachel Harrison, Sam Taylor-Wood
New work influenced by physical factors and interaction with other media.

Thru January 26
Contemporary Japanese Textiles
Focuses on 20 influential artists who use a variety of techniques to create some of the most innovative and beautiful contemporary textiles. (T)

Thru February 2
Jackson Pollock: A Retrospective
Reexamines the challenging and influential work of this American Abstract Expressionist painter, featuring over 120 paintings and 60 works on paper. (T)

Dubuffet to de Kooning: Expressionist Prints from Europe and America
A selection of prints made during the 1940s through 1960s by artists such as Rothko, Motherwell, de Kooning, and others.

January 28-May 4
Julia Margaret Cameron's Women
Explores the emotional content of the innovative 19th-century British photographer's portraits of women. Includes portraits of Julia Jackson and Alice Liddell. Catalogue. (T)

April 1-June 16
Sigmar Polke: Works on Paper, 1963-1974
Drawings, gouaches, and sketchbooks by the imaginative and influential artist.

July-September
Photography and Fame
Explores the changing definition of fame and its relationship with the evolving media of photography through works dating from 1840 to the present.

Permanent Collection
Masterpieces of modern art by nearly every major artist of this century: paintings, sculptures, prints, drawings, illustrated books, architectural designs, photographs, films. **Highlights:** Boccioni, *The City Rises;* Cézanne, *The Bather*; Chagall, *I and the Village*; Van Gogh, *Portrait of Joseph Roulin* and *Starry Night;* Hopper, *House by the Railroad;* Matisse, *The Blue Window*, nine-panel *The Swimming Pool*; Mondrian, *Broadway Boogie-Woogie;* Monet, *Poplars at Giverny* and *Water Lilies;* Picasso, *Les Demoiselles d'Avignon* and *Three Musicians*; Rauschenberg, *Bed;* Rousseau, *The Sleeping Gypsy;* sculpture garden. **Architecture:** 1939 building by Goodwin and Stone; 1984 expansion and renovation by Pelli and Gruen.

Admission: Adults, $9.50; seniors, students with ID, $6.50; members, children under 16 accompanied by adult, free. Fri., 4:30–8:30, donation suggested. Handicapped accessible, including touch tours for the sight-impaired, and sign language tours; wheelchairs available.
Programs for Children: Offers extensive workshops and family programs.
Hours: Sat.–Tues.,Thurs., 10:30–6; Fri., 10:30–8:30. Closed Wed.
Tours: Mon.–Fri., 1, 3; Thurs.–Fri., 3, 6, 7.
Food & Drink: Sette MoMA open daily, 12–3; 5–10:30. Closed Wed. Closed Sun. eve. Reservations required, call (212) 708-9710. Garden Café open daily, 11–5; Thurs., Fri., 12–7:45, live jazz Fri. eve.
Museum Shop: The MoMA bookstore and MoMA Design Store.

National Museum of the American Indian

George Gustav Heye Center, Smithsonian Institution
One Bowling Green, New York, NY 10004
(212) 668-6624
http://www.si.edu/cgi.bin/nav.cgi

Mola of Fish. From *The Art of Being Kuna: Layers of Meaning Among the Kuna Panama.* Photo by Don Cole, courtesy UCLA Fowler Museum of Cultural History and the National Museum of the American Indian.

1999 Exhibitions

Ongoing
All Roads are Good: Native Voices on Life and Culture
A selection of more than 300 objects chosen by 23 Native Americans for their artistic, spiritual, and personal significance.

Creation's Journey: Masterworks of Native American Identity and Belief
Features 165 objects of beauty, rarity, and historical significance, dating from 3,200 B.C. through the 20th century.

March 28-July 25
Pomo Indian Basket Weavers: Their Baskets and the Art Market
An exhibition that examines the effects of the art market on the lives of Pomo women and their communities from 1900 to 1915.

May 2-August 15
Instruments of Change: James Schoppert Retrospective 1947-1992
Showcases the work of Tlinget artist James Schoppert. Includes 50 carvings, masks, and poetry.

September 26-Ongoing
Spirit Capture: Native Americans and the Photographic Image
An examination of photographs of Native Americans from contemporary and Native perspectives reveals how images have created cultural stereotypes.

October 17, 1999-March 2000
Reservation X
Original installation pieces by Native artists from Canada and the U.S. Work by Shelly Niro, Jolene Rickard, and Mateo Romero, among others.

December 1999-March 15, 2000
Down From the Shimmering Sky: Masks of the Northwest Coast
More than 150 contemporary and historical masks produced by First Nation artists of the Pacific Northwest. (T)

Permanent Collection
The George Gustav Heye Center, which opened in 1994, is named for the collector who assembled more than one million Indian artifacts in the course of his travels through the Americas. The National Museum of the American

Indian, Smithsonian Institution, will ultimately include a museum on the National Mall in Washington, D.C., as well as a research and preservation facility in Suitland, MD. **Architecture:** Landmark 1907 Alexander Hamilton U.S. Custom House, designed by Cass Gilbert, one of the finest examples of Beaux-Arts architecture in New York.

Admission: Free. Handicapped accessible, including elevators.
Hours: Daily, 10-5; Thurs., 10-8. Closed Dec. 25.
Programs for Children: Offers ongoing programs.
Tours: Walk-in tours daily. Call (212) 514-3705 for group reservations.
Museum Shop: Gallery shop offers Native American art, books, and gifts; museum shop for children; both open daily, 10-4:45; Thurs., 10-7:45.

The New Museum of Contemporary Art

583 Broadway, New York, NY 10012
(212) 219-1355
http://www.newmuseum.org

1999 Exhibitions

Thru January 12
Xu Bing
Installation work by Xu Bing, one of the leading artists to emerge from post-Mao mainland China. Invites visitor participation in Chinese calligraphy.

January 21-June 20
Fever: The Art of David Wojnarowicz
Spans 20 years of work by the New York artist who died of AIDS in 1992. Includes 75 paintings, sculptures, installations, graphics, and photographs.

Permanent Collection

To maintain a constant focus on recent art, the "semi-permanent" collection consists of works retained for a 20-year period. **Architecture:** 1896 Astor building by Cleverdon and Putzel. Renovation in 1997 by Kiss + Cathcart Architects.

Admission: Adults, $4; seniors, artists, students, $3; children under 12, free. Sat., 6-8, free. Handicapped accessible, including elevator.
Hours: Wed., Thurs., Fri., Sun., 12-6; Sat., 12-8. Closed Mon.-Tues., some holidays; call (212) 219-1355 for information.
Programs for Children: Offers exhibition-related workshops.
Tours: Group visits are available for adults and school groups from grades 7-12; call (212) 614-1222 for information.

The Studio Museum in Harlem

144 W. 125th St., New York, NY 10027
(212) 864-4500
http://www.studiomuseuminharlem.org

1999 Exhibitions

Thru February 28
From the Studio: Artists-in-Residence, 1997-1998
Annual exhibition featuring the work of participants in the Studio
Museum's artists-in-residence program.

Selected Works from the Permanent Collection
65 examples of African-American art from the museum's collection and
important private collections.

March 10-June 27
*To Conserve a Legacy: American Art from Historically Black Colleges and
Universities*
This exhibition of more than 100 works highlights not only African-
American works, but the full range of American art that each institution
holds, including work by Jacob Lawrence, Lois Mailou Jones, Aaron
Douglas, Georgia O'Keeffe, and Arthur Dove. (T)

July 14-September 19
Wrights of Passage: Contemporary African-American Artists in Transition
Celebrating the 30th anniversary of the Studio Museum artists-in-residence
program, this exhibition features the work of participants, past and present.

*From The Studio: Artists-In-
Residence, 1998-1999*

**October 6, 1999-February 28,
2000**
*African-American Artists and
American Modernism*
Approximately 85 paintings and
sculpture represent the
contributions of African-American
artists to the development of
American modernism.

Norman Lewis, *Processional*, 1965. Collection Mary P. Bramwell.
Photo by Becket Logan, courtesy Studio Museum in Harlem.

Permanent Collection

Over 1,600 objects of 19th- and
20th-century African-American art,
20th-century Caribbean and African
art, and traditional African art and
artifacts. James van der Zee archives of 1920s–1940s photographs of
Harlem. **Highlights:** Work by Romare Bearden, Elizabeth Catlett, Sam
Gilliam, Jacob Lawrence, Betye Saar, and Hale Woodruff. Sculpture
Garden dedicated to works by sculptors of African descent. **Architecture:**
19th-century building, renovated by Max Bond in 1982. Extensive
renovations 1998-1999.

Admission: Adults, $5; students, seniors, $3; children under 12, $1; members, free. Handicapped accessible, including ramps and elevators.
Hours: Wed.-Fri., 10-5; Sat.-Sun., 1-6. Closed Mon., Tues., major holidays.
Programs for Children: Programs throughout the year, including special tours and workshops; annual children's art exhibition. Free art workshops first Sat. of month. Call for details.
Tours: Group tours available: Tues.-Sat.; reservations required; call (212) 864-4500, ext. 230.
Museum Shop: Offers books, jewelry, toys, accessories, home decor, textiles, cards, posters, figurines, baskets, and artwork reflecting African-American, Caribbean, and African cultures.

Whitney Museum of American Art

945 Madison Ave., New York, NY 10021
(212) 570-3676 (information)
http://www.echonyc.com/~whitney

1999 Exhibitions

Thru January 3
Bob Thompson
Narrative works by this African-American artist known for his figurative abstract expressionism and his association with the 1950s New York art scene.

Thru February 14
Gary Hill: Circular Breathing

Thru March 21
Duane Hanson: A Survey of His Works from the '30s to the '90s
Examines the work of this 20th-century American artist known for his life-size and life-like plastic figures of ordinary people. (T)

Thru March 28
Brice Marden Drawings: The Whitney Museum of American Art Collection

Thru March 29
Hindsight

Thru April 11
Seton Smith: Pale Guide to Transparent Things
Installations, sculptures and photography by Seton Smith, whose work deals primarily with space and our emotional relationship to it.

George Bellows, *Dempsey and Firpo,* 1924. From *The American Century: Art and Culture, 1900-2000 (Part I).* Photo courtesy Whitney Museum of American Art.

April-Ongoing
The American Century: Art and Culture, 1900-2000 (Part I)
Explores the complex evolution of the American identity through the eyes of
the century's artists. Over 1,600 works encompass all artistic media.

September-Ongoing
The American Century: Art and Culture, 1900-2000 (Part II)

Permanent Collection
Comprehensive holdings of 20th-century American art; includes works by
Calder, Dove, de Kooning, Lichtenstein, Nevelson, Pollock, Rothko, Stella,
Warhol. **Highlights:** Bellows, *Dempsey and Firpo*; Calder, *Circus*; Hartley,
Painting, Number 5; Henri, *Gertrude Vanderbilt Whitney;* Hopper, *Early
Sunday Morning*; Johns, *Three Flags;* Lachaise, *Standing Woman.*
Architecture: 1966 building by Marcel Breuer.

Admission: Adults, $9; seniors, students, $7; members, children under 12
accompanied by adult, free. Thurs., 6-8, free. Handicapped accessible.
Hours: Wed., Fri.-Sun., 11-6; Thurs., 1-8. Closed Mon., Tues., holidays.
Tours: Wed.-Sun., various times. Call (212) 570-7710.
Food & Drink: Sarabeth's at the Whitney open Tues., noon-3:30, Wed.,
11-4:30; Thurs., 11:30-4:30 (cafe until 7:30); Fri., 11-4:30; Sat.-Sun., 10-
4:30.
Branches: Champion in Fairfield County, One Champion Plaza, Stamford,
CT; Philip Morris, 120 Park Ave., New York, NY.

Neuberger Museum of Art

**Purchase College, State University New York, 735 Anderson Hill Rd.,
Purchase, NY 10577
(914) 251-6100
http://www.neuberger.org**

1999 Exhibitions
Thru January 3
Maurice Prendergast
Paintings by the American
modernist noted for agitated
silhouettes and rich color.

Thru January 17
Revelations
Part of an exhibition series that
focuses on the work of an
emerging artist.

Claes Oldenburg, *Pizza Palette,* 1996. Photo by Jim
Frank, courtesy Neuberger Museum of Art.

Thru January 24
Four Works by Four Women
Features large-scale works by Mary Frank, Joan Snyder, Pat Steir, and
Yayoi Kusama.

Al Loving
Colorful, curvilinear, bold, and bombastic work by this African American painter.

Thru January 31
The Next Word
An interdisciplinary exhibition that explores the visual properties of text through work by artists, poets, and web-based designers.

January 17-March 21
Kay Miller: The Bobcat
Works by Native American artist Kay Miller reflect the study of her own culture's animal mythology.

February 7-April 25
Five Decades in Print: Ed Colker
42 selected woodcuts, lithographs, etchings, and limited editions by this printmaker, poet, teacher, publisher, and arts administrator.
Revelations

February 14-June 6
Welded! Sculpture of the 20th Century
The first comprehensive historical survey of welded sculpture. Includes work by Picasso, David Smith, Louise Nevelson, and more.

April 4-May 30
Cleve Gray, Painter: A Quarter of a Century
This exhibition of 19 paintings traces the artist's fascination with the painted line and celebrates the abstract painting itself.

May 9-October 24
Biennial Exhibition of Public Art
A major showcase of contemporary artists who work in public art.

May 9-August 15
The Dog Show: Paintings by Cynthia Carlson
An installation of paintings that illustrate Carlson's ability to capture the idiosyncratic gestures of dogs.

June 20-August 22
Webs
Artists and weavers use fiber to create works that blend sculpture and craft.

September 6, 1999-January 17, 2000
Carol Sun
Asian-American artist Carol Sun uses icons of domestic life (dishes, wallpaper, and chairs) and manipulates their designs to reestablish our sense of time and public and private life.

September 13, 1999-January 10, 2000
Bareiss Collection of African Art

Permanent Collection
Twentieth-century American and European paintings, sculpture, photographs, prints, drawings; 19th- and 20th-century African art; ancient art. **Highlights:** Works by Avery, Frankenthaler, Diebenkorn, Hopper,

Prendergast, Lawrence, O'Keeffe, de Kooning, Moore, Calder, Pollock. Installation of African art and objects that reflect traditions, rites, and religious beliefs. **Architecture:** 1974 building by Philip Johnson.

Admission: $4 requested donation.
Accessibility: Designated parking, handicapped entrance, wheelchairs available.
Hours: Tues.-Fri., 10-4; Sat.-Sun., 11-5. Closed Mon., holidays.
Programs for Children: Special events and workshops.
Tours: Tues.-Fri., 10-3; Sat., 11-4. Groups call (914) 251-6110.
Food & Drink: Museum Café Tues.-Fri., 11:30-2:30; Sat.-Sun., 12-4.
Museum Shop: Distinctive crafts, jewelry, children's gifts.

Memorial Art Gallery of the University of Rochester

500 University Ave., Rochester, NY 14607
(716) 473-7720

1999 Exhibitions
Thru January 17
Living with Art: Rochester Collects
The gallery celebrates its 85th anniversary with an exhibition of antiquities, American folk art, Asian art, modern masters, and more.

February 21-April 18
Self-Taught Artists of the Twentieth Century: An American Anthology
Approximately 250 paintings, sculptures, drawings, and decorative objects that trace the roots and development of self-taught art in this century. (T)

May 16-August 8
57th Rochester-Finger Lakes Exhibition
Biennial showcase of local area talent in all media.

August 28-November 14
The Frame in America: 1860-1960
An exhibition focusing on a relatively new area of study: the art of the frame as a work of art in its own right.

December 12, 1999-January 30, 2000
Circa 1900
In celebration of the new millennium, this exhibition showcases a dazzling array of artwork and decorative arts created around the turn of the century.

Permanent Collection
Work from antiquity to the present; strong in medieval and 17th-century European art; 19th- and early 20th-century French and American paintings, American folk art, European and American prints and drawings. Works by El Greco, Hals, van Dyck, Rembrandt, Corot, Monet, Cézanne, Degas, Braque, Matisse, Cole, Cassatt, Homer, Benton, and Sloan. **Highlights:** Egyptian 5th-dynasty *Portrait of King Ny-user-ra;* Monet, *Waterloo Bridge, Veiled Sun;*

Homer, *Artist's Studio in an Afternoon Fog*. **Architecture:** 1913 Italian
Renaissance building by Foster, Gade and Graham; 1927 addition by McKim,
Mead and White; 1987 sculpture pavilion by Handler, Grosso.

Admission: Adults, $5; college students with ID, seniors, $4; children 6-18,
$3; children under 5, free; Tues., 5-9, $2. Members, UR students, free.
Handicapped accessible, through main entrance on University Ave.
Auditorium equipped with an induction loop system; signed tours available.
Call (716) 473-7720 ext. 3027 (TDD 473-6152).
Hours: Tues., noon-9; Wed.-Fri., 10-4; Sat., 10-5; Sun., noon-5. Closed
Mon., major holidays.
Programs for Children: The Dorothy McBride Gill Education Center
includes interactive displays similar to those found in children's museums.
Tours: Tues., 7:30; Fri., Sun., 2. Call (716) 473-7720.
Food & Drink: Cutler's Restaurant open Tues.-Sat. for lunch and light
afternoon fare, Sun. for brunch, and Tues. and Sat. for dinner.
Museum Shop: Open during regular gallery hours and Wed.-Sat., until 5.

Munson-Williams-Proctor Institute

310 Genesee Street, Utica, NY 13502
(315) 797-0000
http://www.mwpi.edu

1999 Exhibitions

Thru January 3
Victorian Yuletide
Featuring lavish and festive decorations, this exhibition explores the holiday
traditions of the second half of the 19th century.

Seeing Jazz
Over 70 works reflect the artistic and literary responses to the 20th-century
musical expression of jazz. Includes works by Bearden, Basquiat, Davis,
Parks, and others. Catalogue. (T)

Thru January 31
Jaws, Claws, and Paws
Illustrates how artists adopt and adapt animal motifs in the fine and decorative
art of the 19th- and 20th centuries.

Thru December 31
The Gilded Edge: Frames in the Permanent Collection
An usual look at the frame as a work of art in its own right.

February 13-May 9
Pious Pages: Gothic and Renaissance Book Art from the Munson-Williams-Proctor Institute Collection
Beautiful and rare illuminated manuscript pages, incunabula, and early
printed leaves, ranging in date from the early-13th century to the late-16th
century.

May 2-October 31
Masterpieces of American Furniture from the Munson-Williams-Proctor Institute Collection
The first comprehensive, scholarly analysis of the finest examples of American furniture in the museum's renowned collection.

June 5-September 12
Satoru Takahashi: The Sculpture Court Project
A new, site-specific sculpture by the acclaimed Japanese artist Satoru Takahashi, known for his work addressing issues of language, nature, and culture.

Permanent Collection:

Chiefly 18th-, 19th-, and 20th-century American paintings, drawings, sculptures, and photographs. **Highlights:** Proctor watch, thimble, manuscript, and rare book collections; Thomas Cole, *The Voyage of Life*.
Architecture: 1958–60 building by Philip Johnson, 1995 connecting wing to Fountain Elms, a mid-nineteenth century house-museum featuring exhibition galleries and four Victorian-era period settings.

Admission: Free. Handicapped accessible.
Hours: Tues.-Sat., 10-5; Sun., 1-5. Closed Mon.
Programs for Children: Programs offered throughout the year.
Tours: Call (315) 797-0000, ext. 2170 for information.
Food & Drink: Diverse menu and daily specials, Mon.-Fri., 11-5.
Museum Shop: Jewelry, cards, art reproductions, books, children's items, and more.

Mint Museum of Art

2730 Randolph Rd., Charlotte, NC 28207
(704) 337-2000; 333-MINT (recording); (704) 337-2096 [TDD]
http://www.mintmuseum.org

1999 Exhibitions

Thru January 3
Lois Mailou Jones and Her Students: An American Legacy 1930-1995
A tribute to the late Lois Mailou Jones, an artist and teacher at Howard University, and 38 of her students, whose accomplishments demonstrate the triumphs of African-American artists in this century. (Last venue)

Thru February 14
Earth, Fire, and Spirit: African Pottery and Sculpture
Highlights a newly acquired collection of West African ceramic objects, ranging from a Yoruba fertility vessel to a Dakari ceramic grave marker.

Thru March 14
William Littler: An Eighteenth-Century English Earth Potter
Focuses on the artist's refinement of English soft paste porcelain and salt glazes and innovations in stoneware.

July 24-December 5
From Ship to Shore: Marine Paintings
Over 60 paintings highlight the fascination with marine culture since
colonial times.

Mint Museum of Craft & Design
220 North Tryon St., Charlotte, NC

1999 Exhibitions
January-June
The White House Collection of American Craft
Features 72 objects of America's leading craft artists working today,
including contemporary glass, ceramic, fiber, wood, and metal.

Harvey K. Littleton Reflections, 1946-1994
Spans 50 years of the artist's glass sculptures and vitreographs.

June 24, 1999-January 9, 2000
Dale Chihuly: Installations
Work by the founder of the studio glass movement and one of the
foremost glass artists working today.

Permanent Collection
Important holdings of American and European paintings; furniture and
decorative arts; African, pre-Columbian, and Spanish Colonial art; an
internationally acclaimed collection of porcelain and pottery; regional
crafts and historic costumes. Mint Museum of Craft & Design scheduled
to open in January 1999. **Architecture:** 1835 Federal-style building by
Strickland; 1967 Delhom Gallery by Odell & Associates; 1985 Dalton
Wing by Clark, Tibble, Harris, and Li.

Admission: Adults, $6; seniors, students, $4; children 12 and under, free.
Groups of 10 or more, $1 off. Handicapped accessible, including ramps,
elevators, and braille signage.
Hours: Tues., 10-10; Wed.-Sat., 10-5; Sun., noon-5. Closed Mon.,
Jan. 1, Dec. 25.
Programs for Children: Family Days, art day camps, DIGS I and II
(schools), and exhibition scavenger hunts offered throughout the year.
Tours: Daily, 2; call (704) 337-2032 for group reservations.
Food & Drink: Food and drink machines on premise.
Museum Shop: Specialty items include pottery, jewelry, and other crafts
by artisans from North Carolina and across the U.S. Catalogue service
allows access to thousands of posters. Full range of publications,
stationery, and gift items for every occasion. Books, games, and creative
toys for children.

Southeastern Center for Contemporary Art (SECCA)
750 Marguerite Dr., Winston-Salem, NC 27106
(336) 725-1904

1999 Exhibitions
Thru February 7
In Sequence: Selections from the Metropolitan Savings Bank Photography Collection
Explores the work of contemporary photographers who work sequentially. Includes work by Paul McCarthy, Hiroshi Shigimoto, Bruce Nauman, Catherine Opie, William Wegman, and Robert Mapplethorpe.

The Art Guys
The Houston-based collaborative team Michael Galbreth and Jack Massing create work that is at once serious and humorous, drawing from Dadaism, Fluxus, and conceptual art.

February 20-May 30
Accounts Southeast
A group exhibition featuring the work of artists who live and work in the Southeast.

Ce Scott
In her mixed-media sculptures and installations, Ce Scott uses the traditional feminine enterprises of knitting and sewing to delve into racial and feminist concerns.

Sliding Scale
A selection of contemporary work that exaggerate or otherwise exploit scale to enhance or question the viewer's perception.

June 19-September 29
Artist and the Community: Mr. Imagination
Self-taught artist Gregory Warmack, also known as Mr. Imagination, creates innovative and engaging carvings.

Triad Artist Exhibition
The third biennial exhibition of work produced in the Piedmont Triad metropolitan area.

October 1999-February 2000
Millennium
A look at significant moments, events, and occurrences of the late 20th century as interpreted by a select group of contemporary American artists.

Admission: Adults, $3; seniors, students, $2; children under 12, members, free. Handicapped accessible, except second floor; braille signage.
Hours: Tues.-Sat., 10-5; Sun., 2-5. Closed Mon., holidays.
Programs for Children: Creative Center for children's programs; contact Programs Dept. at (336) 725-1904, ext. 14 for information.
Tours: Call for information.
Food & Drink: Picnic areas available on grounds.
Museum Shop: Focuses on contemporary crafts and designs.

Weatherspoon Art Gallery

The University of North Carolina
Spring Garden & Tate Sts., Greensboro, NC 27402
(336) 334-5770
http://www.uncg.edu/wag/

1999 Exhibitions

Ongoing
Henri Matisse: Prints and Bronzes from the Cone Collection
Six early bronze sculptures, as well as lithographs from the 1920s, when the artist resided in Nice.

Collection Highlights
Twentieth-century American art, including works by Rauschenberg, Calder, and de Kooning.

Thru January 10
Art on Paper: Thirty-fourth Annual Exhibition
Showcases works on paper by a wide variety of nationally recognized and local artists.

Thru January 17
Falk Visiting Artist Exhibition: Jon Isherwood
Monolithic stone work that is metaphorical, monumental, and intimate.

Thru February 7
Sculpture from the Permanent Collection
Works in various media by Raol Hague, Willem de Kooning, John Storrs, and others.

Thru May 16
Sculptors' Drawings from the Permanent Collection
Works by Peter Shelton, John Flannagan, William Tucker, Dorothy Dehner, and more, offer insight into the artists' creative processes.

January 31-March 21
Bert Carpenter: A Retrospective
Surveys the artistic career of the former director of the Weatherspoon Art Gallery.

February 14-April 11
Juried Senior Exhibition
An annual exhibition of work by UNCG's graduating seniors.

February 21-April 18
Falk Visiting Artist Exhibition: Pat Steir
The artist's densely composed, abstract images are poetic equivalents for natural phenomena and states of mind.

Permanent Collection

More than 4,500 works on paper, paintings, and sculptures, focusing primarily on 20th-century American art. Asian art collection of Dr. Lenoir Wright. **Highlights:** The Cone Collection of Matisse prints and bronzes, which is shown on a rotating basis; important works by de Kooning, Calder, Rauschenberg, and Warhol. **Architecture:** Anne and Benjamin Cone

Building, designed by internationally acclaimed architect Romaldo Giurgola, opened in 1989. Weatherspoon Sculpture Courtyard showcases selections of American sculpture from 1900 to the present.

Admission: Free. Handicapped accessible, including ramps, elevators, and braille map upon request.
Hours: Tues., Thurs., Fri., 10-5; Wed., 10-8; Sat.-Sun., 1-5.
Programs for Children: Monthly Saturday workshops; Halloween program. Call (336) 334-5770 for details.
Tours: First Sunday of every month, 2. Groups call (336) 334-5770.
Food & Drink: Shops and eateries within easy walking distance.
Museum Shop: The Inside Corner, open Tues.-Fri., 11-2; Sun., 2-4. Hours may vary; call ahead at (336) 334-5770.

North Carolina Museum of Art

2110 Blue Ridge Rd., Raleigh, NC 27607
(919) 833-6262
http://www2.ncsu.edu/ncma

1999 Exhibitions
Thru February 14
Selections from the Frances M. and William R. Roberson Jr. Collection
Spans three decades of work by North Carolina artists.

Alphonse Mucha, *Vin des Incas.* From *Alphonse Mucha: The Spirit of Art Nouveau.* Photo courtesy North Carolina Museum of Art.

January 31-March 28
Alphonse Mucha: The Flowering of Art Nouveau
The first comprehensive exhibition of the work of Alphonse Mucha in the U.S. since 1921. Features paintings, posters, decorative panels, and pastels in *le style Mucha,* which became synonymous with French Art Nouveau. (T)

March 21-June 27
The Haskell Collection of Contemporary Art
One of the foremost corporate collections of contemporary art. Includes works by Frankenthaler, Frank Stella, Rauschenberg, Sam Francis, Al Held, Gerhard Richter, Jasper Johns, Ellsworth Kelly, Joan Mitchell, Lichtenstein, and Diebenkorn.

April 17-September 26
Together Forever: Portrait Pendants from the North Carolina Museum of Art
Portrait pendants from the Dutch, English, Flemish, and American collections of the North Carolina Museum of Art.

June 13-September 19
North Carolina Artists Exhibition 1999
The 49th NCAE triennial, a selection of work by some of the most talented North Carolina artists working today.

September 19-December 5
The Newby Collection of Contemporary Art

Permanent Collection
The paintings and sculpture in the state's art collection represent more than 5,000 years of artistic heritage from ancient Egypt to the present. Also represented are collections of African, Oceanic, and New World art; Egyptian, Greek, and Roman art; 20th-century art; and Jewish ceremonial art. **Highlights:** Renaissance and Baroque paintings, with works by Van Dyck, Rubens, and Botticelli; American paintings with works by John Singleton Copley, Winslow Homer, and Georgia O'Keeffe. The outdoor Museum Park features Barbara Kruger's sculptural installation "Picture This." **Architecture:** International Style building of 1983 by Edward Durell Stone & Assoc., New York, and Holloway-Reeves, Raleigh.

Admission: Free. Handicapped accessible.
Hours: Tues.-Sat., 9-5; Fri., 9-9; Sun., 11-6. Closed Mon.
Tours: Daily, 1:30; call (919) 839-6262, ext. 2145, for group reservations.
Food & Drink: Museum Café open Tues.-Fri., 11:30-2:30; Sat.-Sun., 11-3; Fri., 5:30-10.
Museum Shop: Open Tues.-Sat., 10-4:45; Sun., 11-5:45.

Cincinnati Art Museum

953 Eden Park Dr., Cincinnati, OH 45202
(513) 721-5204
http://www.cincinnatiartmuseum.org

1999 Exhibitions
Thru January 17
The Cecil Family Collects: Four Centuries of Decorative Arts from Burghley House
A collection of decorative arts in gold, silver, diamonds, rubies, and quartz crystals from one of the grandest Elizabethan houses in England. (T)

February 21-May 2
An Expressionist in Paris: The Paintings of Chaim Soutine
Major exhibition of 50 works by this expressive French painter, focusing on his years in Paris until his death during WWII. Examines the role of Soutine and other Jewish artists in the development of modern art in Paris. (T)

June 6-September 5
John Henry Twachtman: An American Impressionist
A major retrospective of the Cincinnati-born artist arranged thematically to highlight the four important periods of his career: his early work, European period, Connecticut and Gloucester years, and late work. (T)

October 22, 1999-January 9, 2000
Jim Dine
Works by this American artist known for his paintings of mundane objects.

Permanent Collection

Ancient art of Egypt, Greece, and Rome; Near and Far Eastern art; furniture, glass, silver, costumes, and folk art; paintings by European old masters such as Titian, Hals, Rubens, and Gainsborough; 19th century works by Cézanne, Van Gogh, Cassatt, and Monet; 20th century works by Picasso, Modigliani, Miró, and Chagall; American works by Cole, Wyeth, Wood, Hopper, and Rothko as well as major artists from the 1970s and 1980s. **Highlights:** The only collection of ancient Nabateanen art outside of Petra, Jordan; renowned Herbert Greer French collection of old master prints; European and American portrait miniatures. **Architecture:** 1886 Romanesque building by

Chaim Soutine, *Chartres Cathedral,* c. 1934. From *Chaim Soutine.* Photo courtesy Museum of Modern Art, New York and the Cincinnati Art Museum.

James MacLaughlin; early 1890s Greek Revival addition by Daniel Burnham; 1930 Beaux Arts wings by Garber & Woodward; 1937 addition by Rendings, Panzer & Martin; 1965 International Style addition by Potter, Tyler, Martin & Roth; 1993 renovation by Glaser & Associates.

Admission: Adults, $5; seniors, students, $4; children under 18, free. Groups, $4 each. Handicapped accessible, including parking, ramp, and elevators.
Hours: Tues.–Sat., 10–5, Sun., 12–6. Closed Mon., except holidays.
Tours: Groups of 10–60: Tues.–Sat., 10–3. Call (513) 721 5204, ext. 291, for reservations at least four weeks in advance.
Food & Drink: Museum Café open Tues.–Sat., 10–3; Sun., 12–3.

The Contemporary Arts Center

115 E. 5th St., Cincinnati, OH 45202
(513) 345-8400

1999 Exhibitions
Thru January 17
Theater of Excess: An Installation by David Mach
Scottish-born sculptor David Mach presents a grand, dramatic installation made out of ordinary or recycled materials.

Henry Gwiazda: buzzingreynold'sdreamland
A fantastic world of sound, creating natural and urban environment, by this noted composer and sound experimenter.

January 30-March 21
Amnesia: New Art from South America
Explores the work of new and established artists from South America, an area that is often overlooked by the Western art world.

January 30-March 28
The Photography of Jim Dine
Cincinnati native Jim Dine constructs and re-assembles the iconic object in pictorial space using photogravure and computer-manipulated printing.

April 3-June 6
The American Lawn: Surface of Everyday Life
Examines America's obsession with the lawn, from gender roles in yard work to critical reflections on the landscape and suburbia.

June 19-August 22
Joep van Lieshout
Utilitarian sculptural objects that straddle the borderline between art and craft.

June 19-August 29
In the Kitchen with Liza Lou
A self-contained, room-size installation of a kitchen covered entirely with beads.

Martin Puryear
Sculptures of wood, tar, and metal elegantly blend the art and architecture of disparate cultures.

Jim Dine, *Help for the Deaf,* 1997. From *The Photography of Jim Dine.* Photo by Rodney Todd-White and Son, London, courtesy Contemporary Arts Center.

Permanent Collection
Continually changing exhibitions highlight recent painting, sculpture, photography, architecture, multimedia installations, and experimental, conceptual, and video art.
Admission: Adults, $3.50; seniors, students, $2; children under 12, Mon., free.
Hours: Mon.-Sat., 10-6; Sun., 12-5.
Programs for Children: Various school programs focus on visual literacy and critical thinking for students.
Tours: Call (513) 345-8400 for information.
Museum Shop: Books, cards, jewelry, and other gift items.

Taft Museum

316 Pike St., Cincinnati, OH 45202
(513) 241-0343

1999 Exhibitions

Thru January 10
Heaven and Nature Sing: An Italian Baroque Nativity Scene
An extraordinary 18th-century *presepio* from the collection of Francesca
Pérez de Olaguer Angelón.

Thru February 14
Framing a Century: American Art from The Dicke Collection, 1862-1997
American paintings, sculpture, and decorative arts, including works by
Gustave Stickley, Louis Comfort Tiffany, Alexander Calder, William
Merritt Chase, Louise Nevelson, Andy Warhol, and Jim Dine.

March 5-March 28
Artists Reaching Classrooms
Student artwork inspired by visits to artists' studios and the Taft Museum.

April 16-June 13
Rembrandt: Treasures from the Rembrandt House, Amsterdam
Seventy-five etchings and drawings by the 17th-century Dutch master,
including self-portraits, landscapes, portraits, and studies. (T)

July 16-October 17
Americans in Munich: Duveneck, Chase, and the Whistling Boys
A look at the career of Frank Duveneck, one of the most influential
American expatriate realist painters, and the work of his mentor, William
Merritt Chase.

Permanent Collection

The collections of Charles Phelps and Anna Simon Taft include European
master paintings, European decorative arts, and Chinese ceramics.
Highlights: Gothic ivory *Virgin and Child* from the Abbey Church of St.
Denis; Turner, *Europa and the Bull;* Whistler, *At the Piano;* Rembrandt,
Portrait of a Man Rising from His Chair. **Architecture:** Former Baum-Taft
House, designed ca. 1820 by an unknown architect. Federal style mansion,
opened to the public in 1932, is a National Historic Landmark. Interior,
featuring 1850 entrance murals by Robert S. Duncanson, decorated in period
style with early 19th-century New York furnishings. Franco-Dutch formal
garden, memorializing those who served in World War II.

Admission: Adults, $4; seniors, students, $2; children 18 and under, free;
free Wednesdays. Handicapped accessible; sensory tours available.
Hours: Mon.-Sat., 10-5; Sun., 1-5. Closed Jan. 1, Thanksgiving, Dec. 25.
Programs for Children: Saturday family programs, art daycamps, other
special tours and programs.
Tours: Call (513) 241-0343.
Museum Shop: Items related to museum's collection of old master
paintings, porcelains, decorative arts, and American federal furniture.

The Cleveland Museum of Art

11150 East Blvd., Cleveland, OH 44106-1797
(216) 421-7340
http://www.clemusart.com

1999 Exhibitions

Thru January 10
Cleveland Collects Contemporary Art
Survey of key artists and trends that have defined contemporary art during
the last 30 years, drawn from local collections.

Thru February 21
Mediterranean: Photographs by Mimmo Jodice
Includes recent work by this Neopolitan photographer, influenced by his
five-year voyage through Europe and the Near East.

February 21-May 2
Diego Rivera: Art and Revolution
The first major retrospective of the artist's work in 13 years. Includes 125
paintings, drawings, frescoes, and prints executed in Rivera's innovative and
highly influential painting style: a combination of European traditions with
socialist ideals and Mexican culture. Catalogue. (T)

March 14-May 23
Mexican Prints from the Collection of Reba and Dave Williams
In conjunction with *Art and Revolution*, approximately 130 works, drawn
from one of the largest private collections of prints, surveys the full range of
Mexican graphic arts from the 1920s to 1950s. (T)

Painting in Focus: Jean-Bernard Restout's Somnus *and the French Royal
Academy*
Highlights one of the museum's finest 18th-century paintings and examines
the influence of the Royal Academy on this and other works.

June 13-August 29
Twentieth-Century Works on Paper from the Israel Museum, Jerusalem
A rare opportunity to view exceptional drawings and prints that represent
major artistic trends of the past century. Includes works by Käthe Kollwitz,
Egon Schiele, Emil Nolde, Gustav Klimt, Henri Matisse, and more.

July 18-September 19
Bugatti
The first U.S. exhibition to encompass the design work of three generations
of the Bugatti family. Includes furniture, silver, drawings, plaster models,
sculpture, and automobiles.

September 19-November 28
Edward Weston and Modernism
152 vintage platinum and gelatin-silver prints illustrate the artist's stylistic
evolution from his early constructivist-inspired work through his surrealist
images of the 1940s. Highlights include portraits of contemporaries Diego
Rivera, Igor Stravinsky, and e.e. cummings. (T)

September 24-September 26
Egyptian Galleries Renovation: Public Opening/Festival
An installation reflecting new scholarship and the latest techniques in gallery and lighting design.

October 31, 1999-January 9, 2000
Still-Life Paintings from the Netherlands, 1550-1720
Surveys the accomplishments of Dutch and Flemish still-life artists of the 17th century and examines the function and significance of these works within their socio-economic context. (T)

Permanent Collection

More than 34,000 works of art which range over 5,000 years, from Ancient Egypt to the present, and include masterpieces from Europe, Asia, Africa and the Americas. **Highlights:** Chinese paintings from the Song, Ming, Qing dynasties; Warring States Period *Cranes and Serpents*; Cambodian Krishna Govardhana; the Guelph Treasure (medieval German liturgical objects in precious metal, enamel, ivory); alabaster mourners from tomb of Philip the Bold; 18th-century French decorative arts, including silver tureen by Meissonnier; sculpture garden; Caravaggio, *Crucifixion of Saint Andrew*; Kline, *Accent Grave*; Monet, *Water Lilies*; Picasso, *La Vie*; Rubens, *Portrait of His Wife, Isabella Brant*; Ryder, *Death on a Pale Horse*; Turner, *Burning of the Houses of Parliament*; Zurbarán, *Holy House of Nazareth*; Mount, *The Power of Music,* Kiefer, *Lot's Wife*; Warhol, *Marilyn X 100.* **Architecture:** 1916 Beaux Arts building by Cleveland's Hubbell and Benes; major expansion in 1958; 1971 expansion by Marcel Breuer; 1983 wing houses the Ingalls art library.

Admission: Free; some fees for special exhibitions and programs. Handicapped accessible.
Hours: Tues., Thurs., Sat., Sun., 10-5; Wed., Fri., 10-9. Closed Mon., Jan. 1, July 4, Thanksgiving, Dec. 25.
Tours: Groups call (216) 421-7340, ext. 380, during museum hours.
Food & Drink: Museum Café open Tues., Thurs., Sat., Sun., 10-4:30; Wed., Fri., 10-8:30.
Museum Shop: Open during museum hours. For information, call (216) 421-0931.

Columbus Museum of Art

480 E. Broad St., Columbus, OH 43215
(614) 221-6801; 221-4848 (recording)
http://www.columbusart.mus.oh.us

1999 Exhibitions

Ongoing
Eye Spy: Adventures in Art
Objects in architectural settings that relate to the time and place they were made in an interactive exhibition for children and families.

Thru January 3
Chihuly Over Venice
Chandeliers made by Dale Chihuly in cooperation with glass masters of
Finland, Ireland, and Mexico for installation over the canals of Venice.

Thru January 10
Shadows and Light: Man Ray and His Legacy
Features photograms, camera-less images created with photosensitive paper,
from *Les Champs Delicieux*, a 1922 portfolio by Man Ray.

January 16-March 21
Edward Eberle, Contemporary Ceramics
Highlights the ceramic work of Edward Eberle with his fluid, black-and-
white wash drawings on handmade paper.

January 22-March 28
Photographic Tableaux: Tina Barney's Family Album
25 of Barney's large-scale, color portraits of her family and friends.

*A Basketmaker in
Rural Japan*
Utilitarian bamboo
burden baskets,
fishing creels, farm
implements, and
storage baskets by
Hiroshima Kazuo,
whose career spans
65 years.

Andreas Gursky
11 large-scale
works by the
German
photographer
Andreas Gursky
depict surreal
landscapes and environments. (T)

Canaletto (Bernardo Bellotto), *Dresden from the Right Bank of the Elbe,
Below the Augustus Bridge*, c. 1751. From *Dresden in the Age of Splendor
and Enlightenment: 18th Century Paintings from the Old Masters Picture
Gallery.* Photo courtesy Columbus Museum of Art.

March 27-July 18
Joseph Marioni
Monochromatic acrylic paintings evoke sensations through pure color.

April 3-June 6
William Little, Columbus Pictorialist, 1850-1937
A newly discovered photographic archive revealing the breadth and artistic
sensibility of this Columbus-born artist.

April 23-October 24
*From the Age of Splendor to the Age of Enlightenment: 18th-Century
Paintings from the Old Masters Picture Gallery in Dresden*
More than 70 paintings drawn from Dresden's legendary Old Masters
Picture Gallery include works by Canaletto, Belotto, Tiepolo, and Watteau.

July 24-October 31
Julian Stanczak
Stanczak carefully manipulates color and form to create powerful geometric abstract paintings.

October 23, 1999-January 2, 2000
This Land is Your Land/Marilyn Bridges
52 black-and-white photographs celebrating the grandeur of the American landscape.

November 19, 1999-January 30, 2000
Spectacular St. Petersburg: 100 Years of Russian Theatre Design
The tumultuous changes of 20th-century Russia are reflected in 40 costumes and 75 theatrical design sketches, which bring to life the extraordinary cultural world of St. Petersburg.

Permanent Collection

European and American collections from 1850 to 1945, including Impressionist, Post-Impressionist, German Expressionist, Cubist, Fauvist works; 16th- and 17th-century Dutch and Flemish painting; pre-Columbian and South Pacific art; Oriental ceramics. Galleries arranged chronologically, focusing on artistic movements in different countries from the Renaissance to the modern era. **Highlights:** Monet, *View of Bennecourt*; Degas, *Houses at the Foot of a Cliff* and *Dancer at Rest;* Renoir, *Christine Lerolle Embroidering*; a group of 11 works by Klee; Bellows paintings, lithographs; Boucher, *Earth*; Ingres, *Raphael and the Fornarina*; O'Keeffe, *Autumn Leaves*; Rubens, *Christ Triumphant over Sin and Death*; 350 coverlets by Ohio and Midwest artists; sculpture by Archipenko, Maillol, Manzù, Moore. **Architecture:** 1931 Italian Renaissance revival building, based on drawings by Charles Platt; 1974 new wing; 1979 Sculpture Garden and Park; 1998 Children's Education Center.

Admission: Donation suggested: adults, $4; seniors, students, children 5-12, $2; children under 5 and members, free. Thurs. evenings, free. Handicapped accessible.
Hours: Tues.-Sun., 10-5:30; Thurs. 10-8:30. Closed Mon., Jan. 1, July 4, Thanksgiving, Dec. 25.
Programs for Children: Children's Education Center offers ongoing programming, including Eye Spy and Adventures in Art.
Tours: Usually available Fri. at noon, Sun. at 2. Groups call (614) 221-6801, ext. 236, 30 days ahead.
Food & Drink: The Palette Café serves homemade soups, salads, entrees, sandwiches, and dessert. Open daily, 11:30–2.
Museum Shop: Features a large collection of exhibition-related books, crafts, unique jewelry by local artisans, gifts, and books, games, and toys for children.

Wexner Center for the Arts

The Ohio State University
1871 N. High St., Columbus, OH 43210
(614) 292-3535
http://www.cgrg.ohio.state.edu/wexner

1999 Exhibitions

Thru January 3
Body Mécanique: Artistic Explorations of Digital Realms
Work in a variety of media by selected international artists who examine the subject of the human body and its relationship to technological realms.

January 30-April 18
On the Table: A Succession of Collections 3
This exhibition of tables and place settings documents the shift in American decorative arts away from ornamentation toward more simplified forms.

David Reed Paintings: Motion Pictures
The first U.S. overview of work by San Diego-born artist David Reed, known internationally for his abstract painting. (T)

Ray Johnson: Correspondences
One of the first opportunities to explore in depth five decades of work by one of the progenitors of pop art.

Rirkrit Tiravanija
A conceptual installation by Rirkrit Tiravanija, known his transformation of gallery spaces into interactive environments.

May 15-August 15
Willem de Kooning: Drawing Seeing/Seeing Drawing
Through four series of drawings from 1958 to the 1970s, this exhibition provides a close-up view of the artist's working process and artistic explorations, which can also be traced in his paintings.

Self-Taught Artists of the Twentieth Century: An American Anthology
Approximately 250 paintings, sculptures, drawings, and decorative objects that trace the roots and development of self-taught art in this century. (T)

Permanent Collection

A multidisciplinary contemporary arts center with active performing and media arts programs, as well as exhibitions. Artists' residencies and commissioned works are emphasized. Permanent indoor or outdoor installations by Maya Lin, Sol LeWitt, and Barbara Kruger. **Architecture:** Designed by Peter Eisenman and Richard Trott, the 1989 building is one of the most challenging public buildings to be built in recent years. Its deconstructivist program reflects the city's history as it recalls the forms of earlier buildings on the same site. Landscape design by Laurie Olin.

Admission: Adults, $3; students, seniors, $2; members, OSU students & faculty, children under 12, free. Free to all Thurs., 5-9. Handicapped accessible, including ramps and other services; call (614) 292-3535.
Hours: Tues.-Wed., Fri.-Sun., 10-6; Thurs., 10-9. Closed Mon.
Programs for Children: Family Days, Young Arts programs, and programs for teachers.
Tours: Thurs., Sat., 1. Call (614) 292-6982 for group information.
Food & Drink: Wexner Center Café, call (614) 292-2233.
Museum Shop: Something for everyone at the Wexner Center Bookshop: a unique selection of cards, gifts, jewelry, and toys; an unmatched selection of publications on the contemporary art scene.

The Dayton Art Institute

456 Belmonte Park North, Dayton, OH 45405
(936) 223-5277; (800) 296-4426
http://www.daytonartinstitute.org

1999 Exhibitions
January 16-March 21
Still-Life Paintings from the Phillips Collection
More than 75 oil paintings from the world-renowned Phillips Collection, Washington, D.C., on the subject of the still-life. Works by Milton Avery, Pierre Bonnard, Georges Braque, and others reflect more than half a century of changing attitudes toward style and subject. (T)

May 8-July 18
Sinners and Saints, Darkness and Light: Caravaggio and His Dutch and Flemish Followers in America
Showcasing more than 35 paintings by Dutch and Flemish artists who responded directly or indirectly to the powerful works of Caravaggio. (T)

August 7-October 3
Modotti and Weston: Mexicanidad
Photographs from the mid-1920s document the period that Modotti and Weston lived and worked in Mexico. 65 vintage gelatin silver prints. (T)

October 30, 1999-January 2, 2000
In Praise of Nature: Ansel Adams and Photographers of the American West
Examines how the American West has been depicted through the photographic medium, from the romanticism of the 19th century to the realism of the 20th century. Includes works by Adams, Lange, and Weston.

Permanent Collection
American, European, Asian, Oceanic, African, Pre-Columbian, contemporary, and ancient art. **Highlights:** Dicke Wing of American Art: Hopper, *High Noon*; Cassatt, *Portrait of a Woman*; O'Keeffe, *Purple Leaves*; Warhol, *Russell Means*. Berry Wing of European Art: Monet, *Water Lilies*; Rubens, *Two Study Heads of an Old Man*; Preti, *St. Catherine of Alexandria;* Patterson/Kettering Wing of Asian Art: Indian, 12th century, bronze, *The Great Goddess*; Chinese, Han Dynasty, earthenware, *Watching*

Tower; Thai Sukhothai period, bronze, *Seated Buddha*. Dicke Family Glass Gallery: American and European glass from Tiffany, Duam, Chihuly, and more. **Architecture:** Listed on the National Register of Historic Places, 1930 Italian Renaissance Revival style building by Edward B. Green, modeled after Vignola's Villa Farnese; 1997 renovation and expansion.

Admission: Free. Some fees for special exhibitions. Handicapped accessible.
Hours: Daily, 10-5; Thurs., 10-9.
Programs for Children: EXPERIENCENTER, a hands-on interactive gallery; family days, art classes, and other programs. Call for details.
Tours: Tues.-Sun., noon and 2; Thurs. 7 (sign language tours available); or call for appointment.
Food & Drink: Café Monet open 11-4 daily; Thursday 5-8:30.
Museum Shop: Open during museum hours. Additional shop located in the Town & Country Shopping Center, open during mall hours.

Allen Memorial Art Museum

Oberlin College, 87 N. Main St., Oberlin, OH 44074
(440) 775-8665
http://www.oberlin.edu/~allenart

NOTE: The nearby Weltzheimer/Johnson House, a Usonian house designed by Frank Lloyd Wright between 1948 and 1950, is open to the public the first Sun. and third Sat. of each month, 1-5. Tickets may be purchased at the museum.

1999 Exhibitions
Thru January 4
Now Tomorrow
Multi-media installation by Diana Thater.

Thru January 10
Mini-Modern Masters

January 26-March 21
Native American and Pre-Columbian Art from the Permanent Collection

January 26-May 30
Kuniyoshi's Kisokaido Road Series

February 5-May 30
Tall Ships and *Learning Curve*
Two video installations by Gary Hill.

Peter Henry Emerson, *During the Reed Harvest,* 1887. Photo courtesy Allen Memorial Art Gallery, Young-Hunter Art Museum Acquisition Fund.

April 9-June 6
Masami Teraoka: From Tradition to Technology, the Floating World Comes of Age

June 22-August 9
Decorative Arts from the Permanent Collection

August 26-December 19
Photographs from the Permanent Collection

Permanent Collection

More than 11,000 objects ranging over the entire history of art. Outstanding holdings of 17th-century Dutch and Flemish painting, Old Master and Japanese *ukiyo-e* prints, early 20th-century art, contemporary American art. Early works by Domenichino, Monet, Mondrian, Picasso, Warhol, Oldenburg. **Highlights:** Monet, *Garden of the Princess, Louvre*; Rubens, *The Finding of Erichthonius*; Terbrugghen, *St. Sebastian Attended by Irene*; Modigliani, *Nude with Coral Necklace*; Kirchner, *Self Portrait as Soldier*; Gorky, *The Plough and the Song.* **Architecture:** Landmark 1917 building by Cass Gilbert; 1976 addition by Venturi, Rauch and Associates, decorative ironwork by Philadelphian Samuel Yellin.

Admission: Free. Handicapped accessible (ramp entrance, Lorain Street).
Hours: Tues.–Sat, 10–5; Sun., 1–5. Closed Mondays and major holidays.
Programs for Children: Range of programs includes Family Days and KIDZHIBIT, which allows children to create art and organize exhibitions.
Tours: Call (440) 775-8048 for information.
Museum Shop: Uncommon Objects, located at 39 S. Main Street.

The Toledo Museum of Art

2445 Monroe St., Box 1013, Toledo, OH 43697
(419) 255-8000; (800) 644-6862
http://www.toledomuseum.org

1999 Exhibitions

January 22-May 16
Photography from the Permanent Collection
100 photographic masterpieces by such artists as Ansel Adams, Weegee, and others.

February 14-May 2
Sandy Skoglund: Reality Under Siege
The first major retrospective of this sculptor, photographer, and installation artist. Features *Radioactive Cats, Peaches in a Toaster,* and other works. (T)

Spring
Jewelry from the Permanent Collection: Recent Jewelry Acquisitions
Works by Louis Comfort Tiffany, Lalique, Pradier, among others.

July-August
81st Annual Toledo Area Artists Exhibition

October 1999-January 2000
An American Treasury: Master Quilts from the Museum of American Folk Art

November 1999-January 2000
Picasso: Graphic Magician Prints from Norton Simon Museum

Photography of Philippe Halsman
A Life magazine photographer from the 1940s through the 1970s, Halsman's portraits of Albert Einstein, Marilyn Monroe, and Salvador Dalí have become 20th-century icons. (T)

Sandy Skoglund, *The Lost and Found,* 1986. From *Sandy Skoglund: Reality Under Seige.* Photo courtesy Toledo Museum of Art.

Permanent Collection

Traces the history of art from Ancient Egypt to the present: European and American paintings, sculpture; extensive glass collection; graphic arts; photographs; tapestries; decorative arts. **Highlights:** Chase, *The Open Air Breakfast;* Cole, *The Architect's Dream;* El Greco, *Agony in the Garden*; Rembrandt, *Man in a Fur-lined Coat*; Rubens, *The Crowning of Saint Catherine.* **Architecture:** 1912 Neoclassical building by Edward Green; 1992 addition by Frank Gehry.

Admission: Free. Entrance fee for selected exhibitions. Handicapped accessible; wheelchairs, strollers available.
Hours: Tues.-Thurs., Sat., 10-4; Fri., 10-10; Sun., 11–5. Closed Mon., holidays.
Programs for Children: A wide range of art classes and activities. Family Center open Thurs., 10-3, Sun., 11-4.
Tours: Call (419) 255-8000, ext. 352 for information.
Food & Drink: Cafeteria-style Museum Café features a full menu of hot entrees, salads, and desserts.
Museum Shop: Open during museum hours.

The Butler Institute of American Art

524 Wick Ave., Youngstown, OH 44502
(216) 743-1711

1999 Exhibitions
Thru January 10
Michael Fabian
Works by Ohio-born artist Michael Fabian, known for his fascinating map paintings of intertwined figures in geographic boundaries.

Thru January 24
Elsie Manville
Spans five decades of the career of the well-known still-life artist.

Thru February 21
Treasures from the Petit Palais of Modern Art, Geneva, Switzerland
A distinguished collection of French Impressionist paintings by such artists
as Caillebotte, Monet, Degas, Renoir, Forain, and Toulouse-Lautrec.

Thru February 28
Peter Halley: Selected New Works
Features recent work by America's "Neo-Geo" master.

Gary Stephan

March 7-April 18
Norman Bluhm

April 25-June 27
Darryl Pottorf

Robert Rauschenberg

May 2-June 27
Edward Hopper: The American West

Permanent Collection
More than 10,000 works by American artists, from the colonial period to the
present. Includes significant holding of Ashcan School artists. Lester F.
Donnell Gallery of American Sports Art includes athletic images by
Bellows, Grooms, and Warhol. **Highlights:** Homer, *Snap the Whip*;
important works by West, Copley, Cassatt. Unique collection of Western art
by Bierstadt, Remington, and others. **Architecture:** Landmark 1919
McKim, Mead and White building. Several additions, including post-
modern 1987 West Wing with Butler Sculpture Garden and Terrace.

Admission: Free. Handicapped accessible, including ramps and elevators.
Hours: Tues., Thurs., Fri., Sat., 11–4; Wed., 11–8; Sun., 12–4. Closed
Mon., holidays.
Programs for Children: Art classes and tours throughout the year.
Tours: Call (330) 743-1711 for information.
Museum Shop: Open during museum hours.

Gilcrease Museum
1400 Gilcrease Museum Road, Tulsa, OK 74127
(918) 596-2700
http://www.gilcrease.org

1999 Exhibitions
Ongoing
Las Artes de Mexico
Tells the story of Mexico from pre-Columbian times to the present in a
permanent, hands-on installation.

January 22-April 25
Symbols of Faith and Belief: Art of the Native American Church
A look at the societal role and the artistic traditions of the Native American Church from its inceptions to the modern day.

February 19-May 16
Norman Rockwell–An American Portrait
Magazine covers from 1916 through 1963 reflect Rockwell's vision of a wholesome, innocent American society.

April 30-July 4
Gilcrease Rendezvous 1999
Featuring painter William Acheff and sculptor Oreland Joe.

May 16-July 18
Art Patronage in Taos, New Mexico: 1898-1950
Celebrating its 50th anniversary, the Gilcrease Museum hosts an exhibition of oils, watercolors, prints, and sculptures from the Taos Society of artists.

August 27-November 7
Down from the Shimmering Sky: Masks of the Northwest Coast
More than 150 contemporary and historical masks produced by First Nation artists of the Pacific Northwest. (T)

November 5-December 5
American Art in Miniature 1999
Annual exhibition of artworks no larger than 9 by 12 inches.

Permanent Collection
Comprehensive collection of art of the American West. Native American art and artifacts. Art and history of Mexico. Historical manuscripts, documents, and maps. **Highlights:** John Wesley Jarvis, *Black Hawk and His Son Whirling Thunder*. **Architecture:** Original building designed to resemble an Indian Longhouse, renovated in 1987 by John Hilberry and Associates. Areas of the museum grounds are landscaped with historic theme gardens.

Admission: Suggested donation, adults, $3; families, $5. Partially handicapped accessible, including ramps and some braille signage.
Hours: Tues.-Sat., 9-5; Sun., holidays, 11-5; Memorial Day through Labor Day: Mon., 9-5; Closed Dec. 25.
Programs for Children: Art over the Break; Summer Tour Program.
Tours: Daily, 2. Special tours can be arranged at least 2 weeks in advance; call (918) 596-2712.
Food & Drink: Rendezvous Restaurant serves lunch, 11-2, Tues.-Sat.; brunch, 11-2, Sun.
Museum Shop: Features full-color prints of Gilcrease Museum paintings, reproduction bronzes, art and history books, jewelry, pottery, kachinas, baskets, and unusual gifts.

The Philbrook Museum of Art

2727 S. Rockford Rd., Tulsa, OK 74114-4104
(918) 749-7941; (800) 324-7941

1999 Exhibitions

January 31-March 14
Pure Vision: American Bead Artists
The rich history of beads as a vehicle for
cultural expression and personal adornment
is the subject of this visually stunning
exhibition.

Beads: A Cross-Cultural Medium
Drawn form Philbrook's own collection, this
exhibition features premiere examples of
traditional beadwork designs.

Philbrook Art Center, Tulsa, Oklahoma.

April 24-June 20
*Alphonse Mucha: The Flowering of Art
Nouveau*
The first comprehensive exhibition of the
work of Alphonse Mucha in the U.S. since
1921. Features paintings, posters, decorative
panels, and pastels in *le style Mucha*, which
became synonymous with French Art Nouveau. (T)

July 11-August 29
Milton Avery Paintings from the Collection of the Neuberger Museum of Art
29 paintings from the finest collection of work by Milton Avery, one of
America's foremost artists and colorists.

September 12-November 7
Contemporary American Landscape
Charts the portrayal of the American landscape over the past 50 years.
Includes work by Andrew Wyeth and Fairfield Porter, among others.

Permanent Collection

Collections include Italian painting, sculpture; Native American basketry,
pottery, paintings; 18th- and 19th-century European paintings; 19th- and
20th-century American art; African sculpture. **Architecture:** 1927 Villa
Philbrook by Edward Buehler Delk; 1990 wing by Urban Design Group in
association with Michael Lustig.

Admission: Adults, $5; seniors, students, groups of 10 or more, $3 per
person; children 12 and under, members, free. Handicapped accessible.
Hours: Tues.-Sat., 10-5; Thurs., 10-8; Sun., 11-5. Closed Mon., major
holidays.
Programs for Children: Family and children's programs offered year
round.
Tours: Call (918) 748-5309, preferably two weeks in advance.
Food & Drink: La Villa Restaurant, Tues.-Sun., 11-2; Thurs. cocktails, 5-7.
Museum Shop: Open regular museum hours.

Portland Art Museum

1219 S.W. Park Ave., Portland, OR 97205
(503) 226-2811
http://www.pam.org

1999 Exhibitions

Thru January 1
Monet at Giverny: Masterpieces from the Musée Marmottan
Blockbuster exhibition features 22 paintings by Claude Monet (1846-1926).
Includes lesser-known later works featuring the flower and water gardens of
Monet's property in the rural village of Giverny. (T)

January 15-March 18
M.C. Escher: A Celebration
Examines the Dutch artist's contemporary *trompe l'oeil* masterpieces which
have been highly popular since the 1960s.

January 15-March 21
Robert Colescott: Recent Paintings, 47th Venice Biennale
Recent works by the first African-American artist to be included in the
prestigious Venice Biennale exhibition. (T)

April 9-July 11
Down From the Shimmering Sky: Masks of the Northwest Coast
More than 150 contemporary and historical masks produced by First Nation
artists of the Pacific Northwest. (T)

April 11-July 11
Photographs of Edward S. Curtis
A selection of photogravures by Seattle-based photographer Curtis (1868-
1952), who is known for his 20-volume collection of haunting images of
Native American life.

May 6-July 18
Otto Fried: Spheres and Atmospheres
Works made during the past 15 years by this artist who came to Portland as
a refugee from Nazi Germany in 1936. Includes paintings, sculptures, and
assemblages derived from his interest in geometric volumes.

May 14-July 11
Rodin's Monument to Victor Hugo
One of Rodin's least-known, most problematic and politically charged
monuments was this tribute to French writer Victor Hugo. 20 sculptures
illustrate the different stages of Rodin's concept. (T)

Permanent Collection

19th- and 20th-century works; Northwest Native American art; Kress
collection of Renaissance and Baroque paintings; Cameroon sculptures;
Elizabeth Cole Butler collection of Native American art. **Highlights:** Pre-
Han *Standing Horse*; Brancusi, *Muse*; Monet, *Water Lilies*; Renoir, *Two
Girls Reading*; Tlingit *Wolf Hat*; new Vivian and Gordon Gilkey Center for
the Graphic Arts. **Architecture:** 1932 building by Belluschi; 1989 and
1995 renovation.

Admission: Adults, $6; seniors, students age 16 and over, $4.50; students age 15 and under, $2.50; children under 5, free. Handicapped accessible.
Hours: Tues.-Sun., 10-5; first Wed., Thurs., 10-9. Closed Mon.
Programs for Children: Family Museum Sunday, contact the museum for upcoming events.
Tours: Call (503) 226-2811, ext. 889 for information.
Museum Shop: Open during museum hours.

Brandywine River Museum

Brandywine Conservancy, Route 1, Chadds Ford, PA 19317
(610) 388-2700
http://www.brandywinemuseum.org

1999 Exhibitions
Thru January 10
A Brandywine Christmas
Celebrates the holiday season with an exhibition of dolls, model trains, a Victorian dollhouse, and thousands of ornaments.

January 23-March 21
Political Satire of Thomas Nast
Focuses on the work of one of America's greatest political cartoonists.

Permanent Collection
American art with special emphasis on the art of the Brandywine region. 19th- and 20th-century landscapes by Cropsey, Doughty, Moran, Trost, Richards; 19th-century *trompe l'oeil* works by Cope, Harnett, Peto; illustrations by Darley, Pyle, Parrish, Gibson, Dunn. **Highlights:** Paintings

Brandywine River Museum, Chadds Ford, Pennsylvania.

by three generations of Wyeths; Andrew Wyeth Gallery; Brandywine Heritage Galleries. **Architecture:** 1864 grist mill renovated in 1971 by James Grieves; 1984 addition by Grieves features glass-walled lobbies with spectacular views of the river and countryside.

Admission: Adults, $5; seniors, $2.50; students with ID, children, 6-12, $2.50; members, children under 6, free. Handicapped accessible.
Hours: Daily, 9:30-4:30; Dec. 26-30, 9:30-6. Closed Dec. 25.
Tours: Groups call (610) 388-8366.
Food & Drink: Charming restaurant, open daily, 11-3. Closed Mon., Tues., Jan.-Mar.

James A. Michener Art Museum

138 S. Pine St., Doylestown, Bucks County, PA 18901
(215) 340-9800

1999 Exhibitions

Ongoing
Outdoor Sculpture Program
Features a variety of styles and materials by regional and national sculptors.

Thru January 17
"Machinery Can't Make Art": The Pottery and Tiles of Henry Chapman Mercer
Celebrates the 100th anniversary of Mercer's Moravian Pottery and Tile Works, organized to "master the potter's art and establish a pottery under personal control."

Thru March 7
A Legacy Preserved: The First Decade of Collecting at the Michener Art Museum
In conjunction with the Michener's 10th anniversary, *A Legacy Preserved* features some of the most significant objects from the permanent collection.

January 30-May 23
From Artist to Child: The Bucks County Intermediate Unit Collection
A collection of stunning work by Pennsylvania Impressionists and other artists, assembled in 1949 for display in area public schools.

March 20-June 27
Bucks County Invitational III: Contemporary Woodworkers
Six small solo exhibitions by regional contemporary artists.

June 5-September 5
From Soup Cans to Nuts: Prints by Andy Warhol
This exhibition of works from the Warhol Museum features some of the most celebrated images by 20th-century icon.

July 10-October 3
The Philadelphia Ten: A Women's Artist Group, 1917-1945
Presents the work of thirty Philadelphia-based painters and sculptors known as the Philadelphia Ten, who provided much-needed support and exhibition opportunities to women at a time when the art world was dominated by men.

Permanent Collection
Traces the history of Bucks County art from colonial times to the present. Collection features 19th- and 20th-century American art, including Impressionist and Abstract Expressionist paintings; James A. Michener memorabilia, celebrating his career as a writer, public servant, and philanthropist; Nakashima Reading Room, featuring classic furniture by local woodworker George Nakashima. **Highlights:** Thomas Hicks, *Portrait of Edward Hicks*; 22-foot mural by Pennsylvania Impressionist painter Daniel Garber.

Admission: Adults, $5; seniors, $4.50; students, $1.50; children under 16, members, free. Handicapped accessible, including ramps, elevators, parking, and aids for the hearing impaired.
Hours: Tues.-Fri., 10-4:30; Sat.-Sun., 10-5.
Programs for Children: Studio and gallery workshops, family programs, and other programming throughout the year.
Tours: Call (215) 340-9800, ext. 126 for information.
Food & Drink: Espress Café open Tues.-Sat., 10-4:30.
Museum Shop: Features crafts from Bucks County. (215) 340-9800.

Institute of Contemporary Art

**University of Pennsylvania, 118 S. 36th St., Philadelphia, PA 19104
(215) 898-7108
http://www.upenn.edu/ica**

1999 Exhibitions

Thru January 3
Tacita Dean
Film, video, and drawings by Tacita Dean construct narratives that weave together fact and fiction.

Steven Pippin: Laundromat/Locomotion
As an homage to the locomotion studies of Eadweard Muybridge, Pippin transformed washing machines into cameras and created his own motion photographic series.

January 16-March 7
Three Stanzas: Miroslaw Balka, Robert Gober, and Seamus Heaney
An exhibition of poetry and sculpture that express sadness, memory, and vulnerability and explore the emotional receptiveness of viewers.

Sticker Shock: Artists' Stickers
Stickers created by artists evoke an adolescent playfulness.

March 20-April 25
Teresita Fernandez
Combining pre-made elements with site-specific manipulations, Fernandez addresses the emotive effects of architecture and ornamentation.

Biographies: Philadelphia Narratives
Personal, diaristic work by area artists, including Don Camp, Sarah McEneaney, Marilyn Holsing, Bhakti Ziek, Michael O'Reilly, and Shashwati Talukdar.

May 14-July 3
Penn Collects: Four Alumni Collections
Showcases contemporary art collections of University of Pennsylvania alumni.

August
Note: Galleries closed for annual maintenance.

September 11-October 31
John Isermann: Fifteen
Terry Adkins: Muffled Drums

Permanent Collection
No permanent collection. **Architecture:** New ICA boasts a 10,000 sq. ft., two-story exhibition gallery, auditorium, garden, archival library, and cascading public spaces in a Neo-Industrial style building, completed in 1991 by Adele Naude-Santos and Jacob/Wyper Architects.

Admission: Adults, $3; artists, seniors, students $2; children under 12, PENNcard holders, free. Sun., free, 11-noon. Handicapped accessible.
Hours: Wed.-Fri., 12-8; Sat.-Sun., 11-5. Closed Mon. and Tues.
Programs for Children: Special education programs and workshops available. Call for dates and descriptions.
Tours: Thurs., 5:15. Groups call (215) 898-7108.
Food and Drink: Visitors can picnic on the nearby University of Pennsylvania Campus.
Museum Shop: Museum catalogues, prints, and other merchandise on sale in lobby.

Pennsylvania Academy of the Fine Arts

Broad & Cherry Sts., Philadelphia, PA 19102
(215) 972-7600
http://www.pafa.org

1998 Exhibitions
Continuing
Two Centuries of Collecting
Comprehensive survey of the museum's 18th- to 20th-century collection combines paintings and sculpture with interpretive components.

Interior of the Museum of American Art of the Pennsylvania Academy of the Fine Arts, Philadelphia, Pennsylvania.

Thru January 3
Ida Applebroog: Nothing Personal, Paintings 1987-1997
Paintings by the New York artist that explore real and ideal views of human relationships with irony and macabre humor.

Season's Greetings: Artists' Holiday Cards
Greeting cards by historical and contemporary artists.

January 9-March 7
Parks and Portraits: Dona Nelson, 1983-88
The "Park Series" by this noted Philadelphia painter.

January-April
I'll Make Me a World
In conjunction with a city-wide celebration of African American culture, an exhibition of selected graphics by African-American artists from the collection.

early March-early May
Postwar Prints: Recent Acquisitions
Recent acquisitions from the museum's graphics collection.

May 8-May 30
Annual Student Exhibition and Graduate Thesis Exhibition
Works in all media by Pennsylvania Academy students. Most works for sale.

June 19-September 26
"Golden Age" Illustration
Turn-of-the-century graphics from the museum's permanent collection.

Maxfield Parrish, 1870-1966
Retrospective explores the artistic influences of this American illustrator's 70-year career, including paintings, mural studies, drawings, prints, artifacts, and ephemera. (T)

October 9, 1999-January 2, 2000
John Henry Twachtman: An American Impressionist
A major retrospective of the Cincinnati-born artist arranged thematically to highlight the four important periods of his career: his early work, European period, Connecticut and Gloucester years, and late work. (T)

December 1999-February 2000
Barry Goldberg
Works by this recent Pennsylvania Academy graduate.

Permanent Collection

Paintings, sculptures, works on paper spanning more than three centuries of American art. **Highlights:** Diebenkorn, *Interior with Doorway;* Eakins, *Portrait of Walt Whitman*; Graves, *Hay Fever*; Henri, *Ruth St. Denis in the Peacock Dance*; Hicks, *The Peaceable Kingdom*; Homer, *Fox Hunt*; Peale, *The Artist in His Museum*; Pippin, *John Brown Going to His Hanging;* Rush, *Self-Portrait*; Wyeth, *Young America*. **Architecture:** Philadelphia's finest example of High Victorian Gothic and a National Historic Landmark, designed in 1876 by Frank Furness and George Hewitt; restorations in 1976 by Hyman Myers and 1994 by Tony Atkin & Associates.

Admission: Adults, $5; seniors, students, $4; children under 12, $2; members, children under 5, free. Handicapped accessible.
Hours: Mon.–Sat., 10–5; Sun., 11–5. Closed holidays.
Programs for Children: Saturday workshops throughout the year; Tues. and Thurs. activities and art camp during summer.
Tours: Weekends at 12:30, 2. Free with admission. Group tours available daily with reservation, call (215) 972-1667.
Food & Drink: The Museum Café serves breakfast breads, lunch, and snacks. Open Mon.–Fri., 8:30–3; Sat., 10-3; Sun., 11-3.
Museum Shop: Offers variety of gift items, art books, cards, handcrafted jewelry, gifts for children, and Persian miniatures.

Philadelphia Museum of Art

26th St. & Benjamin Franklin Pkwy., Philadelphia, PA 19130
(215) 763-8100
http://www.philamuseum.org

Branches: The Rodin Museum, 22nd St. & Benjamin Franklin Pkwy.,
Philadelphia, Pa. 19104, (215) 763-8100. Fleisher Art Memorial, 719
Catharine St., Philadelphia, Pa. 19147, (215) 684-4015. Fairmount Park
Houses, Cedar Grove and Mt. Pleasant, Philadelphia, Pa. (215) 684-7820.

1999 Exhibitions

Thru January 3
*Joseph Cornell/Marcel Duchamp: In
Resonance*
Explores the artistic collaboration between
two celebrated and highly individual 20th-
century artists. Features about 40 works by
each artist, including the *Marcel DuChamp
Dossier*, Cornell's tribute to his friend. (T)

Delacroix: The Late Work
The later work of painter Eugène Delacroix
(1798-1863), major artist of the Romantic
movement. (T) (Last venue)

Thru late January
Delacroix and the Romantic Image
25 works on paper by Delacroix and his
Romantic contemporaries to complement
Delacroix: The Late Work.

Joseph Cornell, *Untitled (Bébé
Marie)*, c. 1940. From *Joseph
Cornell/Marcel Duchamp: In
Resonance.* Collection Museum of
Modern Art, New York. Photo
courtesy Philadelphia Museum of Art.

Thru February 3
*Threads of Cotton, Threads of Brass: Arts of
Eastern India and Bangladesh from the
Stella Kramrisch Collection*
A range of objects of aesthetic power created for domestic and village use
from the 19th and 20th centuries.

Thru April 6
*Church Vestments and Embroideries from the 14th through the 18th
Century*
Some of the finest examples of European embroidery.

Thru August 2
Ink Traces: East Asian Calligraphy
Screens, handscrolls, album leaves, and decorative arts from the permanent
collection featuring calligraphy by Chinese, Japanese, and Korean masters.

January 23-April 4
Jasper Johns: Process and Printmaking
Examines the creative process behind the prints of this important American
artist, featuring proofs and finished prints spanning his entire career. (T)

February-May
Georgia O'Keeffe and Alfred Stieglitz
Focuses on the relationship between the legendary American painter and her photographer/gallery-owner husband, featuring four recently acquired drawings by O'Keeffe.

March 7-May 16
Mad for Modernism: Earl Horter and His Collection
This exhibition reunites over 50 works by Picasso, Duchamp, Braque, Matisse, and Brancusi, among others, from the now dispersed collection of this Philadelphia artist.

May 2-July 3
Raymond Pettibon
The first major American museum presentation of work by Pettibon, known for his compelling drawings and illustrated books. (T)

October 10, 1999-January 2, 2000
Pennsylvania Baroque: 1695-1755
The first comprehensive examination of developments in decorative and fine arts during Pennsylvania's pre-Revolutionary period.

The Kingdoms of Edward Hicks
Paintings, decorated objects, and important manuscript materials illuminate Bucks County artist Edward Hicks's deep spirituality and artistic talent. (T)

Permanent Collection

Significant works from many periods, styles, cultures in diverse media. Architectural installations and period rooms include a 12th-century French Romanesque façade and portal; 16th-century carved granite Hindu temple hall; Japanese tea house, temple and garden; Robert Adams's drawing room from Lansdowne House. Modern sculpture with major Brancusi collection; German folk art; Kretzschmar von Kienbusch collection of arms and armor. **Highlights:** Cézanne, *Large Bathers*; Duchamp, *Nude Descending a Staircase*; van Eyck, *Saint Francis Receiving the Stigmata*; Van Gogh, *Sunflowers*; Picasso, *The Three Musicians*; Poussin, *Birth of Venus*; Renoir, *The Bathers*; Rubens, *Prometheus Bound*; Saint-Gaudens, *Diana*; van der Weyden, *Crucifixion with the Virgin and Saint John*. **Architecture:** 1928 Greek revival building by the firm of Horace Trumbauer, and Zantzinger, Borie, and Medary; 1940 Oriental Wing; 1992–95 reinstallation of European collection, Jeffrey D. Ryan of Jackson & Ryan Architects.

Admission: Adults, $8; senior citizens, students with ID, children 5-18, $5. Handicapped accessible; wheelchairs available, TDD 215 684-7600.
Hours: Tues.-Sun., 10-5; Wed., 10-8:45. Closed Mon., holidays.
Programs for Children: Family Day each Sunday, with programs that include a studio session; $1 for member's children, $2 for children of non-members. Parents may attend programs free.
Tours: Tues.-Sun., hourly, 10-3. Call (215) 684-7923 for information.
Food & Drink: Restaurant open Tues.-Fri., 12-3; Wed., 5-7:30; Sat., 12-5; Sun., 11-4. Espresso Cafe open Sat.-Sun., noon. Cafeteria open Tues.-Fri., 8:30-3:30; Sat.-Sun., 10-4.
Museum Shop: Offers books, jewelry, textiles, ceramics, and other gifts.

University of Pennsylvania Museum of Archaeology and Anthropology

**33rd and Spruce Streets,
Philadelphia, PA 19104
(215) 898-4000
http://www.upenn.edu/
museum**

1999 Exhibitions

Thru January 3
Treasures of the Chinese Scholar
Selections of "scholar art" dating from the Han Dynasty of 206 B.C. through the Qing Dynasty of the 20th century, including calligraphy, painting, works in wood, lacquer, ivory, stone, horn, and metal.

Thru May
Roman Glass: Reflections on Cultural Change
More than 200 examples of Roman glass and associated materials dating from the first century B.C. through the sixth century A.D.

Goddess Astarte with Lotus Flowers, Canaanite, Late Bronze Age (c. 1539-1175 B.C.) Photo courtesy University of Pennsylvania Museum of Archaeology and Anthropology.

January 23-March 28
Layers Through the Mist
Features more than 40 color photographs of Vietnamese life taken during the 1994 Tet celebration.

Permanent Collection

The museum is dedicated to the understanding of cultural diversity and the exploration of the history of mankind. The collection includes Ancient Egyptian and Mesopotamian antiquities dating to 3000 B.C. and beyond, including a 12-ton granite Sphinx of Ramses II and the world's earliest known ancient wine jar (circa 5400-5000 B.C.); classical Greek pottery and coins; African gallery features West African masks and Benin bronze collection; Mayan stele and other objects from Meso-America; monumental Chinese sculptures and Buddhist art from Asia; several exhibitions exploring Native American cultures.

Admission: Adults, $5; students, seniors, $2.50; members, children under 6, free. Sun., free through May 23. Handicapped accessible.
Hours: Tues.-Sat., 10-4:30; Sun., 1-5. Closed Mon., holidays.
Programs for Children: Offers workshops, programs associated with special exhibitions. Pyramid Shop features toys and books.
Tours: Most Sat., Sun., 1:30. Call (215) 898-4015 for information.
Food & Drink: Café open Tues.-Sat., 10-3:30; Sun., 1-4. Closed Mon.
Museum Shop: Open during museum hours, closes Sun. at 4:30. Pyramid Shop for children open Tues.-Fri., 10-2:30; Sat., 11-4:30; Sun., 1-5.

The Carnegie Museum of Art

4400 Forbes Ave., Pittsburgh, PA 15213
(412) 622-3131
http://www.clpgh.org/cma

1999 Exhibitions

Ongoing
An Art Deco Masterpiece: The Chariot of Aurora *from the Normandie*
A dazzling, recently restored 18' x 26' wall relief of gilded and lacquered plaster by French artists Jean Dupas and Jean Dunand that celebrates the glory of French decorative arts.

Thru January 10
Philip Pearlstein World War II Drawings
40 early drawing and watercolor studies depicting soldiers and prisoners of war by one of the century's foremost figurative painters.

Thru January 31
Christopher Wool
The artist examines abstraction of image and language through patterns, stenciled words, stamped images, and silkscreens.

Thru February 14
Forum: James Welling
The first one-man museum show of Welling's photography, which ranges from depictions of local landscapes to thoroughly abstract works.

Thru March 21
C'est Magnifique: French Decorative Art
Objects from the permanent collection, ranging from Sèvres porcelain to silver by Christofle.

Thru March 28
Zigzags and Speed Stripes: The Art Deco Style
A look at the exuberant, colorful, and eclectic style of the 1920s and 1930s that was applied to everything from skyscrapers to tea services.

May 1-July 11
Soul of Africa: African Art from the Han Coray Collection
More than 200 outstanding works from Central and West Africa assembled between 1916 and 1928, including masks, sculptures, and objects. (T)

November 6, 1999-March 26, 2000
1999 Carnegie International
One of the most important and prestigious international surveys of contemporary art in North America.

Permanent Collection
French Impressionist and Post-Impressionist paintings; 19th- and 20th-century American art; contemporary American and European paintings, sculpture; American, English, Continental furniture, silver, ceramics; Asian and African art; monumental architectural casts. **Highlights:** Baumgarten, *The Tongue of the Cherokee*; Serra, *Carnegie*; Kiefer, *Midgard*; Bonnard, *Nude in Bathtub*; Homer, *The Wreck*; de Kooning, *Woman VI*; Monet, *Water*

Lilies; de Saint-Germain, *Long Case Clock*; Meissen, *Covered Beaker*; film and video program; sculpture court. **Architecture:** 1896–1907 Beaux Arts Carnegie building by Longfellow, Alden and Harlow; 1974 Bauhaus-style Sarah Scaife Galleries by Edward Larrabee Barnes.

Admission: Adults, $6; seniors, $5; students, children 3-18, $4; members, free. Handicapped accessible; wheelchairs available.

Hours: Tues.-Sat., 10-5; Sun., 1-5; Mon., 10-5, July-Aug. only.

Programs for Children: Offers programs and classes. Call (412) 622-3288.

Tours: Free gallery tours are held daily. Special group tours may be arranged by appointment, (412) 622-3289.

Food & Drink: Museum Café open Tues.-Sat., 11:30-3. Coffee Cart open Tues.-Sat., 10-4; Sun., 1-4.

Museum Shop: Open during museum hours.

The Frick Art Museum

7227 Reynolds St., Pittsburgh, PA 15208
(412) 371-0600

1999 Exhibitions

Thru Jan. 10

William Sydney Mount: American Genre Painter

Examines visions of everyday life through paintings, oil sketches, drawings, and prints by this 19th-century American genre painter. Catalogue. (T)

February 12-April 11

François Bonvin: Realist painter

An exhibition to introduce visitors to this early mentor of Courbet and important but often overlooked painter of still-life and genre scenes.

William Sidney Mount, *The Banjo Player*, 1856. From *William Sidney Mount: Painter of American Life*. Photo courtesy Museum at Stony Brook and American Federation of Arts.

May 7-July 4

A Victorian Salon by the Sea: Paintings from the Russell-Cotes Collection

A rare opportunity to view 19th-century British art in its original aesthetic context: a salon-style installation. (T)

July 30-October 10

Shamans, Gods, and Mythic Beasts: Colombian Gold and Ceramics in Antiquity

Gold and ceramic objects, from 1200 B.C. to A.D. 1600, comprise this first traveling exhibition to highlight ancient Colombian ceramic sculpture. (T)

November 5, 1999-January 10, 2000

The Museum and the Photography: Collecting Photography at the Victoria and Albert Museum, 1853-1900

19th-century photographs, including images by Julia Margaret Cameron.

Permanent Collection

Rare 14th- and 15th-century Florentine and Sienese paintings by Duccio, Sassetta, Giovanni de Paolo; portrait by Rubens; landscape by Boucher, devotional altarpiece by Jean Bellegambe; Dutch genre scene on panel by Jan Steen; 16th-century tapestries; Chinese porcelains; Renaissance bronzes; terra-cotta bust by Houdon; 18th-century French salon room; 17th-century English country-house room. **Architecture:** An intimately scaled classical structure built in 1969 by Pratt, Schafer, and Slowik.

Admission: Free. Handicapped accessible.
Hours: Tues.-Sat., 10-5:30; Sun., noon-6. Closed Mon.
Tours: Wed., Sat.-Sun., 2. Call (412) 371-0606 to arrange group tours.
Food & Drink: Frick Café open Tues.-Sat., 10-5:30; Sun., noon-6.

The Andy Warhol Museum

117 Sandusky Street, Pittsburgh, PA 15212
(412) 237-8300
http://www.clpgh.org/warhol/

1999 Exhibitions

Thru January 17

In Your Face
Explores how society uses photography to categorize behavioral types. Includes Warhol's *Thirteen Most Wanted Men* series of 1964 and work by Deborah Kass, Arne Svenson, Nancy Burson, and Rineke Dijkstra.

Permanent Collection

The Andy Warhol Museum, opened in May 1994, is a collaborative project of the Carnegie Institute, the Dia Center for the Arts, and The Andy Warhol Foundation for the Visual Arts. Covers the entire range of Warhol's works, including 1950s illustrations and sketchbooks, 1960s Pop paintings of consumer products and celebrities; portraits and works from the 1970s and 1980s; and collaborative paintings made with younger artists. Extensive archival holdings of working and source material, time capsules, video and audiotapes, scripts, diaries, and correspondence. **Architecture:** Former industrial warehouse built in 1911, with terracotta façade of ivory-colored Classical ornament; renovated by New York architect Richard Gluckman.

Admission: Adults, $6; seniors, $5; students with ID, children over 3, $4; members, free.
Hours: Wed., Sun., 11-6; Thurs.-Sat., 11-8. Closed Mon.-Tues.
Tours: Call (412) 237-8300 two weeks in advance for group reservations.
Food & Drink: Café open during museum hours. Friday Happy Hour, 5-7.

The Barnes Foundation

300 North Latch's Lane, Merion, Pennsylvania 19066-1759
(610) 667-0290
http://www.thebarnes.org

Permanent Collection

One of the finest private collections of early French modern and post-Impressionist paintings in the world with over 2,500 art objects, including 800 paintings. Established by Dr. Albert C. Barnes in 1922 to "promote the advancement of education and the appreciation of the fine arts." Arboretum noted for its diversity of species and rare specimens. **Highlights:** Works by Picasso, Renoir, Cézanne, Matisse, Monet, and Degas. **Architecture:** 1925 French limestone structures; 1994 renovations.

Admission: Adults, children 7 and over, $5. Handicapped accessible.
Hours: Fri., Sat., 9:30-5; Sun., 12:30-5.
Tours: Self-guided tours; audio tour available.
Museum Shop: A wide variety of prints from the collection, along with specialty items, educational books, and an award-winning CD of the entire collection.

Pablo Picasso, *Harlequins,* 1905. Photo courtesy Barnes Foundation.

Museum of Art, Rhode Island School of Design

224 Benefit St., Providence, RI 02903
(401) 454-6500
http://www.risd.edu/museum

1999 Exhibitions

Thru January 3
Gifts of the Nile: Ancient Egyptian Faience
Over 150 works covering 3,000 years explore the use of this non-clay ceramic medium, which the ancients compared to the moon and stars. (T)

Joseph Lindon Smith and His Circle in Dublin, New Hampshire

Thru January 17
Drawn from the Collection: Part of the Fabric

Thru March 7
Nineteenth-Century Japanese Printmaking

Thru April 4
Tradition and Innovation in American Watercolors

January 20-April 4
Tactile Technology: Contemporary Japanese Textile Design

January 27-April 11
Works from the Museum's Permanent Collection

February 17-April 11
Pepon Osorio

March 10-June 6
Spring Blossoms: Seasonal Japanese Prints

April 7-July 11
The Sari

May 19-October 3
Sitings '99

May 21-June 6
Annual Graduate Student Exhibition

June 9-September 5
Meisho: *Depictions of Famous Places in Japan*

June 16-October 24
Barnaby Evans

July-August
Recent Acquisitions 1994-99

September-December
Islamic Objects

Gorham Manufacturing Company, *Pendant Necklace,* c. 1900. Photo by Erik Gould, courtesy Museum of Art, Rhode Island School of Design, Helen M. Danforth Acquisition Fund.

September 24-November 7
RISD Faculty Biennial

November 19, 1999-January 16, 2000
Ewing Show

Permanent Collection
Highlights include Greek and Roman art; Asian art and textiles; masterpieces of European and American painting and sculpture; French Impressionist painting; American furniture and decorative arts.
Architecture: 1897 original galleries; 1906 Colonial Revival addition by Stone, Carpenter & Willson, called Pendleton House, the first American wing in the U.S.; 1926 Radeke Building (main building) by William T. Aldrich; 1993 Contemporary Daphne Farago Wing by Tony Atkin & Associates.
Admission: Adults, $5; seniors, $4; college students with ID, $2; children 5-18, $1; under 5, free. Handicapped accessible. Aids are available.
Hours: Wed.-Sun., 10-5; Fri., 10-8. Closed Mon., Jan. 1, July 4, Thanksgiving, Dec. 25.
Programs for Children: Workshops, after-school activities, and family programs throughout the year.
Tours: Call (401) 454-6534.
Museum Shop: Posters, cards, catalogues, art reproductions, jewelry, handicrafts, work by RISD faculty and alumni, children's activity books and kits. (401) 454-6540.

Gibbes Museum of Art
135 Meeting St., Charleston, SC 29401
(843) 722-2706

Giuseppe Ceracchi, *George Washington.*
From *In Pursuit of Refinement:
Charlestonians Abroad, 1740-1860.* Photo courtesy Gibbes Museum of Art.

1999 Exhibitions

Thru January 7
Bearing Witness: Contemporary Works by African-American Women
The collective artistic achievement of Alison Saar, Faith Ringgold, Carrie Mae Weems, and Lorna Simpson, among others. (T)

Thru January 31
The Roman Remains: John Izard Middleton's Visual Souvenirs, 1820-1823
Features 49 pencil and ink works by American expatriate John Izard Middleton, who dedicated his life to the study of antiquity and classical ruins.

Thru March 14
Edward Rice: Selected Architectural Paintings, 1978-1998
Approximately 30 work that depict the artist's broad range of intellectual and visual statements.

Thru September 6
The Charleston Renaissance: Anna Heyward Taylor
Focuses on the work of Anna Heyward Taylor, an artist of the Charleston
Renaissance and colleague of William Merritt Chase.

Thru October 10
An Inside Look: Conserving Miniature Portraits
This exhibition highlights small landscapes and images of Charleston and
miniature portraits and explores conservations practices for various media.

Thru November 28
Embracing the Far East: The Hume Collection
The third in a series of exhibitions focusing on the development of the
Gibbes Japanese Print Collection and the local artists who were influenced
by these works. Includes woodblock prints by Hokusai and Hiroshige.

April 9-July 3
In Pursuit of Refinement: Charlestonians Abroad, 1740-1860
125 fine and decorative art objects associated with 18th-century and
antebellum aristocratic life in Charleston. Explores the interaction between
Charleston and Europe before, during, and after the Revolutionary War.

July 13-September 19
Trains that Pass in the Night: The Railroad Photographs of O. Winston Link
Features over 70 photographs that chronicle the history of the Norfolk and
Western Railway and capture images of the last steam engines.

Permanent Collection
Over 7,000 objects ranging from paintings, prints, and drawings to
photography, sculpture, and miniature rooms. Significant collection of
American paintings, reflecting Charleston's history and culture from the
Colonial South to the present. **Highlights:** Japanese print collection;
Elizabeth Wallace miniature rooms; and portrait miniatures.

Admission: Call for rates. Members, free. Handicapped accessible,
including elevators.
Hours: Tues.-Sat., 10-5; Sun., 1-5. Closed Mon.
Programs for Children: Programs throughout the year. Call for details.
Tours: Available by appointment.
Museum Shop: Open during museum hours.

Greenville County Museum of Art
420 College St., Greenville, SC 29601
(864) 271-7570

1999 Exhibitions
Thru January 10
Barbara Cooney: The Year of the Perfect Christmas Tree
Book illustrations from by the award winning illustrator.

Colorprint USA
The 25th annual exhibition of original color prints by 50 distinguished
American printmakers.

Thru January 17
African-American Art from the Permanent Collection
The museum's outstanding collection of African-American art includes
work by Jacob Lawrence, Romare Bearden, and William H. Johnson.

Betye Saar
In her new assemblages of found objects, Saar continues her satirical
commentary on the African-American experience.

Thru March 7
The Charleston Renaissance
A look at how Charleston artists used their work to call attention to the
city's charms, spurring historic preservation and tourism.

February 3-April 4
Shaman's Fire: The Late Paintings of David Hare
Although known primarily as a sculptor, Hare (d. 1992) devoted himself to
painting during the last decade of his career.

February 3-April 18
John Acorn
Features the series *Reflections on the 20th Century,* inspired by childhood
memories of WWII, and *Camouflage Man,* monumental wooden sculptures.

February 13-May 23
Morris Graves: The Early Work
Oil paintings from 1931 to 1938 show the young artist's movement toward
his own startling personal vision.

May 5-July 3
William Halsey
Explores important sub-themes developed at different stages of the artists
career, including Charleston architecture and figurative wall-paintings.

Permanent Collection
Southern-related art and contemporary art; the collection contains at least
one example from every major movement in American art from the early
1700s to the present day. Artists represented include Washington Allston,
George Healy, Georgia O'Keeffe, and Jasper Johns. **Architecture:**
Modernistic, reinforced concrete 1974 building with four floors of galleries,
by Craig, Gaulden & Davis.

Admission: Free. Handicapped accessible.
Hours: Tues.-Sat., 10-5; Sun., 1-5. Closed Mon., major holidays.
Programs for Children: School tours and gallery treasure hunts.
Tours: For information call (864) 271-7570.
Museum Shop: Unique gift items, original crafts, children's section.

The Knoxville Museum of Art

1050 World's Fair Park Dr., Knoxville, TN 37916
(423) 525-6101
http://www.knoxart.org

1999 Exhibitions

Thru January 10
Trashformations: Recycled Materials in American Art and Design
Chronicles the history of recycling in American art. (T)

Thru January 31
Lynn Chadwick: Sculpture from the Ursinus College Collection
Eleven large-scale bronze sculptures with maquettes and drawings illustrate
the development of Chadwick's artistic style.

Thru February 14
Contemporary Paintings from the Permanent Collection

Thru February 28
India: A Celebration of Independence, 1947-1997
Features 240 photographs that show the changing cultural awareness in
India over the past 50 years. (T)

February 5-May 23
Inner Eye: Contemporary Art from the Marc and Livia Straus Collection
Works by some of the most prominent contemporary artists, including
Deborah Butterfield, Anslem Kiefer, and Jeff Koons, among others.

May 4-July 11
*Twentieth-Century American Drawings from the Arkansas Art Center
Foundation Collection*
Drawings by Milton Avery, Edward Hopper, Thomas Hart Benton, Georgia
O'Keeffe, and others from one of the finest drawing collections in the U.S.

July 11-Ongoing
East Tennessee Art Currents II
The second in an exhibition series focusing on contemporary trends in
regional art.

October 15, 1999-February 6, 2000
The Haskell Collection of Contemporary Art
One of the foremost corporate collections of contemporary art. Includes
works by Frankenthaler, Frank Stella, Rauschenberg, Sam Francis, Al Held,
Gerhard Richter, Jasper Johns, Ellsworth Kelly, Joan Mitchell, Lichtenstein,
and Diebenkorn.

Permanent Collection

Strong holdings of art in all media by nationally and regionally known
artists since the 1960s. A broad range of artistic expression serves the
museum's diverse audience. **Highlights:** Works by Robert Rauschenberg,
Janet Fish, Red Grooms, Robert Longo, Charles Burchfield, Eudora Welty
and Robert Stackhouse. Recent acquisition of work by William T. Wiley,

John Ford, Carolyn Plochmann, Joseph Delaney, and David Bates, Chuck Forsman, John Kelley, Andrew Saftel, and Robert Van Vranken.
Architecture: Steel and concrete building faced in Tennessee pink marble, by renowned museum architect Edward Larrabee Barnes of New York, opened in 1990.

Admission: Adults, $4; seniors, $3; youths, $2; children under 12, members, free. Handicapped accessible.
Hours: Tues.-Thurs., Sat., 10-5; Fri., 10-9; Sun., noon-5. Closed Mon.
Programs for Children: ARTcade interactive gallery; Summer Art Workshops; Family Day.
Tours: Docent-led tours, Sun., 3.
Food & Drink: KMA Café open Tues.-Sat., 11-2.
Museum Shop: Two shops offer a wide range of jewelry, children's items, books, music, and unique gift items. Exhibition-related and regional-interest merchandise available.

Dixon Gallery and Gardens
4339 Park Avenue, Memphis, TN 38117
(901) 761-5250
http://www.dixon.org

1999 Exhibitions
Thru January 24
All Things Bright and Beautiful: California Impressionist Painting from the Irvine Museum
Over 50 paintings representing the work of regional California impressionists from 1890 to 1925.

February 7-April 18
Celebrating America: Paintings from the Manoogian Collection
A compelling visual record of American life from the 1820s to the 1920s through the stellar works of influential American artists.

June 27-September 5
Raoul Dufy: The Last of the Fauves
Presents 50 of the strongest oil paintings of the French artist's oeuvre and aims to restore his reputation as one of the most original and talented artists of the first half of the 20th century. (T)

September 19-November 28
A Taste for Splendor: Russian Imperial and European Treasures from the Hillwood Museum
A lavish exhibition of celebrated paintings, gorgeous decorative objects, and fine furnishings from the Hillwood collection. (T)

Permanent Collection
Fine arts museum specializing in French and American Impressionist and Post-Impressionist paintings; Stout Collection of 18th-century German porcelain, one of the finest in the world. **Architecture:** Georgian-style residence and gallery complex, surrounded by 17 acres of beautiful gardens, including formal English gardens, open vistas, and woodland areas.

Admission: Adults, $5; seniors, $4; students, $3; Children under 12, $1; members, free. Wheelchair accessible, interpretive tours for hearing impaired, braille handouts.
Hours: Tues.-Sat., 10-5; Sun., 1-5. Closed Mon., but gardens open with half-price admission.
Programs for Children: Tours, seasonal workshops, and performances.
Tours: Reserve at least one week in advance, (901) 761-5250.
Museum Shop: Gift and specialty items.

Edgar Degas, *Dancer*, c. 1885. Photo courtesy Dixon Gallery and Gardens.

Memphis Brooks Museum of Art

Overton Park, 1934 Poplar, Memphis, TN 38104
(901) 722-3500
http://www.brooksmuseum.org

1999 Exhibitions

Thru January 17
Treasures of Deceit: Archeology and the Forger's Craft
Explores how art historians and scientists determine whether a work of art is a genuine antiquity or a forgery. (T)

January 17-March 14
Ancient Gold: The Wealth of the Thracians, Treasures from the Republic of Bulgaria
Over 200 masterpieces of gold and silver metalwork from ancient Thrace, located in central Europe between 4,000 B.C. and the 4th century A.D. (T)

April 18-June 13
Duane Hanson
Examines the work of this 20th-century American artist known for his life-size and life-like plastic figures of ordinary people. (T)

July 11-September 12
A Renaissance Treasury: The Flagg Collection of European Decorative Arts and Sculpture
This exhibition features 70 precious objects dating from the 14th to the early 18th century from the private collection of Richard and Erna Flagg. (T)

August 22-November 21
Marsden Hartley: An American Modern
A survey of the art work of Marsden Hartley, an acclaimed artist and writer and key figure in the development of early American modernism.

October 3-November 28
The Allure of the East: Islamic Decorative Arts and European Orientalist Paintings
Features 55 paintings, textiles, furniture, decorative arts, and embellished copies of the Koran representing the exquisite ornamentation of Islamic art.

Permanent Collection
Spans twenty centuries of art, including core collections of Italian and Northern Renaissance and Baroque paintings and 18th- and 19th-century English and American portraiture; works by French Impressionists and contemporary American artists; selection of 17th- and 18th-century European decorative arts and Doughty ceramics.

Architecture: 1916 Beaux Arts building by James Gamble Rogers; 1973 and 1990 renovations and expansions; 1993–94 gallery renovation.

Marsden Hartley, *Still Life,* 1912. From *Marsden Hartley: American Modern.* Photo courtesy Frederick Weisman Art Museum, University of Minnesota and the Memphis Brooks Museum of Art.

Admission: Adults, $5; seniors, $4; students with I.D., youth (6-17), $2; members, children under 6, free. Handicapped accessible; wheelchairs available.

Hours: Tues.-Fri., 9-4; Sat., 9-5; Sun., 11:30-5. Closed Mon., July 4, Thanksgiving, Dec. 25, Jan. 1.

Programs for Children: Programs throughout the year. (901) 722-3515.

Tours: Sat., 10:30, 1:30; Sun., 1:30. Groups call (901) 722-3515.

Food & Drink: Brushmark Restaurant serves American bistro cuisine with daily soup, sandwich, seafood, and pasta specials. Open Tues.-Sun., 11:30-2:30.

Museum Shop: Items from around the world and the Mid-South region, including reproductions from the museum's permanent collection and special exhibitions.

Austin Museum of Art
Downtown
823 Congress Ave., Austin, TX 78701
(512) 495-9224
http://www.amoa.org

1999 Exhibitions
Thru January 17
New Works II: Mark Todd
Texas painter and poet Mark Todd creates large-scale, mixed-media paintings that combine words and images to examine American life.

Thru January 22
Cindy Sherman: The Complete Untitled Film Stills
A series of 69 black-and-white self-portrait photographs regarded as a landmark achievement of contemporary visual art.

January 30-April 3
It's Only Rock and Roll: Rock and Roll Currents in Contemporary Art
The first major exhibition to explore the emotional and intellectual force of
rock-and-roll in art since the '60s. Features work by such artists as
Rauschenberg, Warhol, Nam June Paik, Barbara Kruger, and Alan Rath.

April 17-June 20
Nature Morte: Late Twentieth-Century Meditations on the Natural World
Features paintings, photographs, mixed-media works, and installations by
six leading young artists who depict their vision of the natural world.

June 26-August 22
Queen of My Room: A Survey of Work by Julie Speed, 1989-1999
The first solo museum exhibition of the intricate, surreal narratives by the
Austin-based artist.

June 26-August 22
Oil Patch Dreams: Images of the Petroleum Industry in American Art
Traces the development of oil and the oil industry's impact on the world's
economies, environments, and cultures through approximately 60 paintings,
by artists such as Warhol, Thomas Hart Benton, Charles Umfauf, and more.

Admission: Adults, $3; seniors, students, $2; Thurs., $1; children under 12,
free. Wheelchair accessible.
Hours: Tues.-Sat., 11-7; Thurs., 11-9; Sun., 1-5. Closed Mon., holidays.
Programs for Children: Art School offers classes for all ages.
Tours: Call the Education Dept. at (512) 458-8191, ext. 238. Reservations
required for groups.
Museum Shop: Open during museum hours; also Mon., 11-7.

Austin Museum of Art—Laguna Gloria

3809 W. 35th St., Austin, TX 78703
(512) 458-8191

**1999
Exhibitions**
Thru January 3
*The Art School
Faculty
Exhibition*

**January 30-
April 3**
*It's Only Rock
and Roll*
In conjunction
with *It's Only
Rock and Roll* exhibition at the downtown location.

Julie Speed, *Setting the World on Fire*, 1997. From *Queen of My Room: A Survey
of Work by Julie Speed, 1989-1999*. Photo courtesy Austin Museum of Art.

April 24-July 25
Nature: The 18th Annual Family Exhibition

Permanent Collection

Changing exhibitions of 20th-century American art. Objects from the small permanent collection are not always on exhibit. Outdoor sculpture from the permanent collection is displayed on the grounds. **Architecture:** 1916 historic landmark Mediterranean-style villa by Page.

Admission: Adults, $2; seniors, students, Thurs., $1; children under 12, free.
Hours: Tues-Sat., 10-5; Thurs., 10-9; Sun., 1-5. Closed Mon., holidays.
Tours: Call (512) 458-8191 for reservations.

Jack S. Blanton Museum of Art
(formerly the Archer M. Huntington Art Gallery)
The University of Texas at Austin
23rd & San Jacinto, Austin, TX 78712
(512) 471-7324
http://www.utexas.edu/cofa/hag

1999 Exhibitions
January 16-March 7
Cantos Paralelos: Visual Parody in Contemporary Argentinean Art
Drawing from private and public collections in Buenos Aires, this exhibition includes 70 works by Argentina's most innovative artists, including Antonio Berni, Jorge de la Vega, Alberto Heredia, and others.

Permanent Collection

Two locations on the University campus offer over 12,000 works of art that span the history of Western civilization, from

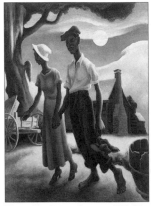

Thomas Hart Benton, *Romance,* 1931-32. Photo by George Holmes, courtesy Jack S. Blanton Museum of Art, Gift of Mari and James A. Michener.

antiquity to the present, including examples of 20th-century American art, Western American art, contemporary Latin American art, and European painting, sculpture, and ancient art. **Highlights:** Gutenberg Bible, on display at the Harry Ransom Center, located at 21st & Guadalupe.

Admission: Free. Handicapped accessible, including ramp and elevator.
Hours: Mon.-Fri., 9-5; Thurs., 9-9; Sat.-Sun., 1-5.
Programs for Children: Programs offered to grades K-12, including the Art Enrichment and Expanding Horizons programs for 4th-6th grades.
Food & Drink: Cafeterias nearby in Fine Arts building, Thompson Conference Center, or Dobie Mall (across from Harry Ransom Center).
Museum Shop: Located at guard desk; offers books postcards, and catalogues.

Dallas Museum of Art

1717 N. Harwood, Dallas, TX 75201
(214) 922-1200, (214) 922-1355 [TDD]
http://www.dm-art.org

1999 Exhibitions

Thru January 10
The Jewels of Lalique
A dazzling display of jewelry designed by master artisan René Lalique.

Thru January 16
Concentrations 32: Anne Chu and Bonnie Collura
Two emerging and ambitious sculptors whose work reflects a variety of contemporary issues in form and content.

Thru February 7
Quilts: Off the Bed and on the Wall
Selected 19th- and 20th-century quilts from the permanent collection.

Thru April 11
Bill Viola: The Crossing
A video/sound installation that portrays the passing from life into death with poetic power and unforgettable beauty, grace, and clarity.

February 14-April 25
Brice Marden: Works of the 1990s
A survey of the American artist's recent paintings, drawings, and prints, on loan from important private and public collections. (T)

May 30-September 5
Golden Treasures from the Ancient World
Two exhibitions, *Treasures from the Royal Tomb of Ur* and *Ancient Gold Jewelry from the Dallas Museum of Art*, depict wonders from ancient western civilization. (T)

July 11-October 3
Fabulous Forms: Prestige Art of the Edonda of Zaire

September 12-November 28
Diego Rivera: Art and Revolution
The first major retrospective of the artist's work in 13 years. Includes 125 paintings, drawings, frescoes, and prints executed in Rivera's innovative and highly influential painting style: a combination of European traditions with socialist ideals and Mexican culture. Catalogue. (T)

Pablo Picasso, *Bottle of Port and Glass,* 1919.
Photo courtesy Dallas Museum of Art.

October 30, 1999-January 30, 2000
Georgia O'Keeffe: The Poetry of Things
Examines the aesthetics of the acclaimed 20th-century American artist through her paintings of objects, including shells, rocks, trees, bones, and doors. Features approximately 60 paintings and works on paper. (T)

Permanent Collection

Arts of Africa, Asia and the Pacific; contemporary paintings and sculpture; ancient American art. **Highlights:** Wendy and Emery Reves Collection of Impressionist paintings, sculpture and decorative arts. **Architecture:** 1984 minimalist building of Indiana limestone and 1993 addition by Edward Larrabee Barnes; 1985 recreated Mediterranean villa housing Reves collection.

Admission: Free. (Fees for some special exhibitions.) Handicapped accessible, including elevators, ramps, wheelchairs, and braille signage.
Hours: Tues., Wed., Fri., 11-4; Thurs., 11-9; Sat.-Sun. and holidays, 11-5. Closed Mon.
Programs for Children: Gateway Gallery Family Education Area: recent addition, Stories in Art, features interactive displays based on works in DMA's collection, includes computers and hands-on activities. Drop-in Art, Sat. 1-3:30.
Tours: Daily collection tour, Tues.-Fri., 1; Sat.-Sun., 2; Thurs., Art Talk, 7.
Food & Drink: Atrium Café serves light refreshments, open Tues., Wed., Fri., 11-3:30, Thurs. 11-8:30, Sat.-Sun., 11-4:30. Seventeen Seventeen Restaurant serves exceptional gourmet meals, open Tues.-Fri., Sun., 11-2. Picnic areas available in Sculpture Garden. For reservations call (214) 880-9018.
Museum Shop: Offers a variety of art related books, posters, and cards, jewelry, and other unique gift items. Call (214) 922-1256.

Amon Carter Museum

3501 Camp Bowie Blvd., Fort Worth, TX 76107
(817) 738-1933
http://www.cartermuseum.org

1999 Exhibitions

Thru January 3
Masterworks of the Photography Collection: Picturing Modern Life
A look at how different functions of photography have impacted our lives.

Stuart Davis, *Bass Rocks No. 2,* 1939. Photo courtesy Amon Carter Museum, gift of Nancy Lee and Perry R. Bass.

Thru January 24
Self-Taught Artists of the Twentieth Century: An American Anthology
Approximately 250 paintings, sculptures, drawings, and decorative objects that trace the roots and development of self-taught art in this century. (T)

January 9-April 11
Masterworks of the Photography Collection: Land of Plenty, Land of Contrast
Examines the idea of America as a land of plenty, through examples of American photography from 1840 to the present. Includes works by Dorothea Lange, Edward Curtis, Alfred Stieglitz, and others.

February 5-April 4
William Sydney Mount: American Genre Painter
Examines visions of everyday life through paintings, oil sketches, drawings, and prints by this 19th-century American genre painter. Catalogue. (T)

Permanent Collection
Art of the American West including works by Remington and Russell; 19th- and 20th-century painting, sculpture, graphic art by Davis, Demuth, Harnett, Homer, Marin, Nadelman, O'Keeffe. **Highlights:** Comprehensive collection of American photography; Heade, *Thunderstorm over Narraganset Bay*; Lane, *Boston Harbor*; Remington, *A Dash for the Timber*. **Architecture:** 1961 building by Philip Johnson.

Admission: Free. Handicapped accessible, including parking spaces.
Hours: Tues.-Sat., 10-5; Sun., 12-5. Closed Mon., holidays.
Programs for Children: Education programs for all ages, year-round.
Tours: Tues.-Sun., 2. Groups call (817) 737-5913 two weeks in advance.
Museum Shop: Recently expanded product line offers books, cards, and other items related to American art.

Kimbell Art Museum

3333 Camp Bowie Blvd., Fort Worth, TX 76107
(817) 332-8451
http://www.kimbellart.org

1999 Exhibitions
Thru January 17
The Kimbell Collections
Surveys over 150 works from antiquity to the 20th century.

Guests of Honor: Masterpieces by Caspar David Friedrich from the Nationalgalerie, Berlin, and the Museum Folkwang, Essen
A rare opportunity to view three stunning masterworks by the German Romantic landscape painter.

January 31-April 25
Gifts of the Nile: Ancient Egyptian Faience
Over 150 works covering 3,000 years explore the use of this non-clay ceramic medium, which the ancients compared to the moon and the stars. (T)

January 31-May 2
Matisse and Picasso: A Gentle Rivalry
Documents the competitive artistic dialogue between two of the greatest masters of the 20th century.

Permanent Collection
European painting and sculpture through the early 20th century; Asian paintings, sculptures, ceramics; Meso-American, African, ancient Mediterranean art. Recent acquisitions include Jacopo Bassano, *Franciscan*

Friar, and Claude Monet, *Weeping Willow.* **Highlights:** Caravaggio, *Cardsharps*; Cézanne, *Man in a Blue Smock*; Duccio, *Raising of Lazarus*; Fra Angelico, *Saint James Freeing Hermogenes*; Guercino, *Portrait of a Lawyer*; Houdon, *Portrait of Aymard-Jean de Nicolay* ; de La Tour, *Cheat with the Ace of Clubs*; Mantegna, *Holy Family with Saint Elizabeth and the Infant Saint John the Baptist;* Matisse, *L'Asie*; Mondrian, *Composition No. 8*; Monet, *Pointe de la Heve at Low Tide*; Picasso, *Man With a Pipe* and *Nude Combing Her Hair*; Poussin, *Venus and Adonis*; Rembrandt, *Portrait of a Young Jew*; Rubens, *The Duke of Buckingham;* Ruisdael, *A Stormy Sea*; Titian, *Madonna and Child with Saint Catherine and the Infant Saint John the Baptist.* **Architecture:** One of Louis Kahn's finest creations, designed between 1967 and 1972, set in a park environment with reflecting pools.

Admission: Free, except special exhibitions: adults, $6-10; seniors, students, $4-8; children 6-11, $2-6. Handicapped accessible. Hearing-impaired workshops held regularly.
Hours: Tues.-Thurs., Sat., 10-5; Fri., 12-8; Sun., 12-5. Closed Mon., holidays.
Programs for Children: Workshops, storytelling, family festivals, and treasure hunts.
Tours: Group tours call two weeks in advance, (817) 332-8451, ext. 249 (school groups) or ext. 229 (all other groups).
Food & Drink: Enjoy famous homemade soups, salads, sandwiches, light entrées, desserts, gourmet coffees, tea, wine, and beer. Tues.-Thurs., Sat., 11:30-2; Fri., 12-2, 5:30-7:30; Sun., 12-2. Reservations recommended for 8 or more; (817) 332-8451.
Museum Shop: An incredible variety of books, games, toys, crafts, jewelry, notecards, postcards, posters, videos, and hard-to-find books on art and architecture. (817) 332-8451, ext. 244.

Modern Art Museum of Fort Worth

1309 Montgomery St. at Camp Bowie Blvd., Fort Worth, TX 76107
(817) 738-9215
http://www.mamfw.org

1999 Exhibitions
Thru January 24
Self-Taught Artists of the 20th Century: An American Anthology
Approximately 250 paintings, sculptures, drawings, and decorative objects that trace the roots and development of self-taught art in this century. (T)

February 13-April 11
The Architecture of Reassurance: Designing the Disney Theme Parks
Explores the architecture of one of the great postwar American icons: Disneyland. Includes plans, drawings, paintings, and models. (T)

May 30-August 8
Bruce Nauman
An early installation by Bruce Nauman, whose 12-ft.-high sculptural work *Left or Standing* manipulates space and color to evoke powerful emotions.

August 22-October 24
Francis Bacon: A Retrospective Exhibition
A landmark exhibition of one of 20th-century Britain's greatest painters, known for his images of isolation, despair, horror, and tortured human forms. 60 paintings represent each significant period of the artist's career. Catalogue. (T)

Permanent Collection
Surveys all major developments in 20th-century figurative and abstract art, focusing on American and European art after 1945. International collection of contemporary photography. Contemporary sculpture outside on museum grounds. Includes 3,000 paintings, sculptures, photographs, drawings, and prints ranging from Pollock and Motherwell to Rothenberg and Sherman.
Highlights: Picasso, *Reclining Woman Reading* and *Head of a Woman*; Rothko, *Light Cloud, Dark Cloud*; Still, *Untitled*; Guston, *Wharf*; Kiefer, *Quaternity*; Richter, *Emma* and *Ferrari*; Warhol, *Twenty-five Colored Marilyns*; extensive collection of works by Motherwell. **Architecture:** 1901 gallery; 1954 first museum building by Bayer; 1974 addition with garden courtyard and solarium by Ford & Associates.

Admission: Free. Handicapped accessible (ramp and chair lift).
Hours: Tues.-Fri., 10-5; Sat., 11-5; Sun., 12-5. September 18-November 17, Tues., 10-9. Closed Mon., holidays.
Programs for Children: Learning to Look tours and a variety of classes offered year-round.
Tours: Free. For group tour reservations call (817) 738-9215 at least two weeks in advance.
Museum Shop: Extensive collection of books relating to modern art.

The Modern at Sundance Square
410 Houston St., Fort Worth, TX 76102
(817) 335-9215
http://www.mamfw.org

Admission: Free. Handicapped accessible.
Hours: Mon.-Thurs., 11-6; Fri.-Sat., 11-10; Sun., 1-5.
Opened in 1995 as an annex of the Modern Art Museum of Fort Worth, to exhibit selections of modern and contemporary American and European art and small-scale traveling exhibitions. Located downtown in the historic 1929 Sanger Building, with 1995 renovation by architect Ames Fender.

Contemporary Arts Museum

5216 Montrose Blvd., Houston, TX 77006
(713) 284-8250
http://www.camh.org

1999 Exhibitions

Through January 3
Liz Ward: Genealogies
New work that examines ecology, environmental issues, passage and loss.

Andreas Gursky
11 large-scale works by the German photographer Andreas Gursky depict surreal landscapes and environments. (T)

Through February 14
Mexico Ahora: Punto de Partida/Mexico Now: Point of Departure
Features 15 emerging Mexican artists whose work is characterized by invention and force of expression.

January 8-February 7
At Home & Abroad: 20 Contemporary Filipino Artists
A dynamic exhibition of works by a post-martial law generation of Filipino artists explores issues of identity and cultural heritage.

February 12-April 18
Texas Draws
Exciting works on paper by established and emerging artists in Texas.

March 3-April 25
The Chase Manhattan Collection
A selection of the finest works from Chase Manhattan's corporate collection of 9,000 art objects. (Also at Museum of Fine Arts, Houston.)

May 8-July 4
Other Narratives: Fifteen Years
Works by prominent artists of the 1980s, including the Guerilla Girls and others, address issues of self, society, history, and cultural marginalization.

November 1999-February 2000
Tony Oursler
Retrospective of popular artist Tony Oursler, who has been working in the field of video art since the 1970s. (T)

Permanent Collection
No permanent collection. **Architecture:** 1972 stainless-steel parallelogram building by Gunnar Birkerts and Associates; 1997 renovation by William F. Stern & Associates.

Admission: Free. Handicapped accessible, including ramp, parking.
Hours: Tues., Wed., Fri., Sat., 10-5; Thurs., 10-9; Sun., 12-5. Closed Mon., Jan. 1, July 4, Thanksgiving, Dec. 25.
Programs for Children: Family programs designed around exhibitions.
Tours: Call the Education Dept. at (713) 284-8257 for information.
Food & Drink: Starbucks coffee and tea; urban park picnic area nearby.
Museum Shop: A fabulous selection of books and merchandise.

The Menil Collection

1515 Sul Ross, Houston, TX 77006
(713) 525-9400
http://www.menil.org

1999 Exhibitions

Ongoing
Surrealism
Comprehensive overview of the evolution of Surrealism from 1910 through
1970, featuring 75 works by Dalí, Duchamp, Ernst, Magritte, and others.

Thru January 3
The Elusive City: Photographs by Paul Hester
Poignant views of urban and suburban landscapes.

Thru January 17
Dan Flavin/Donald Judd: Aspects of Color
In celebration of the opening of the Dan Flavin Gallery, this exhibition
explores the work of two pioneering minimalists.

January 29-May 16
Joseph Cornell/Marcel Duchamp: In Resonance
Chronicles the friendship and working relationship between two influential
and original 20th-century artists. (T)

Permanent Collection

The Menil Collection opened in 1987 to house the art collection of Houston
residents John and Dominique de Menil. Considered one of the most
important privately assembled collections of the 20th century, The Menil
Collection includes masterpieces from antiquity; the Byzantine world; the
tribal cultures of Africa, Oceania, and the American Pacific Northwest; and
the 20th century. **Highlights:** In Feb. 1995, The Menil Collection, in
collaboration with Dia Center for the Arts, New York, opened the Cy
Twombly Gallery, a satellite space designed by Renzo Piano that houses a
permanent installation devoted to the work of the American artist Cy
Twombly. **Architecture:** Designed by a joint venture of Renzo Piano
Building Workshop and Richard Fitzgerald & Associates.

Admission: Free. Handicapped accessible.
Hours: Wed.-Sun., 11-7. Closed Mon., Tues., holidays.
Tours: Call (713) 525-9400.
Museum Shop: The Menil Collection Bookstore is located at 1520 Sul
Ross; open Wed.-Fri., 11-6; Sat.-Sun., 11-6:45. Tel. (713) 521-3814.

The Museum of Fine Arts, Houston

1001 Bissonnet St., Houston, TX 77005
(713) 639-7300
http://www.mfah.org

1999 Exhibitions

Ongoing
Sub-Saharan African Collection and the Glassell Collection of African Gold
Objects created by the Akan peoples of the Ivory Coast and Ghana, as well
as works from the Fulani of Mali and the Swahili of Kenya.

*Impressionist and Modern Paintings: The John A. and Audrey Jones Beck
Collection*
Represents all of the avant-garde movements in Paris, including
masterpieces by Bonnard, Derain, Kupka, Matisse, Monet and others.

Art of Asia
Spans a wide geographic area from India to Tibet, Indonesia, China, Korea,
and Japan. Includes gold, bronze, and ceramic objects; paintings, textiles,
prints, and screens from 2500 B.C. to the present.

Thru January 4
Junior School Holiday Exhibition
Work by Glassel Junior School students.

Thru January 10
*A Grand Design: The Art of the Victoria
and Albert Museum*
Presents the history of a museum through a
comprehensive exhibition of 250
masterworks from the V&A's immense
collections, spanning 2,000 years of artistic
achievement. Catalogue. (T)

Thru January 24
Tobi Kahn: Metamorphoses
Approximately 30 paintings and 15 shrine
sculptures with photographs of monumental
sculptures *in situ* by this New York artist.
Catalogue.

Vivienne Westwood, *Blue "Mock-Croc"
Platform Shoes,* Autumn/Winter 1993-94.
From *A Grand Design: The Art of the
Victoria and Albert Museum.* Photo
courtesy Museum of Fine Arts, Houston.

Thru February 14
Rhapsodies in Black: Art of the Harlem Renaissance
This international exhibition explores the Harlem Renaissance and its
influence on the culture of early-20th-century America and Europe. Includes
paintings, sculptures, film, vintage posters, books, and decorative arts. (T)

Thru February 28
Brassaï: The Eye of Paris
Retrospective exhibition celebrates the centenary of the birth of the
Transylvanian artist, described by Henry Miller as "the eye of Paris."
Includes 150 photographs of the nocturnal life of 1930s Paris. Catalogue.
(T)

March 3-May 2
The Chase Manhattan Collection
A selection of the finest works from Chase Manhattan's corporate collection of 9,000 objects. (Also at Contemporary Arts Museum, Houston.)

March 5-April 25
Annual Core Exhibition
The 17th annual exhibition of works by students at the Glassell School of Art.

March 28-May 23
American Painting, Sculpture, and Decorative Arts from the Permanent Collection
Installation of pre-1945 American painting, including works by Cole, Church, Sargent, Eakins, and more.

April 27-28
Florescence: The Arts in Bloom
A juried exhibition of expertly and imaginatively staged horticulture and flower arrangements.

May 21-July 9
Annual Studio School Student Exhibition
Features the work of students at the Glassell School of Art.

July 23-September 5
Biennial Studio School Faculty Exhibition

June 20-August 15
Bearing Witness: Contemporary Works by African-American Women Artists
The collective artistic achievement of Alison Saar, Faith Ringgold, Carrie Mae Weems, and Lorna Simpson, among others. (T)

September 23-November 28
Innate Contours: James Surls Drawings
The drawings of James Surls, one of Texas's most acclaimed contemporary artists, provide insight into his beautiful, monumental wood sculpture, for which he is internationally known.

October 24, 1999-January 9, 2000
Baroque Masterpieces from the Dulwich Picture Gallery
Magnificent examples of Flemish, French, Italian, Dutch baroque painting from one of the oldest museums in England. Includes works by Rembrandt, Canaletto, Rubens, Poussin, and Watteau, among others.

Permanent Collection

Over 40,000 works are housed in the largest museum in the Southwest. Works ranging from ancient to modern: Blaffer Collection of Renaissance and Baroque works; Beck collection of Impressionist and Post-Impressionist art; Glassell Collection of African gold and Asian art. **Highlights:** The Bayou Bend Collection of 17th- to 19th-century furniture, silver, ceramics, paintings; Derain, *The Turning Road, L'Estaque*; Bouguereau, *The Elder Sister*; Calder, *The Crab*; Van Gogh, *The Rocks*; Noguchi sculpture garden. **Architecture:** 1924 building by William Ward Watkin; 1926 east and west wings; 1958 and 1974 additions by Mies van der Rohe. Bayou Bend, New

building that will double existing gallery space designed by Rafael Moneo, scheduled to be completed in 1999.

Admission: Adults, $3; seniors, college students with ID, children 6-18, $1.50; children under 5, members, free. Thurs., free. Handicapped accessible.
Hours: Tues.-Sat., 10-5; Thurs., 10-9; Sun., 12:15-6. Closed Mon., major holidays.
Programs for Children: Self-guided Postcard or Discovery tours, Tues.-Sun.
Tours: Daily, noon. Call (713) 639-7324 for groups.
Food & Drink: Café Express offers variety of hot and cold entrees.
Museum Shop: Comprehensive selection of art books, periodicals and gifts.

Marion Koogler McNay Art Museum

6000 N. New Braunfels Ave., San Antonio, TX 78209
(210) 824-5368
http://www.mcnayart.org

1999 Exhibitions

Thru January 3
Gabrielle Münter: The Years of Expressionism, 1903-1920
More than 100 works by one of the major artists of German Expressionism, showing her important role in the development of early 20th-century art. (T)

January 19-March 14
The Great American Pop Store: Multiples of the Sixties
Celebrates the delightful and witty world of Pop Art multiples and its influence on later object design, featuring 100 pieces by Jim Dine, Jasper Johns, Andy Warhol, and others. Catalogue. (T)

March 25-May 30
Out of Russia: A Gift of Scene Designs from Robert L. B. Tobin
A spectacular collection of scene and costume designs by Russian artists.

April 10-June 6
Imágenes Mexicanas: Rivera, Siqueiros, and their Contemporaries
A survey of Mexican graphics from the permanent collection, including work by Rivera, Siqueiros, Orozco, Mendez, and Covarrubias.

July 12-September 12
César A. Martinez: A Retrospective
The fourth in a series of retrospectives honoring artists who have made significant contributions to the arts in San Antonio and South Texas.

August 17-October 17
After the Photo Secession: American Pictorial Photography 1910-1955
The first major examination of pictorial photography in the U.S. during this time, with works by Edward Dickson, Ira Martin, D. J. Ruzicka, William Mortensen, and Aubrey Bodine.

December 8, 1999-February 26, 2000
Raoul Dufy: Last of the Fauves
Presents 50 of the strongest oil paintings of the French artist's oeuvre and aims to restore his reputation as one of the most original and talented artists of the first half of the 20th century. (T)

Permanent Collection
Art of the 19th and 20th centuries including French Post-Impressionist paintings; American paintings before World War II; European and American art after World War II; medieval and Renaissance European sculpture and painting; 19th- and 20th-century prints and drawings and theatre arts. **Architecture:** Spanish-Mediterranean style residence by Atlee B. and Robert M. Ayres, built 1926-1928.

Admission: Free; fees for some special exhibitions. Handicapped accessible, including ramps and elevators.
Hours: Tues.-Sat., 10-5; Sun., noon-5. Closed Mon., Jan. 1, July 4, Thanksgiving, Dec. 25.
Programs for Children: Family Day: May 20.
Tours: Call (210) 805-1722 for information and group reservations.
Museum Shop: Offers notecards, postcards, posters, catalogues and t-shirts relating to the permanent collection and special exhibitions; decorative textiles, ironworks, jewelry, children's art resources, pottery, handmade pens, and many other unique gifts.

San Antonio Museum of Art
200 W. Jones Ave., San Antonio, TX 78215
(210) 978-8100
http://www.samuseum.org

1999 Exhibitions
Thru March
Collective Visions
A collection of works by local contemporary artists.

March 6-April 4
Texas Watercolor Exhibit

San Antonio Museum of Art, located in the historic Lone Star Brewing Company building of 1884.

May 29-August 8
A Taste for Splendor: Treasures from the Hillwood Museum
A lavish exhibition of celebrated paintings, gorgeous decorative objects, and fine furnishings. (T)

November 7, 1999-January 30, 2000
Scythian Gold in the Ukraine: Treasures from Ancient Ukraine
Features 170 vessels, weapons, and other objects, mostly of gold, left behind by the warring, seminomadic peoples that roamed Asia from the 7th to the 2nd century B.C. (T)

Permanent Collection

Contains some of South Texas's best collections of 18th- and 19th-century European and American paintings; Modern and Contemporary art, including New York School abstract paintings and sculpture; contemporary Texas art; recently expanded Asian galleries contain Chinese ceramics, bronzes, archaic jades, Japanese, East Asian, and Korean art; Egyptian and Classical collection spans 5,000 years, including ancient Greek, Roman, and Byzantine antiquities; collection of Latin American art, including Spanish Colonial/Republican, modern/contemporary, folk art, and pre-Columbian art. **Highlights:** New Latin American Arts Center. Works by Copley, West, Stuart; Roman sarcophagi; heroic statue of Roman Emperor Marcus Aurelius; Meso-American art, Andean ceramics, stone objects from Aztec, Mixtec, and Toltec periods; important group of 17th- and 18th-century Guatemalan *estofado* images of Santa Teresa de Avila; Contemporary works by Frankenthaler, Guston, Stella, and Hoffman. **Architecture:** Historic 1884 Lone Star Brewery building, renovated in 1981; 1990 Ewing Halsell Wing; 1998 Nelson A. Rockefeller Center for Latin American Art.

Admission: Adults, $4; seniors, students, $2; children ages 4-11, $1.75; members, children 3 and under, Tues. 3-9, free. Handicapped accessible.
Hours: Wed.-Sat., 10-5; Tues., 10-9; Sun., 12-5; Closed Mon., Thanksgiving, Dec. 25.
Programs for Children: Art workshops, Sun., 1-4; Family day first Sun. of each month, with workshops and tours. Call for more information.
Tours: Call (210) 978-8138 for group reservations and information.
Food & Drink: Picnic areas available in the Luby Courtyard.
Museum Shop: Open during museum hours.

The Chrysler Museum of Art

245 W. Olney Rd., Norfolk, VA 23510
(757) 664-6200
http://www.whro.org/cl/cmhh

1999 Exhibitions

Thru January 3
Renoir's Studio Mannequin
The actual mannequin used by the French Impressionist painter is displayed beside the artist's double portrait of *The Daughters of Durand-Ruel* (1882).

Thru January 10
Andy Warhol
Retrospective of 50 works by the monumental 20th-century American icon surveys his career as a painter and graphic artist.

Portrait of a City at Mid-Century: Kenneth Harris's Views of Norfolk
Selection of watercolors from local artist's 1950 series, *Portrait of a City*, featuring views of old downtown Norfolk, Virginia.

Thru May 30
The Sandler Collection of 20th-century Italian Glass
Celebrates the Sandler family's recent donation of their collection, which
represents the whimsical beauty of 60 years of Italian glass production.

February 5-May 2
M.C. Escher: A Centennial Tribute
Examines the artist's contemporary *trompe l'oeil* masterpieces which have
been highly popular since the 1960s. (T)

April 17-August 29
Art of Glass
A selection of works dating
from the 6th century B.C.
from the Chrysler
Museum's permanent
collection, in celebration of
the regional glass festival.

Winter
James Montford

Permanent Collection

Art of many cultures and
historical periods spanning
5,000 years. European
painting and sculpture,

Peter Stephenson, *The Wounded Indian*, 1848-50. Photo
courtesy Chrysler Museum of Art.

14th–20th centuries; 19th–20th century American painting and sculpture;
Glass Galleries including the finest selection of Tiffany creations; decorative
arts; one of the finest photography collections in the world; Greek, Roman,
Egyptian, pre-Columbian, African works and Asian bronzes. **Highlights:**
Degas, *Dancer with Bouquets*; Renoir, *The Daughters of Durand-Ruel;*
Gauguin, *The Loss of Innocence*; Bernini, *Bust of the Savior;* Cassatt, *The
Family*; Matisse, *Bowl of Apples;* John Northwood, *The Milton Vase*;
Christian Boltanski, *Reserve of Dead Swiss*; Veronese, *The Virgin
Appearing to Saints Anthony Abbott and Paul the Hermit.* **Architecture:**
1933 building; 1967 Houston Wing; 1976 Centennial Wing; 1989
renovation and expansion by Hartman-Cox; 1997 Educational Wing and the
James H. Ricau Collection of Sculpture; 1998 renovation and expansion
McKinnon Galleries of Modern Art.

Admission: Adults, $4; students and seniors, $2; members, Wed., free.
Handicapped accessible; wheelchairs, reserved parking, and ramp entrance.
Hours: Tues.-Sat., 10-5; Sun., 1-5. Closed Mondays and major holidays.
Programs for Children: Contact the Education Dept. at (757) 664-6268 or
(757) 664-6269.
Tours: Call (757) 664-6269 for information about museum, and (757) 664-
6283 about Historic Houses.
Food & Drink: Phantoms Restaurant open Tues.-Sat., 11-3; Sun., 12-3.
Museum Shop: Brimming with fine gifts, art reproductions, notecards,
jewelry, and children's books and toys. Open during museum hours. Call
(757) 664-6241 for more information.

Virginia Museum of Fine Arts

2800 Grove Ave., Richmond, VA 23221
(804) 367-0844
http://www.vmfa.state.va.us

1999 Exhibitions

Thru January 31
Designed for Delight: Alternative Aspects of 20th Century Decorative Arts
Over 200 decorative objects explore the major stylistic movements from art nouveau and art deco to postwar and postmodern. Catalogue. (T)

Thru February 28
From the Looms of India: Textiles from the Permanent Collection
Sampling of India's textile production from the 17th to mid-19th centuries.

Thru March 14
Fiery Steeds: French Romantic Studies by Carle Vernet from the Ritzenberg Collection
Rapid sketches on paper and more developed compositions comprise this exhibition of works by Carle Vernet (1758-1836).

March 1999-January 2000
Highlights of Late-Twentieth-Century Art from the Sydney and Frances Lewis Collection
Selected paintings and sculptures from the 1960s to the 1980s.

May 25-November 28
Splendors of Ancient Egypt
One of the largest exhibitions of ancient Egyptian treasures to visit the U.S. in decades, featuring over 200 pieces dating back 4,500 years, including statues, mummy cases, jewelry, wall carvings, and ceramics. (T) (Last venue)

Permanent Collection

Comprehensive holdings dating from ancient times to the present: Byzantine, Medieval, African art; extensive Himalayan collection; American painting since World War II; art nouveau and art deco works.

Highlights: Statue of Caligula; Mellon

Anthropoid Sarcophagus of Amen-em-opet (detail), New Kingdom, Dynasty 18 (c. 1490 B.C.). Collection Pelizaeus Museum, Hildesheim, Germany. From *Splendors of Ancient Egypt.* Photo courtesy Virginia Museum of Fine Arts.

collections of English sporting art and French Impressionist, Post-Impressionist works; Fabergé Easter eggs from the Russian Imperial collection; Goya, *General Nicolas Guye*; Monet, *Irises by the Pond*; sculpture garden; Fabergé Gallery; Classical and Egyptian galleries. **Architecture:** 1936 building by Peebles and Ferguson; 1954 addition by Lee; 1970 addition by Baskerville & Son; 1976 addition by Hardwicke Associates; 1985 addition by Holzman.

Admission: $4; special fees for some exhibitions. Handicapped accessible.
Hours: Tues.-Sun., 11-5; Thurs. 11-8. Closed Mon.
Programs for Children: Classes, family open houses, events and programs, call (804) 367-6234.
Tours: Tues.-Sat., hourly, 11:30-2:30. For reservations call (804) 367-0859 three weeks in advance.
Food & Drink: Arts Café and Cappucino Bar open Tues.-Sat., 11-4; Sun., 1-4.
Museum Shop: Not-to-be-missed museum store offers great values in unique gift items and a dazzling array of museum reproduction jewelry, lacquerwares, textiles, pottery, posters, and items for children.

Frye Art Museum

704 Terry Avenue, Seattle, WA 98104
(206) 622-9250
http://www.fryeart.org

1999 Exhibitions

Thru January 3
The Russian Connection: Paintings and Drawings by Fechin, Gaspard, and Bongart

Thru January 17
The Spirit of the West: Selections from the Charles M. Russell Museum

Thru January 31
Looking at People Looking at Art: Marvin Albert Photographs

January 8-February 28
Viewpoints: Stephen Assael Paintings

January 29-March 28
William Keith: California's Poet Painter

January 29-April 4
American Masters from the Permanent Collection

February 4-March 28
Carol Mothner: Still Lifes

March 5-May 9
Viewpoints: Carlo Maria Mariani Paintings

April 1-May 30
Carol Anthony: Monotypes

April 9-June 6
Mark Spencer Paintings

The Hermitage School

May 9-June 27
Viewpoints: Tony Foster Retrospective

June 3-August 1
Richard Buswell: Photographs

June 18-September 5
Earthscape: Artists on the Copper River Delta

July 2-August 29
Viewpoints: John Register Paintings

August 5-October 3
Tom Jones: Watercolors

September 3-October 31
Viewpoints: Norman Lundin Paintings and Drawings

September 17, 1999-January 2, 2000
Victorian Painting from the Royal Academy

October 7-November 28
Kristin Capp: Hutterite Photographs

November 5, 1999-January 2, 2000
Rie Munoz: Portrait of Alaska

December 2, 1999-January 30, 2000
Jon Swihart: Paintings

Permanent Collection

Collection of 1,200 paintings, including early-19th- and 20th-century American paintings; French Impressionist paintings; Alaskan and Northwest regional art; extensive collection of 19th-century German art. **Highlights:** Works by Renoir, Pissaro, Eakins, Hartley, Prendergast, and Wyeth. **Architecture:** Museum founded in 1952 by Charles and Emma Frye; 1997 renovation by Olson/Sundberg Architects.

Admission: Free. Handicapped accessible; call ahead for special needs.
Hours: Tues.-Sat., 10-5; Sun., 12-5; Thurs., 10-9. Closed Mon., Thanksgiving, Dec. 25, Jan. 1.
Programs for Children: Offers art education workshops for all ages.
Tours: Group tours available with reservations; call (206) 622-9250, ext. 212.
Food & Drink: Gallery Café offers casual, light lunch and dinner (Thurs. evenings) in elegant museum setting. Fresh soups, sandwiches, and entrees. Open Tues.-Sat., 11-4; Sun., 12-4; Thurs., 11-7:30.
Museum Shop: Offers artful gifts for everyone's tastes, including a wonderful selection of illustrated art books, museum reproduction jewelry, classical music videos, elegant stationery, and art posters and catalogues.

Allan Sekula, *Panorama. Mid-Atlantic,* 1993. From *Fish Story.* Photo courtesy Henry Art Gallery.

Henry Art Gallery

15th Ave. NE and NE 41st St., University of Washington
UW Box 351410, Seattle, WA 98195
(206) 543-2280; (206) 543-2281
http://www.henryart.org

1998 Exhibitions

Thru January 24
Deep Storage, The Arsenal of Memory
Features work by more than 40 German and American artists, including Andy
Warhol, Robert Rauschenberg, and Joseph Beuys, who engage the ideas
archive and storage as important issues in 20th century culture.

Thru February 7
Surrogate: The Figure in Contemporary Sculpture and Photography
Six installations focusing on issues imbedded in representations of the figure.
Works by Kiki Smith, Annette Messager, Tony Oursler, and more.

January 29-May 30
Josiah McElheny
An installation by the Seattle glass artist that documents a unique narrative for
the history of fashion and glass.

February 11-May 16
Fish Story
A complex documentary photography project that investigates the changing
appearance and social and political life of nine major port cities.

February 25-June 13
Coming to Life: The Figure in American Art 1955-1965
Explores the changes in figurative representation from Abstract
Expressionism to Pop and performance art through the art of Willem de
Kooning, Robert Motherwell, Roy Lichtenstein, Andy Warhol, and more.

Permanent Collection
Focuses on art from the 19th century to the present, including paintings,
prints, ceramics, and video. **Highlights:** The Joseph and Elaine Monsen
Photography Collection; plus 16,000-piece costume and textile collection.
Architecture: Original 1927 Tudor Gothic building designed by Carl Gould.
Recent expansion and renovation designed by Charles Gwathmey quadrupled
the museum's space.

Admission: Adults, $5; seniors, $3.50; students, members, UW staff,
children under 13, Thurs. 5-8, free. Handicapped accessible.
Hours: Tues.-Sun., 11-5; Thurs., 11-8. Closed Mon., July 4, Thanksgiving,
Dec. 25, Jan. 1.
Programs for Children: Workshops to help children learn to look at, talk
about, and make art using visual thinking strategies. Call (206) 543-2881.
Tours: Call (206) 453-2281 for information and reservations.
Food & Drink: The Henry Café is connected to an outdoor sculpture court
and offers espresso, snacks, and light lunches.
Museum Shop: Extensive selection of contemporary art books, gifts and
crafts.

Seattle Art Museum

100 University St., Seattle, WA 98101
(206) 625-8900; 654-3100 (recording)
http://www.seattleartmuseum.org

1999 Exhibitions

Ongoing

Africa Possessed
Marita Dingus's installation, *400 Men of African Descent*, the winning
selection made by museum visitors who voted on the museum's latest
acquisition.

Is Egyptian Art African?
Visitors are invited to compare Egyptian deities to Sub-Saharan
masqueraders and view examples of personal adornment, posture, and
divine kinship that are shared over different parts of the continent.

The Plestcheeff Collection of Art
Recent acquisitions of Russian porcelain and decorative arts.

*Kiln Art for Palaces, Priests, and the Proletariat: Korean Ceramics of the
Koryo and Choson Periods*
A survey of Korean ceramic arts from the 10th to 20th centuries.

Aboriginal Australian Art
Contemporary Aboriginal artists explore the ancient creation myths of the
Dreamtime.

Thru January 10

*Egypt, Gift of the Nile: Ancient Egyptian Art and Architecture from the
University of Pennsylvania Museum*
Stunning objects from excavations in Egypt and Nubia.

Thru January 24

*Documents Northwest: The PONCHO series: The Art of Ross Palmer
Beecher and Barbara Earl Thomas*
Works by two Seattle artists known for their highly imaginative, symbol-
laden imagery.

George Tsutakawa
A small memorial exhibition honors Seattle artist George Tsutakawa.

Anne Gerber Exhibition: Cindy Sherman
Works by the modern photographer known for her self-portraits in costume.

*The Paving of Paradise: A Century of Photographs of the Western
Landscape*
Photographs from the permanent collection, including works by Ansel
Adams, William Henry Jackson, and Joe Deal, that reflect different notions
of the West as Paradise.

Gifts from the Gerbers: Modern Paintings and Drawings
A selection of modern paintings and drawings from the Gerber Collection,
including works by Kandinsky, Léger, and Willem de Kooning.

Thru April
Roots, Bark, and Grass:
Northwest Coast Basketry from
the Collection of Warren Hill
Northwest Coast First Nations
basketry, including lidded
trunks, made in the coiled and
imbricated style, and smaller,
finer baskets of twined spruce
root.

Thru March 14
Silver Servers

Seattle Art Museum. Photo by Susan Dirk.

A collection of contemporary
silver servers by over 50
American and British silversmiths and 19th-century silver from the Ruth J.
Nutt Collection.

Thru June 13
Reflections in the Mirror: A World of Identity
An exhibition co-curated by local school children that explores issues of
identity.

Growing Up with Art

February 18-May 9
Chuck Close
Surveys the full spectrum of this American artist's remarkable career,
including over 90 paintings, drawings, prints, and photographs featuring his
early gray-scale works and later colorful patchwork paintings. Catalogue.
(T)

March 4-May 9
The Virginia and Bagley Wright Collection of Modern Art
Modern works from this world-renowned collection.

June 3-October 24
Documents Northwest: The PONCHO Series: Roy McMakin

June 12-August 29
Impressionism: Paintings Collected by European Museums
A highly selective and important exhibition of about 60 Impressionist
paintings, including works by Monet, Cézanne, Pissaro, Degas, Renoir,
Morisot, Caillebotte, and Sisley, from major museums in London, Paris,
Oslo, Budapest, Cologne, and Stuttgart. (T)

September 30, 1999-January 2, 2000
An American Century of Photography: From Dryplate to Digital
Approximately 140 images, drawn from the Hallmark Photographic
Collection, provide a broad perspective on the art and history of modern
American and European photography from the late 19th century to the
present. Catalogue. (T)

Seattle Asian Art Museum
Volunteer Park
1400 East Prospect St., Seattle

1999 Exhibitions
Ongoing
Wonders of Clay and Fire: Chinese Ceramics Through the Ages
A comprehensive survey of Chinese ceramic history, from the 5th
millennium B.C. though the 15th century A.D.

Thru April 4
Ancient Masterworks of Japanese Art
Works from the permanent collection, including the *Crow* screen, the *Deer*
scroll, and the *Hell of Shrieking Sounds* scroll.

May 6, 1999-February 13, 2000
Modern Masters of Kyoto: Transformation of Japanese Painting Traditions
Nihonga *from the Griffith and Patricia Way Collection*
The third in a chronological series on Japanese painting. Features works
from the late 19th to the 20th centuries.

October 23, 1999-October 2000
Explore Korea: A Visit to Grandfather's House
Visitors are invited to walk through a replica of a traditional 1930s Korean
home.

Permanent Collection
Over 21,000 objects, from Ancient Egyptian sculpture to contemporary
American painting. Internationally known for its collections of Asian,
African, Northwest Coast Native American, and modern Pacific Northwest
art; other holdings include ancient Mediterranean, medieval and early
Renaissance, Baroque, early and late 20th-century art. **Highlights:** Classical
coins; 18th-century European porcelain; Chinese jades and snuff boxes.
Architecture: Downtown: 1991 building by Robert Venturi.

Admission: Suggested admission: adults, $6; seniors, students, $4; members
and children 12 and under (accompanied by adult), free. First Thurs. of each
month, free. Tickets from one branch are valid for admission at the second
branch for a one-week period. Handicapped accessible.
Hours: Tues.-Sun., 10-5; Thurs., 10-9. Closed Mon., except some Mon.
holidays.
Programs for Children: *Growing Up With Art* program; Teacher
Resource Center open Thurs., 2-8; Fri., 2-5; Sat., 1-5, at SAAM Volunteer
Park.
Tours: Available for the museum and special exhibitions. Call (206) 654-
3123. Signed-language tours are available; call (206) 654-3124 [TDD].
Food and Drink: Café open museum hours. Tea Garden at Asian Art
Museum, with 55 varieties of tea.

Milwaukee Art Museum

750 N. Lincoln Memorial Dr., Milwaukee, WI 53202
(414) 224-3200; (414) 224-3220 (recording)
http://www.mam.org

1999 Exhibitions

Thru January 10
Half Past Autumn: The Art of Gordon Parks
The first retrospective exhibition to synthesize different aspects of Parks's art, his films, books, poetry, and music compositions, with his photojournalism, for which he is best known. (T)

January 29-April 18
Sinners and Saints, Darkness and Light: Caravaggio and His Dutch and Flemish Followers
Examines how Dutch and Flemish artists responded to the powerful work of Caravaggio in the first half of the 17th century. (T)

March 19-May 30
Escape to Eden: The Pastoral Vision in 18th-Century France
An exhibition of paintings, prints, drawings, and decorative arts that explores how French pastoral themes represented nostalgia for a lost golden age and hopes for a utopian future.

May 14-August 8
Under Construction: Photography, 1900-2000
Spans the history of photography through images of construction, a metaphor

Gabriele Münter, *The Green House, Murnau*, 1911. Gift of Mrs. Harry Lynde Bradley. Photo courtesy Milwaukee Art Museum.

for progress and technological power. Includes work by Weston, Stieglitz, Gursky, and others.

September 10, 1999-January 2, 2000
The Last Show of the Century: A History of the 20th Century Through Its Art
Rather than trace the history of art, this exhibition looks at the major events of this century through the art of Picasso, the German Expressionists, and Warhol, among others.

Permanent Collection

Includes 20,000 18th- to 20th-century works of European and American art, decorative art, photography, prints, and drawings, including works by German Expressionists, American Ashcan School artists. **Highlights:** Archive of Prairie School architecture; Bradley collection of early modern

and contemporary art; Fragonard, *Shepherdess*; Johnson, *The Old Stage Coach*; Zurbarán, *Saint Francis*; the Georgia O'Keeffe Collection; folk art; Haitian art. **Architecture:** 1957 building by Eero Saarinen; 1975 addition by David Kahler. Addition under construction by Santiago Calatrava. Planned opening in mid-2000.

Admission: Adults, $5; seniors, students, $3; children 12 and under, members, free. Handicapped accessible.
Hours: Tues., Wed., Fri., Sat., 10-5; Thurs., 12-9; Sun., 12-5. Closed Mon.
Programs for Children: Classes, Family Sundays, tours.
Tours: Call (414) 224-3825
Food & Drink: Café open for midday refreshments. Hours vary.
Museum Shop: Offers art books, catalogues, cards, and other unique gifts.

Buffalo Bill Historical Center
720 Sheridan Ave., Cody, WY 82414
(307) 587-4771
http://www.truewest.com/BBHC

1999 Exhibitions
April-July
Imagining the Open Range: Photographer Erwin E. Smith

Permanent Collection
With four museums in one, the Buffalo Bill Historical Center contains the largest collection of western Americana in the world. The Buffalo Bill Museum contains personal and historical memorabilia of William F. "Buffalo Bill" Cody; Plains Indian Museum displays materials reflecting artistic expression of Arapaho, Blackfeet, Cheyenne, Crow, Shoshone, Sioux, and Gros Ventre Tribes; Whitney Gallery of Western Art features paintings and sculpture of Bierstadt, Catlin, Miller, Moran, Remington, Russell, Sharp, and Wyeth; Cody Firearms Museum presents story of firearms in the U.S. **Architecture:** 1927 log building; 1959 Whitney Gallery and 1969 Buffalo Bill Museum by George Tresler; 1979 Plains Indian Museum by Adrian Malone; 1991 Cody Firearms Museum by Luckman Assoc. 237,000-square-foot complex also contains a research library.

Admission: Adults, $10; students 18 and over, $6; children 6-17, $4; under 6, free.
Hours: June-Sept.: daily, 7 a.m.-8 p.m.; Call for off-season hours, which vary.
Programs for Children: Workshops offered during peak season, occasionally during off-season.
Tours: Call for information regarding organized school groups.
Food & Drink: Restaurant open June-Sept.: daily, 7 a.m.-8 p.m. Hours vary during off-season.
Museum Shop: Open during museum hours.

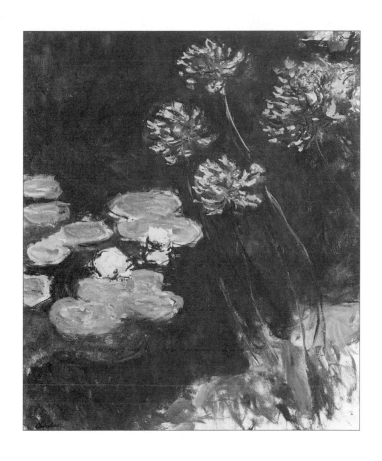

SELECTED MUSEUMS
OUTSIDE THE UNITED STATES

Claude Monet, *Nymphéas et Agapanthes,* 1914-1917. Collection
Musée Marmottan, Paris. From *Monet at Giverny: Masterpieces
from the Musée Marmottan,* a traveling exhibition. Photo
courtesy Musée de Beaux-Arts de Montréal, Canada.

National Gallery of Australia

Parkes Place, Canberra, ACT 2601, Australia
(61) (2) 6240 6502
http://www.nga.gov.au

1999 Exhibitions

Thru January 26
Wall to Wall
Focuses on the idea of collections and art collecting as seen through rarely viewed works from the National Gallery's permanent collection. Features the Max Ernst Collection of tribal art to showcase the artist as collector.

Thru February 21
Re-take: Contemporary Aboriginal and Torres Strait Islander Photography
Reevaluates the depiction of Aboriginal subjects and examines Aboriginal culture through photographs by Aboriginal artists.

Thru March 14
In a Flash: Dr. Harold E. Edgerton and Split-Second Photography
Scientifically motivated photographic studies by the man who invented modern flash and stop-action photography. Includes works by Edgerton's contemporaries, such as Lartigue and Cartier-Bresson.

January 30-April 26
A Stream of Stories: Indian Miniatures from the National Gallery of Australia
Small, intimate, and often decorative paintings provide insight into the richness and diversity of Indian art, culture, and religion.

Hyderabad, Andhra Pradesh, India, *The Emperor Akbar Seated on an Elephant*, c. 1780. The Gayer-Anderson Gift. Photo courtesy National Gallery of Australia.

February 13-April 26
Emily Kame Kngwarreye: Alhalkere, Paintings from Utopia
Traces the brief but impressive career of one of Australia's leading painters of modern times, including landscapes inspired by the artist's native land, Alhalkere, north of Alice Springs.

March 20-July 11
Matisse: The Art of Drawing
Showcases over 80 drawings, prints, and illustrated books by 20th-century French colorist and draughtsman Henri Matisse (1869-1954).

May 15-August 1
From Russia with Love: Costumes for the Ballets Russes 1909-1933
More than 200 works, including costumes worn by legendary dancer Njinsky
in productions such as *Petrushka* (1911) and *The Blue God* (1912), and
designs by Matisse, Bakst, Goncharova, De Chirico, and other 20th-century
artists.

Permanent Collection

Concentrated on the development of 20th-century art in Europe, the United
States, and Australia; major artists represented include Picasso, Matisse,
Rubens, Monet, Kiefer, and Kounellis. Other collections include Aboriginal
and Torres Strait Islander Art, the Asian collection, and the Sculpture
Garden. **Highlights:** Jackson Pollock, *Blue Poles*; *Aboriginal Memorial* by
Ramingining Artists; Brancusi, *Birds in Space*. **Architecture:** 1982 building
by Edward Madigan Torzillo & Briggs. A new wing, designed by Andrew
Andersons of Peddle Thorpe, is under construction.

Admission: Adults, Aus$3; students, members, free (except certain major
exhibitions). Handicapped accessible, including ramps and elevators.
Hours: Daily, 10-5. Closed Good Friday and Dec. 25.
Programs for Children: School excursions and workshops.
Tours: Australian and International art, daily, 11, 2; Aboriginal art, Thurs.,
Sun., 11. Call (61) (2) 6240 6502 for more information.
Food & Drink: The Gallery Brasserie, daily, 10-4:30; The Mirrabook
Outdoor Restaurant in the Sculpture Garden, daily, 12-2:30, Sept.-June; The
Sculpture Garden, located near Lake Burley Griffin, is a popular picnic spot.
Museum Shop: Open daily, 10–5.

The Queensland Art Gallery

Melbourne Street, South Brisbane, Queensland 4101, Australia
(61) (7) 3840 7303
http://www.qag.qld.gov.au

1999 Exhibitions

Thru February 7

Picasso's The Vollard Suite
The artist's great graphic masterpiece of the 1930s, *The Vollard Suite*, which
is rarely shown in its entirety. 100 works inspired by classical artwork and
literature.

Scary Monsters
The second of the gallery's children's exhibitions brings together the scariest
works from the permanent collection.

Thru March 20

Still Life 1650-1994: Reworking the Tradition
A survey of still lifes from the permanent collection, ranging from an early
Dutch still life by Coosemans to a contemporary work by Luke Roberts.

April 22-June 14
Yvonne Audette
This exhibition of lyrical and meditative abstract paintings demonstrates Audette's contribution to post-war Australian modernism.

September 9, 1999-January 26, 2000
Third Asia-Pacific Triennial of Contemporary Art
"Beyond the Future" is the theme of this internationally renowned triennial.

Permanent Collection

Includes contemporary art from Australia, Asia, Europe, and America; traditional and contemporary Indigenous Australian works; historical works from Australia, Asia, and Europe. **Highlights:** Picasso, *La Belle Hollandaise*; Rubens, *Portrait of a Young Lady;* Sidney Nolan, *Mrs. Fraser and Convict.* **Architecture:** 1982 award-winning building by Robin Gibson.

Admission: Free; some fees for special exhibitions. Handicapped accessible.
Hours: Daily, 10-5. Closed Good Friday and Dec. 25.
Programs for Children: Offers a range of activities and programs for children, including a new series of exhibitions designed specifically for kids.
Tours: Mon.-Fri., 11, 1, 2; Sat.-Sun., 11, 2, 3. For group reservations, call (61) (7) 3840 7255.
Food & Drink: Gallery Bistro provides indoor and outdoor dining with a terrace overlooking sculpture courtyard. Open daily, 10–4:30.
Museum Shop: A browser's delight! Choose from art-inspired gift or original ceramics, jewelry, and glassware by Australian artists. Books on fine art, Australian art, architecture, design, contemporary literature, and exhibition catalogues.

Art Gallery of New South Wales

Art Gallery Rd., The Domain, Sydney, NSW, Australia 2000
(61) (2) 9225 1700
http://www.artgallery.nsw.gov.au

1999 Exhibitions

Not available at press time.

Permanent Collection

Australian and Aboriginal art, international art, and photography.

Admission: Free. Handicapped accessible.
Hours: Daily, 10-5. Closed Christmas Day and Easter Friday.
Programs for Children: "Sunday Afternoon for Families" at 2:30, includes performances of drama, storytelling, music, and mime. Free of charge.
Tours: Available daily.
Food & Drink: Gallery Café looks out onto Sydney Harbour. The Brasserie offers a wide selection of luncheon dishes.
Museum Shop: Offers a comprehensive range of art books, both Australian and international, as well as souvenirs, posters, cards, and giftwares.

Museum of Contemporary Art

140 George St., Circular Quay West, The Rocks, Sydney, NSW, Australia 2000
(61) (2) 9252 4033
http://www.mca.com.au

1999 Exhibitions
Thru March
The Seppelt Contemporary Art Award 1998
Works by nine Australian and New Zealand finalists.

Thru March 14
The Warhol Look: Glamour, Style, Fashion
Explores art, fashion, and glamour in the films and paintings of the infamous 20th-century American artist and icon, Andy Warhol.

June 4-August 29
Cindy Sherman: Retrospective
Mid-career survey of the 20th-century American photographer. Includes selections from each of her key series, including Untitled Film Stills. (T)

Permanent Collection
Wide-ranging collection of over 4,000 contemporary works by Australian and international artists. **Architecture:** 1991 building by Peddle Thorpe, Architects, with spectacular views of the harbor and Opera House.

Admission: Adults, Aus$9; seniors, students, concessions, Aus$6; families, Aus$18. Handicapped accessible; wheelchairs available.
Hours: Daily, 10-6. Closed Dec. 25.
Tours: Mon.-Fri., 12, 2; Sat.-Sun., 1:30, 2:30, 3:30.
Food & Drink: MCA Fish Café open weekdays, 11-5; Sat.-Sun., 9-5. Reservations recommended, call (61) (2) 9241 4253.
Museum Shop: Exclusive gifts, cards, and art books. Open daily, 10-5.

Graphische Sammlung Albertina
Augustinerstrasse 1, A–1010 Vienna, Austria
(43) (1) 534 830

1999 Exhibitions
NOTE: During the major renovation and expansion of the museum, exhibitions will take place at the Akademiehof, 1010 Wien, Makartgasse 2.
Thru January 10
Heiliger Frühling: Gustav Klimt and the Beginning of the Vienna Secession

February 5-March 28
Pravoslav Sovak: Work on Paper

Von Hoher und Niederer Minne: Deutsche Zeichnungen und Stiche der Spätgotik

April 16-June 20
From Dürer to Rauschenberg

July 9-September 19
Raphael

October 22, 1999-January 2000
Russian Art

Permanent Collection

One of the most important print and drawing collections in the world, including masterpieces by Raphael, Dürer, Rembrandt, Rubens; European drawings, prints from the 15th century to the present; special collections of architectural drawings, posters, miniatures, illustrated books. **Highlights:** Dürer, *Young Hare* and *The Large Piece of Turf;* Raphael, *The Virgin with the Pomegranate*; Michelangelo, *Seated Male Nude;* Rubens, *Rubens' Son Nicholas*; Greuze, *Head of a Girl*; Schiele, *Male Nude with Red Loincloth.*

Admission: ÖS 10.
Hours: (Akademiehof) Tues.-Sun., 10-5.

KunstHaus Wien

Weissgerberstrasse 13, A-1030 Vienna, Austria
(43) (1) 712 04 96
http://www.kunsthauswien.at

1999 Exhibitions

Thru January 31
Peter Lindbergh: Images of Women
A retrospective of the work of Peter Lindbergh, one of the most influential and widely emulated fashion photographers working today.

February 11-May 2
Jean-Michel Basquiat: 100 Works
A look at the intensely expressive work of this protegé of Andy Warhol and golden child of the New York art scene.

Peter Lindbergh, *Linda Evangelista, Pin-up Studio, Paris, 1989.* From *Peter Lindbergh: Images of Women.* Photo courtesy Kunsthaus Wien.

Permanent Collection

Houses the Collection Friedensreich Hundertwasser, containing work by one of the most popular living Austrian artists. Features rotating exhibitions of contemporary art. **Highlights:** Scale models of the Hundertwasser Architecture Projects. **Architecture:** 1892 Thonet Bros. factory and office buildings renovated in 1991 by artist Friedensreich Hundertwasser. Beautifully whimsical mosaic façade reminiscent of the sinuous forms of Austrian art nouveau.

Admission: Adults, 90 ATS; children under 12, free. Mon., 50% reduction (except holidays). Handicapped accessible. There may be additional fees for special exhibitions.
Hours: Daily, 10-7.
Programs for Children: Children's activities, Dec. 24, 10-5; other programs available upon request.
Tours: Regularly scheduled guided tours.
Food & Drink: Picnic areas nearby.
Museum Shop: This first museum store in Austria contains a world of manifold and beautiful art objects.

Kunsthistorisches Museum
Burgring 5, 1010 Vienna, Austria
(43) (1) 525 24 404

1999 Exhibitions
Thru January 24
Portraits from the Desert
Mummy portraits from the Egyptian Museum in Cairo.

Thru January 31
Il Bambino Gesù
Italian figures of the Christ child made over 300 years.

Thru February 21
Yemen–Art and Archaeology in the Land of the Queen of Sheba

Treasures of the Caliphs: Islamic Art of the Fatimid Period

Thru Summer
Celtic Money
Reopened collection of coins and medals.

March-May
The Szilagysomloy Treasure

April-May
The Shoguns and their Mounted Warriors

Spring
The Medicis–A Princely Family of the Renaissance

June-October
The Shumei Collection

Summer
Kunsthistoriches Museum's Collection of Historical Uniforms

September 10-October 20
Franz Hubmann–A Retrospective
A survey of the photographic work of Franz Hubmann.

Karl Korab

Permanent Collection
Houses one of the richest collections of art in the world. The painting collection contains many outstanding works by the Flemish, Dutch, German,

Italian, Spanish, and French schools including masterpieces by Dürer, Rubens, Rembrandt, and Titian. **Highlights:** The Brueghel collection; impressive Egyptian-Oriental, Classical Antiquity collections.

Architecture: The museum itself was built between 1871 and 1891 by the Emperor Franz Joseph for the collections it still houses today. Together with its companion across the square, the Natural History Museum, and the Hofburg, it was planned as part of the Imperial Forum on the Ringstrasse which was, however, never completed. The architects were Gottfried Semper and Carl Hasenauer. In accordance with the style of Historicism prevalent in the late 19th century, they chose the Neo-Renaissance style for the interior and exterior decorations of this palatial building.

Admission: Adults, ATS 100; children, senior citizens, students, ATS 70. Handicapped accessible.
Hours: Tues.-Sun., 10-6; Thurs., 10-9; Closed Mon.
Programs for Children: Special guided tours for children. Call for information.
Tours: Call (43) (1) 525 24 416 for information.
Food & Drink: Coffee-shop in Cupola Hall, open museum hours.
Museum Shop: Two shops, open during museum hours.

Royal Museum of Fine Arts
Leopold de Wael Plaats, B-2000 Antwerp, Belgium
(32) (3) 238 7809
http://www.dma.be/cultuur/kmska

1999 Exhibitions
May 15-August 15
Anthony Van Dyck
Over 80 paintings survey the career of 17th-century Flemish artist Anthony Van Dyck, court painter for Charles I of England, in celebration of the 400th anniversary of the artist's birth. (T)

October 17, 1999-January 16, 2000
Women Artists in Belgium and the Netherlands, 1550-1700

Permanent Collection
Fine collection of Netherlandish, French, Italian, and German Old Master paintings. Modern masters of Belgium from the 19th century to the present, representing the avant garde artists of the Royal Academy of Fine Arts, realism, Impressionism, Post-Impressionism, futurism, and new realism. **Highlights:** South Netherlandish art from the 14th- to the 18th-centuries; 15th-century Burgundian masterpieces by Jan van Eyck, Roger van der Weyden, and Hans Memling; art from the "golden age" of 17th-century Antwerp, including paintings by Quinten Metsys, Frans Floris, the Brueghel family, Peter Paul Rubens, Jacob Jordeans, and Anthony van Dyck; 21 paintings and oil sketches by Rubens. Works by James Ensor, the Flemish Expressionists, René Magritte, Paul Delvaux, Appel, Breitner, Chagall, David, Degas, Fontana, Modigliani, Rodin, Willink, and Zadkine.

Admission: 150 BEF; special discount, 120 BEF. Handicapped accessible.

Hours: Tues.-Sun., 10-5. Closed Mon., January 1, 2, May 1, Ascension Day, December 25.
Programs for Children: Workshops and special activities for children.
Tours: Call (32) (3) 3238 7809 for information.
Food & Drink: Self-service restaurant offers

Royal Museum of Fine Arts, Antwerp.

drinks and small dishes. Open Tues.-Sun., 10-4:45.
Museum Shop: Catalogues, art books, postcards, and posters. Open Tues.-Sun., 10-4:30.

Musées Royaux des Beaux-Arts de Belgique

Musée d'Art ancien & Musée d'Art moderne
3, Rue de la Régence, 1000 Brussels, Belgium
(32) (2) 508 32 11
http://www.fine-arts-museum.be

1999 Exhibitions
September 24, 1999-February 13, 2000
James Ensor (1860-1949)
A major retrospective of one of the boldest and most imaginative painters of the late-19th century. Includes paintings, drawings, notebooks, and sketches.

Permanent Collection
Musée d'Art ancien: 14th–18th centuries. Works from Flemish, Dutch, German, Italian and French schools, including Van der Weyden, Memling, Brueghel the Elder, Massys, Rubens, Van Dyck, Cranach, Hals, Rembrandt, Lorrain, Guardi, Ribera; 19th-century works from Belgian School and Impressionism. **Highlights:** Brueghel the Elder, *La Chute d'Icare (The Fall of Icarus).*
Musée d'Art moderne: 20th century; abstract art, CoBrA, Cubism, Dada, Expressionism, Fauvism, Futurism, Surrealism. International scope with emphasis on Belgian art. Works by Braque, Bacon, Calder, Chagall, Dalí, De Chirico, Delvaux, Ernst, Magritte, Segal. **Architecture:** Musée d'Art ancien housed in 1880 building by Balat; Musée d'Art moderne housed in a 1984 below-ground addition by R. Bastin.

Admission: 150BEF. Handicapped accessible; special entrance.
Hours: Tues.-Sun, 10-12, 1-5. Closed Mon., Jan. 1, 2nd Thurs. of Jan., May 1, Nov. 1 & 11, Dec. 25.
Tours: Call (32) (2) 508 32 11 for reservations and information.
Food & Drink: Cafeteria open 10:30-4:30.
Museum Shop: Books, posters, videos, postcards, etc. Open 10-4:30.

Canadian Centre for Architecture

1920 rue Baile, Montréal, Québec, H3H 2S6, Canada
(514) 939-7000; 939-7026 (recording)
http://www.cca.qc.ca

1999 Exhibitions
Thru April 25
Venice–Marghera: Photography and Transformation in an Industrial Zone
Presents the vision of 15 contemporary Italian photographers who have
documented and interpreted the vast changes at a little-known industrial site.

Thru March 21
Irene Whittome: Embarkation for Katsura
Whittome uses photographs of the Katsura temple in Kyoto by Yasuhiro
Ishimoto as inspiration for her recent work, which delves into the
relationship between nature and architecture.

Permanent Collection
World-acclaimed study center devoted to the art of architecture. The
research collection and archive includes some 165,000 volumes on the
history and theory of architecture; 22,000 architecture-related prints and
drawings from the 15th century to the present; 50,000 architectural
photographs; archives of work by significant architects. **Architecture:** The
1989 award-winning building designed by Peter Rose is integrated with the
historical Shaughnessy House (1874) and a Sculpture Garden (designed by
Melvin Charney) that illustrates the history of architecture in Montréal.

Admission: Adults, $6; seniors, students, $3; children under 12, members,
free. Group rates available. Handicapped accessible.
Hours: Oct.-May: Wed., Fri., 11-6; Thurs., 11-9; Sat., Sun., 11-5. June-
Sept.: Tues.-Sun., 11-6; Thurs., 11-9. Closed Mon.
Programs for Children: Youth and family workshops.
Tours: Guided architectural tours of the museum and Shaughnessy House,
Sun. Call (514) 939-7026 for more information.
Museum Shop: Offers a selection of current architectural publications.
Open during museum hours.

Musée des Beaux-Arts de Montréal

1379-80 Sherbrook Street West, Montréal, Quebec, H36 2T9, Canada
(514) 285-1600; 285-2000 (recording)
http://www.mmfa.qc.ca

1999 Exhibitions
Thru April 25
Life in Africa: The Collins Collection of Angolan Objects

Thru May 30
Flying Colours

January 14-March 14
René Derouin: Frontiers, Frontières, Fronteras
More than 50 drawings, prints, ceramics, and installations by the Canadian artist explore themes of land, memory, and migration in works dating from the 1950s to the present.

January 28-May 9
Monet at Giverny: Masterpieces from the Musée Marmottan
Features 22 paintings by Claude Monet (1846-1926). Includes lesser-known later works featuring the flower and water gardens of Monet's property in the rural village of Giverny. Catalogue. (T)

February 4-April 4
David Blackwood: Works from 1980 to 1990
Features 27 engravings by the Canadian artist, influenced by the forces of nature and Methodist austerity in Newfoundland.

April 1-June 6
India: Commemorating Independence, 1947-1997
Nearly 250 works by 21 renowned Indian and European photographers.

April 1-June 13
Goodridge Roberts Revealed
Exhibition of 117 works, including still life, portraits, and landscapes, by Canadian artist Goodridge Roberts (1904-1974).

June 17-October 17
Cosmos: From Romanticism to the Avant-Garde, 1801-2001
An exploration of the era of conquest, from Columbus and the American Promised Land to the Cosmos–the frontier of the 1960s. Includes 350 paintings, sculptures, photographs, drawings, and decorative art objects.

September 9-November 7
Audubon's Wilderness Palette: The Birds of Canada
Features 150 hand-colored prints of Canadian birds by the celebrated artist and naturalist John James Audubon (1785-1851). (T)

Maurice Brault, *Chalice*, c. 1956. Gift of the Honorable Serge Joyal. Photo courtesy Musée des Beaux-Arts de Montréal.

November 11, 1999-February 17, 2000
Modern Mexican Art, 1900-1950
Explores the birth and flowering of modernism in Mexico, with works by Rivera, Orozco, Kahlo, Tamayo, Izquierdo, and others.

Permanent Collection

Canada's oldest and one of its most important arts institutions, the museum has assembled one of Canada's finest encyclopedic collections, totalling over 25,000 objects, from antiquity to the present, from all cultures. Includes Canadian and Inuit art, Ecclesiastical Silver of Quebec, ancient glass, Etruscan and Roman art, European Decorative Arts, Old Master paintings, Modern and Contemporary art, English porcelain, and the world's largest

collection of Japanese incense boxes. **Architecture:** 1912 Benaiah Gibb Pavilion by Edward & W. S. Maxwell; 1939 Norton wing annex; 1976 pavilion by Fred Lebensold; 1991 Jean-Noël Desmarais Pavilion, incorporating facade of 1905 apartment building, by Moshe Safdie and Associates, Inc.

Admission: Temporary exhibitions: adults, $10; students, seniors, $5; children 3–12, $2; family groups, $20; groups of 20 or more, $8 per person. Permanent collection only: free at all times. Handicapped accessible, including ramps and elevators; wheelchairs available upon request.
Hours: Tues.-Sun., 11-6; Wed., 11-9 for special exhibitions. Closed Mon.
Tours: For reservations, call (514) 285-1600 ext. 196, Mon.-Fri.
Programs for Children: Esso-Sundays Self-Serve Cart, including activity cards, drawing materials and games, encourages appreciation of the arts.
Food & Drink: Café open during museum hours.
Museum Shop: Features reproduction art works and elegant stationery.

Le Musée du Québec

Parc des Champs-de-Bataille, Quebec, G1R 5H3, Canada
(418) 643-2150
http://www.mdq.org

1999 Exhibitions
January 27-April 11
African Art

May 26-September 5
Dallaire
Features works by a major Canadian artist.

December 15, 1999-March 12, 2000
James Tissot (T)

Permanent Collection
Over 20,000 works from the early 17th century to the present, reflecting Québec's cultural heritage. Includes works in all media. **Highlights:** Largest collection of Québec art in Canada. **Architecture**: Three linked pavilions, including the Great Hall; the 1860s Charles-Baillairgé pavilion; Neoclassical 1933 Gérard Morisset Pavilion. The heritage building housed the former Québec City prison.

Admission: Adults, $5.75; seniors, $4.75; students, $3.75; children under 16, free. Handicapped accessible; ramps, elevators, wheelchairs available.
Hours: Summer (June 1-Sept. 8): Daily, 10-5:45; Wed., 10-9:45. Winter (Sept. 8-May 31): Tues.-Sun., 11-5:45; Wed., 11-8:45.
Tours: Call (418) 643-4103 for information. Reservations required.
Food & Drink: Café open during museum hours. Call (418) 644-6780 for reservations. The Café patio is adjacent to the lovely Battlefields Park.
Museum Shop: Open during museum hours.

National Gallery of Canada

380 Sussex Dr., Ottawa, Ontario, K1N 9N4, Canada
1-800-319-ARTS; (613) 990-1985
http://national.gallery.ca

1999 Exhibitions

June 3-September 6
Honoré Daumier
The first comprehensive survey of the important and powerful 19th-century French artist (1808-1879). Includes 230 works in all media. (T)

Permanent Collection

Most extensive collection of Canadian art in the world; European, Asian, Inuit, American art; international collection of contemporary film, video; Canadian silver; indoor garden court, water court. **Highlights:** Paintings and sculpture by Cranach the Elder, Grien, Bernini, Murillo, Poussin, Rubens, Rembrandt, West, Chardin, Turner, Constable, Degas, Pissarro, Monet, Cézanne, Klimt, Ensor, Matisse, Picasso, Braque, Moore, Bacon, Pollock, Newman; photography by Cameron, Atget, Evans, Sander, Weston, Model, Arbus; completely reconstructed 19th-century Rideau Convent Chapel. **Architecture:** 1988 building by Moshe Safdie.

Admission: Free. Fees for special exhibitions. Handicapped accessible.
Hours: May-Sept 1999, daily 10 6, Thurs. until 8.
Programs for Children: Workshops, guided and self-guided tours.
Tours: Daily, 11, 2. Groups call (613) 993-0570 three weeks in advance.
Food & Drink: Café l'Entrée, 11:30-5, open until 8 on Thurs.; Cafeteria des Beaux-Arts open 10-4.
Museum Shop: Selection of art books and handcrafted gifts.

Art Gallery of Ontario

317 Dundas St. West, Toronto, Ontario, M5T 1G4, Canada
(416) 977-6648
http://www.ago.net

1999 Exhibitions

Thru January 3
Michael Lambeth
Over 100 works by the influential 20th-century Canadian documentary photographer, known for his compelling depictions of the drama of everyday life.

Barend Cornelis Koekkoek, *Winter Landscape.* From *Art in the Age of Van Gogh: Dutch Paintings from the Rijksmuseum.* Photo courtesy Art Gallery of Ontario.

Thru February 14
Art in the Age of Van Gogh: Dutch Paintings from the Rijksmuseum
Features approximately 70 oil paintings produced in Holland during the 1800s, including several works by Van Gogh, Piet Mondrian, and more.

Thru March 7
The Art of Betty Goodwin
Works by one of Canada's most respected contemporary artists.

February 20-April 18
French Drawings from the Horvitz Collection
Rare and diverse 17th- and 18th-century French master drawings. Includes drawings by Claude Lorrain, Poussin, and Jacques Bellange.

April 24-June 20
Angels from the Vatican: The Invisible Made Visible
A truly remarkable exhibition of angels in art from 1000 B.C. to the present day. More than 100 rare and sacred objects by Gentile da Fabriano, Fra Angelico, Masolino, Veronese, Raphael, and Dalí, among others. (T)

October 1, 1999-January 2, 2000
Cindy Sherman: Retrospective
Mid-career survey of the 20th-century American photographer. Includes selections from each of her key series, including Untitled Film Stills. (T)

Permanent Collection
More than 20,000 works of European, American, and Canadian art since the Renaissance, including Impressionist, Post-Impressionist, Modernist, and contemporary works; Inuit art. **Highlights:** European masterworks by Hals, Rembrandt, Rubens, Chardin, Gainsborough, Degas, Pissarro; world's largest public collection of sculpture by Henry Moore. **Architecture:** The Grange, an 1817 brick Georgian-style private home fully restored and furnished to the 1830s period; 1936 expansion, Walker Memorial Sculpture Court; 1974 Henry Moore Sculpture Centre and Sam and Ayala Zacks Wing; 1977 Canadian Wing and Gallery School; 1993 additions by Barton Myers, Architect, Inc., in joint venture with Kuwabara Payne McKenna Blumberg Architects.

Admission: Suggested donation: $5. Handicapped accessible.
Hours: Tues.-Sun., 10-5:30; Wed., 10-10. Closed Mon, except holidays.
Programs for Children: Off the Wall! dress up in period costumes, and other interactive art activities; Family Sundays. Call for details.
Tours: Call (416) 979-6601 for information. Signed tours available.
Food & Drink: Agora Restaurant open Wed.-Fri., 12-8:30; Sat.-Sun., 12-5. Café Medici offers indoor and outdoor seating; call for hours.
Museum Shop: Open Wed.-Fri., 10-9; Sat.-Tues., 10-6.

The Power Plant
231 Queens Quay West, Toronto, Ontario M5J 2G8, Canada
(416) 973-4949
http://www.culturenet.ca/powerplant

1999 Exhibitions
January 22-April 5
Sophie Ristelhueber
Eugène Leroy

April 16-June 13
Mike Kelley/Paul McCarthy: A Collaboration from L.A.

Permanent Collection

No permanent collection. Devoted solely to the exhibition and interpretation of contemporary art. **Architecture:** Red brick power plant, built in 1926 and active until 1980, when the building was renovated by Peter Smith of Lett/Smith Architects. Opened to the public in 1987.

Admission: Adults, $4; seniors, students, $2; members and children 12 and under, free. Handicapped accessible.
Hours: Tues.-Sun., 12-6; Wed., 12-8. Closed Mon. except holidays.
Programs for Children: Children's tours available; call (416) 973-4932.
Tours: Sat.-Sun., 2, 4; Wed., 6:30; Groups, call (416) 973-4932.
Food & Drink: Restaurants located nearby at the Queens Quay Terminal.
Museum Shop: None, but publications available at the Gallery Desk.

Vancouver Art Gallery

750 Hornby Street, Vancouver, British Columbia V6Z 2H7, Canada
(604) 662-4700
http://www.vanartgallery.bc.ca

1999 Exhibitions

Thru January 10
James Wilson Morrice and His Contemporaries
Ten recently donated paintings by one of Canada's most important expatriates.

Thru January 24
The Natural World: Lee Bul, Mark Dion, Cornelia Hesse-Honneger, Mike Kelley
International contemporary artists investigate the scientific world and systems of classification.

Audubon's Wilderness Palette: The Birds of Canada
Features 150 hand-colored prints of Canadian birds by the celebrated artist and naturalist John James Audubon (1785-1851). (T)

Thru January 31
Weak Thought
A two-part exhibition of late-modernist abstraction, including post-minimal art from the 1970s and 1980s and more recent abstract work by local artists.

February 27-May 24
Stan Douglas
Photographs, film and video projects by the internationally recognized Vancouver installation artist.

February-June
Toulouse-Lautrec from the Baldwin Collection
Features satirical drawings, prints, and posters of Parisian nightclub and racetrack life by late-19th-century French artist Toulouse-Lautrec.

June 17-September 26
About Face
Explores the fascination with the human image through 400 years of diverse portraiture in painting, photography, sculpture, and drawing. Includes works by Titian, Cindy Sherman, and Chuck Close.

October 20, 1999-January 23, 2000
New Frontiers
End-of-the-millennium project explores changing notions of the "frontier." Includes works by Canadian artists such as Varley, Tauber, and Macdonald.

Permanent Collection
Contemporary and international art, featuring works by Canadian and local British Columbia artists. Significant collection of American and British prints; British and Dutch paintings. **Highlights:** The world's foremost collection of paintings by Emily Carr. **Architecture:** 1907 Neoclassical courthouse building designed by F.M. Rattenbury, renovated by Arthur Erickson and Associates in 1983; Robson annex designed by Thomas Hooper.

Admission: Adults, $7-10, depending on exhibition; senior and student discounts; children under 12, free. Handicapped accessible.
Hours: Winter (October-April): Wed.-Sat., 10-6; Thurs., 10-9; Sun., holidays, 12-5:30; Closed Mon., Tues. Summer (April-October): Mon.-Wed., Sat., 10-6; Thurs.-Fri., 10-9; Sun., holidays, 12-5.
Programs for Children: Super Sunday offers creative workshops; summer programs, school tours available.
Tours: Call Public Programs office (604) 662-4717 two weeks in advance.
Food & Drink: Gallery Café features West Coast cuisine; open during gallery hours.
Museum Shop: Open during gallery hours.

Additional Museums in Canada...

Edmonton Art Gallery
2 Sir Winston Churchill Sq., Edmonton, Alberta, Canada T5J 2C1, (403) 422-6223

Glenbow
130 9th Ave., SE, Calgary, Alberta, Canada T2G 0P3, (403) 268-4100

Canadian Museum of Civilization
100 Laurier St., Hull, Quebec, Canada J8X 4H2, (819) 776-7000

Royal Ontario Museum
100 Queen's Park, Toronto, Ontario, Canada M5S 2C6, (416) 586-5551

Emily Carr, *The Crying Totem,* c. 1922-23. Photo by Jim Gorman, courtesy Vancouver Art Gallery.

Mucha Museum

Panská 7, Praha 1, 110 00, Czech Republic
(420) (2) 628 41 62
http://www.mucha.cz

Permanent Collection
Opened in 1998, the Mucha Museum is
the world's first museum dedicated
exclusively to the work of world-
renowned, Czech art nouveau artist
Alphonse Mucha (1860-1939). A
comprehensive cross-section of the artist's
career, including lithographs, drawings,
pastels, statues, photographs, and personal
memorabilia. **Highlights:** Decorative
panels, posters advertising Sarah
Bernhardt performances. **Architecture:**
1782 neo-rococo Kaunitsky Palace; 1996
reconstruction.

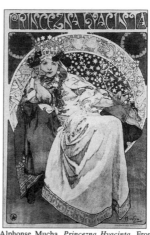

Alphonse Mucha, *Princezna Hyacinta.* From
Alphonse Mucha: The Flowering of Art Nouveau.
Photo courtesy North Carolina Museum of Art.

Admission: 120, Kc. Handicapped
accessible.
Hours: Daily, 10-6
Programs for Children: Guided tours upon request.
Tours: Guided tours in English, German, and French upon request.
Advance reservations required.
Food & Drink: Small café with summer terrace in courtyard. Open daily.
Museum Shop: An exclusive selection of gifts with Mucha motifs. Open
daily, 10-6.

National Gallery in Prague

Hradcanské nám 15, Prague 012, 119 04, Czech Republic
(420) (2) 20 51 31 80
http://www.czech.cz/NG

1999 Exhibitions
Note: Full exhibition schedule not available for all branches. Call ahead.

Admission: Adults, 70 Kc; children 10-18, students with ID, 40 Kc.
Hours: Tues.-Sun., 10-6.
Programs for children: Art studio workshops available.
Tours: Call (420) (2) 57 92 19 29 for information. HAPTIC exhibit of
Japanese sculpture by touch for visually impaired visitors.
Food & Drink: Tea room open 10-6. Call (420) (2) 57 92 16 38.
Museum Shop: Offers catalogues. Open 10-6.

St. George's Abbey
Jirske namesti 33, Prague 1-Hrad, Czech Republic
(420) (2) 57 32 05 36; (420) (2) 53 52 40

Permanent Collection
Early Bohemian art; Gothic panel paintings; Gothic sculpture; Baroque painting and sculpture; Rudolfine art. **Architecture:** A former Benedictine abbey founded in 973, attached to the earlier St. George's Basilica, 921.

Sternberg Palace
Hradcanské namesti 15, Prague 1-Hradcany, 119 04, Czech Republic
(420) (2) 20 51 46 34-7

Permanent Collection
European art from the 14th through 18th centuries, including works by Gossaert, Dürer, Cranach, Brueghel, El Greco, Tiepolo, Canaletto, Rembrandt, and Rubens. **Architecture:** Baroque palace, c. 1697–1707, Giovanni Battista Alliprandi.

Convent of St. Agnes of Bohemia
U Milosrdnych 17, Prague 1-Stare Mesto, 110 00, Czech Republic
(420) (2) 24 81 06 28; (420) (2) 24 81 08 35

1999 Exhibitions
Thru April
Josef Navrátil
Czech painter (1798-1865).

Permanent Collection
Czech painting and sculpture from the 19th century including works from the schools of Classicism, Romanticism, Realism, and Symbolism. **Architecture:** The first convent for nuns of the order of St. Clare north of the Alps. Founded in 1232 by St. Agnes of Bohemia, daughter of Premyslid King Otakar I. The building is one of the earliest examples of the penetration of Cisterian-Burgundian-Gothic style into Bohemia.

Zbraslav Chateau
Zbraslav n. Vltavou, Ke Krnovu 2, Prague 5, C2-15600 Czech Republic
(420) (2) 79 83 19-0; (420) (2) 59 11 88-9

1999 Exhibitions
May 13-September 5
Hiroshi Ohnari: The Wind
Carpets and Their Context

Permanent Collection
Permanent exhibitions of Czech sculpture and Asian art from the museum's extensive collection. **Highlights:** Japanese lacquer and woodblock prints; Chinese tomb figures; Tibetan thankas; manuscript of Koran. **Architecture:** The Chateau received its current Baroque appearance when it was rebuilt according to the design of Giovanni Santinni and FM Kanka. The centerpiece of the complex consists of a royal hunting lodge, dating from 1268, and a Cisternian monastery founded by Wencelas II in 1292.

Kinsky Palace
Staromestke namesti 12, Prague 1-Stare Mesto, Czech Republic
(420) (2) 24 81 07 58

Permanent Collection
Collection of prints, old drawings, 19th- and 20th-century drawings.
Architecture: Kinsky Palace was built between 1775 and 1765 in the late-Baroque Classical style by Alselmo Lurago according to an earlier design by K.I. Dientzenhofer.

Veletrzni Palace
Dukelskych hrdinu 47, Prague 7-Holesovice, Czech Republic
(420) (2) 24 30 10 24

Permanent Collection
A collection of world modern art with an emphasis on Czech artists.
Architecture: The building was constructed according to the plans of Oldrich Tyl and Josef Fuchs from 1925 to 1929. It was used for various purposes until 1974 when a fire destroyed much of the interior. After extensive reconstruction that closely followed the original design, the National Gallery in Prague's Center for Modern and Contemporary Art opened here December 1995. With 25,000 square meters, it is the largest site for modern art in Europe.

Louisiana Museum of Modern Art

Gl. Strandvej 13, DK-3050 Humlebaek (nr. Copenhagen), Denmark
(45) 4919 0719; (45) 4919 0991 (recording)
http://www.louisiana.dk

1999 Exhibitions
Thru January 10
Joan Miró
Retrospective of 150 works that the experimental Spanish artist created between the 1920s and the 1970s. Includes paintings, sculptures, drawings, watercolors, and collages.

Permanent Collection
Works by 20th-century masters Giacometti, Moore, and Picasso; postwar U.S. and European art by Baselitz, Dubuffet, Dine, Kiefer, Kirkeby, Warhol; Constructivism, CoBrA. **Highlights:** Sculpture by Calder, Arp, Serra, and Giacometti. **Architecture:** Spectacular waterfront setting; airy modern building by Jorgen Bo and Vilhelm Wohlert; Landscape architects: Norgaard & Holscher.

Admission: Adults, 55 dkk; children, 15 dkk. Handicapped accessible.
Hours: Daily, 10-5; Wed., 10-10.
Programs for Children: Children's Wing and lake garden; also workshops.
Tours: Call (45) 4919 0719 for reservations.
Food & Drink: Café open daily 10-4:30; Wed., 10-9:30.
Museum Shop: Features postcards, posters, design and art books.

Barbican Art Gallery

Level 3, Barbican Centre, Silk St., London, EC2Y 8DS, England
(44) (171) 382-7105
http://www.uk-calling.co.uk

1999 Exhibitions

January 19-March 28
Picasso & Photography

April 15-June 20
David Bailey: Photographs 1960s and 1990s

Malevich's Museum of Fine Art Culture

October-December
Joseph Beuys: Multiples
This post-WWII German artist saw multiples as a means to effect social change. Includes 300 objects that reflect his ideas about nature, healing, communication, energy, politics, and teaching. (T)

Permanent Collection

No permanent collection; rotating exhibitions that focus on late-19th- to early-20th-century art from Britain and abroad, photography, mixed media, and forms of artistic production. **Architecture:** 1982 Barbican Centre.

Admission: Adults, £5; reduction, £3; after 5, Mon.-Fri., £3. Handicapped accessible.
Hours: Mon., Thurs.-Sat., 10-6:45; Wed., 10-7:45; Sun. & bank holidays, 12-6:45.
Programs for Children: Call (44) (171) 638-4141, ext. 7639 for information.
Tours: For information, join free mailing list.
Food & Drink: A choice of three restaurants located in the Barbican Centre.
Museum Shop: Offer posters, postcards, books, and gifts. Open during museum hours.

British Museum

Great Russell St., London, WC1B 3DG, England
(44) (171) 636-1555; (44) (171) 580-1788 (recording)
http://www.british.museum.ac.uk

1999 Exhibitions

Ongoing
Arts of Korea
Overview of the development of Korean art, a precursor to the new Korean Gallery scheduled to open in the year 2000.

Thru January 10
Rubbish Heap of Riches: 100 Years of Oxyrhynchus Papyri

Drawings from the Weld Collection

Claude Prints and Drawings

Thru mid-April
Arts of Japan: Selections from the British Museum's Collection

Thru April
The Golden Sword: Sir Stamford Raffles and the East

January-March
Edward Falkener: A Victorian Orientalist

January-April
Roman and Baroque Drawings

Selection from the Permanent Collection: Prints and Drawings

January 12-April 11
Leaden Hearts: Convict Tokens of the 19th Century

April 1-June 30
Indian Folk Bronzes from the Polsky Collection

May-September
Kyushu Ceramics

The Popular Print Tradition in Britain, 1530-1930

Castiglione in Context

June-October
Cracking Codes: The Rosetta Stone and Decipherment

September-December
Landscape Drawings by Van Dyck and His Contemporaries

Gifts from the National Art Collections Fund to the Department of Prints and Drawings

October-December
Burmese Lacquer

December 1999-early 2000
Japanese Clocks, Zodiac and Calendar Prints

December 1999-Spring 2000
The Apocalypse and the Western Pictorial Tradition
A selection from the museum's Department of Prints and Drawings.

December 1999-May 2000
Divine Rule

Permanent Collection
One of the largest museum collections in the world, tracing the history of human activity from prehistoric times to the present day. Includes antiquities from Egypt, Western Asia, Greece and Rome; Prehistoric and Romano-British, Medieval, Renaissance, Modern and Oriental collections; prints and drawings; coins and medals. **Highlights:** Parthenon sculptures; the Rosetta Stone; Sutton Hoo treasures; Portland vase. **Architecture:** Neoclassical mid-19th-century building by Robert Smirke.

Admission: Free. Themed evenings, £5. Most galleries accessible for disabled visitors; touch tours available. During 1998-2000 major building work may affect some areas. Phone in advance of visit.

Hours: Mon.-Sat., 10-5; Sun., 12-6. Themed evenings with special programs: first Tues. of every month. Call (44) (171) 323-8605 for details. Closed major holidays.

Programs for Children: During school holidays. Call for details.

Tours: Lectures, tours, and gallery talks daily. Call (44) (171) 323-8299 for information.

Food & Drink: Self-service restaurant offers hot and cold food.

Museum Shop: Giftshop and bookshop open during museum hours.

Courtauld Gallery

Somerset House, Strand, London WC2R ORN, England
(44) (171) 873-2526
http://www.courtauld.ac.uk

1999 Exhibitions

Thru January 24
Material Evidence: Drawings from the Courtauld Collection
Offers visitors a fresh way of looking at Old Master drawings and a chance to experiment with materials used. Includes works by Michelangelo, Rembrandt, Constable, Watteau, and others.

February 11-May 3
Piranesi, Canaletto, Tiepolo: Etchings from the Courtauld Collection
Features rare, complete sets of etchings by three great artists. Includes Piranesi's monumental Prison series *Le Carceri.*

May 27-August 30
The Value of Art
Explores the ways viewers are affected by learning the value of works of art. Includes paintings, sculpture, ivories, glass, and works on paper from the gallery's collection.

October 1999-January 2000
Roger Fry's Vision of Art
Celebrates the life and achievements of British painter, critic, and impressario Roger Fry (1866-1934). Themes include the Omega Workshop, Post-Impressionism, and the relationship between European and non-European art.

Permanent Collection

Important collection of western European art from the 14th century to the present. Courtauld Collection of Impressionists and Post-Impressionists, including works by Bonnard, Cézanne, Degas, Gauguin, Manet, Modigliani, Monet, Pissaro, Van Gogh. Old Master paintings; including works by Rubens, Tiepolo, Van Dyck. Fry Collection includes works by Roger Fry, Vanessa Bell, Duncan Grant. **Highlights:** Cézanne, *Lac d'Annecy, The Card Players, Mont Ste. Victoire;* Manet, *Le Déjeuner sur l'Herbe;* Renoir, *La Loge*; Monet, *Antibes.* **Architecture:** 1776–80 Neoclassical "Fine Rooms" of Somerset House by Sir William Chambers.

Admission: Adults, £4; concessions, £2. Handicapped accessible, including parking by prior arrangement, signed tours.
Hours: Mon.-Sat., 10-6; Sun., bank holidays, 2-6; last tickets, 5:15. Closed Jan. 1, Dec. 24-26.
Programs for Children: Free gallery trail.
Tours: Group tours available for up to 25 persons; reservations required.

Edouard Manet, *A Bar at the Folies-Bergère,* 1882.
Photo courtesy Courtauld Institute of Art.

Food & Drink: Coffee shop open Mon.-Sat., 10-5:30; Sun., 2-5:30.
Museum Shop: Books, posters, cards, and gifts.

Hayward Gallery

**South Bank Centre, Belvedere Road, London SE1 8X2, England
(44) (171) 928-3144; (44) (171) 261-0127 (recording)
http://www.hayward-gallery.org.uk**

1999 Exhibitions

Thru January 11
Addressing the Century: 100 Years of Art and Fashion
Explores the creative relationship between art and fashion during the 20th century, from the early modernism of Matisse to recent designs of Miyake. Includes works by Schiaparelli, Dalí, Christo, and others.

Thru January 17
Duane Hanson
Direct-cast sculptures by the internationally acclaimed American artist.

February 4-April 11
Patrick Caulfield
Traces the artistic development of the Royal Academy-educated painter who came to prominence in the 1960s. Includes still lifes, landscapes, interiors and figurative works that span his entire career.

May 6-June 27
Cities on the Move
Examines impact of globalization on art and architecture in modern Asia.

Permanent Collection
Base for Arts Council Collection of postwar British art, but no permanent collection on view. **Architecture:** 1968 building by Greater London Council Department of Architecture and Civic Design.

Admission: Adults, £5; concessions, £3.50; children under 12, accompanied by an adult, free. Group rates available, call (44) (171) 960-4249.
Hours: Daily, 10-6; Tues.-Wed., 10-8. Closed between exhibitions.
Tours: Call (44) (171) 928-3144 for information.
Food & Drink: Café open gallery hours.

The National Gallery

Trafalgar Square, London WC2N 5DN, England
(44) (171) 747-2885
http://www.nationalgallery.org.uk

1999 Exhibitions

Thru Jan. 31
Luca Signorelli in British Collections
Surveys the career of the lesser-known Italian Renaissance artist Luca
Signorelli through altarpieces, panel paintings, frescoes and drawings.

January 27-April 25
Portraits by Ingres: Images of an Epoch
The career of Ingres (1780-1867) spanned six decades of French history,
including the Revolution, the Napoleonic age, and the Second Empire.
Features 40 paintings and 120 drawings. Catalogue. (T)

Thru March 7
Zanobi Strozzi: In the Light of Fra Angelico
Small monographic exhibition examines works attributed to Strozzi, a
follower and contemporary of medieval artist Fra Angelico.

March 3-May 23
Orazio Gentileschi at the Court of Charles I
Survey of the Italian painter Orazio Gentileschi (1563-1639), a follower of
Carravaggio who disseminated his realistic manner in France and England,
where he became court painter to Charles I.

March 18-July 4
Roger van der Weyden
Focuses on the gallery's collection of works by Roger van der Weyden and
his workshop, in celebration of the 600th anniversary of the artist's birth.

June 9-September 5
Rembrandt by Himself
A pictorial autobiography of the 17th-century master traces the development
of Rembrandt's self-portraiture through 75 paintings, drawings, and
etchings. (T)

June 23-August 30
(A Brush with Nature) The Gere Collection of Landscape Sketches
Includes 60 small-scale oil paintings, dating from the late 18th century,
depicting the artists' attempts to capture subtle atmospheric effects of light
and shadow in a plein-air setting.

July 15-September 26
Hans Wertinger: Summer
Focuses on a recently acquired work by the 16th-century German artist.

September 29, 1999-January 2, 2000
Ana Maria Pacheco: Working in the National Gallery
The National Gallery's Associate Artist culminates her 2-year residency by
producing works in relation to the myths and religious stories represented in
the collection.

October 20, 1999-January 20, 2000
Renaissance Florence in the 1470s
Examines the artistic activity of Botticelli, da Vinci, Lippi, and others in 15th-century Florence, when the city became the artistic center of Europe under the rule of Lorenzo de' Medici.

November 17, 1999-end January 2000
Botticelli: Mystic Nativity
Focuses on this controversial late work, painted by Botticelli in 1500.

Permanent Collection

National collection of Western European painting from 1260 to 1900. All 2,300 pictures are on display except those on loan or in restoration. Recent acquisitions include: Francisco de Zubarán, *Cup of Water and a Rose on a Silver Plate*; Julius Schnorr von Carolsfeld, *Ruth in Boaz's Field.*
Highlights: Van Eyck, *The Arnolfini Marriage*; Rubens, *The Judgement of Paris*; Renoir, *Umbrellas*; Piero della Francesca, *Baptism of Christ*; Seurat, *The Bathers, Asnières;* Velázquez, *The Rokeby Venus*; Leonardo da Vinci, *Virgin of the Rocks*; Titian, Tintoretto. **Architecture:** 1838 Neoclassical building by William Wilkins; 1975 northern extension by PSA; 1991 Sainsbury Wing by Venturi, Scott Brown Associates.

Claude Monet, *The Museum at Le Havre.* From *Traveling Companions: Monet and Seurat,* a traveling exhibition organized by the National Gallery, London. Photo courtesy the National Gallery.

Admission: Free. Charge for some special exhibitions. Handicapped accessible, including lifts; wheelchairs available.
Hours: Mon.-Sun., 10-6; Open until 9pm on Wed. Closed Jan. 1, Good Friday, Dec. 24-26.
Programs for Children: Quiz activity booklets available from information desk.
Tours: Mon.-Fri., 11:30, 2:30; Wed., 6:30; Sat., 2, 3:30. Free. Groups call (44) (171) 747-2424. Special tours available for deaf and visually impaired visitors.
Food & Drink: Pret à Manger Café in main building, open daily, 10-5:30, Wed. until 7:30; Brasserie Restaurant in Sainsbury Wing offers coffee, snacks, afternoon tea, open daily 10-5, Wed. until 7:30.
Museum Shop: Two shops offer art books, CD Roms, cards, prints, slides, and gifts. Call (44) (171) 747-2870 for mail-order inquiries. Open daily, 10-5:30; Wed. until 7:30.

National Portrait Gallery

St. Martins Gallery, London WC2H 0HE, England
(44) (171) 306-0055
http://www.npg.org.uk

1999 Exhibitions

Thru January 29
British Sporting Heroes
Examines the phenomenon of the sporting hero and the idea of the heroic
through 250 paintings, drawings, prints, sculptures, photographs, and film
footage, dating from the mid-18th century to the present.

Thru February 14
John Kobal Photographic Award 1998
Includes the winners and a selection of entries from the annual award
competition.

Thru April 6
Gerald Scarfe
A selection of caricatures of major British political figures by Scarfe, who
has been a leading caricaturist for the last 35 years.

February 19-June 6
J.E. Millais
Traces the development of John Everett Millais's portraiture from his Pre-
Raphaelite period to his later, commissioned portraits of the 1870s and
1880s. Subjects include John Ruskin, Lillie Langtry, and W.E. Gladstone.

Permanent Collection

More than 1,000 portraits on display of famous Britons in a variety of
media, including paintings, drawings, sculptures, miniatures, caricatures,
silhouettes, and photographs. **Highlights:** G. L. Brockelhurst, *The Duchess
of Windsor;* Terence Donovan, *Diana, Princess of Wales.* **Architecture:**
Renovations currently under way, including extended gallery space, a new
lecture theatre, and improved facilities for visitors; due to open Spring 2000.

Admission: Free, except some special exhibitions. Handicapped
accessible, including ramps, lifts, Braille signage, and touch tour.
Hours: Mon.-Sat., 10-6; Sun., 12-6.
Programs for Children: Ongoing educational program. Call ext. 251.
Tours: Free lunchtime lectures most days. Call (44) (171) 306-0055 for
information.
Food & Drink: New museum café
opened October 1998.
Museum Shop: Three gallery shops
offer a range of themed merchandise,
including books, postcards, and
catalogues. New museum bookshop
opened November 1998.

Claude Monet, *The Grand Canal,* 1908.
Collection Museum of Fine Arts, Boston.
From *Monet in the 20th Century.* Photo
courtesy Royal Academy of Arts, London.

Royal Academy of Arts

Burlington House, Piccadilly, London WIV ODS, England
(44) (171) 300-8000
http://www.royalacademy.org.uk

1999 Exhibitions

Thru January 17
Charlotte Salomon
Explores this Berlin-born artist's autobiographical series "Life? or Theatre?"
in which she created a multi-layered drama, combining painting, music, and
text, before her untimely death in the Nazi Holocaust.

January 23-April 18
Monet in the 20th Century
Examines a 26-year period in which French painter Claude Monet produced
some of his greatest and most challenging work. Includes over 80 paintings,
featuring his large-scale decorative series *Le Bassin aux Nymphéas.*

September 16-December 16
Anthony Van Dyck
Over 80 paintings survey the career of 17th-century Flemish artist Anthony
Van Dyck, court painter for Charles I of England, in celebration of the 400th
anniversary of the artist's birth. Catalogue. (T)

Permanent Collection

Works by Constable, Gainsborough, Michelangelo, Turner; *The Marriage
Feast of Eros and Psyche* (ceiling painting); Ricci, *Juno and Jupiter on
Olympus, The Triumph of Galatea, Diana and Attendants,* and *Bacchus and
Ariadne;* West, *The Graces Unveiling Nature (ceiling painting);* Kauffman,
Genius, Painting, Composition, and Design; Reynolds, *Self-Portrait*;
Gainsborough, *Self-Portrait*; landscapes, sketches. **Highlights:** works by
Constable, Michelangelo. **Architecture:** 1660 Burlington House, remodeled
(1717) in Palladian style by the 3rd Lord Burlington; 1815 renovation by
Samuel Ware for Lord George Cavendish; bought by the British government
in 1854 and leased to the Academy in 1866. Interior features are Palladian
and include ornate ceiling paintings.

Admission: Varies from £5-£8 depending on exhibition; reduced rates for
seniors, students, children. Handicapped accessible; wheelchairs available;
please call ahead.
Hours: Daily, 10-6. Last admission, 5:30. Closed Good Friday, Dec. 25.
Programs for Children: Offers educational programs around special
exhibitions; call (44) (171) 300-5733 for details.
Tours: Permanent Collection on view through lunchtime guided tours only;
call (44) (171) 300-8000 for information.
Food & Drink: Restaurant open daily, 10-5:30; Courtyard Café open during
summer months; coffee shop.
Museum Shop: Open Fri.-Wed., 10-5:45; Thurs., 10:30-5:45. Offers cards,
gifts inspired by current exhibitions, and artists' equipment.

Tate Gallery

Millbank, London SWIP 4RG, England
(44) (171) 887-8000
http://www.tate.org.uk

1999 Exhibitions

Thru January 10
The Turner Prize
Annual exhibition of contemporary art.

Thru January 17
John Singer Sargent
Major survey of prolific American painter John Singer Sargent (1856-1925), known for his astute and elegant society portraits. More than 100 paintings and watercolors include portraits, landscapes, and figure sketches. Catalogue. (T)

Pablo Picasso, *Head of a Woman*, 1924. From *The Spirit of Cubism.* Photo courtesy Tate Gallery Liverpool.

March 11-June 6
Jackson Pollock
Reexamines the challenging and influential work of this American Abstract Expressionist painter, featuring over 120 paintings and 60 works on paper. (T)

July 8-September 26
International Contemporary Theme

October 1999-January 2000
The Turner Prize

November 4, 1999-January 30, 2000
The Art of Bloomsbury: Roger Fry, Vanessa Bell, and Duncan Grant

Permanent Collection

Houses the national collection of British art from the 16th century to the present day; also the national gallery for modern art, including British, European, and American art since 1900. **Highlights:** 1987 Clore Gallery houses the Turner Collection, comprising paintings, watercolors, and drawings by J.M.W. Turner; works by Bacon, Blake, Cézanne, Constable, Degas, Dalí, Gainsborough, Giacometti, Van Gogh, Hogarth, Lowry, Moore, Picasso, the Pre-Raphaelites, Rodin, Rothko, and Warhol, amongst others. **Architecture:** 1897 Neoclassical building overlooking the Thames by Sidney J. R. Smith; Clore Gallery by James Stirling, Michael Wilford and Assoc.

Admission: Free; fees for special exhibitions. Handicapped accessible.
Hours: Daily, 10-5:50. Closed Dec. 24-26.
Tours: Call (44) (171) 887-8725 for information.
Food & Drink: Café open daily, 10:30-5:30. Restaurant open daily, 12-3. Groups call (44) (171) 887-8725.

Tate Gallery Liverpool

Albert Dock, Liverpool L3 4BB, England
(44) (151) 709-3223; (44) (151) 709-0507 (recording)
http://www.tate.org.uk

1999 Exhibitions
Ongoing
Modern British Art
Includes paintings, sculpture, photographs, and videos by 20th-century British artists such as Hepworth, Moore, Hockney, and Bacon.

Thru January 31
Salvador Dalí: A Mythology
Exhibition of 30 paintings and 25 works on paper, dating primarily from the 1930s, focusing on the Surrealist artist's engagement with Classical and Catholic myth, legend, and belief.

Thru April
Urban
A selection of works from the Tate's permanent collection relating to the specifics of city life and its development during the 20th century.

The Spirit of Cubism
Features paintings, sculptures, drawings, and collages by Picasso, Braque, Gris, Léger, and other Cubist artists, on loan from the Tate Gallery London.

February 20-May 16
Richard Deacon

Permanent Collection
National Collection of Modern Art, see description under Tate Gallery London. **Architecture:** 1846 Albert Dock warehouse, converted to gallery space by James Stirling, Phase 1 in 1988, Phase 2 completed in 1998.

Admission: Free (except for some special exhibitions). Handicapped accessible, including lifts. Braille and large print leaflets available.
Hours: Tues.-Sun., 10-6. Closed Mon. (except Bank Holiday Mon.), Jan. 1, Good Friday, Dec. 24-26.
Programs for Children: Weekend workshops for children; programs for young people, school groups, and university students. Call for details.
Tours: Daily, 2. Free. No reservations required.
Food & Drink: Cafe-Bar open daily, 10am until late.
Museum Shop: Open Tues.-Sun., 10-5:50. Offers a selection of Tate merchandise, including posters, books, cards, and souvenirs.

Tate Gallery St. Ives
Porthmeor Beach, St. Ives, Cornwall, TR26 1TG England
(44) (1736) 796-226
Rotating displays of works by 20th-century artists associated with St. Ives, Cornwall, from the collection. Includes the Barbara Hepworth Museum and Sculpture Garden, Barnoon Hill, St. Ives.

Victoria and Albert Museum

South Kensington, London SW7 2RL, England
(44) (171) 938-8500; (44) (171) 938-8441 (recording)
http://www.vam.ac.uk

1999 Exhibitions

Thru January 10
Aubrey Beardsley
Traces the career of Beardsley (1872-1898) as an illustrator and designer of
books and posters through 200 striking examples of his work, inspired by
the vibrant literary and cultural life of London and Paris in the 1890s.

Thru January 24
Grinling Gibbons and the Art of Carving
First-ever exhibition surveys the career of the 17th-century master
woodcarver through wood sculptures, drawings, and tools. Includes the
magnificent *Cosimo* panel commisioned in 1682 by Charles II.

March 25-July 25
The Arts of the Sikh Kingdoms
Explores the turbulent and fascinating
cultural history of the 19th-century
Maharajas of the Punjab through paintings,
jewels, textiles, and weapons. (T)

October 1999-January 2000
*A Grand Design: The Art of the Victoria
and Albert Museum*
Presents the history of a museum through a
comprehensive exhibition of 250
masterworks from the V&A's immense
collections, spanning 2,000 years of artistic
achievement. Catalogue. (T)

Akali Turban, Lahore, 19th century. From
The Arts of the Sikh Kingdoms. Photo
courtesy Victoria and Albert Museum.

Permanent Collection

The most important decorative arts
museum in the world, known fondly as the "attic," including enormous
collections of applied art in all media, dating from 3,000 BC to the present.
Highlights: The Raphael Gallery houses seven cartoons by Raphael which
are among the greatest surviving works of Renaissance Art in the world;
world's greatest collection of Constables and the national collection of
watercolors; Devonshire Hunting Tapestries; Dress Collection showing the
history of fashion from 1500 to today; Asian collection; medieval treasures;
Renaissance sculpture, Victorian plasters; Jewelry Gallery; 20th Century
Gallery; National Art Library. **Architecture:** 1891 building by Captain
Francis Fowke; 1899-1909 south front by Aston Webb.

Admission: Full price, £5.00; concessions, £3.00; students, youth under 18,
handicapped and their carers, ES40 holders, daily 4:30-5:45, free.
Handicapped accessible; use Exhibition Road entrance.

Hours: Tues.-Sun., 10-5:45; Mon., 12-5:45; Wed. Late View (seasonal), 6:30-9:30. Closed Dec 24-26.
Programs for Children: Activities for families every Sunday with special events over school holidays. Tel. (44) (171) 938-8638 for further details.
Tours: Tues.-Sun., on the half hour, 10:30-3:30; Mon., on the half hour, 12:30-3:30. Free. Specialist gallery talks, Mon.-Sat., 2. Tours available for the visually-impaired.
Food & Drink: The New Restaurant offers coffee, tea, snacks, salads, and meals, open daily until 5. Jazz Brunch, Sun., 11-5.
Museum Shop: Two shops stock a collection of art and design, books, gifts, stationery, and specially commissioned jewelry, ceramics, and textiles. Open daily until 5:30. Call (44) (171) 938-8434.

Whitechapel Art Gallery

Whitechapel High St., London E1 7QX, England
(44) (171) 522-7888; (44) (171) 522-7878 (recording)

1999 Exhibitions
Thru February 7
Rosemarie Trockel
Contemporary paintings, clothing, installations, and video featuring images inspired by anthropology, consumerism, and everyday objects. Features several themed spaces, including a Brigitte Bardot room. (T)

February 19-April 25
Henri Michaux
Exhibition in celebration of the birth of Michaux (1899-1984) focuses on the artist's works on paper, including calligraphy and watercolor.

Terry Winters
Large, vibrantly colorful abstract paintings by a contemporary artist from Brooklyn, N.Y.

Permanent Collection
No permanent collection. Temporary exhibitions of works by modern and emerging artists. **Architecture:** 1901 vernacular structure, 1984-5 renovation.

Admission: Free. Special charges for some exhibitions. Handicapped accessible, including lift; audio tape and large print information available; BSC interpreted talks; workshops for people with visual impairment or mobility needs.
Hours: Tues.-Sun., 11-5; Wed., 11-8. Closed Mon.
Programs for Children: Workshops accompanying exhibitions. Teacher's packs available.
Tours: Call (44) (171) 522-7888.
Food & Drink: Café open Tues.-Sun, 11-4:30; Wed., 11-6. Closed Mon.
Museum Shop: Zwemmer Art books, open during gallery hours.

Museum of Modern Art, Oxford

30 Pembroke St., Oxford OX1 1BP, England
(44) (1865) 722-733; (44) (1865) 813-830 [recording]

1999 Exhibitions

Thru January 10
Gustav Metzger
Mitja Tusek

January 24-April 4
Willie Doherty: Somewhere Else
Examines the way the media controls and manipulates our perception of events, people, and places, by this artist from Northern Ireland.

James Casebere: New Photographs
A selection of approximately 25 recent works by this American photographer currently living in New York.

April-June
Sam Taylor-Wood
The first major solo exhibition of work by the award-winning video and photographic artist.

April 18-June 27
Anna Gaskell
Recent work by the American artist, including drawings, photographs, and her first film, *Untitled (ophelia),* inspired by *Ophelia* by Pre-Raphaelite painter Sir John Everett Millais. (T)

July 11-October 3
Alfred Hitchcock
Work by contemporary artists who have been influenced directly or indirectly by the great British film director Alfred Hitchcock, in celebration of the centenary of his birth. Includes clips of Hitchcock films.

October 17, 1999-January 2, 2000
Michaelangelo Pistoletto: The Shifting Perspective
An investigation into the work of contemporary artist Michaelangelo Pistoletto, one of the founders of the Italian *Arte Povera* movement.

Permanent Collection

No permanent collection. Internationally acclaimed as center for the display of 20th-century visual culture, including painting, sculpture, photography, film, video, architecture, design, and performance from all over the world.

Admission: Adults, £2.50; concessions, £1.50; children under 16, Wed., 11-1, Thurs., 6-9, free. Handicapped accessible.
Hours: Tues.-Sun., 11-6; Thurs., 11-9; Closed Mon.
Programs for Children: Contact the Education Dept.
Food & Drink: Café MoMA known for its wide range of delicious and healthy food, especially its vegetarian dishes and desserts. Open Tues.-Sat., 9-5; Sun., 2-5.
Museum Shop: A wide range of art books, biography, and fiction. Unusual gifts and cards.

Centre National d'Art Contemporain de Grenoble

Magasin, 155 Cours Berriat, 38028 Grenoble, France
(33) (4) 76 21 95 84
http://www.magasin-cnac.org

1999 Exhibitions
January 17-February 7
Les Écoles d'Art Exposent leurs Artistes
A selection of work by recent graduates of five art schools in the Rhône-Alpes region.

Sarkis, *Scenes de Nuit–Scenes de Jour.* Photo by Egon V. Furstenberg, courtesy Centre National d'Art Contemporain de Grenoble.

Extra-Muros/Intra-Muros
A presentation of project organized for the Magasin outside of its walls.

March 7-May 16
La Désolation
Nearly 80 works by Belgian artists.

June 6-September 5
Art et Micro-Politiques

Admission: Adults, 15 F; students, children under 18, unemployed people, groups, 10 F; children, members, fine art or architecture students, free.
Hours: Tues.-Sat., 12-7
Programs for Children: Free tours by reservation.
Tours: Free tour, Sat., 5. Group tours by reservation, 220 F.
Museum Shop: Bookstore specializes in contemporary art and architecture.

Musée des Beaux-Arts de Lyon

Palais St. Pierre, 20 Place des Terreaux, 69001 Lyon, France
(33) (4) 72 10 17 40
http://www.mairie-lyon.fr

1999 Exhibitions
January 28-April 18
Raoul Dufy
Retrospective of the modern French artist's entire career, from his vital contribution to Fauvism to his later *Cargos Noirs (Black Ships).* Also features his work as a silk designer in Lyon, and his ceramic and decorative creations. (T)

May 20-August 29
The Portrait Album of Hippolyte Flandrin
60 drawings made by this student of Ingres as preparatory sketches for portraits provide a rare glimpse into the working methods of the Lyonnais artist.

Permanent Collection

French, Flemish, Dutch, Italian, and Spanish paintings; Impressionist and modern art; Puvis de Chavannes murals; medieval sculpture; Islamic collection; works by regional artists; drawings, prints, furniture, and numismatics. **Architecture:** 1659 former Benedictine abbey; 19th-century restoration and modernization; renovations to the South wing and the Church of St. Peter completed in April 1998.

Admission: Adults, 25 F; concessions, 13 F; children under 18, free. Handicapped accessible, including tours for the sight- and hearing-impaired.
Hours: Wed.-Sun., 10:30-6.
Programs for Children: Workshops, tours, and other activities.
Tours: Call (33) (4) 72 10 17 40 for information.
Food & Drink: Cafeteria opened in April 1998.
Museum Shop: Bookshop open during museum hours; gift shop open Tues.-Sun., 10:30-7.

Musée d'Art Moderne et d'Art Contemporaine

Promenade des Arts, 06300 Nice, France
(33) (4) 93 62 61 62

1999 Exhibitions
Thru January 10
Joël DuCorroy

Thru March 21
Enrico Baj

January 23-March 7
Suzy Gomez

March 13-May 2
David Bade

Musée d'Art Moderne et d'Art Contemporain de Nice. Photo by Muriel Anssens.

Permanent Collection

Collection of French and American avant-garde artists from the 1960s to the present. Includes works by the Nice School of the New Realists and International Fluxus. American modernism by Warhol, Rauschenberg, Lichtenstein, Oldenburg, and Dine. **Highlights:** Large collection of works by Yves Klein, Arman Cesar, and other Nice artists; sculpture garden with works by Calder, Borofsky, and Sandro Chio.

Admission: Adults, 25 F; students, 15 F; guided visit, 20 F; reduced fees, 10 F; first Sun. of each month, free. Handicapped accessible.
Hours: Wed.-Mon., 10-6. Closed Tues., holidays.
Tours: Wed., 4. Group reservations required two weeks in advance at a cost of 20 F.
Food & Drink: Café Sud, noon-midnight; Grand Café des Arts, 10 a.m.-midnight.

Matisse Museum

164 Avenue des Arènes de Cimiez, 06000, Nice, France
(33) (4) 93 81 08 08

1999 Exhibitions

Thru March 5
In the Footsteps of Matisse: Nice and the Region
An ensemble of documents, photographs, and texts written by Matisse give insight into the importance of Nice and the region to the life and work of the 20th-century master.

March 12-June 11
Matisse and Antiquity
A look at the impact of Antiquity on Matisse's work, from his Hellenistic-inspired works *La Danse* and *La Nymphe dans la forêt* to his illustration for *Pasiphaé* and Joyce's *Ulysses*.

June 18-October 3
Donation Marie Matisse
Recently acquired graphic works, fabrics, clothing, illustrations, and ceramic objects.

October 15-December 31
Regards sur la Collection du Musée Matisse

Permanent Collection
Works donated by Matisse, his family, and others span every period of the painter's life. **Highlights:** Oil paintings: *Portrait de Mme Matisse*, 1905; *Odalisque au Cofret Rouge*, 1926; *Fauteuil Rocaille*, 1946; *Nature morte aux grenades*, 1947; Paper cut-outs: *Nu bleu IV, La Vague*, 1952, *Fleurs et Fruits*, 1953; Bronzes; life-sketch for *La Danse*; Vence Chapel Chasubles. **Architecture:** Magnificent 17th-century Italian villa with trompe l'oeil decoration; 1993 renovation and expansion by Jean-François Bodin.

Admission: Adults, 25 F; groups of 15 or more, 15 F; curatorial staff from museums, children under 18, free. Handicapped accessible.
Hours: Oct.-Mar.: Wed.-Mon., 10-5; Apr.-Sept.: Wed.-Mon., 10-6. Closed Tues., Jan. 1, May 1, Dec. 25.
Programs for Children: Workshops, Sept.-June; call (33) (4) 93 82 18 12.
Tours: Call (33) (4) 93 81 08 08 for information.
Food & Drink: Picnic areas available in adjacent park.
Museum Shop: Offers books relating to Matisse and his contemporaries.

Galeries Nationales du Grand Palais

3 Avenue du Général Eisenhower, 75008 Paris, France
(33) (1) 44 13 17 30

1999 Exhibitions

Thru January 4
Gustave Moreau
In honor of the 100th anniversary of the death of the French symbolist painter, featuring masterpieces from each stage of his career. (T)

Thru January 11
Lorenzo Lotto (1480-1556), Un Genie Inquiet de la Renaissance

Thru January 25
Tresors du Musee National du Palais, Taipei: Memoire d'Empire

March 17-June 29
Robert Delaunay: De l'Impressionnisme a l'Abstraction, 1906-1914

April 9-July 12
L'Art Egyptien au Temps des Pyramides

September 11, 1999-November 22, 2000
Chardin

October 2, 1999-January 9, 2000
L'Europe au Temps d'Ulysse

October 9, 1999-January 2, 2000
Honoré Daumier: Retrospective
The first comprehensive survey of the important and powerful 19th-century French artist (1808-1879). Includes 230 works in all media. (T)

Permanent Collection
No permanent collection. Exhibitions of contemporary art.

Admission: Varies with exhibition. Handicapped accessible.
Hours: Thurs.-Mon., 10-8; Wed., 10-10. Closed Tues., holidays.
Tours: Groups call (33) (1) 44 13 17 17 for reservation.
Food & Drink: Contemporary design café open museum hours.
Museum Shop: Offers catalogues, cards, and gift items.

Galerie Nationale du Jeu de Paume

1 Place de la Concorde, 75008 Paris, France
(33) (1) 47 03 12 50

1999 Exhibitions
Thru January 31
Jean-Pierre Raynaud

February 16-April 11
Georges Pompidou and Modernity (The Implication of Government in Contemporary Arts)

May 4-June 27
Gutaï: Japanese Art in the Late '50s and '60s

July 13-September 15
Richard Meier: Models and Drawings

Marie-Jo Lafontaine
Features a video installation by the artist.

October 5, 1999-early 2000
L'Autre Moitié de l'Europe
Highlights art from eastern Europe.

Permanent Collection

No permanent collection. Exhibitions of contemporary art. **Architecture:** 1861 building; 1990 interior renovation by architect Antoine Stinco.

Admission: 38 F. Handicapped accessible; including ramps and elevators.
Hours: Tues., 12-9:30; Wed.-Fri., 12-7; Sat.-Sun., 10-7. Closed Mon.
Programs for Children: On request in English with reservations.
Tours: Tues., 3; Wed.-Thurs., 1; Fri.-Sat., 3; Sun., 11.
Food & Drink: Café du Jeu de Paume open museum hours.
Museum Shop: Bookshop specializes in contemporary art, cinema.

Musée du Louvre

Rue de Rivoli, 75001 Paris, France
(33) (1) 40 20 53 17; (33) (1) 40 20 51 51 (voice server in 5 languages)
http://www.louvre.fr

1999 Exhibitions

Thru January 4
Portraits from Roman Egypt
Examines the revolution in Egyptian art during the Roman Empire as the painted portrait came to replace mumification in funerary practices.

February 10-May 10
The Eternal Monuments of Ramses II
Combining years of research, this exhibition presents the living temples of the Pharaoh Ramses II through monument plans, photos, and texts.

April 16-July 12
The Essence of Architecture
Prints and drawings examine the art of creating living spaces.

The Bronzes of the Crown
Over 300 bronze objects, many from the royal collection of Louis XIV, reflect the interests and the tastes of the times.

Permanent Collection

One of the largest collections in the world; 30,000 works on display, divided into seven departments: Oriental antiquities; Egyptian antiquities; Greek, Roman, and Etruscan antiquities; paintings, sculpture, decorative art, prints, and drawings through the mid-19th century. **Highlights:** Leonardo

da Vinci, *Mona Lisa (La Joconde)*; *Hera of Samos (570 B.C.)*; *Venus de Milo* (c. 100 B.C.); *Winged Victory of Samothrace; Winged Bulls of Khorsabad; The Squatting Scribe*; *The Sceptre of Charles V;* Michelangelo, *the Slaves*. **Architecture:** 800-year-old building, originally palace of French kings; changed and enlarged over the centuries. The original building was a medieval fortress; moats of this early building, c. 1200, can be visited. It became the first museum in Europe in 1793. Central Glass Pyramid (1989) by I. M. Pei acts as museum entrance and reception area. North wing of the palace, formerly the Ministry of Finance, restored as a museum space and opened in 1993. New galleries in Denon wing. Sully wing opened 1997. Grand Louvre project 1999.

Admission: Adults, 45 F until 3; 26 F after 3 and all day Sun.; children under 18, free. First Sun. of month, free. Handicapped accessible.
Hours: Permanent collections: Thurs.-Sun., 9-6. Partial evening openings Mon. and Wed., 9-9:45. Closed Tues., and certain public holidays. Pyramid Hall open Mon., Wed., 9-10; Thurs.-Sun., 9-8:30. Exhibition rooms under the Pyramid, 10-10.
Programs for Children: Workshops and guided tours, call (33) (1) 40 20 52 09.
Tours: In French and English call (33) (1) 40 20 52 09; groups call (33) (1) 40 20 51 77 for reservations.
Food & Drink: Restaurant Le Grand Louvre, cafeteria and bar located under the pyramid.
Museum Shop: Spacious underground pavilion houses a multitude of shops and offers a dazzling array of art catalogues, guide books, art magazines, CD Roms, posters, etchings, gifts, video cassettes, items for children, jewelry, cast reproductions of pieces from the permanent collections, and decorative objects.

Musée National d'Art Moderne– Centre National d'Art et de Culture Georges Pompidou

(Centre Beaubourg)
75191 Paris CEDEX 04, France
(33) (1) 44 78 12 33; (33) (1) 44 78 49 19
http://www.cnac-gp.fr

1999 Exhibitions
Note: The museum will be partially closed for renovation for the next two years. Atelier Brancusi open until April 26.

South Gallery
January 27-April 26
David Hockney: Spaces–Landscapes
Dazzling works by one of the foremost artists of the 20th century. (T)

Permanent Collection

Outstanding collection of major 20th-century movements, including Impressionism, Cubism, abstract art, Surrealism, Pop Art. Artists include Brancusi, Braque, Chagall, Dalí, Dubuffet, Léger, Kandinsky, Kline, Matisse, Mondrian, Picasso, Pollock, Rouault, Tàpies, Warhol. **Highlights:** Niki de Saint-Phalle courtyard fountain sculptures; Braque, *Woman with Guitar*; Matisse, *The Sadness of the King*; Picasso, *Harlequin.* **Architecture:** 1977 building by Renzo Piano and Richard Rogers.

Admission: Tipi: free. Atelier Brancusi: 20 F. South Gallery: 30 F, 20 F.
Hours: Tipi: Mon., Wed., Thurs., Fri., Sun., and holidays, 12:30-6; Sat., 2-6. South Gallery: Wed.-Mon., 10-10. Atelier Brancusi: Mon.-Fri., 12-10; Sat., Sun., and holidays, 10-10.
Programs for Children: Wednesday mornings children are invited to take part in an expression session with visiting painters, choreographers, or musicians.

Musée d'Art Moderne de la Ville de Paris

11 Avenue du President Wilson, 75116 Paris, France
(33) (1) 53 67 40 00

1999 Exhibitions

Thru mid-February
ARC/Rosemarie Trockel, Carsten Holler

Thru September 19
The Collection of the Centre Georges Pompidou, a Choice

January 8-April 18
Mark Rothko
This retrospective reveals the depth of Rothko's career, with an emphasis on his surrealist and classic periods. Includes 100 works on canvas and paper dating from the 1920s to 1970. Catalogue. (T)

Mark Rothko, *Untitled,* 1948. Collection Kate Rothko Prizel. From *Mark Rothko.* Photo courtesy National Gallery of Art, Washington, D.C.

Permanent Collection

Specifically Parisian and European, thanks to the generosity of artists and collectors who contributed to the collection. From Fauvism and Cubism to Contemporary Art, Abstract Art, New Realism, Arte Povera. It reflects currents that determined 20th-century art, including diverse media such as sculpture, installations, photography and video. Its primary focus and committment is to the art of today. **Highlights:** Matisse, *La Danse*; Dufy, *La Fee Electricité*; a large collection of works by Robert Delaunay; Raoul Dufy, Jean Fautziez; Gleizes; Villon. **Architecture:** Constructed for the International Exposition in 1937. It occupies the east wing of the Palace of Tokyo. It was inaugurated as a museum in 1961.

Hours: Tues.-Fri., 10-5:30; Sat.-Sun., 10-6:45. Closed Mon. Handicapped accessible, including elevators.
Programs for Children: Call the Educational and Cultural Dept. (33) (1) 53 67 40 80.
Tours: Daily. Call (33) (1) 40 70 11 10 for information.
Food & Drink: Cafeteria, open museum hours.
Museum Shop: Open during museum hours.

Musée d'Orsay

62 Rue de Lille, 75007 Paris, France
(33) (1) 40 49 48 14
http://www.musee-orsay.fr

1999 Exhibitions

Thru January 3
Millet–Van Gogh

Stéphane Mallarmé (1842-1898)
1886-1887, a Theatrical Season for Mallarmé
Mallarmé and Music

Thru January 24
"En Collaboration avec le Soleil": Victor Hugo, Photographies de l'Exil

January 27-April 25
The Collection of Doctor Gachet
More than 50 paintings and drawings from the Gachet collection, Musée d'Orsay. Presents major examples of work by Van Gogh, Cézanne, Monet, Renoir, and others. (T)

February 17-April 30
Six Tableaux du Städel Fancfort

March 4-June 6
Sir Edward Burne-Jones (1833-1898)
Presents over 200 diverse works by this pivotal 19th-century British Pre-Raphaelite artist, in celebration of the centenary of his death. Includes paintings, watercolors, drawings, tapestries, stained glass, and jewelry. Catalogue. (T)

Gothic Revival: Architecture et arts décoratifs de l'Angleterre

Mise en Scéne Photographiques Victoriennes (1840-1880)

Lewis Carroll, Portraitiste (Accrochage Photographique)

La Collection d'Edmund Davis (Accrochage)

May 19-August 22
Eugène Jansson (1862-1915)

Permanent Collection
Impressionist works from by Manet, Monet, Renoir, Degas, Van Gogh, Cézanne, Gauguin, Daumier, Derain, Pissarro, Seurat, Toulouse-Lautrec, Marquet; vast collection of 19th-century Neoclassicism; several outstanding

works by Rodin. **Highlights:** Daumier, *Caricatures* (busts); Degas, *Au Café, dit l'Absinthe*; Gauguin, *Arearea, Le Bel Ange*; *Autoportrait au Christ Jaune*; Van Gogh, *Chambre à Arles, La Nuit Etoilé (Starry Night);* Ingres, *La Source*; Manet, *Le Déjeuner sur l'Herbe (Luncheon on the Grass);* Millet, *L'Angélus*; Courbet, *L'Origine du Monde*; Monet, *La Cathédrale de Rouen* (five paintings); Renoir, *Bal du Moulin de la Galette (Dance at the Moulin de la Galette);* Toulouse-Lautrec, *Jane Avril*; Whistler, *La Mère de l'Artist (Whistler's Mother).*

Architecture: Railway station built in 1900 by Victor Laloux; building renovation by architectural firm ACT and the Italian architect Gae Aulenti, inaugurated in December 1986.

Admission: Adults, 40 F; reduced fee, 30 F. Fees subject to change. Handicapped accessible, including elevators and braille signage.
Hours: Tues.-Sat., 10-6; Thurs., 10-9:45; Sun., 9-6. June 20-Sept. 20: opens at 9. Closed Mon.
Programs for Children: Activities available. Call for details.
Tours: Group reservations, call (33) (1) 45 49 16 15.
Food & Drink: Restaurant open for lunch, 11:30-2:30; for dinner, Thurs., 7-9; Café des Hauteurs open 1-5; Mezzanine Café open 11-5.
Museum Shop: Offers more than 8000 books, CD Roms, and catalogues on art, literature, architecture, sculpture from 1848-1914. Cards, posters, jewelry, scarves, reproductions of sculpture and more. Open Tues.-Sun., 9:30-6:30; Thurs. until 9:30. Bookstore, (33) (1) 40 49 47 22; Boutique, (33) (1) 40 49 49 99.

Musée des Arts Décoratifs

Palais du Louvre, 107 Rue de Rivoli, 75001 Paris, France
(33) (1) 44 55 57 50
http://www.ucad.fr

Note: The museum is in the process of complete renovation as part of the Grand Louvre project. The Medieval-Renaissance collections are open. The reopening of all other collections is scheduled for 2000. During renovations, temporary exhibits will be held on display in the Marsan Wing, 111 Rue de Rivoli.

Musée des Arts Décoratifs, Paris. Photo by Laurent-Sully Jaulmes.

Permanent Collection
Furniture, glassware, silver, and jewelry, from the Middle Ages to the present. Part of the Union Centrale des Arts Decoratifs, which includes the Fashion and Advertising Museums, as well as several libraries and schools.
Highlights: decorative arts from the reigns of Louis XIII-XVI; recreated 1920s apartment of Jeanne Lanvin.

Musée de la Mode et du Textile

1999 Exhibitions
Thru March
Touches d'Exotisme, 14th-20th Siècles
This exhibition explores aspects of exoticism through costumes, accessories, jewelry, and textiles from North Africa to Asia.

Permanent Collection
Part of the Musée des Arts Décoratifs, the collection explores major trends in fashion through the ages. Includes costumes from the 17th through 19th centuries, fashion accessories, and rare fabric samples. Also on view are major contributions and prototypes from 20th-century haute couture artists, including Chanel, Schiaparelli, Dior, and Lacroix. Excellent medieval and Renaissance collections.

Musée de la Publicité

Note: The museum is closed for renovation until Spring 1999.

Musée Nissim de Camondo
63 rue de Monceau, 75008 Paris
(33) (1) 53 89 06 40

Permanent Collection
Now under the supervision of the Musée des Arts Décoratifs, the outstanding collection includes furniture, paintings, porcelains, and gold and silver pieces from the 18th century. **Architecture:** 18th-century aristocratic residence bordering Monceau Park. 1986 restoration.

Admission: Adults, 30 F; reduction, 20 F; children 18 and under, free (for permanent collections only). Price includes admission to both the Musée des Arts Décoratifs and the Musée de la Mode du Textile. Handicapped accessible.
Hours: Tues.-Fri., 11-6; Sat.-Sun., 10-6; Wed. until 9. Closed Mon.
Programs for Children: Visits and workshops available by appointment.
Tours: Call (33) (1) 44 55 59 26 for information.
Museum Shop: 105 Rue de Rivoli. Open daily, 10-7; Wed. until 9.

Musée Jacquemart-André
158 Blvd. Haussmann, 75008 Paris, France
(33) (1) 42 89 04 91

Permanent Collection
Originally the private collection of Edouard André and Nélie Jacquemart. Outstanding collection of European masterpieces, including works by the major painters of the 18th-century French school, the work of the Flemish masters, Italian Renaissance paintings and sculpture, and English art. Decorative arts, busts, and antiquities. **Highlights:** Works by Boucher,

Chardin, Fragonard, Vigée-LeBrun, Rembrandt, Franz Hals, Ruysdaël, Uccello, Tiepolo, Mantegna, Bellini, and della Robbia. **Architecture:** Sumptuous 19th-century palace; renovated and opened to the public 1996.

Admission: 47 F; groups of 15 or more, 35 F per person; school groups of 15 or more children, 25 F per child.
Hours: Daily, 10-6 (last entry, 5:30).
Programs for Children: Educational packs for schools.

Paolo Uccello, *Saint George and the Dragon.* Photo courtesy Musée Jacquemart-André, Paris.

Tours: For information, call (33) (1) 42 89 04 91. Tour and tea or lunch packages available.
Food & Drink: Refreshments available in the Café Jacquemart-André, decorated with tapestries and a Tiepolo fresco. Open Mon.-Fri., 11:30-6; Sat.-Sun., 11-6. Reservations required.
Museum Shop: Bookstore open during museum hours.

Musée Picasso

Hotel Salé, 5 Rue de Thorigny, 75003 Paris, France
(33) (1) 42 71 25 21
http://www.oda.fr/aa/musee-picasso

1999 Exhibitions

Thru January 18
Masterpieces from the Metropolitan Museum of Art

September-December
Brassaï: Selections from the Permanent Collection

Permanent Collection
Extraordinary and enormous collection of paintings, drawings, prints by Picasso that cover many periods of his career, emphasizing later works; works by other artists from Picasso's own collection. **Architecture:** Housed in an elegant mansion designed in 1656 by Jean Boullier for Pierre Aubert, Lord of Fontenay, in the ancient Marais section, near La Place des Vosges. The house had an eventful history, serving as the Embassy of the Republic of Venice in the late 17th century, expropriated by the State during the Revolution, and in 1815 housing a boys school which Balzac attended. It subsequently

housed other educational institutions and a bronzesmith's studio before opening in 1985 as the Musée Picasso.

Admission: Call ahead for prices. Handicapped accessible.
Hours: Apr. 1-Sept. 30: Wed.-Mon., 9:30-6; Oct. 1-Mar. 31: Wed.-Mon., 9:30-5:30. Closed Tues., Dec. 25, Jan. 1.
Programs for Children: Group visits for schools, advance reservations required.
Tours: Reservations required for groups. Call (33) (1) 42 71 12 99 for information.

Pablo Picasso, *Verre, Bouteille de Vin, Pacquet de Tabac.*
Photo courtesy Musée Picasso, Paris.

Food & Drink: Cafeteria in the garden, open April 15-October 15.
Museum Shop: A wide selection of guide books, reference works on Picasso, and educational books for children.

Additional Museums in France...

Musée Marmottan
2 Rue Louis-Bouilly, 75016 Paris, France

Orangerie des Tuileries
Place de la Concorde, 75001 Paris, France

Musée du Petit Palais
Avenue Winston Churchill, 75008 Paris, France

Musée Rodin
Hôtel Biron, 77 Rue de Varenne, 75007 Paris, France

Musée des Beaux-Arts
33 Avenue des Baumettes, 06000 Nice, France

Fondation Maeght
06570 St. Paul, France

NOTE: In Paris, passes are available, valid for entrance to all Paris museums.

Bauhaus Archive & Museum of Design

Klingelhöferstrasse 14, D-10785, Berlin, Germany
(49) (30) 25 40 02 0
http://www.bauhaus.de

1999 Exhibitions

Ongoing
Das Bauhaus: Weimar, Dessau, Berlin, 1919-1933

Thru January 31
The Bauhaus is Weaving
Selection of works from the weaving workshop at the Bauhaus.

Bauhaus Archive. Photo courtesy Landesbildstelle Berlin.

March 31-May 31
Alfred Arndt and the Bauhaus-Master

June 8-August 1
Design Between Culture and Commerce

Summer
Max Peiffer Watenphul
A selection of photographs taken by the painter in Italy, 1931-1934.

August 10-October 10
Incunabulum of Modernism
Features the Villa Tugenghat by legendary architect Mies van der Rohe.

October 26, 1999-January 2000
New European Graphic
Prints from the Weimar Bauhaus.

Permanent Collection

Material relating to the activities and ideas of the Bauhaus, the influential art school which flourished between 1919 and 1933. Includes architectural models, furniture, metal ware, ceramics, weaving, murals, paintings, drawings, sculpture, and photography. **Highlights:** Klee, *Neues im Oktober*; Kandinsky, *Meinem Lieben Galston*; Schlemmer, *Abstrakter*; Brandt, *Tea and Coffee Set*; architectural models by Bayer, Feininger, Itten, Moholy-Nagy. **Architecture:** 1979 structure built from plans by the late Walter Gropius, founder and director of the Bauhaus.

Admission: Adults, 5DM; concessions, 2.50DM. Handicapped Accessible, including ramps, elevators; wheelchairs available.
Hours: Wed.-Mon., 10-5.
Tours: Call (49) (30) 25 40 02 43 for information.
Food & Drink: Café offers selection of light dishes, cake, and beverages, open during museum hours; outdoor terrace open, weather-permitting.
Museum Shop: Offers over 200 items representing modern design history, including exceptional objects by internationally renowned designers and metal work reproduced from Bauhaus originals.

Berlinische Galerie

Museum of Modern Art, Photography, and Architecture
Martin-Gropius–Bau, Stresemannstrasse 110, D-10963 Berlin,
Germany
(49) (30) 25 486 0

1999 Exhibitions
Not available at press time.

Permanent Collection
Features Dadaist works, modern art, Berlin Secession, Russian avant-garde, photography, architecture after 1945. **Highlights:** Höch, *The Journalists*; Dix, *Portrait of the Poet*; Grosz, *Self-Portrait*; Gabo, *Torso Construction*; *Hell, It's Me*; Middendor, *Natives of the Big City, Salomé, Judith and Holofernes*; Killisch, *The Artist's Atelier*; Sonntag, *Little Oedipus Head*. **Architecture:** 1881 Renaissance revival building, modeled on Schinkel's destroyed Bauakademie, by Martin Gropius and Heino Schmieden, destroyed in 1945; 1978–86 reconstruction by W. Kampmann.

Admission: DM 6; groups, seniors, students, DM 3. Special exhibits: DM 8; groups, seniors, students, DM 4. Handicapped accessible.
Hours: Tues.-Sun., 10-8. Closed Mon.
Food & Drink: Café open during museum hours.

Kunst-und Ausstellungshalle der Bundesrepublik Deutschland

Friedrich-Ebert Allee 4, D-53113 Bonn, Germany
(49) (228) 9171-200
http://www.kah-bonn.de

1999 Exhibitions
Thru January 10
Gene Worlds: Prometheus' Laboratory?
Fascinating genetic discoveries and their importance for both our real world and our imagination, in the context of cultural history.

100 Years of Art on the Move: The Berlinische Galerie Comes to Bonn
A selection of works from the Berlinische Galerie includes examples of Dada, Constructivism, and other 20th-century art movements.

Thru April 11
The Great Collections VIII: High Renaissance in the Vatican: Art and Culture at the Papal Court (1503-1534)
Continues the *Great Collections* series, with 16th-century works commissioned by Popes and Cardinals, on loan from the Vatican.

January 22-April 18
The Collection of the German Bundestag

March 26-June 20
The Great Collections IX: Masterpieces from the Museu Nacional de Arte Antiga, Lisbon

May 7-August 8
The Bronze Age–Europe at the Time of Odysseus

May 12-October
Eduardo Chillida

May 28-September 12
David Hockney
Dazzling works by one of the foremost artists of the 20th century. (T)

September 10, 1999-January 9, 2000
Alexander von Humboldt

October 8, 1999-April 28, 2000
The Great Collections X: Museo del Prado in Bonn: Velasquez, Rubens and Lorrain Painting at the Spanish Court of Philip IV

December 17, 1999-April 28, 2000
Zeitwenden

Permanent Collection
No permanent collection. Changing exhibitions of visual arts, cultural history, and science and technology. **Architecture:** 1992 building by Viennese architect Gustav Peichl.

Admission: Adults, DM 10; concessions, DM 5. Group rates available. Handicapped accessible, including ramps, elevators, and entry buttons.
Hours: Tues.-Wed., 10-9; Thurs., Sat.-Sun., 10-7; Fri., 9-7. Closed Mon.
Programs for Children: Workshops designed to accompany exhibitions.
Tours: Tues.-Wed., 3, 7; Thurs.-Sat., 3; Sun., 11, 3.
Food & Drink: Restaurant open Tues.-Sun., 10-8.
Museum Shop: Bookshop offers catalogues, posters, cards, and gifts; open Tues.-Sun., 10-7.

Kunstmusem Bonn

Friedrich-Ebert-Alleez, D-53113 Bonn, Germany
(49) 228 776260
http://www.bonn.de/kunstmuseum

1999 Exhibitions
January 21-March 14
Drawings Today III

January 28-March 14
Die Macht des Alters

March 25-June 16
Fritz Klemm: Work on Paper

March 26-June 6
Contemporary Portuguese Art

June 3-August 8
Paul Klee in Switzerland

June 17-August 15
Thomas Demand and Andreas Gursky Photography

August 19-October 17
August Macke–Watercolors and Drawings

August 26-October 17
Philip Guston

September
Bonn Art Award

December 1, 1999-May 28, 2000
Zeitwenden: Rückblick und Ausblick

Permanent Collection
Work by August Macke, Joseph Beuys, Gerhard Richter, Sigmar Polke, and others.

Admission: Adults, DM 5; children, DM 3. Handicapped accessible.
Hours: Tues.-Sun., 10-6; Wed., 10-9.
Programs for Children: Regularly scheduled courses and programs for children.
Food & Drink: Café open 10-8.
Museum Shop: Open 10-6.

Museum für Moderne Kunst

Domstrasse 10, D-60311 Frankfurt am Main, Germany
(49) (69) 212 30447
http://www.frankfurt-business.de/mmk/

1999 Exhibitions
February 5-April 25
Change of Scene XIV: Bill Viola 25 Year Survey Exhibition
Retrospective of works by internationally known video artist Bill Viola. Includes video installations, drawings, and notebooks. Catalogue. (T)

Permanent Collection
Features contemporary art, including Pop Art, and other works from the 1960s to the present. Shows rotate every six months. **Architecture:** 1991 building by Hans Hollein.

Admission: Adults, DM 7; concessions, DM 3.50. Handicapped accessible, including ramp and elevator.
Hours: Tues.-Sun., 10-5; Wed., 10-8. Closed Mon.
Tours: Call (49) (69) 212 30447 for information.
Food & Drink: Café open Tues.-Sun, 10-1.
Museum Shop: Open during museum hours.

Hamburger Kunsthalle

Glockengießerwall, D-20095 Hamburg, Germany
(49) (40) 2486 2612

1999 Exhibitions

Thru January 3
Chagall, Kandinsky, Malevitch, and the Russian Avant-Garde
Traces the evolution of Russian painting from 1905 to 1920 through rarely
seen works of art. (T)

Thru February 14
*Franz Horny 1798-1824: A Romantic in
Italian Light*

March 12-May 23
Whistler: The Print

May 13-August 15
Andy Warhol: Photography

June 4-August 8
Annette Messager

July 30-October 24
*Robert Delaunay: From Impressionism to
Abstraction, 1906-1914*

November 19, 1999-March 2000
Art of the Middle Ages in Hamburg

Andy Warhol. From *Andy Warhol:
Photography.* Photo courtesy Andy
Warhol Foundation for the Visual Arts
and Hamburger Kunsthalle.

Permanent Collection

Paintings from Gothic to contemporary; 19th- and 20th-century sculpture;
drawings, graphics. **Highlights:** paintings by Meister Bertram, *The Creation
of the Animals*; Rembrandt, *Simeon and Anna Recognize Jesus as the Lord*;
Claude, *The Departure of Aeneas from Carthage*; Friedrich, *The Sea of Ice*;
Runge, *Morning*; Beckmann, *Ulysses and Calypso*; Hockney, *Doll Boy*.
Architecture: 1869 building by Hude und Schirrmacher; 1919 annex;
building by Oswald Mathias Ungers opened February 1997.

Admission: DM 6. Additional fees for some exhibitions.
Hours: Tues.-Sun., 10-6; Thurs., 10-9. Closed Mon.
Tours: Call (49) (40) 2486 3180 for information.
Food & Drink: Café Liebermann open 10-5; Thurs., 10-8.

Museum Ludwig Köln

Bischofsgartenstrasse 1, 50667 Köln, Germany
(49) (221) 221 23 82
http://www.museenkoeln.de

1999 Exhibitions
Thru February 1
I LOVE NEW YORK

February 26-May 16
Bill Traylor

May 21-August
Endre Tot

May 28-August
C. O. Paeffgen

August 3-October 23
100 Years of Architecture

August 15-October 3
Letztes Rendez-vous

November 3, 1999-early-March 2000
Global Art 2000

Permanent Collection
One of the most extensive collections of 20th-century art in the world. The collection consists of German Expressionism, Russian avant-garde, Italian cubism, futurism, and pittura metafisica, Dada, Russian constructivism, and Bahaus school. **Highlight:** 80 works by Robert Rauschenberg.
Architecture: After an international architecture competition, the Cologne architecture team of Busman and Haberer were selected to design the imposing complex of museum buildings. Generous piazza designed by Israeli artist Dani Karavan. Roof-top sculpture garden.

Admission: Permanent Collection: Adults, DM 10; children, DM 5.
Hours: Tues., 10-8; Wed.-Fri., 10-6; Sat., Sun., 11-6.
Programs for Children: School of painting for children; special tours.
Food & Drink: Cafeteria seats 240 people.
Museum Shop: Catalogues, posters, jewelry, CDs, and more.

Haus der Kunst
Prinzregenstrasse 1, 80538 Munich, Germany
(49) (89) 21127 0

1999 Exhibitions
Thru January 24
Lyonel Feininger 1871-1956
Retrospective of paintings from *Gelmeroda* to *Manhattan*.

Thru February 7
The Night
Night paintings in occidental art from the late Gothic period through surrealism.

February 5-April 18
Angelica Kauffmann
Works by one of the foremost 18th-century women portrait painters.

February 19-May 30
Masterpieces of the Classic Modernism: Josef Mueller Collection

April 30-June 27
Dimensions
Works by Douglas Gordon, Pipilotti Rist, Tony Oursler, Bernd and Anna
Blume, Barbara Kruger, and Gilbert + George.

June 11-September 19
Max Ernst
A selection of work by one of the most important artists of the 20th century.

Admission: Varies by exhibition, approx. DM 10-15. Handicapped
accessible.
Hours: Tues.-Fri., 10-10; Sat.-Mon., 10-6.
Programs for Children: Guided tours and workshops.
Tours: Call (49) (89) 2112 7115.
Food & Drink: Self-service café open museum hours.
Museum Shop: Well-equipped bookshop open museum hours.

Kunsthalle der Hypo-Kulturstiftung

Theatertinerstrasse 15, D-80333 Munich, Germany
(49) (89) 22 44 12

1999 Exhibitions
Thru February 21
The Splendor of the Medicis: Europe and Florence
A look at one of the greatest family of arts patrons ever.

March 12-May 30
Ernst Ludwig Kirchner
Works by one of the most compelling artists of the 20th century.

Permanent Collection
No permanent collection.

Admission: Varies by exhibition, approx. DM 8-14. Discounts for
students, children, groups.
Hours: Daily, 10-6; Thurs., 10-9.

Staatsgalerie Stuttgart

Konrad-Adenauer Strasse 30-32, 70173 Stuttgart, Germany
(49) (711) 212 4050
http://www.staatsgalerie.de

1999 Exhibitions
Thru January 10
Marc Chagall: The Dream Lovers: Lithographs from the Sorlier Collection

Thru February 21
Picasso, Klee, Giacometti: The Steegmann Collection

January 23-March 14
Eugène Atget – Paris

March 13-May 30
Rosemarie Trockel
Contemporary paintings, clothing,
installations, and video featuring images
inspired by anthropology, consumerism,
and everyday objects. (T)

March 27-June 27
Giovanni Battista Piranesi: The Poetic Truth

Opens April 17
*New Presentation of Modern Classics
from the Steegmann Collection*

Max Beckmann, *Die Reise auf dem Fisch,*
1934. Photo courtesy Staatsgalerie Stuttgart.

May 29-October 31
Italian Gothic Painting in the Staatsgalerie

June 29-September 12
In Sich Geschlossen: 100 Self-portraits and 1 Photo by Partyka

July 10-September 19
Drawings from Private Collections for the Graphische Sammlung Stuttgart

July 24-November 7
HAP Grieshaber

October 9, 1999-January 16, 2000
Richard Serra: Print Work of the 1990s

November 27, 1999-January 30, 2000
Variations on a Theme: Giovanni Domenico Tiepolo: The Flight to Egypt

December 11, 1999-April 30, 2000
Camille Pissarro and Impressionism

Permanent Collection

Early German, Dutch and Italian Painting; 19th-century French painting and
Swabian Classicism; large collection of European modern art, including
Fauve, Expressionist and Constructivist works; American Abstract
Expressionism, Pop Art, and Minimalism; More than 400,000 prints and
drawings from the 15th century to the present day. **Highlights:** Works by
Hals, Rembrandt, Corot, Cézanne, Monet, Matisse, Picasso, Schlemmer,
Baselitz, Warhol. **Architecture:** 1843 Old Staatsgalerie by G.G. Barth;
1984 New Staatsgalerie by James Stirling.

Admission: Adults, DM 9; concessions, DM 5. Handicapped accessible.
Hours: Tues.-Sun., 11-7. Closed Mon. Handicapped accessible.
Programs for Children: Children's tours, Fri., 3.
Tours: Available Tues.-Fri., 10-5; call (49) (711) 212 4057.
Food & Drink: Café Fresko in New Staatsgalerie, open Tues.-Sun., 10-2.
Museum Shop: Exhibition catalogues, posters, prints, calendars, postcards,
and slides are available in the entrance foyers.

Irish Museum of Modern Art

Royal Hospital, Military Road, Kilmainham, Dublin 8, Ireland
(353) (1) 612 9900

Hughie O'Donoghue, *3 Studies for a Crucifixion,* 1996.
From *Hughie O'Donoghue.* Photo courtesy Irish Museum of Modern Art.

1999 Exhibitions
Thru February
Hughie O'Donoghue

Thru April
Ilya and Emilia Kabakov: The Children's Hospital

April-June
Glen Dimplex Artists Award

May 9-July 25
Joseph Beuys Multiples
This post-World War II German artist saw multiples as a means to effect social change. Includes 300 objects that reflect his ideas about nature, healing, communication, energy, politics, and teaching. (T)

Autumn 1999-Ongoing
Selections from the Museum's Collection

Permanent Collection
Comprises works by 20th-century and contemporary artists and has been developed through aquisitions, long term loans, and donations since the museum was established in 1991. Works from the collection are shown in a series of changing displays. **Architecture:** Unusually fine 17th-century hospital, founded by James Butler of Kilkenny Castle; 1986 restoration.

Admission: Free. Handicapped accessible.
Hours: Tues.-Sat., 10-5:30; Sun., bank holidays, 12-5:30. Closed Mon.
Programs for Children: Workshops and exhibitions of children's artwork.
Tours: Wed., Fri., 2:30; Sat., 11:30. Call (353) (1) 612-9900 to make reservations for other times.
Food & Drink: Coffee shop serves soups, salads, sandwiches, and hot and cold snacks. Open Mon.-Sat., 10-5; Sun., bank holidays, 12-5.
Museum Shop: A wide range of cards, gifts, and art books.

National Gallery of Ireland

Merrion Square W., Dublin 2, Ireland
(353) (1) 661 5133
http://www.nationalgallery.ie

1999 Exhibitions
Thru January 3
P.S. Krøyer and the Artists' Colony at Skagen
Works by Krøyer and other 19th-century Danish artists who painted at Skagen, the northernmost fishing village of Denmark.

January 1-31
Turner Watercolours
Works by Joseph Mallord William Turner (1775-1851) are featured in a popular annual exhibition. Includes 35 works donated to the National Gallery by Henry Vaughan in 1900.

Permanent Collection
National collection of Irish Art, 17th–20th centuries; national collection of European Old Master paintings, 14th–20th centuries, with works by Fra Angelico, Mantegna, Rembrandt, Claude, David, Rubens, and Van Dyck. Also a fine collection of Irish, British and Continental watercolors, prints, and drawings. **Highlights:** Caravaggio, Vermeer, Poussin. **Architecture:** 1864, Dargan Wing by Francis Fowke; 1903, Milltown Wing by Thomas Newenham Deane; 1968, Modern Wing by Frank du Berry; 1996 renovation of Modern Wing, renamed The North Wing.

Admission: Free. Handicapped accessible, including ramps and lifts.
Hours: Mon.-Sat., 10-5:30; Thurs., 10-8:30; Sun., 2-5.
Programs for Children: Contact the Education Dept. at 661 5133.
Tours: Free public tours: Sat., 3; Sun., 2:15, 3, 4. Other tours may be booked by writing the Education Dept. two weeks in advance. Tours for visually and hearing impaired, including the use of Tactile Picture Sets available by writing the Education Dept.
Food & Drink: Fitzer's Restaurant serves Mediterranean style menu.
Museum Shop: Open during gallery hours; call (353) (1) 678 5450.

The Israel Museum, Jerusalem
Givat Ram (Ruppin Road across from Knesset)
Jerusalem, Israel
(972) (2) 6708811
http://www.imj.org.il

1999 Exhibitions
January 31
Merzbacher Collection

Thru February 2
Avigdor Arikha

Thru February 15
Marcel Janko

Shrine of the Book, Israel Museum, Jerusalem. Photo by Daniel Harris.

Permanent Collection
Includes Judaic art from the Israelite period to the present day; archaeological collections from the prehistoric period to medieval; Israeli and international art, from old masters to masterpieces of modern art. **Highlights:** The Dead Sea Scrolls (discovered 1947); Jewish ceremonial art; illuminated Passover manuscripts; interior of a 17th century Venetian synagogue; Cézanne, *Landscape*; Picasso, *Woman*; sculptures by Moore, Rodin, Lipchitz.
Architecture: Set on a 22-acre hilltop overlooking Jerusalem, the 1965

building integrates six separate glass and stone pavilions separated by beautiful rising paths and esplanades: the Bezalel Art Wing; the magnificent Billy Rose Sculpture Garden, designed by Isamu Noguchi in a series of semicircular terraces divided by stone walls; and the white-domed Shrine of the Book, by Frederick Kiesler and Armand Bartos, which houses the Dead Sea Scrolls and a new permanent exhibition, *A Day at Qumran*.

Admission: Adults, NIS 26; seniors and students, NIS 20; Children, NIS 12; families, NIS 75. Handicapped accessible, including ramp and elevators.
Hours: Mon, Wed., Thurs., Sun., 10-5; Tues., 4-10; Fri. and holiday eves., 10-2; Sat. & holidays, 10-4. Shrine of the book, also open Tues. 10-10.
Programs for Children: Includes Youth-Wing; multimedia exhibitions.
Tours: Mon., Wed., Thurs., Sun., 11; Tues., 4:30; Fri., 11. Shrine of the Book: Mon., Wed., Thurs., Sun., 1:30; Tues., 3; Fri., 12:45.
Food & Drink: Restaurant and outdoor café with full menu; kiosk.
Museum Shop: Open during museum hours.

Museo Nazionale del Bargello

Via del Proconsolo 4, 50125 Florence, Italy
(39) (55) 23 88 606

1999 Exhibitions
Not available at press time.

Permanent Collection
Treasure house of Italian sculpture; ceramics, Renaissance medals, sacred goldworks, seals, and coins. **Highlights:** Donatello, *St. George, David* (marble), and *David* (bronze); Michelangelo, *Bruto, Bacco, Toudo Pitti,* and *Apollo-David*; Giambologna, *Mercury*; works by Brunelleschi, Ghiberti, Desiderio da Settignano, Mino da Fiesole, Luca della Robbia, Verrocchio. **Architecture:** 1280 medieval palace by Arnolfo di Cambio; 1860 restoration by Francesco Mazzei.

Admission: Adults, 8,000 lire; children under 18, seniors over 60, free.
Hours: Tues.-Sat., 8:30-1:50; Sun., 2-4. Closed June 1, May 1, Dec. 25.

Galleria degli Uffizi

Loggiato degli Uffizi 6, 50121 Florence, Italy
(39) (55) 23 88 5
http://www.uffizi.firenze.it

1999 Exhibitions
Thru May
The Restoration of Perseus
Visitors can witness the restoration and conservation of a sculpture by Benvenuto Cellini from the collection. Includes an interactive multimedia exhibition.

Permanent Collection

One of the world's most important collections of Italian painting, including galleries of the Sienese School, Giotto, Botticelli, Leonardo, Pollaiuolo, Lippi, Michelangelo and Florentine masters, Raphael, Andrea del Sarto, Titian, Caravaggio; also salons of Rembrandt, Rubens. **Highlights:** Botticelli, *Birth of Venus*; Da Fabriano, *Adoration of the Magi*; Giotto, *Madonna and Child;* Leonardo, *Annunciation*; Michelangelo, *Holy Family*; Raphael, *Madonna of the Goldfinch;* Titian, *Venus of Urbino.* **Architecture:** 1560–81 building by Giorgio Vasari and others, created by Francesco I de' Medici to house key Medici collections.

Admission: 12,000 lire. Ticket sales stop 45 minutes before closing.
Hours: Tues.-Sat., 9-7; Sun., holidays, 9-2. Closed Mon.
Food & Drink: Snack bar and terrace café open museum hours.

Vatican Museums

Viale Vaticano, 00120 Città del Vaticano, Italy
(39) (6) 69 88 3333
http://www.christusrex.org/wwwl/vaticano

1999 Exhibitions
Thru Jan. 31
The Torso of the Belvedere: From Aiace to Rodin

Permanent Collection

One of the world's most spectacular collections, founded by Pope Julius II (1503-1513) when he installed the *Laocoön* and the *Apollo Belvedere* statues in the Statue Courtyard. Etruscan, Greek, Roman, Asian, Paleochristian, Byzantine, and Egyptian antiquities. Medieval and Renaissance ceramics and micro-mosaics. Christian devotional art from the past 2000 years. **Highlights:** Newly restored Sistine Chapel; Chapel of Nicholas V, *Mars of Todi; Apollo Belvedere*; *Laocoön*; *Belvedere* torso; tapestries of the Old School from Raphael's cartoons; School of Athens and Raphael rooms; Gallery of Maps; works by Giotto, Leonardo, Raphael, Titian and Caravaggio in the painting gallery. Vatican Historical Museum.

Il Torso del Belvedere. Featured in *The Torso of the Belvedere: From Aiace to Rodin.* Photo courtesy Vatican Museums.

Admission: Adults, 18,000 lire; reduced fee for pilgrimages (with written authorization from local diocese), 12,000 lire; school groups, 6,000 lire; last Sun. of month and September 27, 6,000 lire. Handicapped accessible.
Hours: November-March 15, Mon.-Sat., 8:45-12:45. March 16-October Mon.-Fri., 8:45-3:45; Sat., 8:45-12:45. Last Sun. of month, 8:45-12:45. Closed Sun. (except last Sun. of month), Jan. 1, Jan. 6, Feb. 11, Mar. 19, Easter Sun. and Mon., May 1, Ascension Thurs., Corpus Christi Thurs., June 29, Aug. 15-16, Nov. 1, Dec. 8, 25, 26.
Tours: Mon.-Sat., 8-2. Call (39) (6) 69 88 4947.
Programs for Children: Special guided tours for school groups.
Food & Drink: Cafeteria open during museum hours.
Museum Shop: Book and gift shops offering books, souvenirs, and reproductions.

Palazzo Grassi S.P.A.

San Samuele 3231, 30124 Venice, Italy
(39) (41) 52 35 133
http://www.palazzograssi.it

1999 Exhibitions
Thru May 16
The Maya

Permanent Collection
No permanent collection. **Architecture:** 1986 renovation of the 18th-century Grassi family palazzo on the Grand Canal by Gae Aulenti and Antonio Foscari.

Admission: 14,000 lire; children (18 and under), 10,000 lire. Handicapped accessible.
Hours: Daily, 10-7. Closed Dec. 24, 25, and Jan. 1.
Food & Drink: Cafeteria open daily, 10-6:30.

Peggy Guggenheim Collection

Palazzo Venier dei Leoni, 701 Dorsoduro, 30123 Venice, Italy
(39) (41) 52 06 288

1999 Exhibitions
Thru January 12
Peggy Guggenheim: A Centennial Celebration

February 10-May 10
Anni Albers
In celebration of the centenary of one of the greatest textile designers of the 20th century, this exhibition presents Albers's most important creations together with preparatory studies and graphic works.

Permanent Collection

Focus on Cubism, Futurism, European abstract art, Constructivism, De Stijl, Surrealism, early American Abstract Expressionism; postwar European artists also represented. **Highlights:** Picasso, *The Poet* and *On the Beach*; Kandinsky, *Landscape with Red Spots*; Léger, *Men in the City*; Mondrian, *Composition*; Brancusi, *Maiastra*; De Chirico, *The Red Tower*. Sculpture garden of works by Duchamp-Villon, Giacometti, Arp, Moore and Ernst. **Architecture:** The Collection is housed in the Palazzo Venier dei Leoni, an unfinished Venetian palazzo

Amadeo Modigiani, *Portrait of the Painter Frank Haviland,* 1914. Photo courtesy Peggy Guggenheim Collection.

on the Grand Canal acquired by Peggy Guggenheim in 1949. In 1993, a new wing housing the Museum Shop, the Museum Café and temporary exhibitions rooms was inaugurated.

Admission: 12,000 lire; students, 8,000 lire.
Hours: Wed.-Mon., 11-6. Closed Tues., Dec. 25.
Tours: Call (39) (41) 52 06 288 for information.
Food& Drink: Tables overlook sculpture garden, (39) (41) 522 8688.
Museum Shop: Offers books, posters, cards, and gifts, (39) (41) 520 6288.

Bridgestone Museum of Art

**10-1 Kyobashi 1-chome, Chuo-ku, Tokyo 104, Japan
(81) (3) 3563-0241**

1999 Exhibitions
January 13-April 25
Subjects and Symbols: Classical Mythological and Christian Iconography

NOTE: The museum plans to undergo renovation during 1999. Please call ahead for exhibition listings.

Permanent Collection
Modern European and Japanese art; European paintings from the 19th to the early 20th centuries; Impressionists; Post-Impressionist and Ecole de Paris works by Signac, Gauguin, Van Gogh, Rouault, Matisse, Picasso, Modigliani; Japanese paintings in the Western style from the Meiji period to the present. Housed on the second floor of the Bridgestone corporate headquarters building.

Admission: Adults, ¥500; high school/college students, ¥400; elementary school students, ¥200.
Hours: Apr.-Oct.: daily, 10-6. Nov.-Feb.: daily, 10-5:30.

National Museum of Western Art, Tokyo

7-7 Ueno-koen, Taito-ku, 110-0007 Tokyo, Japan
(81) (3) 3828-5131
http://www.nmwa.go.jp

1999 Exhibitions

January 12-March 7
Goya
Haunting and beautiful works by one of the greatest Spanish artists of all time.

March 20-June 20
Firenze and Venezia
Renaissance art from the collection of the State Hermitage Museum, St. Petersburg.

July 6-August 29
Eloquentness of the Body
Work from the Albertina Graphic Art Collection, Vienna.

September 14-December 12
The Collection of the Musée d'Orsay
Stunning examples of 19th-century art from this world-famous Paris museum.

Permanent Collection
Old Master paintings of the 15th to the 19th centuries; 20th-century paintings, sculptures, drawings, and prints; sculpture by Rodin; paintings by Delacroix, Courbet, Millet, Daumier, Boudin, Manet, Monet, Degas, Pissarro, Renoir, Cézanne, Gauguin, Van Gogh, and Signac; 20th-century works by Picasso, Léger, Ernst, Miró, Dubuffet, and Pollock. **Highlights:** Rodin, *The Kiss, The Thinker, The Gates of Hell*; The Matsukata Collection of modern French paintings. **Architecture:** Main building by Le Corbusier, 1959; new wing designed in 1979 by the Kunio Maekawa Studio; special exhibition wing designed in 1997 by Maekawa Studio.

Admission: Adults, ¥420; high school/college students, ¥130; children, ¥70. Second and fourth Sat. of every month, free. Handicapped accessible.
Hours: Tues.-Sun., 9:30-5; Fri., 9:30-7. Last admission 30 mins. before closing. Closed Mon., Dec. 28-Jan. 4.
Programs for Children: Exhibition for Children (summer).
Tours: For information, call (81) (3) 3828-5131.
Food & Drink: Café Suiren looks out onto the museum's central courtyard, comfortably seats 84 guests, and offers a varied menu. For reservations call (81) (3) 5814 2891. Open 10-4:45.
Museum Shop: Offers museum publications, books related to Western art, and a variety of merchandise (postcards, stationery, handkerchiefs) based on the designs of works in the collection.

Rijksmuseum Amsterdam

Stadhouderskade 42, 1071 ZD Amsterdam, The Netherlands
(31) (20) 673 21 21

1999 Exhibitions

Thru March 14
Adriaen de Vries 1556-1626: Imperial Sculptor
Sculpture, prints, and drawings by the late-Mannerist Dutch artist who worked under Emperor Rudolf II in Prague. (T)

Thru April 5
Van Gogh in the Rijksmuseum
Masterpieces from the Van Gogh Museum.

June 19-September 19
Still Lifes from the Golden Age
Surveys the accomplishments of Dutch and Flemish still-life artists of the 17th century and examines the function and significance of these works within their socio-economic context.

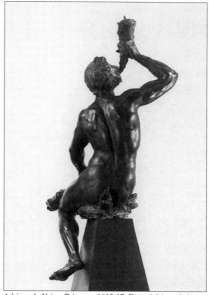

Adriaen de Vries, *Triton*, c. 1615-17. From *Adriaen de Vries 1556-1626: Imperial Sculptor*. Photo courtesy Nationalmuseum, Stockholm and Rijksmuseum, Amsterdam.

Permanent Collection

Unrivaled collection of 15th- to 19th-century paintings including Rembrandt, Vermeer, Hals; sculpture and applied arts; Dutch history; Asiatic art; alternating exhibitions. **Highlights:** Hals, *The Merry Drinker*; Rembrandt, *The Night Watch* and *The Jewish Bride*; *The Draper's Guild*; Vermeer, *Young Woman Reading a Letter* and *The Kitchen Maid*. **Architecture:** 1885 Renaissance Revival building by P. J. H. Cuypers.

Admission: Adults, NLG 15; students and children 6-18, NLG 7.50. Handicapped accessible. Wheelchairs available; free admission to those persons accompanying wheelchair users and blind visitors.
Hours: Daily, 10-5. Closed Jan. 1.
Tours: Reservations required four weeks in advance; (31) (20) 673 21 21.
Food & Drink: Self-service restaurant for coffee, soft drinks, beer, wine, and hot and cold food.
Museum Shop: Books, catalogues, postcards, posters, reproductions, and replicas are on sale in the museum's front hall and South Wing.

Stedelijk Museum

Paulus Potterstraat 13, 1071 CX Amsterdam, The Netherlands
(31) (20) 5732 911
http://www.stedelijk.nl

1999 Exhibitions
Thru February 7
Breitner & Contemporaries

February 20-April 11
Georg Baselitz

April 24-June 13
David Salle

May 29-July 18
Luigi Ghirri

Permanent Collection
Modern and contemporary art, with a concentration in work after 1945; includes paintings, sculptures, drawings, prints, photographs, graphic design, and applied arts, with works by Beckmann, Chagall, Cézanne, Kirchner, Matisse, Mondrian, Monet, Picasso; unique collection of Malevich and major postwar artists including Appel, dc Kooning, Newman, Judd, Stella, Lichtenstein, Warhol, Nauman, Long, Kiefer, Polke.
Architecture: 1895 Neo-Renaissance building by A.W. Weissman; 1954 addition by J. Sargentini and F.A. Eschauzier.

Admission: Adults, Fl. 7.50; seniors, groups of 15 or more, children 7-16, Fl. 3.75; children 6 and under, free. Fee for special exhibitions. Handicapped accessible.
Hours: Daily, 11-5. Summer hours, Apr. 1-Sept. 30: 10-6.
Tours: Call (31) (20) 5732 911 for reservations two weeks in advance.
Food & Drink: Restaurant open during museum hours.
Museum Shop: Open during museum hours.

Van Gogh Museum

Paulus Potterstraat 7, 1071 CX Amsterdam, The Netherlands
(31) (20) 570 5200

1999 Exhibitions
Summer
Theo Van Gogh (1857-1891)
Examines the life of Vincent Van Gogh's brother Theo, who was an art dealer and collector.

Kisho Kurokawa, Architect
Retrospective exhibition of the architect.

September 10-December 5
Van Gogh to Cézanne
Works by the two great modern artists from the collection of Dr. Gachet.

October 26, 1999-January 4, 2000
Jean-François Millet: The Painter's Drawings
An exhibition of pastels, paintings, watercolors, and drawings by the 19th-century French painter. Includes the world-renown work *The Gleaners* and explores the social issues that Millet addressed in his art. (T)

December 17, 1999-March 3, 2000
Prague 1900: Poetry and Ecstasy
Features paintings, drawings, sculptures, photographs, and decorative arts.

Permanent Collection
More than 200 paintings and almost 500 drawings from each period of Van Gogh's life; background materials; works of contemporaries, including Toulouse-Lautrec, Gauguin, Fantin-Latour, Monet, Sisley, Isaac Israëls and many others. **Highlights:** Works by Van Gogh: *The Potato Eaters; Still-life with Sunflowers; Self-Portrait with Old Felt Hat; Bedroom at Arles* and *Wheatfield with Crows.* **Architecture:** 1973 building by Gerrit Rietveld and I. van Dillen.

Admission: Adults, Fl. 12,50; children ages 6-17, Fl. 5; children under 6, free. Group rates available. Handicapped accessible, including elevators and wheelchairs.
Hours: Daily, 10-5; closed Jan. 1.
Tours: Call (31) (20) 570 5200 for information.
Food & Drink: Café open daily, 10-5; terrace open summer months.
Museum Shop: Open daily, 10-5; (31) (20) 570 5944.

Mauritshuis

Korte Vijerberg 8, 2513 AB The Hague, The Netherlands
(31) (70) 302 34 56

1999 Exhibitions
Thru January 10
Rembrandt Under the Scalpel
17th-century documents and recent restoration give insight into Rembrandt's anatomical training with the surgeon's guild of Amsterdam.

June 26-August 22
Copper as Canvas: Two Centuries of Masterpiece Paintings on Copper, 1525-1775
Highlights the practice of painting on copper, featuring 75 to 100 of the most spectacular and best-preserved examples of works by masters. (T)

September 25, 1999-January 9, 2000
Rembrandt by Himself
A pictorial autobiography of the 17th-century master traces the development of Rembrandt's self-portraiture through 75 paintings, drawings, and etchings. (T)

Permanent Collection

Dutch and Flemish paintings of the 15th-17th centuries. Many works previously held in the collection of Stadholder-Prince Willem V, including Rembrandt, *Portrait of the Artist as a Young Man;* Rubens, *Adam and Eve in Paradise;* and Vermeer, *View of Delft.* Other works by van Ruisdael, van der Weyden, Hals, Jordaens, Van Dyck, and Memling. **Highlights:** Works by Vermeer; Picture Gallery of Stadholder-Prince Willem V.
Architecture: City palace commissioned by Count Johan Maurits van Nassau Siegen, former governor of Dutch Brazil; 17th-century Dutch classical style palace designed by Jacob van Campen and built under supervision of Pieter Post, 1634-1644.

Admission: Adults, NLG 10; Children under 17, seniors, NLG 5.
Hours: Tues.-Sat., 10-5; Sun., holidays, 11-5; Closed Mon.
Tours: Call (31) (70) 302 34 35 for guided tour reservations.
Food & Drink: Coffee machine; Cafés and restaurants located nearby.
Museum Shop: Open during museum hours.

Kröller–Müller Museum

**Houtkampweg 6, P.O. Box 1, 6730 AA Otterlo, The Netherlands
(31) (318) 59 12 41**

1999 Exhibitions

Thru January 3
The Root of Everything is Drawing
Drawings by Vincent Van Gogh from the museum's collections.

May 8-June 27
Boezem

July-September
Carel Visser in the Rietveld Pavilion

Autumn-Winter
Isaac Israëls (1865-1934)
A look at the career of Dutch Impressionist Israëls, featuring works from Dutch museums and important private collections. (T)

Permanent Collection

Paintings by Corot, Fantin Latour, Van Gogh, Seurat, Signac, Ensor, Picasso, Léger, Gris, Mondrian; sculpture by Rodin, Maillol, Lipchitz, Moore, Hepworth, Snelson, Rickey, Oldenburg, Serra, Merz, Penone; 60-work sculpture park. **Architecture:** 1938 building by Henry van der Velde; 1977 wing by Wim Quist.

Admission: Contact the Hoge Veluwe National Park (includes museum); (31) (318) 59 16 27. Handicapped accessible.
Hours: Tues.-Sun., holidays, 10-5. Closed Mon. and Jan. 1.
Tours: By appointment; call (31) (318) 59 12 41 for information.
Food & Drink: Self-service restaurant open during museum hours.
Museum Shop: Offers books, catalogues, prints, and postcards.

Kunsthal Rotterdam

Museumpark, Westzeedijk 341, 3015 AA Rotterdam, The Netherlands
(31) (10) 44 00 300
http://www.kunsthal.nl

1999 Exhibitions

Thru February 28
Flower Still Lifes from the Netherlands and Belgium
A survey of modern interpretations of this classic Dutch genre, from works
by Van Gogh to Mondrian.

January 16-March 28
Odd Nerdrum: Two Decades
Highlights the work of Odd Nerdrum (b. 1944), Norway's leading
contemporary painter, known for his unorthodox personal style and social
criticism. Features 50 paintings made between 1978 and 1998. (T)

January 24-May 9
Missing Links-Alive!
Through the use robotic tour guides, video images, tools, and food, this
interactive exhibition traces the history of human evolution.

April 3-June 13
Helmut Newton/Alice Springs
A double exhibition featuring the work of the world-famous team of fashion
photographers.

June 19-August 29
Chinese Erotica: The Bertholet Collection
Late-Ming period erotic art, an important aspect of Chinese cultural
heritage, is characterized by profound beauty and harmony.

June 19-September 5
Balinese Modernists 1928-1942
Examines the art of Bali, the impact of Western artists who settled there and
the persistence of local traditions, during this interbellum period.

September 4-November 28
Isaac Israëls (1865-1934)
A look at the career of Dutch Impressionist Israëls, featuring works from
Dutch museums and important private collections. (T)

December 11, 1999-March 5, 2000
Leo Gestel: Watercolors and Drawings
The first comprehensive survey of work on paper by Leo Gestel, whose
"luministic art" laid the foundations for modern art in the Netherlands.

The Rauert Collection: German Expressionists
Paintings, drawings, and prints, as well as letters, postcards, and early
exhibition catalogues of Die Brücke document the development of
Expressionism in Germany.

Permanent Collection
Focus on modern art, design, and photography.

Admission: Adults, Fl. 10; children 6-15, groups of 20 or more, Fl. 7.50.
Handicapped accessible.
Hours: Tues.-Sat., 10-5; Sun., holidays, 11-5.
Tours: Call (31) (10) 44 00 300 for information.
Food & Drink: Hot and cold lunches available.
Museum Shop: Offers a variety of books, postcards, posters, and gifts.

Museum Boijmans Van Beuningen Rotterdam
Museumpark 18-20, 3015 CX Rotterdam, The Netherlands
(31) (10) 44 19 400
http://www.boijmans.rotterdam.nl

1999 Exhibitions
Thru January 10
Francis Bacon: A Retrospective Exhibition
A landmark retrospective of one of 20th-century Britain's greatest painters,
known for his images of isolation, despair, horror, and tortured human
forms. 60 paintings represent each significant period of the artist's career.
Catalogue. (T)

Navin Rawanchaikul & Rirkrit Tiravanija
Lifesize poster of Thai artists Navin Rawanchaikul and Rirkrit Tiravanija.

January 30-April 1
Crimson
Presentation by Rotterdam collective of critics and architecture historians in
The City Collection series.

January 30-April 5
Rotterdam Design Prize

April 17-June 13
Dutch Landscape
Ger van Elk selects works from
the permanent collection.

*Watercolors from "Hoekse
Waard"*

May 22-September 5
*150 Years Boijmans Van
Beuningen*
Includes work by Boijmans, D.
G. Van Beuningen, H. J. Van

Jan de Bray, *The Finding of Moses,* 1661. Photo courtesy
Museum Boijmans Van Beuningen, Rotterdam.

Beuningen, Van Ryckevorsel, Willem Van der Vorm, Van Rede, Van der
Schilden, Frederiks, and D. Nieuwenhuijs.

July 3-September 5
Drinkcultuur in the 18th Century

September 1999-January 2000
Egyptomania

September 25, 1999-January 2000
The Other Face of the Golden Age: The Discovery of Dutch Classicism
17th-century painting inspired by Classical Antiquity as an alternative to
Dutch Realism. Includes work by de Braij, De Grebber, and Van Campen.

Classicism from Dutch Collections
Features drawings, furniture, glass, books, and more.

Permanent Collection

Old Masters, sculpture, drawings, paintings, applied art, industrial design,
modern and contemporary art. **Highlights:** Brueghel, *Tower of Babel;*
Bosch, *The Prodigal Son.* **Architecture:** 1935 building by A. van der Steur;
1972 addition by A. Bodon; 1991 pavilion by H. J. Henket.

Admission: Adults, Fl. 7.50; seniors, children, groups of 15 or more, Fl. 4.00
per person. Additional charges for some special exhibitions. Handicapped
accessible.
Hours: Tues.-Sat., 10-5; Sun. and holidays, 11-5. Closed Mon.
Tours: Mon.-Fri.; call (31) (10) 44 19 471 for information.
Food & Drink: Café Restaurant open Tues-Sat., 9:30-5; Sun., 10:30-5.

Astrup Fearnley Museum of Modern Art

Dronningens GT. 4, Oslo, Norway
(47) (22) 93 60 60
http://netvik.no/storgata/af-museet

1999 Exhibitions

Thru January 3
Odd Nerdrum: Two Decades
Highlights the work of Odd Nerdrum (b. 1944), Norway's leading
contemporary painter, known for his unorthodox personal style and social
criticism. Features 50 paintings made between 1978 and 1998. (T)

Evocative Moods
Works from the permanent collection reflect changing themes.

January 1-August 17
Selections from the Permanent Collection

January 17-April 1
Gerhard Richter–Paintings 1964-1998

April 14-June 1
Norwegian Painting in the 1990s

June 10-August 1
"The School of Oslo"–Expressive Norwegian Figurative Art

August 19-September 26
Anna Gaskell
Recent work by the American artist, including drawings, photographs, and
her first film, *Untitled (ophelia),* inspired by *Ophelia* by Pre-Raphaelite
painter Sir John Everett Millais. (T)

August 20-October 10
Photography in Focus

October 8, 1999-January 4, 2000
Kjell Torriset–Retrospective

October 22-December 5
Out of Africa–Contemporary Art from Mozambique

Permanent Collection

The collection consists of post-war works with an emphasis on Norwegian and international artists, including pieces by Francis Bacon, Lucian Freud, Anselm Kiefer, Gerhard Richter, Gary Hume, Knut Rose, Bjorn Carlsen, Olav Christopher Jenssen, and Odd Nerdrum; the latest addition to the museum is a sculpture hall featuring works by Willem de Kooning, Damien Hirst, and Richard Deacon. **Highlights:** Anselm Kiefer, *Zweistromland* (*High Priestess*), Odd Nerdum paintings, Gerhard Richter, *River*, Damien Hirst, *Mother and Child Divided.* **Architecture:** 1993 modern building by well-known Norwegian architect LPO A/S; situated in the oldest part of Oslo with buildings dating back to the 17th century.

Admission: Adults, NOK 30; children over 7, students, NOK 15; group reductions Handicapped accessible, including ramp and elevator.
Hours: Tues.-Sun., 12-4; Thurs., 12-7; closed Mon.
Programs for Children: Tours available upon request.
Tours: Sat.-Sun., 1. Call (47) (22) 93 60 47 for reservations.
Museum Shop: Open during museum hours.

Munch Museet

Tøyengt. 53, 0578 Oslo, Norway
(47) (22) 67 37 74

1999 Exhibitions

Ongoing
Munch and Photography
In Edvard Munch's Footsteps

Thru February
Munch and Ekely
Paintings, drawings, and graphic work created between 1916 and 1944 at the artist's estate in Ekely.

Spring
Warnemünde
A presentation of paintings from the summer resort of Warnemünde, by the Baltic Sea, painted during the years of 1907-8.

Permanent Collection

The bequest of Edvard Munch (1863-1944), pioneer Scandinavian Expressionist, includes a vast collection of the artist's paintings, graphics, drawings, and sculpture. **Highlights:** Munch, *The Scream* (1893), *Death in the Sickroom*, *Madonna*. **Architecture:** 1963 building by Gunnar Fougner and Einar Myklebust.

Admission: Adults, NOK 50; concessions, NOK 20; groups of 10 or more, NOK 25. Handicapped accessible, including elevator.
Hours: June 1-September 15: daily, 10-6; September 16-May 31: Tues., Wed., Fri., Sat., 10-4; Thurs., Sun., 10-6. Closed Mon.
Programs for Children: Art education rooms for children; special guided tours.
Tours: Sun., 1. Call (47) (22) 67 37 74 for information.
Food & Drink: Café Edvard Munch serves light meals, desserts, drinks, and coffee. Open during museum hours.
Museum Shop: Books, catalogues, posters, postcards, reproductions, t-shirts, and more.

Nasjonalgalleriet
Universitetsgaten 13, N-0164 Oslo, Norway
(47) (22) 20 04 04
http://www.nasjonalgalleriet.no

1999 Exhibitions
Not available at press time.

Permanent Collection
Norwegian art from 1814 to 1920, highlighting romantic landscape painting, realism, neo-romanticism, Impressionism, Post-Impressionism, and Expressionism. Sculpture and French art from the 19th and 20th centuries. Norwegian and international drawings and graphic art. Outstanding collection of Russian icons. **Highlights:** 58 paintings by Edvard Munch, including the *Frieze of Life, Moonlight,* the *Scream,* and the *Dance of Life;* J. C. Dahl, *View from Stalheim over Noerødalen and Stugunøset* and *Stugunøset at Fileffjell;* Tidemand, *Low Church Devotion;* Erik Werenskiold, *Peasant Burial;* work by Thomas Fearnley, Peder Balke, Christian Krohg, Harriet Backer, Frits Thaulow, Gerhard Munthe, Christian Skredsvig, Kitty Kieland, Eilif Peterssen; El Greco, *St. Peter the Repentant;* Orazio Gentileschi, *Judith and Her Maidservant;* Jacob Jordaens, *Allegory of the Blessings of the Peace of Westphalia;* work by Delacroix, Courbet, Manet, Degas, Monet, Léger, Renoir, Gauguin, Van Gogh, Cézanne, Bonnard, and Matisse.

Admission: Free, except for special exhibitions. Handicapped accessible.
Hours: Mon., Wed., Fri., 10-6; Thurs., 10-8; Sat., 10-4; Sun., 11-4.
Tours: By reservation on weekdays, 9-10.
Museum Shop: Offers cards, catalogues, and books on Norwegian artists.

The Royal Castle in Warsaw
Plac Zamkowy 4, 00277 Warsaw, Poland
(48) (22) 635 08 08; (48) (22) 657 21 50

1999 Exhibitions
January-March 15
Sarden. Form, Symbol, Dream.

Opens December 15
Iconography of Death

Permanent Collection

16th–17th century Court Rooms; ancient Parliament Chambers; Royal Apartments of King Stanislaus Augustus, reconstructed, with original furnishings and paintings; Castle cellars; Polish coins and medals; collection of Far Eastern carpets. **Highlights:** Bernarolo Bellotto, 23 *Views of Warsaw.* **Architecture:** Reconstruction of Poland's Royal Castle (16th-18th century), destroyed during World War II. Open to the public since 1984.

Admission: Regular, 11LP; reduced, 5LP; Sun. and holidays, free. Handicapped accessible; ramps, elevators, and wheelchairs available.
Hours: Oct. 1-Apr. 14: Tues.-Sun., 10-4; Apr. 15-Sept. 30: Daily, 10-6.
Programs for Children: Offered during school year. Call for details.
Tours: Call (48) (22) 65 72 338 or fax (48) (22) 65 72 170 for reservations.
Food & Drink: Restaurant and Café open Tues.-Sun., 12-12.
Museum Shop: Offers books, cards, and maps.

Museo de Arte de Ponce

2325 Avenida de las Americas, Ponce, Puerto Rico 00732
(787) 848-0505

1999 Exhibitions
January 30-March 7
After the Loss of the Colonies

April-May
Celebrating Renoir

Summer
Young Artists Competition

Dante Gabriel Rossetti, *The Roman Widow.* Photo courtesy Ponce Museum of Art.

Permanent Collection

Paintings and sculptures by Rubens, Velázquez, Murillo, Strozzi, Delacroix, and Bougereau; 18th-century paintings from Peru and South America, as well as 18th- and 19th-century works by Puerto Rico's Jose Campeche and Francisco Oller. Contemporary artists include Fernando Botero, Claudio Bravo, Myrna Báez, Jesús Rafael Soto, and Antonio Martorell. **Highlights:** Collection of Pre-Raphaelites and Leighton's *Flaming June.* **Architecture:** Museum founder Don Luis A. Ferré commissioned Edward Durrell Stone to design the museum, which opened in 1965. A "work of art housing works of art," with 14 galleries and two gardens, one based on Moorish design from Granada, the other contemporary.

Admission: Adults, $4; children, $2; students with ID, $1; special group rates; members, free.
Hours: Daily, 10-5. Closed Dec. 25, Jan. 1, Three Kings Day, Good Friday.
Tours: Daily in English and Spanish; group reservations required.
Food & Drink: Snack bar in Granada Garden.
Museum Shop: Open during museum hours.

Pushkin Museum of Fine Arts

Ul. Volkhonka 12, Moscow, Russia
(7) (95) 203-7412
http://www.global-one.ru/english/culture/pushkin

1999 Exhibitions
Not available at press time.

Permanent Collection
World-class art, with 4300 sq. ft. of Ancient Greek and Roman sculpture, including the marble sarcophagus *Drunken Hercules*, a torso of Aphrodite, and more, plus classical masterpieces and one of the best collections in the world of French Barbizon and Modern painting. **Highlights:** Botticelli, *The Annunciation;* San di Pietro, *Beheading of John the Baptist*; six Rembrandts, including *Portrait of an Old Woman*; five Poussins; Picasso, from blue period; Cézanne, *Pierrot and Harlequin*; Van Gogh, *Landscape at Auvers after the Rain* and *Red Vineyards*; Monet, *Rouen Cathedral at Sunset*; Renoir's well-known *Bathing on the Seine* and *Nude on a Couch,* plus ten fantastic Gauguins, and more. **Architecture:** Neoclassical (1895-1912). Two-storey dark gray stone building with a large colonnade and glass roof by architect Roman Klein.

Hours: Tues.-Sun., 10-7.
Tours: Group tours by reservation only.
Food & Drink: Cafés located nearby.

Tretyakov Gallery

Lavrushinsky Pereulok 12, Moscow, Russia
(7) (95) 231-1362

Permanent Collection
More than 100,000 works of Russian art including ancient Russian art, myriad icons, classical 18th- and 19th-century Russian works, and 20th-century works by Kandinsky and Malevich, with selections on display in brand new expanded and restored exhibition galleries. Original collections donated by Tretyakov brothers in 1895 from their private home next door have grown to museum of twenty buildings. **Architecture:** Unique creative 1900 design by Viktor Vasnetsov in the style of early art nouveau, with architecture and decorative styles interwoven.

Hours: Tues.-Sun, 10-7.
Tours: Call (7) (95) 238-2054.

State Hermitage Museum

34 Dvortsovaya Naberezhnaya, St. Petersburg 190000, Russia
(7) (812) 311-3420
http://www.hermitage.ru

1999 Exhibitions

January 17
I. I. Tolstoy–Collector
A collection of coins and medals, dating from the 10th to the 18th centuries, that was presented to the museum by Tolstoy in 1916.

Thru January 24
The Collection of Glass by Galle and Brothers Domm
Work from the permanent collection, including objects from the private collection of Nicholas II and Alexandra.

Thru February 7
Jacob Philipp Hackert
Works by German 18th-century landscape-artist Jacob Philipp Hackert.

Thru March
Danaë–*The Fate of Rembrandt's Masterpiece*
This masterwork is once again on view after 12 years of restoration.

Thru March 14
Works of Art by Leonardo da Vinci's School
An installation of work from the permanent collection.

Thru 2000
The Hermitage Golden Rooms
Originally known as the Treasure Gallery of Catherine the Great, the Golden Rooms have been renovated and reopened to the public, and display the museum's spectacular collection of jewelry and gem stones.

April 27-September 12
Catherine the Great and Gustav III
Explores themes of war, peace, science, trade, and the fine arts, as influenced by the cultural and political contact of these two royal cousins. (T)

May-December
Women's Portraits in Coins
Examples from the permanent collection.

October-November
Etchings by Rembrandt

November
Bernini's Rome: Italian Baroque Terracottas from The State Hermitage Museum
An exhibition of 35 rarely-exhibited *bozzetti* clay sculptures, originally created as unfinished, preliminary sketches, they can now be fully appreciated as works of art. Features works by Gian Lorenzo Bernini and 13 other Italian Baroque artists. Catalogue. (T)

Permanent Collection

One of the most all-encompassing repositories of art in the world, begun with Tsarist treasures and including, since the Revolution, private collections. More than four hundred exhibition galleries house a veritable treasure trove of antiquities from Egypt, Babylon, Byzantium, Greece, Rome and Asia; Russian pre-historic artifacts; elaborate medals and decoration. Old masters from every period of Western Art and the largest collection (along with the Pushkin Museum) of major French Impressionist, Post-Impressionist and the Barbizon School outside Paris. The lavish Winter Palace adjoins the museum. **Highlights:** Osobaya Kladovya—the Gold Room—with spectacular gold, silver and royal jewels; the Jordan staircase; works by Leonardo, including *Madonna with Flowers*, *Madonna Litta*; Raphael, *Madonna Connestabile*, *Holy Family*; eight Titians; works by El Greco, Velazquez, Zurbarán, Goya; Van Dyck, *Self Portrait*; 40 Rubens and 25 Rembrandts including *Danaë* and *The Prodigal Son*; Matisse, *The Dance*; Cézanne, *The Banks of the Marne*; Picassos from blue, pink and cubist periods. British masters are also on view. **Architecture:** Built in several phases, first as a retreat for Catherine the Great, then the Great (Bolshoi) Hermitage, then the New Hermitage, the building is in the quintessentially St. Petersburg style of monumental Imperial Russian architecture with an assimilation of western architectural principals on a scale that is uniquely Russian. Court Architects: Bartolomo Francesco Rastrelli (1764-1775); Mikhail Zemstov, (1839-1852); Shtaakenshneider renovations 1852.

Admission: Adults, 60 rubles; Russian citizens, 15 rubles; students and children under 17, free.
Hours: Tues.-Sat., 10:30-6; Sun., 10:30-5.
Tours: Daily. Advance booking required for groups, (7) (812) 311-8446.

National Galleries of Scotland

National Gallery of Scotland
The Mound, EH2 2EL Edinburgh, Scotland
(44) (131) 556-8921 (information for all three museums)

1999 Exhibitions
January 1-31
Turner Watercolours
Annual display of magnificent watercolors by English painter J.M.W. Turner (1775-1851), including 38 works from the collection bequeathed to the Gallery by Henry Vaughan.

Permanent Collection
Masterpieces from the Renaissance to Post-Impressionism by Raphael, Titian, El Greco, Velázquez, Rembrandt, Turner, Constable, Cézanne, Van Gogh; Scottish paintings include works by Ramsay, Raeburn, Wilkie, and MacTaggart. **Architecture:** 1859 Neoclassical building by William Playfair.

Scottish National Portrait Gallery
1 Queen St., Edinburgh, Scotland

1999 Exhibitions
Thru January 5
William Klein: New York
A series of innovative, hard-edge, black and white street photographs that capture the energy of the city, shot in New York during 1954 and 1955.

Thru March 7
Prophets and Pilgrims: Ruskin, Proust and Northern Gothic
Explores the influence of Victorian art critic John Ruskin on late-19th-century literary and artistic figures such as Wilde, Morris, and Proust, who called Ruskin the "High Priest of Beauty." Includes daguerreotypes, photographs, drawings, and watercolors.

January 22-April 4
Raeburn's Rival: Archibald Skirving, 1749-1819
Celebrates the life and work of Archibald Skirving, a portraitist who worked in Edinburgh during the Scottish Enlightenment. Includes over 80 works, featuring pastels, drawings, miniatures, prints, and oil paintings. Catalogue.

Permanent Collection
Subjects include Mary, Queen of Scots; Bonnie Prince Charlie; Robert Burns; Sir Walter Scott; Charles Rennie Macintosh; Queen Elizabeth. Scottish Photography Archive, including work by Hill & Adamson and contemporary photographers.

Scottish National Gallery of Modern Art
Belford Rd., Edinburgh, Scotland

1999 Exhibitions
Thru February 14
John Maxwell
Retrospective exhibition of work by Maxwell, a member of the Edinburgh School. Includes 70 paintings, watercolors and drawings inspired by the artist's love of poetry and music.

John Singer Sargent, *Lady Agnew of Lochnaw.* Photo courtesy National Gallery of Scotland.

Permanent Collection
Twentieth-century paintings, sculpture, graphics, including works by Picasso, Matisse, Giacometti, Moore, Hepworth, Lichtenstein, Hockney. National collection of Scottish art, from the Colorists to contemporary.

Admission: Free. Charge for some loan exhibitions.
Hours: Mon.-Sat., 10-5; Sun., 2-5. During Edinburgh International Festival: Mon.-Sat., 10-6; Sun., 11-6. Closed Dec. 25–26, Jan. 1.
Tours: Call (44) (131) 556-8921
Food & Drink: Cafés at Modern Art and Portrait Galleries open Mon.-Sat., 10:30-4:30; Sun., 2-4:30.

Additional Museums in Scotland...

Art Gallery and Museum
Kelvingrove, Glasgow, Scotland, G3 8AG

The Burrell Collection
2060 Pollokshaws Road, Glasgow, Scotland, G43 1AT

Gallery of Modern Art
Queen Street, Glasgow, Scotland, G1 3AZ

Fundació Joan Miró

Parc de Montjuïc, 08038 Barcelona, Spain
(34) (3) 329 19 08
http://www.bcn.fjmiro.es

1999 Exhibitions
Thru February 7
Magritte
Over 70 oil paintings, gouaches, and drawings examine themes of mystery, narration, language, and metamorphosis in the work of Belgian surrealist René Magritte (1898-1967).

February 26-April 18
Ian Hamilton Finlay
Features the innovative installation work of the avant-garde poet and landscape designer now living in Stonypath, Scotland.

May 7-July 4
Droog Design
Contemporary works by the latest generation of designers in the Netherlands, on loan from the Centraal Museum in Utrecht.

André Ricard
Examines the effect of design on everyday life, featuring works designed by the pioneer in the theory and practice of industrial design in Catalonia.

Permanent Collection
More than 200 paintings, sculptures, works on paper, textiles (1917–1970s) donated by Miró to his native city. Foundation is dedicated to conserving and showing his work, and that of both major and emerging artists.
Highlights: Major works by Miró; "To Joan Miró" (works dedicated to Miró by major artists). **Architecture:** 1975 building by Joseph Lluis Sert, enlargement in 1986 by Jaume Freixa.

Admission: 700 ptas. Handicapped accessible.
Hours: Tues.-Sat., 11-7; Thurs. 11-9:30; Sun., holidays, 10:30-2:30. Closed Mon. Summer hours: Tues.-Sat., 10-8; Thurs., 10-9:30; Sun., holidays, 10-2:30. Closed Mon.
Programs for Children: Guided tours, call 329 19 08 for reservations.
Tours: General public, Sat.-Sun., 12:30; schools, weekdays; call 329 19 08 for reservations.
Food & Drink: Buffet and restaurant with outdoor café open during museum hours.
Museum Shop: Open during museum hours. Gift catalogue available.

Museu Picasso

Carrer de Montcada, 15-19, 08003, Barcelona, Spain
(34) (3) 319 63 10

1999 Exhibitions
Thru April
Picasso: Engravings, 1900-1940
Surveys the artist's engravings from his early career through 1940.

April 29-July 11
Raoul Dufy
Retrospective of the modern French artist's entire career, from his vital contribution to Fauvism to his later *Cargos Noirs (Black Ships)*. Also features his work as a silk designer in Lyon, and his ceramic and decorative creations. (T)

Permanent Collection
More than 3,500 works from Picasso's formative years, including early paintings, drawings, engravings, ceramics, and graphics, installed in a former private mansion. **Architecture:** Berenguer d'Aguilar, Baró de Castellet, and Meca palaces, 13th century.

Admission: Permanent Collection: adults, 600 ptas; seniors, students, unemployed, 300 ptas; children under 12, free; Wed., half-price; first Sun. of the month, free. Temporary exhibitions: adults, 700 ptas; seniors, students, unemployed, 400 ptas. Handicapped accessible.
Hours: Tues.-Sat., holidays, 10-8; Sun., 10-3. Closed Mon., Jan. 1, Good Fri., May 1, June 24, Dec. 25-26. Ticket office closes half hour before museum closing time.
Tours: Call the Visits Department Mon.-Fri., 10-2. Group reservations required in advance.
Food & Drink: Café and Terrassa del Museu open during museum hours.

Fundació Antoni Tàpies

Aragó 255, 08007 Barcelona, Spain
(34) (3) 487 03 15

1999 Exhibitions
January 21-March 21
Merce Cunningham
Celebrates the past fifty years of the innovative American dancer's career, from his role in the Martha Graham Dance Company and the formation of his own company at Black Mountain College, to his recent work using computer programs.

Merce Cunningham, *Walkaround Time,* 1968. Set design by Jasper Johns. From *Merce Cunningham.* Photo courtesy Fundació Antoni Tàpies, Barcelona.

Includes designs and collaborations by Rauschenberg, Johns, Cage, Nauman, Warhol, and others.

April 15-June 20
Art & Language
Relationship and dialogue with art shown in an immense mural by Ramsden and Baldwin.

Permanent Collection
Over 300 paintings, drawings, and sculptures representing every aspect of the artist's work; library collections on Tàpies, modern art history, and art of the Orient. **Architecture:** 1885 building by Lluís Domènech i Montaner; 1990 renovation by Roser Amadó and Lluís Domènech Girbau.

Admission: Adults, 500ptas; students, 250ptas. Handicapped accessible.
Hours: Tues.-Sun., 11-8. Closed Mon., except holidays.
Tours: Groups by appointment; call (34) (3) 487 03 15.
Museum Shop: Open during museum hours.

Museo Guggenheim Bilbao

Abandoibarra Etorbidea 2, 48001 Bilbao, Spain
(34) (94) 435 9080
http://www.guggenheim.org

1999 Exhibitions
Ongoing
Art of this Century: Masterpieces from the Guggenheim Museum
Selections from the permanent collection of the Guggenheim Foundation survey the spectrum of 20th-century art, from Cubism and Expressionism to Pop Art, Minimalism, and conceptual art.

Thru March 7
Robert Rauschenberg: A Retrospective
Surveys the prolific career of one of the most acclaimed American artists of the 20th century. Includes nearly 400 works from the late 1940s to the present. Catalogue. (T)

Spring
Richard Serra
Installation by this important contemporary artist whose sculptures, made for specific urban or architectural sites, heighten perceptual awareness. (T)

Permanent Collection
American and European art of the 20th century. Focus on works created since mid-century, including all major styles and developments of successive generations. Contemporary Basque and Spanish art, including works by Tàpies, Iglesias, Solano, and Torres. **Highlights:** Modern and contemporary works by de Kooning, Dine, Polke, Kiefer, Still, and Rothko. Special commissions by Serra, Clemente, and Holzer. **Architecture:** Building design by Frank Gehry, 1991; interconnected building blocks organized around a large central atrium; also incorporates a busy traffic bridge, the Puente de la Salve; signature metal roof, called the "Metallic Flower." Museum opened in October 1997.

Hours: Tues.-Wed., 11-8; Thurs.-Sat., 11-9; Sun., 11-3. Closed Mon.

Museo del Prado

Paseo del Prado s/n., 28014 Madrid, Spain
(34) (1) 330 28 00
http://museoprado.mcu.es

1999 Exhibitions
Thru January 10
Felipe II, Prince of the Renaissance

Permanent Collection
One of the major museums of the world, with Master paintings from Italian Renaissance, Northern European, Spanish Court Painters collected by Royal family since the 15th century. Works by Brueghel, Van Dyck, Goya, El Greco, Giorgioni, Rubens, Titian, Velázquez, Zurbarán. **Highlights:** Fra Angelico, *The Annunciation*; Titian, *Danae*; Bosch, *The Garden of Delights*; Brueghel, *The Triumph of Death*; El Greco, *The Nobleman with his Hand on His Chest*; Velázquez, *The Surrender of Breda, Las Meniñas*; Goya, *Nude Maja, Clothed Maja, Third of May*; frescoes; works by Rubens, Titian, Tintoretto, Veronese. **Architecture:** 1780 Neoclassical building by Juan de Villanueva.

Admission: 400 ptas.
Hours: Tues.-Sat., 9-7; Sun., holidays, 9-2. Closed Mon.
Tours: Call (34) (1) 330 28 25.
Food & Drink: Cafeteria, restaurant open 9-5.

Museo Nacional Centro de Arte Reina Sofía

Santa Isabel 52, 28012 Madrid, Spain
(34) (1) 467 50 62; (34) (1) 467 51 61
http://www.spaintour.com/museomad.htm

1999 Exhibitions

February-April
Man Ray

February 2-April 12
Ortega Muñoz

February 11-April 27
Annette Messager

April 6-June 21
Matta

April-July
Zuloaga

May 4-August 16
Ortiz Echagüe

May 18-August 30
Angel Ferrant

May 27-August 22
Campano

July 6-October 11
A Rebours

September 14-November 21
Barcelo

September 16-November 28
J. Sarmiento

September 21-November 29
Bores

September 28, 1999-January 10, 2000
Robert Frank: Photographs

November 2, 1999-February 2000
Louise Bourgeois

December 14, 1999-February 2000
Surrealists in Exile

December 16, 1999-February 20, 2000
Plensa

Joaquin Sorolla, *Preparando y Arrastrando Atunes,* 1912. From *Sorolla and the Hispanic Society of America: A Vision of Spain at the Turn of the Century.* Photo courtesy Fundación Collección Thyssen-Bornemisza.

Permanent Collection

Over 10,400 works spanning European and Spanish modern and contemporary art. Works by Spanish artists Gris, Dalí, Picasso, Miró, and

Gonzalez, and important artists influenced by the Modernist movement, 1900–1940; sculptures, including works by Gargallo, Alfaro, and Serrano; over 4,500 drawings and engravings. **Highlights:** Picasso, *La Naguese, Guernica*; Kapöor, *1000 Names*; large collection of important works by Dali and Miró. **Architecture:** Former Madrid General Hospital created by Sabatini during the reign of Carlos III, 1788; 1990 renovation and expansion, Vasqez de Castro and Iñiquez de Onzoño.

Admission: Adults, 500 ptas; students, half-price; children under 18, seniors, members, Sat. 2:30-9, Sun., free. Handicapped accessible.
Hours: Wed.-Mon., 10-9; Sun., 10-2:30. Closed Tues.
Tours: Mon.,Wed., 5; Sun., 11. For information, call (34) 1 467 50 62.
Food & Drink: Café open museum hours; Restaurant open Mon.,Wed.-Sat., 1-4.

Fundación Colección Thyssen-Bornemisza
Paseo del Prado 8, 28014 Madrid, Spain
(34) (1) 420 39 44
http://www.offcampus.es/museo.thyssen-bornemisza

1999 Exhibitions
Thru January 10
Contexts of the Permanent Collection 6: Kupka, Localization of Graphic Mobiles, *1912-13*

Thru January 17
Sorolla and the Hispanic Society of America: A Vision of Spain at the Turn of the Century
Approximately 70 works by Valencian painter Joaquín Sorolla, including large-scale decorative paintings made in New York between 1906 and 1918. Catalogue. (T)

January 19-May 30
Contexts of the Permanent Collection 7: Picasso, The 1934 Bullfights

February 4-May 16
El Greco: Identity and Transformation

October 1, 1999-January 16, 2000
Exploring Eden: American Landscape

Permanent Collection
Comprises works collected by the Thyssen-Bornemisza family for over two generations. Includes European art, focusing on paintings from the 13th through 20th centuries; 19th century North American painting; German Expressionism. **Highlights:** Works by Giotto, Titian, Bellini, Veronese, Carravaggio, Cranach, Gaddi, El Greco, Beckmann, Miró, Grosz, and Cézanne. **Architecture:** The Neoclassical Palace of Villahermosa, built 18th-19th century; refurbished by architect Rafael Moneo.

Admission: Regular, 700 ptas; reduced, 400 ptas. Handicapped accessible, including elevators and wheelchairs; braille brochures available at desk.
Hours: Tues.-Sun., 10-7. Ticket office closes at 6:30.
Tours: Group tour reservations, call (34) (1) 369 01 51.
Food & Drink: Cafeteria-Restaurant offers hot and cold drinks, pastries, sandwiches, and full à la carte menu; open Tues.-Sun., 10-6:30.
Museum Shop: Offers cards, books, jewelry based on museum works, CD-Rom of the collection, and other gift items.
Branch: Monastery of Pedralbes in Barcelona (Baixada del Monestir 9, 08034 Barcelona, tel: (34) (93) 280 14 34), houses collection of medieval, Renaissance and Baroque works.

Moderna Museet

Skeppsholmen, Box 16382, SE-10327 Stockholm, Sweden
(46) (8) 5195 5200
http://www.modernamuseet.se

1999 Exhibitions

Thru February 14
Ulrik Samuelson – A Retrospective
Since the early 1960s, contemporary Swedish artist Samuelson (b. 1935) has explored the relationship of art to the world around it through constructions of spatial relationships. Includes reinstallations of paintings and objects from the 1950s to the present.

Thru March 7
Oscar Gustave Rejlander, 1813(?)-1875
21 works by the Swedish-born photographer who worked in Great Britain, including *Two Ways of Life,* a work produced from 39 negatives that accounts for the critical choices a young man makes in his life.

Jean Fautrier: Graphics and Works on Paper
Survey includes selection of over 30,000 works on paper from the National Museum collection, in celebration of the centenary of the artist's birth.

March 6-May 24
Alexander Rodchenko (1891-1956)
Retrospective exhibition of works by the classic Russian constructivist, including paintings, sculptures, constructions, designs, and photography. Catalogue. (T)

October 9, 1999-January 9, 2000
After the Wall: Art from Post-Communist Europe
Sheds light on the art, film, photography, and music produced in the former Soviet Union during the decade after perestroika and the fall of the Berlin Wall.

Autumn
Modernism in Sweden–A History
Symposium and exhibition examines modern art, architecture, design, and music in Sweden from 1900 to the early 1940s.

Permanent Collection

Works by Swedish, international artists; modernist works by Braque, Dalí, Duchamp, Ernst, Giacometti, Kandinsky, Picasso; American art of the 1960s and 1970s. Recent acquisitions include works by Calder, Goldin, photographs by Cartier-Bresson, Mapplethorpe. **Highlights:** Brancusi, *Le Nouveau-né*; De Chirico, *Le Cerveau de l'enfant*; Rauschenberg, *Monogram*; Duchamp room. **Architecture:** Museum opened in 1958, housed in a former naval drill hall built by Fredrik Blom in 1852, renovated by Per-Olof Olsson. New museum on Skeppsholmen Island by architect Rafael Moneo opened in February 1998.

Admission: Adults, 60 SEK; under 16, free.
Hours: Tues.-Thurs., 11-10; Fri.-Sun., 11-6. Closed Mon.
Programs for Children: Workshops on Sun. (Swedish language only)
Tours: Call (46) (8) 5195 5264.
Food & Drink: Kantin Moneo offers varied menu, including coffee, pastries, and à la carte selection with a scenic view. Open museum hours.
Museum Shop: Offers cards, posters, gifts, catalogues, and books on art, architecture and critical theory; open museum hours.

Nationalmuseum

Södra Blasieholmshamnen, Box 16176, SE-10324 Stockholm, Sweden
(46) (8) 5195 4410
http://www.nationalmuseum.se

1999 Exhibitions

Thru January 10
Roman Drawings
Old Master drawings made in Rome during the time of Sweden's abdicated Queen Kristina. Includes works by Raphael, Kristina's court painter Pier Francesco Mola, and others.

Thru January 25
Swedish Design Award
Award-winning objects in the field of industrial design, the art industry, and graphic design from this annual celebration of design.

Thru February 28
Catherine the Great and Gustav III
Explores the themes of war, peace, science, trade, and the fine arts, as influenced by the cultural and political contact of these two royal cousins. (T)

Alexander Roslin, *Catherine II of Russia*. From *Catherine the Great and Gustav III*. Photo courtesy Statens Konstmuseer and Nationalmuseum, Stockholm.

March 26-May 30
Gustave Courbet
Works by the celebrated 19th-century French painter.

April 5-August 29
Adriaen de Vries 1556-1626: Imperial Sculptor
Sculpture, prints, and drawings by the late-Mannerist Dutch artist who worked under Emperor Rudolf II in Prague. (T)

May 7-August 22
Erik Dietman Glassworks

September 4-October 31
Look and See What You Can See

October 1, 1999-January 16, 2000
Carl Fredrik Hill

Permanent Collection
Swedish painting and sculpture; 17th-century Dutch painting; 18th- and 19th-century French paintings; 45,000 drawings and prints from the 15th century to the present; fine collection of decorative arts from medieval furniture and tapestries to contemporary design. **Highlights:** Late-19th to early-20th-century Nordic art by Larsson, Liljfors, Zorn; Impressionist works by Renoir, Manet, Degas; Rembrandt, *The Batavians' Oath of Allegiance*; Rubens, *Bacchanal at Andros*. **Architecture:** 1866 Italian Renaissance building, with decorative sculpture by Swedish artists.

Admission: Adults, 60 SEK; seniors, students, 40 SEK. Handicapped accessible, including elevators and hearing aids.
Hours: Tues., Thurs., 11-8, Wed., Fri.-Sun., 11-5. Closed Mon.; Jun. 1-Aug. 31: Open at 10.
Programs for Children: Special children's activities.
Tours: Call (46) (8) 5195 4428, Tues.-Fri., 9-12 for reservations.
Food & Drink: Café and restaurant open during museum hours.
Museum Shop: Offers art books, catalogues, postcards, jewelry, glass, and handicrafts; open during museum hours.

Kunstmuseum Bern

Holderstrasse 8-12, CH-3000 Bern 7, Switzerland
(41) (31) 311 09 44

1999 Exhibitions
Thru January 31
Bill Traylor

Künstlerpaare-Künstlerfreunde: Josef and Anni Albers, Europe and America

February 17-May 2
Bethan Huws: Watercolors

February 24-May 2
André Thomkins: Retrospective

May 28-August 8
Pierre Soulages

September 1-November 7
MediaSkulptur
Video sculpture and video installation
from the Schweizer Künstlern and
Künstlerinnen.

**November 26, 1999-February 20,
2000**
Cuno Amiet
Between Pont Aven and Die Brücke

Paul Klee, *Ad Parnassum (To Parnassus)*, 1932.
Photo courtesy Kunstmuseum Bern.

Permanent Collection
Works from seven centuries with over 3,000 paintings and sculptures and
40,000 works on paper. Focus on Italian Trecento, Bernese art since the 15th
century; French art from Delacroix and Courbet to Dalí and Masson;
German Expressionists; extensive collection of work by Klee; modern and
contemporary art. **Highlights:** Portraits by Anker; altarpieces by Deutsch;
old panels by di Buoninsegna, Angelico; works by Beuys, Byars, Chagall,
Dalí, Matisse, Kirchner, Picasso. **Architecture:** 1879 Classical building by
Eugen Stettler; 1983 ultra-modern annex by Karl Indermühle and Otto
Salvisberg; 1998-9 renovation.

Admission: SFr 6 for the permanent collection; SFr 8 for temporary
exhibits. Handicapped accessible.
Hours: Tues., 10-9; Wed.-Sun., 10-5. Closed Mon.
Programs for Children: Activities for children available.
Tours: Public tours (free with admission) usually Tues. Individual tours by
reservation only, (41) (31) 312 14 94.
Food & Drink: Cafeteria serves light fare.
Museum Shop: Offer books, posters, calendars, and cards.

Hermitage Foundation
2 Route du Signal, CH-1000, Lausanne 8, Switzerland
(41) (21) 320 50 01
http://www.fondation-hermitage.ch

1999 Exhibitions
January 22-May 24
The Golden Age of English Watercolours (1770-1901)
Evokes the luminous, subtle world of English watercolor painting, focusing
on the theme of landscape. Includes works by Sandby, Turner, and others.

June 25-October 24
Victor Brauner
Explores the surrealist art of Brauner (1903-1966) as part of an on-going
review of major pictorial movements of the early 20th century.

Permanent Collection

Temporary exhibitions focus on 19th- and 20th-century painting. The collection (which is not on permanent display) consists of paintings by foreign and local artists, including works by Bocion, Bosshard, Magritte, Sisley, Vallotton; also sculptures, drawings, and prints. **Architecture:** Country villa designed by architect Louis Wenger built for Charles-Juste Bugnion between 1842 and 1850; restoration in 1976.

Admission: Adults, SFr 13; children under 18, free. Handicapped accessible, including ramps and elevator.
Hours: Tues.-Sun., 10-6; Thurs. until 9.
Programs for Children: Offered throughout the year; call for details.
Tours: Thurs., 6:30; Sun., 3; groups by request.
Food & Drink: Cafeteria open during museum hours. Picnic areas available in the Hermitage park.
Museum Shop: Open during museum hours.

Fondation Pierre Gianadda

Rue du Forum 59, 1920, Martigny, Switzerland
(41) (27) 722 39 78
http://www.gianadda.ch

1999 Exhibitions

Thru February 28
Hans Erni

March 6-June 6
Turner and the Alps
Works of sublime beauty by this monumental British painter.

Permanent Collection

Three permanent galleries: **Le Musée Gallo-Romain**, featuring statues, coins, jewelry, and other artifacts from a first-century Roman temple discovered in 1976 (museum is constructed around the site); **Le Musée de l'Automobile**, a collection of vehicles from 1897–1939; and the **Parc de Sculptures**, featuring works by Miró, Arp, Moore, Brancusi, and others. Adjacent to the museum is an excavated Roman amphitheater.

Admission: Adults, SFr 12; seniors, SFr 9; children, students, SFr 5; families (parents and small children), SFr 25. Discounts for groups of 10 or more.
Hours: Open daily; Jun.-Nov.: 9-7; Dec.-May.: 10-6.
Tours: Guided tours in English, German, French. Reservations required; call (41) (27) 722 39 78.
Food & Drink: Garden restaurant in lovely sculpture park open during the summer, 9-7. Picnic areas.
Museum Shop: Open during museum hours.

Kunstmuseum Winterthur

Museumstrasse 52, Postfach 378, 8402 Winterhur, Switzerland
(41) (52) 267 5162

1999 Exhibitions

January 16-March 28
Jerry Zeniuk: Oil and Water
Retrospective of the artist's watercolors
and oil paintings.

April 10-June 20
Marius Borgeaud Retrospective

July 3-August 22
1st Manor Prize for Young Art

September 4-November 21
*Gerhard Richter: Drawings and
Watercolors Retrospective*

Permanent Collection
Modern and contemporary art.
Highlights: Works by Léger, Van
Gogh, Mondrian, and Gerhard Richter.

Admission: Adults, SFr 10; reduction,
SFr 6. Handicapped accessible.
Hours: Wed.-Sun., 10-5; Tues., 10-8.
Programs for Children: School tours
available.
Tours: Tues., 6:30.

Kunstmuseum Winterthur Main Building. Photo by
Michael Speich.

Kunsthaus Zürich

Heimplatz 1, 8024 Zürich, Switzerland
(41) (12) 51 67 65
http://www.kunsthaus.ch

1999 Exhibitions

Thru January 3
Max Beckmann in Paris
A look at Max Beckmann's relationship to his contemporaries, including
Braque, Delaunay, Léger, Matisse, Picasso, and Rouault, through 100
paintings from public and private collections. (T)

January 29-April 25
Chagall, Kandinsky, and the Russian Avant-Garde
Traces the evolution of Russian painting from 1905 to 1920 through rarely
seen works of art from Russian museums. (T)

mid-May-mid-August
Hyper Mental: Contemporary Art with Psychic Power
Work by artists such as Louise Bourgeois, Dieter Roth, Duane Hanson, Jeff
Koons, Douglas Gordon, and Damien Hirst that express psychic realities.

late-August-November/December
End of the World
In celebration of the new millennium, Harald Szeemann displays his
spectacular vision of the end of the world.

December 1999-January 2000
Walter de Maria: The 2000 Sculpture
Walter de Maria's ground installation of 2000 white chalk sticks provides a
vast space for meditation, beginning the new millennium in the spirit of Zen.

Permanent Collection
Features Old Master sculptures and paintings; works by Swiss artists
including Koller, Zünd, Böcklin, Welti, Segantini, Hodler, Augusto
Giacometti, Vallotton, Amiet and Giovanni Giacometti; 20th-century works
by Matisse, Picasso, Max Ernst and Miró; graphic art; photography.
Architecture: 1910 building by Karl Moser; expanded in 1925, 1958 and
1976.

Admission: Permanent Collection: adults, SFr 5; students, groups of 20 or
more, seniors, SFr 3. Sun., free. Special exhibitions: adults, SFr 8-14;
students, seniors, SFr 4-7; groups of 20 or more, SFr 7-12.
Hours: Tues.-Thurs., 10-9; Fri.-Sun., 10-5. Reduced hours on some
holidays. Closed Mon., major holidays.
Tours: Groups call (41) (12) 51 67 65.
Food & Drink: Café-bar and restaurant; garden café open in summer.

Musée Barbier-Mueller
10 rue Calvin, 1204 Geneva, Switzerland
(41) (22) 312 02 70

1999 Exhibitions
Thru April 15
Treasures of African Art

April 20-September
Arts of the South Seas

Admission: Adults, SFr 5; seniors and students, SFr 3.
Hours: Daily, 11-5.
Programs for Children: Special programs depending on exhibition.
Tours: Contact (41) (22) 312 02 70 for information.
Museum Shop: Bookshop offers museum publications.

An Additional Museum in Switzerland...

Museo d'Arte Moderna

Riva Caccia 5, Lugano, 6900 Switzerland

National Museum and Gallery, Cardiff

Cathays Park, Cardiff, Wales, United Kingdom CF1 3NP
(44) (1222) 397951
http://www.cf.ac.uk/nmgw

1999 Exhibitions

March-May
Henry Clarence Whaite

April 24-June 20
The Oppe Collection

June
Art Council Collection

July-September
Cecile Johnson

August-September 12
Gilbert Collection

**October 9, 1999-
January 2000**
John Houghton Morris Bonner

Admission: Adults, £4.25; children, £2.50; families, £9.75. Handicapped accessible.
Hours: Tues.-Sun., 10-5.
Programs for Children: Programs and workshops throughout the year.

National Museum and Gallery of Wales, Cardiff.

Food & Drink: Restaurant, coffee shop, picnic area nearby.
Museum Shop: Sells art, postcards, giftcards, replicas of works in the museum's collection, and items for children.

Index of Museums